INTELLECTUAL BIRDHOUSE

Artistic Practice as Research

INTELLECTUAL BIRDHOUSE

Artistic Practice as Research

Edited by

Florian Dombois, Ute Meta Bauer, Claudia Mareis, Michael Schwab

Koenig Books, London

CONTENT

INTRODUCTION

"And what calamity dost thou worship?" He said, "O my lord, I worship a god made of dates kneaded with butter and honey, and at times I eat him and make me another."
Arabian Nights[1]

No, artistic research is neither a novel phenomenon nor one imbued with an established history. Its distinctness (and lack thereof) has been shaped by historical discourses on the interactions between science, humanities and the arts during the late 19th and 20th centuries. Artistic research has no one essential history that precedes its emergence as a term during the last two decades; rather, it is constituted of many often-conflicting histories that do not tell a coherent story. Depending on one's point of view and the questions asked, 'Artistic Research' becomes legible as an integral part of various narratives—and its agents and outcomes similarly tell us not one but many different stories.

One narrative, for example, might investigate how artistic research is related to scientific research through shared projective practices such as sketching, modelling or designing. It might focus on the concrete material practices of experiencing and knowledge production, which another narrative may link to specific cultures as well as to the contexts of intermediation and application of knowledge. Yet another narrative might focus more on the common or different attitudes, self-perception and images of artists and scientists. Here, one might investigate how these attitudes are influenced and shaped by each other, and how they constantly generate 'boundary objects' and demarcation zones between the socio-cultural domains of art and science.

Outside of this relation to the sciences, additional narratives see artistic research as rooted in the history of art. As part of these, more recent conceptual practices might be mentioned, but high modernist artists, and even Renaissance artists, could also be credited as researchers. In fact, for some, all artists are researchers.

A further narrative focuses on the relationship between artistic research and technology, both in the sense that the latter develops and applies techniques for the production of artworks and in the sense of its roots in the Greek term *techné* (craftsmanship)—as an art that has in essence always been

9

1 642nd night, transl. by Richard F. Burton

epistemologically relevant. Herein may be found the root of another narrative that sees aesthetics as a discourse that in bracketing art and sense has pushed the site of knowledge into non-discursive realms without ever being able to distinguish properly between productive and reflective modes.

By far the most dominant set of narratives has developed around the transformation of art academies into research institutes, i.e. universities. Here, we witness a recent shift from notions such as 'practice-based' or 'practice-led' research to 'artistic' research, indicating that contemporary art refuses to be relegated to a mere basis for research. At the same time, the institutional transformations are so extreme that some narratives may doubt that much artistic freedom will be left once the appropriation of art academies is complete. Narratives put forward by institutional players may focus on quality assessment and impact factors, while their counterparts may concentrate on the exploitative dimensions of present knowledge economies. Aspects of these narratives are embedded in the various research programmes that have been created worldwide over the last few years, introducing extreme diversity into what people study and with whom, how they are assessed and the academic titles that await them in the end. Alternative art schools have recently become an important point of focus, which often either avoid or embrace the notion of research.

Almost independent of any of the above, and lacking cohesive narration, is the increasingly popular notion of research embedded within the work of artists, which in turn has been picked up by curators and gallery owners. In what some might describe as an act of appropriation, these artists and their representatives prefer to replace the still dominant term 'practice' with that of 'research' when describing their creative activity. Equipped with the luxury of ignoring demands for definitions, artists can transgress and thus challenge what any single narrative may project as research. This transgression in the name of art raises the question of whether to exclude art in order to be able to form a coherent concept of research, or to focus on art and to work out its real or fictitious epistemological standing. Since this endeavour can only fail when new narratives are being erected in order to structure what transgresses structure, approaching what artistic research might be clearly needs to adapt. In experiencing artistic research-practice, one may not arrive at an improved definition, but at an understanding of what is at stake when practice shifts into research.

While the subtitle of our book names its theme, with its main title—*Intellectual Birdhouse*—we want to emphasize that it is not so much a theme as an attitude that we seek. If, in the following pages, we do not offer a definition of artistic research, this is deliberate. We believe that artistic research

should not be seen as a discipline or a topic, nor is it really a method. For us, it is an attitude, a perspective, a manner. Thus we have collected the following voices, which in our opinion speak of this attitude. Listening to them hopefully gives a flavour or atmosphere of the direction in which artistic practices as research are heading: something independent from traditional disciplines, something that tries to overcome prejudices and questions itself, something that successfully interweaves the how and the what.

When planning this book, we initially attempted to design a compendium whose aim was both to explain and to survey the field that artistic research is entitled to occupy in the broad terrain of thought. But this quickly proved to be the wrong path. For in our eyes to claim that art is research opens access not to a field that can be delimited, but to the exploration of the surrounding space. Thus it is not our intention here to provide an overview of today's artistic-research positions by drawing borders and limits, but rather to give room to a number of acteurs so that their attitudes towards artistic-research production can unfold. The fact that many contributions deal with the issue of borders is perhaps no coincidence. After reading this volume, it seems to us that artistic research is an activity for border-crossers who, when negotiating frontiers, carry out their research somewhat differently from those who expand knowledge by inflating known territories or by registering a new claim in the hope that they will strike gold while keeping others out.

Intellectual Birdhouse suggests that the notion of 'artistic research' expresses an attitude towards knowledge that can not only be found in the visual arts, but also in music, theatre, design, literature and even in other disciplines such as science and philosophy. In short, to us, 'artistic research' is independent of 'discipline' and might occur in all contexts once epistemic expectations have shifted. For in our view, it is both a matter of productive and reflective work on and with the material, and artistic research often involves testing forms of representation other than text as well as engaging in open negotiations with knowledge that may take an unexpected or even controversial course. Thus we hope that disciplinary thought barriers can be left behind in order to remain open to the specific procedures of the authors and to perceive and set into relation their respective nuances amidst the general clamour about this or that notion of research or art. The intellectual birdhouse that interests us is an open architecture that is set up outside, in the field or forest, and brings together many different living things. It is a place in which space is also given to local and material thought, resisting transparent translation. We are interested in deep knowledge, which cannot be skimmed off to be consumed without effort.

Not all of the chapters directly address 'artistic research'; some do not even mention the term. In contrast to other publications that discuss

the notion head-on, we have tried to give a sense of a position between the present academic and artistic discourses. Just as in our own cases, where despite our different disciplines we share concerns, the authors in this book very often take a stance that is rooted in their own biographies, field of work and interests, from which the bigger picture can emerge. This 'bigger picture' traces a research community that is highly diverse, very specific and extremely engaged. Rather than attempting to define what artistic research might be, this book proposes how artistic research may be carried out. Rather than turning the screw yet again in order to force a definition on a certain type of practice that in the process silences that practice, we believe that the deficiency of definition is necessary if a foothold is to be kept in art. It would be absurd to assume that after a long period of modernity that has been very clear about the negativity of art through which it carved out its particular path of meaning, we should suddenly be able to inscribe positivity, and worse positivism, into its practices with the simple switch of a word. The attitude thus remains artistic.

At the same time, this book cannot be a work of art able to afford its own space; rather, it is just part of the emerging discourse on artistic research, which it tries to steer into a direction that is closer to contemporary artistic practices and the challenges they face. And making this a book about 'artistic research' is not a claim that those challenges can best be addressed in such a way; rather, the contributions in this book might equally be reconfigured to offer a critical perspective onto art, nowadays often missing, and the way it is often naively complicit in the commodity as well as the knowledge market. This is only possible, however, if the artistic attitude is maintained and art is exceeded.

This amounts to saying that there has to be contradiction at the heart of research in art, which explains why the institutionalisation of artistic research that is perpetuated in processes such as 'Bologna' must lose artistic interest if it succeeds. We very much welcome the resistance by which artists refuse to comply with simplistic models by stubbornly continuing to make art. We have witnessed over the last decades the fact that nothing will come out of the shift to research if the rules of knowledge continue to be dictated by a scientism left over from the 19th century. In fact, we would like to state that the waning of this model has created space for art to appear on the epistemological scene. The re-inscription of crude notions of knowledge when politically or institutionally required, such as when a degree has to be awarded or when funding has to be applied for, is nonsensical and does nothing but close down potential. The great transformation that a shift to research in art requires is not only on the side of the arts to make itself absorbed into what has been termed the 'knowledge economy'; it is also on the side of exactly this economy that has to get seriously interested in what it produces

and what these products might mean to all of us who are affected. There is fictitiousness in the 'knowledge economy' as compared with the reality of art, and who would have thought that art would become the link to reality in a world that is losing its grip in the name of knowledge?

So how does one sufficiently limit the definition of artistic research so as to develop epistemic claims while not breaking its own modes of making and thinking? The answer is: we don't know. We leave it up to the authors to calibrate their approach and to create relationships to practice as research. Having received these chapters, we saw a picture emerging that was not wholly unplanned but which nevertheless came as a surprise to us. First, when it comes to attitudes suitable to approach artistic practice as research, it is not a question of discipline but rather a question of sense, which tends to come when one's finger is placed on the pulse of practice, whether artistic, scientific, historical, political or otherwise. Practitioners or not, researchers must get under the skin of practice when they write about artistic research. Second, the conflation of knowledge and identity is questioned. An artistic expansion of knowledge includes the differential creation of identity, which ceases to appear as a given and now seems to be made. If all preceding identities are jeopardized—that of the artist, the writer, the work etc.—prejudices become impossible. The suspension of prejudice in research is an ethical, political and artistic necessity, because for too long knowledge societies have been allowed to repeat their own prejudices about what they consider to be 'rational'. It thus comes as no surprise that in the Intellectual Birdhouse, when attempts are being made towards finding a definition of the phenomenon of research, differential notions have more often than not replaced the customary negative notions that we know from Modernism. If it is possible to sufficiently radicalize these differential notions, we believe that the need to reduce artistic research to a novel identity will simply go away.

Intellectual Birdhouse advocates particular relationships between what has been called 'theory' and 'practice' (if such distinctions are still valid following the radical questioning by both artists and theorists of the delineation of 'theory' as well as 'knowledge' during the last decades). What remains in today's discussion of artistic research are questions concerning the type of models, terms and concepts that might elucidate the processes and outcomes of epistemic-artistic practices and projects. This implies that we must remember theoretical debates full of traditions as well as the ongoing negotiations about and within artistic research. As a consequence, most if not all of the chapters here discuss—from very different perspectives—how borders need to be negotiated as part of the research processes. This includes questions to do with art and science *(Rheinberger, Rickli, Borgdorff, Schwab)*, art and politics

(Holert, Slager, Steyerl, Maharaj & Varela, Raqs Media Collective, Green), art and history *(Svenungsson, Flach, Haralambidou, Carter, Badger & Upitis)* as well as art and philosophy *(Hecker & Matos, Steinweg, Ettinger, Miles)*. Many of the authors see themselves as artists, but it is one of the chief claims of this book that a position is possible beyond the 'theory' and 'practice' labels. The contributions speak of this position and the difficulties in negotiating it in the context of existing discourses and intellectual frameworks.

The format of the book had to respond to these issues. It proved impossible to create a well-ordered textbook where each section covers particular sub-topics. Rather, using the image of the birdhouse, to which many authors responded directly, we created both an open architectural structure—birds fly in and out—as well as a site for a polyphony of voices. In fact, the book suggests a layering of visual and acoustic metaphors throughout, which is yet another case where distinctions break down and dichotomies are negotiated. At the same time, the book is far from being unstructured. A multitude of themes is developed, often in parallel and with shifting emphases, which we chose not to intersect by adding section headings that prepare and guide the reader. In the end, the Intellectual Birdhouse weaves together a multitude of concerns that crisscross each other as the book unfolds. The colourful polyphony of the birdhouse is neither exemplary nor ornamental, but an implicit critique of the kinds of approaches that one encounters in the sprawling mass of recent publications on artistic research. This is because we feel that in the process of translating artistic practices into something labelled 'Artistic Research', many publications *contract*—they breathe in and hold their breath. You may also say that they are trying to close down on their prey, which in the case of artistic research seems to be ever elusive.

We thank the authors for their contributions and committed text work. We also thank Institute Y of Bern University of the Arts, FSP Transdisziplinarität of Zurich University of the Arts, the Royal College of Art London and the MIT Program in Art, Culture and Technology for their direct and indirect financial support; the Institute for Contemporary Arts Research of the Zurich University of the Arts for their contribution towards the translation of the article by Hannes Rickli; Sebastian Viebahn and Burke Barrett for their translations and editing work; and Sarah Stocker and Wolfram Höll for checking the literary references and for their library research. And last, but not least, we thank Fabienne Meyer for designing the book.

The editors:
Florian Dombois, Ute Meta Bauer, Claudia Mareis, Michael Schwab

SPYING ON SPARROWS
Jan Svenungsson

A few years ago I wrote a little book on artists' writing (Svenungsson 2007). As a writing artist myself, I wanted to address the aims and means of those who express their ideas and desires both visually and in words. Having discussed Giorgio de Chirico's 1929 novel *Hebdomeros*, I concluded: 'In this text, I find a kind of moral imperative which says that you may talk about anything, in any manner, as long as you do it with a maximum of precision' (Svenungsson 2007: 54).

These are bold words, and in context they seem to make sense. Decoupled from that context the statement still resonates—but what does it really mean? What, indeed, is 'precision' in a text? Is it any different from the precision involved in the making of an image? And how did I come to think of 'precision' in relation to *Hebdomeros*? This is an excerpt from De Chirico's novel:

> Though the district was now unquestionably elegant and so much more lively, Hebdomeros shunned it in favor of the park where the pine trees grew. They were martyred trees, for a strange epidemic was raging among them, these attractive, friendly trees, so healthy and tonic. Each one bore a stairway made of white wood, twined round its trunk like a giant snake; these spiral staircases ended in a kind of platform, a regular torture-collar which choked the unfortunate tree, on which the man known as King Lear to the habitués of the palace amused himself by spying on the birds, hoping to catch them in little-known poses and expressions. He watched out especially for sparrows. Lying down on the platform, as motionless as a log, he no longer looked like a human being. [...] This strange man looked more as though he were petrified, which is why he brought to mind the corpses uncovered at Pompeii. Through lying so long on the platform, he was finally becoming part of it; he was becoming *platformized*; he was turning into something like a large piece of undressed wood, hastily nailed in place to hold up the floor so that it might withstand an impact which would never come. That was why the platform looked upside down as he lay upon it in watch, for a crossbeam meant to strengthen the possible weakness of the planks could only be imagined as being nailed on *underneath*. Seen from such close quarters, the sparrows looked really monstrous. (De Chirico 1992: 15-16, Italics in original)

One result of the 'precision' employed in this writing is that, from the first time I read it, it immediately coalesced into a powerful image in my mind—one

I've never forgotten. Even so, although this passage has the form of a detailed description of something seen, for me it never translates into a clear visualisation. It's an 'image' which lives on in its exact *wording* and does not fully cohere into a picture. Which is irritating and a promise, all at once. Can 'precision' be an expression of the unfulfilled?

Expressing something unfulfilled is what the best art works do. They create within us a space of irresistible ambiguity, never closure. They contain something we cannot understand completely. Still, what we *do* understand is that this something *is* there, that it has the potential to be understood. Because of this promise, the work attracts our attention and curiosity and we continue thinking about it. On a practical level the work is an answer to a question the artist has advanced or which has come from outside. But this answer, to be meaningful, must, on a fundamental level comprise a new question... leading to an endless generation of interpretative activity. It must never provide an explanation. Thus, resolution is a promise never fulfilled; and the impact art makes on people is, to a significant degree, based on its ability to create confusion. Is it much different for text?

18 Today, text has become a dominant presence in the space surrounding visual art. It is a necessary component of artistic research. Unfortunately, there is much production of discourse, also by artists, that does not recognise the fundamental ambiguity of art. It is ultimately not possible to answer in a text, the question that a visual expression has raised. What most interests me is the artist who experiences a sincere need to express him or herself *in addition* to visual work, in words. A need which goes beyond the strategic demands of the art system and is not intended as an explanation of the visual. The question is raised: In what ways can words and images be complementary? Indeed, visual work may contain any number of words and texts, but within such work they too tend to become image.

Typically (always?) in a work of visual art, several language structures, both symbolic and literal, exist side by side. Think spatial organisation; sound; touch; colour; light; smell; shape, line and volume, all in two or three dimensions; photographic and filmic idioms; art historical and political references; materiality; temporality; digitality—as well as words and written language. These are just some possibilities. This multiplicity of means is obvious in, say, the admirable chaos of an installation by Thomas Hirschhorn, but the argument can also be made for most paintings or film installations. Approaching a work, whatever it is, our eyes flicker over its surface (its space), negotiating multiple entry points, messages and triggers, all the while deciding what to do with what is at hand. (That is, as long as we haven't allowed our response

to the work to be remote-controlled by a didactic text.) Even as we make our choices, other stimuli will continue to beckon for us to switch perspective and consider something else of what is available to our eyes and ears and touch. If the visual work includes writing and texts (or even whole books, as is often the case with Hirschhorn), these will be seen much more than they will be read.

A work of art serves up a range of alternative starting points—and these exist on a basis of equality.

It is different with text. One is conditioned to start reading at the beginning and to proceed along a track which has been laid out by its author, within the language of his or her choosing.

For practical reasons, a text has to take place within one single language (wilfully ignoring some experiments of a poetic nature). I will not suddenly switch to Swedish here just because a certain idea comes to me wrapped in a better phrase in my native tongue. My personal experience is that the limited language of writing allows for a freer approach to subject matter. In the initial stages of writing a text, I can throw around ideas and impulses in preliminary drafts without fear of losing contact with 'the reality of making'. The straitjacket of the chosen language, coupled with my sense of propriety during the editing phase, will eventually take care of reconnecting my text to a coherent line of thinking. Writing can be a very chaotic process only because the form demands such a high level of final discipline.

In contrast, in the studio I always need to start work with quite a clear idea of what it is I hope to make. Here there is too much potential for play. A plan is needed in order not to get lost among all the possibilities of language available. During the development of the work, all sorts of mistakes and deviations might influence its outcome. These are even necessary for the work to happen, for it to acquire independent meaning. If the initial idea were to be carried out in a straightforward fashion, without any surprising developments along the way, it would perhaps be successfully illustrated, but not fertilised. There would be no promise of anything else.

In preparation for this present text I opened *Hebdomeros* again and slowly leafed through it. It felt like returning to a city where I had once lived, spending an afternoon strolling its familiar sunlit streets, while the shadows grew longer. Here and there, I recalled events having taken place, knowledge gained, mysteries still remaining. The text reminded me both of what I had once learned of its author's position on certain issues, as well as the experiences and lines of thought I'd had on earlier readings of particular passages.

I wanted to find another short passage to quote. For the reader of this, my new text, I wanted to demonstrate the double capacity of De Chirico's

writing. How he's able to both elucidate his ideas (mainly through visual evocations) and to inspire thinking processes in the individual reader. This is a book written in one chapter, with very few paragraphs. It is difficult to break the flow of De Chirico's large blocks of text, to isolate a fragment without significantly lessening its impact.

There is a contradictory impact-making-mechanism at work in *Hebdomeros*: no argument or evocation is ever clear in isolation. Before finishing with one line of thought, De Chirico always introduces another, so that they overlap. Consequently, the reader always finds the conclusion to a certain passage somehow lacking, as though the train of thought is already well on its way to the next station. As a reader I have to scramble to make up the connections for myself, rather than being able to relax in my padded chair and see the thinking laid out pedagogically before my eyes.

The eponymous hero of *Hebdomeros* is on a quest which is never articulated, but which seems to have as its aim 'to understand'. He seems to attain something of this goal on two occasions: during the overheated lyricism of the final pages and earlier, during an evening of 'tableaux vivants', to which Hebdomeros has been looking forward with nervous anticipation:

Up to the last moment one had hoped for an "act of God"; something that would have prevented the performance from taking place: an earthquake, a revolution, the passage of a comet, a tidal wave; but, as always in these circumstances, nothing happened; everything took place in calm and perfect order. Hebdomeros mixed with the crowds that filled the restaurants; he still hoped for the "unexpected"; he questioned the people around him, read the papers, lent an attentive ear to the conversation of his neighbors at the next table. Nothing; not a cloud on the horizon; plain quiet everywhere: in heaven and on earth. So he had to bow before the inevitable. That evening, surrounded by his friends, he attended the performance and *understood everything*. The riddle of this ineffable composition of warriors, of pugilists, difficult to describe and forming in a corner of the drawing room a block, many-colored and immobile in its gestures of attack and defense, was at bottom understood by himself alone; he realized this at once when he saw the facial expressions of the other spectators. (De Chirico 1992: 92-93, Italics in original)

Towards the end of the 1920s Giorgio de Chirico painted a number of peculiar and jarring canvases featuring strange 'blocks' of gladiators and warriors in rooms. These figures were characterised by such striking distortions that even today it is difficult to decide whether the draughtsmanship displayed is 'bad' or 'bold'. Fear of ridicule must have been far from the artist's mind.

I have no problem accepting Hebdomeros' word that he was alone in 'understanding everything' about these scenes—provided that the scenes discussed in the text are related to these images, which obviously we cannot know. All through *Hebdomeros* there are such situations, where suddenly my memory of the author's paintings are triggered by some action or setting in the text. That said, the text is also autonomous. These virtual 'illustrations' are there only if you know enough to recognise them.

For the writing artist this is a most potent possibility: that rather than attempting to explain the visual work, one might reflect it in another form, use it as an implicit reference.

For the attentive reader it is easy to see how close De Chirico the writer sometimes follows in the traces of De Chirico the painter. This extra knowledge does not, however, in itself explain the quirks of the novel's narrative. There is no way to know exactly what is supposed to be taken away and learned either from text or image.

Hebdomeros is alone and suddenly he understands everything, yet he is not willing or able to specify what it is he has understood; and it does not matter, because if we don't make this up for ourselves it will be meaningless anyway.

'Precision' in either form of expression, visual or textual, is the tool 21
which will bring us to this point of uncertainty and promise.

References

Svenungsson, Jan. 2007. *An Artist's Text Book.* Helsinki: Finnish Academy of Fine Arts.
De Chirico, Giorgio. 1992. *Hebdomeros* (tr. anonymous). Cambridge: Exact Change.

BEING CONCERNED?
SCATTERED THOUGHTS ON 'ARTISTIC RESEARCH' AND
'SOCIAL RESPONSIBILITY'
Tom Holert

a) Seriousness

As much fun, excitement, play, frivolity, and pleasure works of art may be able
to entice, the seriousness of art has remained indisputable throughout history,
serving as a cornerstone of the belief systems and ideological structures that
support and sustain the institution of art itself. Seriousness in art can be defined
in different ways though. They may include highly conservative, formalist posi-
tions that demand the obedience to the disciplinary orders of composition or
genre, or radical stances of political commitment to and identification with the
causes of e.g. marginalised social groups. What qualifies as 'serious' art therefore
depends on a range of shifting conditions, while the notion of seriousness itself
can be said to belong to different discourses and disciplines. Accordingly, within
the realm of ethics, 'seriousness' can designate a particular value and a relation-
ship of the subject to herself or himself, as much as an obligation to become
(or to continue to be) a serious or sincere person. In sociology, 'seriousness' may
be considered a socially expected and therefore socially produced feature of
a person that is associated with values such as respectability or reliability and
a particular position in the social architecture of a given community or society.
In the field of art with its specific mechanisms of constructing reputation and
visibility, cultural capital, and market value, the seriousness of an artist is pre-
eminently proven by her or his attitude towards being an artist and therefore a
member of a particular professional group. 'In assuming the name of the artist as
a professional name', art historian Howard Singerman states in his 1999 study on
the making of artists in the American university, 'one assumes a responsibility,
an obligation to that name's past as well as its future' (Singerman 1999: 213).
Referring to Pierre Bourdieu's investigations into the technology of social
prestige, Singerman identifies seriousness as the aptitude to be what one is,
based on an identity 'constructed in and by and through the discipline' of con-
temporary art (Ibid.). To perform using the name of the artist means embodying
its history and future; this becomes the central task for everyone aspiring
to make a career in the art world. However, this 'art world' is not one single
and uniform sphere, but has become an increasingly differentiated, stratified,
specialised, heterogeneous universe, offering various options to its inhabitants.
Thus, the expression of an artist's 'seriousness' can include different modali-
ties and may be directed at different audiences for approval and approbation.

b) Research ethics and the question of art's autonomy

For the purpose of this short essay I would like to focus on the kind of 'seriousness' associated with the terms of 'research' and 'responsibility'. It seems to be an important, if unacknowledged motivation of many participants in the current discourse of 'artistic research' (granted its increasing variety and heterogeneity) to further enhance the (alleged) seriousness of 'art'. The established semantics surrounding the notion of 'research' appear particularly helpful in this endeavour. Innumerable guidelines and codes of conduct have shaped and advanced 'research' as a subject of ethical consideration. Especially UNESCO-related organisations, such as the International Association of Universities (IAU), have been instrumental in defining and redefining social contracts in order to set out 'mutual responsibilities, rights and obligations between University and Society' (IAU 1998). Positive traits such as 'collaboration', 'respect', 'honesty', or 'fairness' are fostered to render the relationships among scientists ethically sound; whereas 'social responsibility' and 'environmental responsibility' are considered primary communal goals and values of the scientific community and the scientific enterprise (cf. Evers 2001).

Quite typically, a 2008 booklet by the Committee on Freedom and Responsibility in the Conduct of Science of the International Council for Science (ICSU, founded in 1931) ponders the 'ethical responsibilities of scientific practice and the 'external' responsibilities of scientists to society' (ICSU 2008: 10) Based on sociologist Robert K. Merton's four principles of communalism, universalism, disinterestedness, and organised scepticism (CUDOS) (cf. Merton 1973), formulated in the 1940s, the ICSU paper emphasises the traits of 'honesty and integrity', as well as the reporting of methods and results in an 'accurate, orderly, timely and open fashion'; moreover, scientists are expected to be 'impartial and fair' regarding the assessment of scientific work and 'respectful and considerate, particularly where human subjects or animals are involved or where work can have an adverse impact on the environment' (ICSU 2008: 11). Addressing scholarship, basic research, strategic research, applied research, consultancy, and professional practice, the 2008 *Code of Practice on Research Ethics* issued by the British Research Assessment Exercise (RAE) demands of researchers that they consider 'the ethical implications of the research and the physiological, psychological, social, political, religious, cultural and economic consequences of the work for the participants' and to show 'respect for the rights of others who are directly or indirectly affected by the research' (RAE 2008: 2-3). Furthermore, informed consent by the participants is considered crucial, as is confidentiality and data protection.

The list of standards and policies produced and provided by research ethics is growing rapidly, and since the 1990s the discourse on the rights and

responsibility of research has increasingly entered the university as a discipline of its own (as 'research ethics' or 'academic ethics'). The 1998 Canadian Tri-Council Policy Statement for ethical conduct for research that involves humans, for instance, is based on the 'principle of *distributed justice*' and aims at avoiding any 'unfair share of the direct burdens of participating in research', whilst also preventing the unfair exclusion from research's potential benefits (cf. Bevan 2000: 6). Research ethics have even become an economic asset in the business of higher education, an asset which is framed in terms such as 'the value of long-term investment in an enhanced ethical culture and connection to the strategic plan' of improving the 'climate of research ethics' (Ferguson et al. 2007: 196).

Hence research ethics should be considered an important instrument for not only providing legitimacy and respectability but also for contributing to the kind of bureaucratic control in the research university that includes the peculiar sociological oscillation between 'administrative researchers and research administrators', criticised by Pierre Bourdieu (cf. 1988: 124). When Bourdieu was working on his book on the shifts within the French university system in the late 1970s and early 1980s, the issue of research ethics was not as prominent as it is today. However, reading his remarks on the replacement of the figure of the public, self-determined intellectual by a new set of academic personalities—the academic managers ('busy seeking funds for their "laboratories"'), the theme of research ethics does not seem that far away:

> The claim to bureaucratic reliability which defines the *responsible intellectual* [...] has indeed as its corollary [the] renunciation of the premise of critical detachment from authority and of the total intellectual ambition which defines the social personality of the intellectual [...]. (Ibid.)

Performing 'responsibility' in the academic field has since become unthinkable without reference to the 'ethical' obligations of researchers. Whether the renunciation of critical detachment from authority, diagnosed by Bourdieu for the 'responsible intellectual', also characterises the contemporary researcher following the norms and standards of the ethical codes in the wake of the environmental crisis and human and animal rights concerns, is certainly up for debate. Considering key features of a contemporary governmentality of the 'audit society' (Michael Power)—a 'society organised to observe itself through the mechanisms of audit in the service of programmes for control', it still can be argued that research ethics create specific patterns of accountability, a set of norms that becomes indicative of, e.g., an organisation's or a research depart-

25

ment's 'health' (Rose 1999: 154).[1] By using 'advanced liberal styles of governing' such as 'autonomisation' and 'responsibilisation' (cf. Ibid.), the individual or collective acteurs of science and research are modelled as independent and reliable, and free and responsible, at the same time. The very existence of research ethics as an instrument of monitoring and evaluating research points to a 'problematisation', as Michel Foucault would have called it, a rendering of the (subject) position of the researcher as something in need to be scrutinised and defined, according to historical, social, and institutional circumstances.

Of particular interest in the context of this essay is the extent to which the ideas and expectations of use and utility, of reliability and responsibility associated with research, resonate with ideas about art and artistic practice. Since the outcomes of every research endeavour are expected to be serving the needs and the well-being of society and humanity—especially if the research is funded by public, that is taxpayers' money—the 'traditional' relationship of artists in a modernist and/or *avant-garde* vein *vis-à-vis* society is inevitably affected and reconfigured in some way or the other the moment it enters the realm of research and research funding. Codes of publicness and scientificity, regardless of the site-specifically negotiated terms and framings of artistic research, inevitably recalibrate the mindsets and behavioural patterns, the intellectual and aesthetic strategies of artists working within the funding and employment schemes of the research university.

For, conceived as being couched in the mode of research, contemporary practices associated with and institutionalised by the artistic research paradigm seem a far cry from modernist conceptualisations of art and artistic practice as quintessentially autonomous, i.e. liberated from any obligation and responsibility in relation to the public good, or corporate interests for that matter. Yet, public art and community art programs—as well as various re-orientations within the art field entailed by feminist, post-colonial, ecological, and other political, emancipative agendas—have over and again emphasised, by adapting and sometimes inverting traditions of politically and socially committed art, the unavoidable entanglement and engagement of art and artists (as well as other practitioners in the art field) with the textures and dynamics of social and political life.

c) Responsibility
How do (or should) such interactions and interdependencies affect the ways in which artistic research is imagined and pursued, within and without the

1 With reference to Power (1997).

institutions of higher education? How and by whom are public needs and demands getting identified; and what kind of 'responsibility' results from such identifications for the researching artists? In contradistinction to epis-temological and ontological speculations about the 'artistic', artistic research needs to be discussed by acknowledging the kind of social concerns and concernedness—that is, 'seriousness'—which is expected and required *of* as much as it is invoked and claimed *by* the practitioners. In 2009, the sixth *Sensuous Knowledge* conference at the Bergen National Academy of Arts was held under the heading *Reflection, Relevance, Responsibility*. The conference set out, among other things, to 'shift the debates [around artistic research, TH] into a more urgent context'. The following questions were asked:

> How do we as artistic researchers, through critical reflection, address and engage with what we see around us? How can artistic research make a meaningful and relevant contribution outside of itself? And how can it acknowledge the responsibility of art and research towards the world outside the academy? (SKC 2009)

Aligning 'responsibility', 'art', and 'research' in this way is quite telling, since it already presupposes the very 'responsibility' which is seen as knit-ting together 'art' and 'research'. This convergence implicitly acknowledges what may be called an 'imperative of responsibility'. That expression was made popular through the 1984 English translation of the title of Hans Jonas' neo-gnostic treatise *Das Prinzip Verantwortung* (1979). And even though the ecological responsibility advocated by Jonas should not be confused with the responsibility invoked and deployed as a tool of the neoliberal gover-nance of subjectivity, the 'heuristics of fear' that he proposed as a means to act in a world of long-term and long-distance consequences of technology join a constantly changing, diversifying, and complexifying armature of ethical demands and postulates which affect not only the systems of politics, economy, technology, or science but also culture and the arts.

Society's expectations of the arts may be manifold. However, a central demand, voiced in various sections of public culture and addressed to the artists, has become the call to work on appropriate, adequate, and timely responses to historical events, political change, social crises, or environmental catastrophes. For it is demanded of 'responsible' artists to provide fresh approaches to and surprising representations of such developments, rendering critique and interpretations that exhort to reflect or even revise one's moral or political standpoints. Delivering the 'right' questions and unexpected, hence aesthetic 'solutions' to issues conceived as 'pressing'—concerning the well-being of national societies or specific communities—implies a whole gamut of

preconceptions about the role of the arts in society, as well as the ethical, politi-
cal, psychological, and epistemological conditions of artistic production. In
order to arrive at new conclusions concerning the conditions of artistic knowl-
edge production—considered as a multi-level, transdisciplinary, political,
and necessarily hybridised (and hybridising) process—it is thus vital to inquire
into the frameworks of action and reaction of acteurs in the artistic field.

In order to better understand how contemporary art has become entan-
gled in a logic and technology of governing that uses 'responsibilisation' as one
of its pre-eminent strategic instruments, it might be helpful to at least selec-
tively render the genealogy of the concept-metaphor of 'social responsibility'
in regard to art and artists. To get an idea of how the issue of 'responsibility'
has been discussed in a modernist, mid-twentieth century, cold war context,
one may turn to the four papers read at a session on *The Responsibility of the
Artist in Contemporary Society* at the 1955 College Art Conference at North-
western University, Illinois, a 'symposium' which appears to have remained
without greater resonance in the worlds of art and art education, probably due
to the hardly well-known participants—though it presented a rather interest-
ing critique of traditional conceptions of the social (or civic) roles of artists.

The philosopher John Alford discussed the 'myth' of 'the Artist' and
tried to defend the creative artist from 'much too much responsibility' fas-
tened on him [!] by 'theorists, critics, educators and administrators' giving him
the 'role of oracle and seer' (Alford et al. 1956: 201). In a postscript to his talk,
Alford—anxious about the 'military uses of technological power'—reminds
the readers of the *College Art Journal*, in which the 'symposium' on social
responsibility was published, of the larger political and historical environ-
ment in which this debate resides:

> The inherent structure of a technological civilisation imposes what now looks
> like a crushing weight of responsibility in the organisation of power and publicity
> (or "communication") to humane ends, and by humane ends I do not mean merely
> adequate means of livelihood, a two-car garage and easy shopping. (Ibid.: 204)

Instead of desiring such amenities, he asked (in vintage existentialist manner),
for 'the opportunity for selfdetermination for those with sufficient "courage
to be"' (Ibid.).[2]

2 Behind such utterances of course lurks the debate on freedom and responsibility most prominently led by
 Jean Paul Sartre, before, during and after the Second World War, cf. for instance Sapiro (2006 and 2010).

Holcombe M. Austin, a philosopher teaching at Wheaton College in Norton, Massachusetts, pointed towards attempts to recruit US artists 'for the "cold war"', quoting from a 1955 report on art and entertainment as weapons in a 'global battle of the arts' (Ibid.: 205). American artists, however, were reluctant to participate in propaganda efforts; which Austin believed was exactly the reason that qualified them for their role as respresentatives of the 'free world': 'We, in contrast to the totalitarians, might well undertake to keep open the notion of art as fantasy, art as revel, art as escape from social seriousness' (Ibid.: 211). Hence the responsibility of the Western artist, 'free to experiment and explore', lies precisely in the refusal of a language and a behaviour that would signify 'social seriousness'; instead, art's fictionality and playfulness is turned into a statement against the alleged 'responsibilisation' of the cultural producers of the Communist bloc. Helmut Hungerland, another philosopher and associate editor of the *Journal of Aesthetics and Art Criticism*, urged for precision in the handling of terms such as 'contemporary society', which here seems to be 'roughly equivalent with "Western" society; leaving open for the time being the question whether such a vast conglomerate assembly of subcultures is a sufficiently precise referent for "contemporary society"' (Ibid.: 216). The responsibility assigned to artists therefore depends on the conditions of a very particular social context as well as on the ideas such a context cultivates towards the figure of 'the artist'. Hungerland, however, proposed to abstract the individual artist from responsibility as 'we are concerned, I assume, with the products of their work as they affect our contemporary society' (Ibid.). Further suggesting that one should replace the concern for responsibility and irresponsibility with the 'analysis of function', Hungerland advances a somewhat sociological perspective, resembling Talcott Parson's theory of functional differentation. According to this view, art is a system (or 'component') among others (such as politics, religion, or economics):

> If we accept this concept of society, the artists have as much responsibility in society as they are willing and able to assume and "society" is ready to grant them (keeping in mind that artists are part of society). (Ibid.: 218)

To an extent, responsibility appears to depend, for all members of society, on the negotiations among the systems and acteurs of society. The speakers of the 1955 session agreed on the necessity to change the conceptualisations of art and artists alike, turning them into functional or relational elements of society associated with certain images, practices, and expectations that have become subject of cultural and political debate.

29

The only artist at the symposium, the painter, teacher and art historian George M. Cohen, referred to a certain routine in addressing the issue of responsibility, to 'the many who have written on the problem' and various UNESCO activities promoting the issue. Cohen suggested that 'We must consider not only the artists' goals but the goals of the rest of society. What are society's goals that artists should conform to them?' (Ibid.: 212). Although he did not provide any answer to this question, he emphasised (like Hungerland) the historical, political, and cultural malleability and specificity of the concept of 'society'; furthermore, he questioned the general consensus, shared by Philistines and progressives, that artists 'are leading us toward a destruction of values' and are 'against the standards we would like to believe in' (Ibid.: 214). In a rather subtle dialectic argument, Cohen speaks of the conventional 'value of the artist' in light of the fact 'that he [!] is a kind of guardian against conformity' (Ibid.). This socially consecrated non-conformist stance, however, is usually linked with social perceptions of the artist's exaggerated 'self-expression' and of works that 'are often criticised for being private and for being the result of irresponsible freedom' (Ibid.). But 'how free can an artist be?', Cohen went on to ask. Is he or she, for example, free to refuse the socially constructed norms and standards of 'good art'? Here, an issue of 'rights' emerged in Cohen's talk. Are artists entitled to do what a given society has not asked for and is not ready to accept as legitimate (or even as legally sound) art? '[B]efore we concern ourselves too much with the artist's responsibility', Cohen ventured, 'we ought to concern ourselves with the artist's right to do "bad" painting' (Ibid.: 215). But what kind of 'right' this could possibly be, if not the right to fail in the eyes of the cultured public, to become, as a work or as an artist, unamenable to cultural approbation?

d) Citizenship

Meanwhile 'bad painting' has become the name of a post-modernist genre of its own. The right to debunk existing norms and values of artistic accomplishment does not seem that much of a controversial issue any longer, considering the prevalence of largely pluralist conceptions of the arts in society. However, if 'good' and 'bad' are deployed as value judgements in the register of public morality and civic responsibility, they continue to be applied to the arts, albeit in ways that are sometimes difficult to discern. Recently, the notion of 'artistic citizenship' has gained a certain notoriety. The public role of art and the role of 'public art' are discussed in terms that resemble in part the discussion held in the 1955 symposium on 'The Responsibility of the Artist in Contemporary Society'.

A 2006 collection of essays on the notion of 'artistic citizenship', commissioned by the Department of Art and Public Policy, an initiative at

the Tisch School of the Arts at New York University, considered the various entanglements and obligations artists meet in post-1989 and post-9/11 societies, societies which are marked by neoliberal governmentality, celebrity culture, economic crisis, and war—interrogating the 'common calling' of artists (Martin 2006: 18). How artists are able, willing, or allowed to participate in the public(s) of such societies, is informed to a large extent by the institutions of (higher) education that have since the 1950s evolved from being mainly train- ing grounds for the acquisition of technical skills into the realm of teaching the artist to perform as a professional. Art schools have become sites for a complex orientation—of students, teachers, and researchers—towards the various markets of the commercial gallery system, public art institutions, and research. They may have also become what one of the editors of *Artistic Citizenship* calls 'the commons for artists: the place where their responsibilities to one another are posed, where rights of practice are exercised, where ambitions for the world are honed' (Ibid.: 17); according to this view, art schools

> can be precisely the arena where ethical responsibility and artistic excellence intersect,
> where a commitment to an artistic community is harmonised with civic interests,
> where art earns its freedom to practice by being worthy of worldly attention. (Ibid.)

31

The lofty rhetoric that charges this vision of the art school, as incubator of civic responsibility and worth, mirrors an institutional desire to adapt to the norms and standards of the very public that is (or should be) the subject of criticism and research conducted by artists and other cultural workers. What if the 'citizenship' of artists and art communities is proven less by their conform- ing to 'civic interests' and 'worldly attention' than by their questioning and ultimately attacking the very complicity between art and higher education, research administration, galleries, museums, biennials, government, and social utility? In short, is there an art imaginable that disrupts and splits reality, and makes incompatible claims with regard to what is communally shared?[3] Obviously, such questions address the issue of the political in relation to the arts and the characteristics of a possible artistic practice that would not comply to the control of police-politics, but engender a different and differing mode of participating in the city. Recognition of the public character of art would therefore result in a particular way of rendering citizenship. An example for

3 This, of course, is asked with reference to the work of Jacques Rancière, particularly *Disagreement* (1999); see also Maimon (2009: 96).

such a rendering is artist Simon Leung's response to a 2008 questionnaire on the ways in which 'artists, academics, and cultural institutions responded to the U.S.-led invasion and occupation of Iraq', published in an issue *October* magazine, edited by critics Benjamin H.D. Buchloh and Rachel Churner. Fostering the parallel of radical and ethical subjectivity, Leung wrote: 'Art and activist practices exist in perpetual dialogue with continuous political struggles and social transformations. The continual radicalisation of the political subject lies not in holding onto a narrative of an *a priori* political subjective entity whose contiguity is disrupted by technological assaults, but rather, in a Levinasian sense, in the response-ability of the subject called into difference in the world, where there is always a potential for rupture, which is the condition for change' (Leung 2008: 102). The potential for rupture, however, is critically endangered by the very 'professionalisation' that anchors the artist to the middle class and the bourgeoisie and which, as another artist-respondent to the questionnaire, John Miller, argues, 'in turn leads to quietism' (Miller 2008: 117).

e) Art/Research
Apparently, the 'response-able' artist-citizen—bound for radical change and thus for rupturing the consensus that stultifies the political and lets politics take over—is caught in a complex web of criticality. In particular, the emerging academic environments that aim at producing artistic research seem to be charged with expectations of professionality and ethical conduct alike, therefore projecting a rarified citizen-subject prone to perform the duties of aesthetic and epistemic progression and transgression. *Progressive Disorder,* the title of a 1999 video by artist Christine Borland, renders this dilemma quite aptly, though it belongs to a different semantic register. Borland, an artist-researcher who closely collaborates with medical and forensic practitioners, has studied the work of Armand Duchenne, a mentor and colleague of Jean-Martin Charcot—particularly his research into muscle dystrophy. Named after the nineteenth century physicist and neurologist, Duchenne muscular dystrophy (DMD) is a recessive X-linked form of muscular dystrophy. A rapid progression of muscle degeneration eventually leads to loss of ambulation and death, usually in the second decade of life. Borland's video shows original drawings by Duchenne juxtaposed with filmed images of children suffering from DMD, trying to cope with the disease and rise to the erect posture.[4] In works such as this, Borland has been addressing, since the early 1990s,

32

4 For a short description and discussion of the work, see Barilan (2007: 116-120).

a whole range of ethical dilemmas entailed by art/science encounters. Employing a variety of materials used in DNA research, she has explored issues of morality, mortality, individuality, and the construction of identity. Among her many projects, the contribution to the 1997 Skulptur Projekte Münster exhibition, the 14-part installation *The Dead Teach the Living*, stands out, in terms of controversy.[5] Interested in the collection of the Anatomical Institute of the University of Münster, the artist reconstructed—by means of advanced forensic technology, using a 3D scanner and plastic material—some of the few specimens of anatomic heads that remained in the Institute after the bombings of the Second World War. In the course of her investigation, Borland discovered that 'the University itself had a very dark period during the Nazi time, that their teachers had been associates of Mengele, that specimens were obtained from prisoner war camps to study. It had been a centre for *Rassenhygiene*, racial hygiene, in the National-Socialist years' (quoted from Lu 2010: 97).

The ethically and historically sensitive issues involved in and caused by such an endeavour clearly pose a challenge to the artist's responsibility as 'citizen' of art and science. Using anatomical data, evidence, and materials in artwork almost inevitably provokes questions that fall into the domain of research ethics and medical humanities—including those which were most prominently codified by the Nuremberg code of 1947, which includes such principles as informed consent and absence of coercion, properly formulated scientific experimentation, and beneficence towards experiment participants. Since she works in a trans-disciplinary terrain, connecting visual art, medical humanities, bio-politics, and ethics—and cooperates with medical and forensic institutions such as the Medical Faculty at Glasgow University—Borland considered it necessary to devise a personal moral framework, analogous to the Nuremberg Code or the Code of Medical Ethics, to inform her practice.

The ethics of developing new genetic technologies, of prenatal screening programs and of 'the ability to detect anomalies which lead to congenital abnormalities in newborns and later adult-onset diseases' has interested Borland since the late 1990s. Her quest as an artist is far-reaching:

> Ultimately, the work tries to touch on individual and societal conceptions of identity and in particular to explore the concept of the "normal and the pathological." How in the

33

5 Though the inclusion of *L'homme double*, 1997—a sculptural installation with six busts of Josef Mengele, commissioned by Borland from fellow artists, based on a single photo and some written descriptions, in the 2002 exhibition "Mirroring Evil. Nazi Imagery/Recent Art" at the Jewish Museum, New York—caused the greatest scandal surrounding her work.

future will society deal with disability when it becomes increasingly possible to detect
a wide spectrum of abnormalities by prenatal testing and termination? [...] The specter
of eugenics within this contemporary debate is inevitable. (quoted from Morgan 1999)

Part of Borland's practice as an artist who participates in research while con-
ducting her own aims at avoiding the often sensationalist discourse and the
moral panicking around topics such as genetics. Bringing the debate 'into a
different territory', she claims to be producing art that gives 'more space and
more time' to public, ethical concerns (quoted from Jung 2006). Grounding her
argument on a surprisingly traditional division between scientific rationality
and artistic intuition, Borland finds her place and function at the art/science
interface by providing medical science a different set of material practices and
methodologies. 'Medical researchers will look for logical purity, uncluttered
by real life. But artists are not that pure, so they can create new openings for
a personal approach' (Ibid.). Working with medical students who spend time
at the Glasgow School of Art, she acts as a facilitator but also as an observer of
the students' processes of learning and sharing, eventually ending up doing
collaborative work, using the art school's video equipment, 'where they tape
the actor-patient and student doctor doing consultation set-ups' (quoted from
34 Lu 2010: 92). Presupposing a specific idea and image of artists as collaborators
and facilitators in medical situations, Borland champions the artist's capacity
of 'looking at a bigger picture', instead of studying the symptom in isolation.
Collaboration of artists and medical students would therefore result in 'much
more of an integrated way of looking and using the Humanities' (Ibid.: 94).
 In this sense, the newly created discipline of medical humanities has
become a potentially hybrid area of interaction and cooperation between scien-
tists and non-scientists. This is considered particularly valuable in regard to the
interest in changing the relationships between researchers and the researched.
It thereby responds to the increasing significance of research ethics and the
emergence of a post-Feyerabend 'citizen science', i.e. the harnessing of non-
scientists for scientific problem-solving as a new governmental figure of respon-
sibilisation (cf. Hand 2010). The process of broadening the base of responsibility
increasingly involves and engages artists as participants of research, medical or
otherwise. A specifically relevant area of this development is the collaborative
effort to protect the rights and the wellbeing of research subjects in so-called
human research. Christine Borland has been identified, by scholars working in
the field of medical humanities, as an artist providing examples 'of events in
which the lack of collaboration has caused grave injustice and injury, and has not
been simply a matter of mere indiscretions' (Schwartz 2003: 60). Works such as
HeLa Hot, 2001, negotiating the usage in research of cells from Henrietta Laks,

an African American woman who died of cancer in the 1950s, or *Cet être-là, c'est à toi de le créer! Vous devez la créer!*, 1996, a clandestine documentation of specimens collected by French colonialists and stored in a closed anatomical museum in Montpellier, are being discussed with regard to what extent they may or actually do or do not raise questions about consent and the 'person in the image' (cf. Ibid.). With good reason, the 'incongruity of the presence of tissue, bone, and blood' in Borland's installations are related to a 'contextual strain invoking significant queries about the appropriateness of their use' (Ibid.). Not only the deployment of body parts and genetic material whose origin is dubious and often lacking a legally acceptable certificate of consent creates an ethical issue here—also the very fact that these entities seem to be largely disposable, for the production of arbitrary research results and/or aesthetic sensations. Moreover, it has become an increasingly sensitive matter at the interface between art and research, whether, for instance, art installations or performances that include observational or video documentation qualify as 'research involving humans', thereby being automatically subjected to concerns about informed consent of participants as well as privacy and confidentiality issues related to the storage or banking of data that identify participants on tape, film, or disc (TCPS 2003). The interesting question in regard to the aforementioned issues of responsibility and responsibilisation, of citizenship and the particular 'political' disruption of consensual aesthetics, consists in the possibility or impossibility to distinguish between research and art, since the ethical concerns and regulations seem to be directed accordingly. Hence, if the investigation into people's reactions to an art performance is pursued simply to 'find out how an exhibit is progressing', it would not qualify as 'research', according to a Canadian advisory panel on research ethics. If, however, 'one purpose, use or eventual function' of such recordings is 'to provoke reactions or behaviours, to collect data on those reactions, and then use the data in a study of behaviours', then the project is 'likely to qualify as research involving humans,' and would thus require a proper research ethics review (cf. Ibid.). In other words, the sense of responsibility and the degree of ethical concern may vary, depending on the proximity or distance of a given practice to the discursively shaped realms of either research or art. In addition to already existing ethical codes of research, a discipline such as medical humanities could develop to further complicate the issue of responsibility and its distribution along (or across) disciplinary boundaries. The proposal to restore 'subjectivity to the object of research by passing back some control over image and interpretation' (Schwartz 2003: 64) can be seen as the outcome of overarching methodologies and practices of close collaboration between artists and researchers, within the split figure of the artist-researcher, and between researchers and the researched.

f) Conclusion

The forays into practical-discursive fields of demands and regulations with regard to research, art, and responsibility—made in the course of this essay—hardly converge into a comprehensive or even plausible portrait of the very conundrum that emerges at the intersection of a) ethical and economical concerns, (b) traditions of modernist artistic attitudes (and methodologies), and (c) current reorientations in the art-educational realm towards production with a research bent, along with curatorial strategies aiming at 'knowledge production'. Christine Borland's occupation with ultimately biopolitical issues of medical humanities and the ethical concerns of experiments 'involving humans' clearly belongs to a different order of ethico-political entanglement than, say, the re-invention of an *artiste engagé* who is expected to perform a decidedly political criticality in her work and public appearance, that is displaying a palpable stance of responsibility in the face of current wars, ecological catastrophes, economical crises, racist immigration laws, or the general demise of egalitarian ideas of the social. However, the question remains, in what ways considerations of the artist's 'social responsibility' inform the sometimes latent, often manifest 'responsibilisation' encountered by artists and other cultural producers who invest in ideas and practices (partaking in the politics and economy) of 'research'. It might appear easy and somewhat obviously 'artistic' to repudiate any demand for acting 'responsible', according to ethical norms. For insisting on the artist's right to irresponsibility, assuming the ethics of an aesthetic existence of the subject that disrupts the normativising economy of public claims and expectations of ethical behaviour, is probably something that even proponents of 'artistic research' would demand of an artist who claims to be conducting research. In other words, one of the distinguishing features of 'artistic research' could be the negotiation and questioning of legal or contractual agreements about proper behaviour in the pursuit of scientific research, which could result in the contestation of the existing contractual and legal bounds. For why should artists be interested to attend or even help to maintain such a regulated environment? Considering the resulting, ultimately self-inflicting stance of (ir)responsibility of the researching artist caught in a web of projections and regulations, the particular 'response-ability' of 'the subject called into difference in the world', as evoked by Simon Leung via Emmanuel Levinas (Leung 2008: 102), may indeed prove a useful guiding principle for addressing as much as suspending the imperative of responsibility in artistic research.

..

References

Alford, John, Holcombe M. Austin, George M. Cohen and Helmut Hungerland. 1956. 'The Responsibility of the Artist in Contemporary Society' in *College Art Journal* 15(3) (Spring 1956): 197-227.

Barilan, Y. Michael. 2007. 'Contemporary Art and the Ethics of Anatomy' in *Perspectives in Biology and Medicine* 50(1) (Winter 2007): 104-123.

Bevan, David R. 2000. 'Research Ethics—an Evolving Discipline' in *Canadian Journal of Anaesthetics* 47(1): 5-9.

Bourdieu, Pierre. 1988 [1984]. *Homo Academicus* (tr. Peter Collier). Stanford: Stanford University Press.

Evers, Kathinka. 2001. 'Standards for Ethics and Responsibility in Science: An Analysis and Evaluation of Their Content, Background and Function'. Paris: SCRES. Online at: http://www.icsu.org/publications/reports-and-reviews/standards-responsibility-science/SCRES-Background.pdf/at_download/file (consulted 25.03.2011).

Ferguson, Kryste et al. 2007. 'Enhancing the Culture of Research Ethics on University Campuses' in *Journal of Academic Ethics* 5(2-4): 189-198.

Hand, Eric. 2010. 'People Power: Networks of Human Minds Are Taking Citizen Science to a New Level' in *Nature* 466 (5 August 2010): 685-687.

IAU (International Association of Universities). 1998. 'Academic Freedom, University Autonomy and Social Responsibility'. Online at: http://www.iau-aiu.net/p_statements af_statement.html (consulted 25.03.2011).

ICSU (Committee on Freedom and Responsibility in the Conduct of Science of the International Council for Science). 2008. 'Freedom, Responsibilityand Universality in Science'. Paris: ICSU. Online at: http://www.icsu.org/publications/cfrs/freedom-responsibility-booklet/ICSU_CFRS_booklet.pdf/at_download/file (consulted 25.03.2011).

Jonas, Hans. 1979. *Das Prinzip Verantwortung: Versuch einer Ethik für die technologische Zivilisation.* Frankfurt/M.: Insel Verlag.

Jung, Klaus. 2006. 'Enabling Knowledge'. Keynote address, 'Sensuous Knowledge' conference, Solstrand, Norway, November 2006. Online at: http://www.khib.no/index.php/khib/KU-FoU/Publikasjoner/Bokutgivelser/Klaus-Jung-Enabling-Knowledge/Klaus-Jung-Enabling-Knowledge/Christine-Borland (consulted 25.03.2011).

Leung, Simon. 2008. 'Market Dissent' in *October* 123 (Winter 2008): 102-104.

Lu, Peih-ying. 2010. 'Medical Communication as Art: An Interview with Christine Borland' in *Language and Intercultural Communication* 10(1) (February 2010): 90-99.

Maimon, Vered. 2009. 'The Third Citizen: On Models of Criticality in Contemporary Artistic Practices' in *October* 129 (Summer 2009): 85-112.

Martin, Randy. 2006. 'Artistic Citizenship: Introduction' in Schmidt, Campbell, Mary and Randy Martin (eds) *Artistic Citizenship: A Public Voice for the Arts.* London and New York: Routledge: 1-22.

37

Merton, Robert K. 1973 [1942]. 'The Normative Structure of Science' in Storer, Norman W. (ed.) *The Sociology of Science: Theoretical and Empirical Investigations.* Chicago and London: The University of Chicago Press.

Miller, John. 2008. 'Fictions of the Dismal Theorem' in *October* 123 (Winter 2008): 116-118.

Morgan, Anne Barclay. 1999. 'Memorial for Anonymous: An Interview with Christine Borland' in *Sculpture Magazine* 18(8) (October 1999). Online at: http://www.sculpture.org/ documents/scmag99/oct99/borland/borland.shtml (consulted 25.03.2011).

Power, Michael. 1997. *The Audit Society: Rituals of Verification.* Oxford: Oxford University Press.

RAE (Research Assessment Exercise/University of the Arts London). 2008. 'Code of Practice on Research Ethics'. Online at: http://www.arts.ac.uk/docs/13_RSDC_UAL_Code_ of_Practice_on_Research_-EthicsForRSDCMarch2011.pdf (consulted 25.03.2011).

Rancière, Jacques. 1999. *Disagreement* (tr. Julie Rose). Minneapolis: The University of Minnesota Press.

Rose, Nikolas. 1999. *Powers of Freedom: Reframing Political Thought.* Cambridge: Cambridge University Press.

Sapiro, Gisèle. 2010. 'The Debate on the Writer's Responsibility in France and the United States from the 1920s to the 1950s' in *International Journal of Politics, Culture and Society* 23 (2-3) (September 2010): 69-83.

—2006. 'Responsibility and Freedom: the Foundations of Sartre's Concept of Intellectual Engagement' in *Journal of Romance Studies* 6(1-2): 31-48.

Schwartz, Lisa. 2003. 'Parallel Experience: How Art and Art Theory Can Inform Ethics in Human Research' in *Medical Humanities* 29(2): 59-64.

Singerman, Howard. 1999. *Art Subjects: Making Artists in the American University.* Berkeley, Los Angeles and London: University of California Press.

SKC (Sensuous Knowledge Conference). 2009. 'Call for presentations' ('Reflection, Relevance, Responsibility', sixth Sensuous Knowledge Conference, 2009). Online at: http:// sensuousknowledge.org/2009/03/call-for-presentations/ (consulted 25.03.2011).

TCPS (The Interagency Advisory Panel on Research Ethics, Interpretations of TCPS [Tri-Council Policy Statement: Ethical Conduct for Research Involving Humans]). 2003. 'Research or Art? Video Documentation of Reactions to Performing Arts'. Government of Canada: Panel on Research Ethics. Online at: http://www.pre.ethics.gc.ca/eng/archives/tcps-eptc/ interpretations/interpretation006/ (consulted 25.03.2011).

38

--

Weblinks

http://sensuousknowledge.org/2009/03/call-for-presentations/(consulted 25.03.2011).

http://www.arts.ac.uk/docs/13_RSDC_UAL_Code_of_Practice_on_Research_EthicsForRSDC
 March2011.pdf (consulted 25.03.2011).

http://www.iau-aiu.net/p_statements/af_statement.html (consulted 25.03.2011).

http://www.icsu.org/publications/cfrs/freedom-responsibility-booklet/ICSU_CFRS_booklet.pdf/
 at_download/file (consulted 25.03.2011).

http://www.icsu.org/publications/reports-and-reviews/standards-responsibility-science/SCRES-
 Background.pdf/at_download/file (consulted 25.03.2011).

http://www.khib.no/index.php/khib/KU-FoU/Publikasjoner/Bokutgi-velser/Klaus-Jung-Enabling-
 Knowledge/Klaus-Jung-Enabling-Knowledge/Christine-Borland (consulted 25.03.2011).

http://www.pre.ethics.gc.ca/eng/archives/tcps-eptc/interpretations/interpretation006/
 (consulted 25.03.2011).

http://www.sculpture.org/documents/scmag99/oct99/borland/borland.shtml
 (consulted 25.03.2011).

CONTEXT-RESPONSIVE INVESTIGATIONS
Henk Slager

In a great number of topical art practices, a clear tendency can be seen to work in the realm of public space and to create art dealing with urban and social issues.[1] Of course, there is a long tradition of art in public space, but during the last decade a strikingly different artistic attitude has emerged in that respect. Most artists working today in public space no longer view this—as they did in the 1970s—as a strategic action to oppose the white cube of the institutionalised visual art museum. Today artists engage in researching the medial conditions of public space.

In his publication *Politics, Identity and Public Space* (2009), Mika Hannula describes such a topical form of artistic research as an investigation of narrative power and potentiality of stories. 'These are stories, told and shared stories, that might be able to bridge the gap between particularities and generalizations, between individuals and collectives, between singular acts and the structures where they are seeking to evolve—to emerge, to become a place' (Ibid.: 125).

Art historian Miwon Kwon was the first theorist to observe the initial signs of this paradigmatic shift. In her now classic study *One Place after Another* (1997), she argues that public art no longer focuses on physical, spatial, or institutional relationships, but is rather interested in a discursive bond. 'The distinguishing characteristic of today's site-oriented art is the way in which both the artwork's relationship to the actuality of a location (as site) and the social conditions of the institutional frame (as site) are subordinate to a discursively determined site' (Ibid.: 92-93).

Subsequently, Kwon concludes that site-specific art has lost its site; and because of this, it has in fact been dematerialised and deterritorialised. In short, the once inseparable connection with the material surrounding—the surrounding characterised by physical and architectonic elements, taking the viewer into the mode of a *phenomenological vector* as Merleau-Ponty puts it—seems to no longer exist. The three stable components of this vector—grounded, fixed, and actual—seem to have been definitively replaced by the three completely different basis concepts of ungrounded, fluid, and virtual.

41

--

1 This perspective was analysed further in *DARE (Dutch Artistic Research Event) # 4 Urban Knowledge*, Centraal Museum, Utrecht, September 9, 2009. Participants included Adam Budak, Mika Hannula, and Claire Doherty (cf. Hannula 2010).

Partly inspired by the institutional critique of the 1970s—taking place through informational, textual, expositional, and didactic strategies—the practice of current public art seems to come forth as an aesthetics defining the notion of space anew. In this aesthetics, the notion of space is understood as a discursive construct: space as a platform for knowledge, intellectual exchange, and cultural debate. Today, artists engage in societal, social, historical, and political themes as fields of research. This development means that recent site-specific art has resulted in art approaching the site as 'predominantly an inter-textually coordinated, multiply-located, discursive field of operations' (Kwon 2004: 31).

Thus, no longer is the literal relationship between the work of art and its immediate surroundings central. At stake is now a reflection on the cultural-political conditions within which public art is presented and produced. Miwon Kwon links such a reflection to Henri Lefebvre's concept of *Spatial Practices*.[2] Lefebvre's spatial practices point to a strategy that challenges and alters existing configurations of space, based on the assumption that space is a (discursive) product. Lefebvre says, 'Inasmuch as abstract (capitalist) space tends toward homogeneity, towards the elimination of existing differences or peculiarities, a new space cannot be produced unless it accentuates differences' (Lefebvre 1991: 52).

Although this artistic strategy also leads to a form of site-specificity, such a manifestation of art is ultimately disconnected from its concrete topo-graphical space. An indexical relation between discursive space and artistic interventions is no longer relevant. Consequently, a mobile, multifaceted space comes into being as an ambulant field where aspects such as openness, mobility, and ambiguity express the involvement of today's artistic practice. In line with this, qualities such as consistency, continuity, and certainty are considered obsolete—resulting in a public art drowning in a ubiquitous visual culture. Thus, the danger is lurking that such public art—specifically in our day of globalizing *biennales* and omnipresent city branding—will become an illustration of late-capitalist leveling out, because of its loss of specificity.

2 *DARE (Dutch Artistic Research Event) # 3*, Centraal Museum, Utrecht, September 10, 2008 focused on the topicality of the concept of Spatial Practice. Two artistic PhD researchers (Apolonija Sustersic, Malmo and Staffan Schmidt, Gothenburg) and three architects (Andreas Muller, Phillip Misselwitz, and Doina Petrescu) discussed in this sense their research-based interventionist strategies as e.g. Artistic Knowledge Production and Participatory Action Research (cf. Mueller 2009).

Commenting on that tendency, in *A Voyage on the North Sea* (2000), Rosalind Krauss claims that art should be aware of its medium specificity—particularly now of all times, when the post-medial condition brought about by media art seems to cause a loss of perspective on the medium itself. Consequently, 'the definition of the medium as mere physical object, in all its reductiveness and drive towards reification, has become common currency in the art world' (Ibid.: 6). Only the medium has a critical potential anchored in its inherent aesthetic domain, Krauss argues. That aesthetic domain is connected with a layer of conventions which, in Krauss' view, is characteristic of artistic mediation. The artistic medium as a complex structure of perceptual and conceptual conventions could not be reduced to a form of communicative one-dimensionality. According to Krauss, medium-specificity exists thanks to a multilayeredness which could never coincide with the physical conditions of the signifier. 'The specificity of mediums, even modernist ones, must be understood as differential, self-differing, and thus as a layering of conventions never collapsed into the physicality of their support' (Ibid.: 53).

With this description, Rosalind Krauss also gives a clear and workable guideline for significant art as a form of art embracing the idea of differential specificity, reinventing and/or rearticulating the medium anew. Then the question arises whether the site could also be understood from such medium-specific perspective. For example, in the form of a public art disconnected from the material parameters of locations, but employing instead the history —photographs, books, historical objects—of a certain place, as building blocks for an archive-type of documentation. But how could site-specific interventions and differential specificity be connected? The methodology of a spatial practice mentioned above seems to offer a constructive point of departure for answering that question. However, in deploying that artistic methodology, one should be aware that a discursive paradigm is dominant indeed, and at the same time acknowledge that phenomenological thought in terms of a material signifier and the strategies of institutional critique are still relevant as well. Then that methodological perspective could suit a topical, research-based practice, i.e., a context-responsive practice that operationally connects in each project the material conditions of location, the discursive network, and the prevailing modes of criticality, while articulating the site as a differential place and medium.

These issues were starting points for two research projects: *Shelter 07, The Freedom of Public Art in the Cover of Urban Space* and *Translocalmotion, the 7th Shanghai Biennale*. Of course, both events cannot be compared in their scale and significance. Still, the level of curatorial issues and research shows a clear similarity, since both events focus on the articulation of various modes of

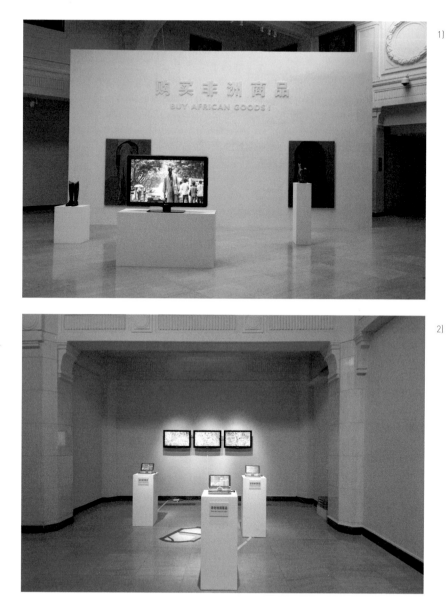

Fig. 1) Installation view of Tiong Ang, *Models for (the) People*, 2008.
Fig. 2) Installation view of Hito Steyerl, *DeriVed*, 2008.

Fig. 3) Installation view of Jeanne van Heeswijk, *Shanghai Dreaming. Holding an Urban Gold Card*, 2008.
Fig. 4) Installation view of Tiong Ang, *Multatuli Tippel*, 2007.

connection between the mediated character of a historical location (the inner city of a medieval city in the Netherlands and a politically and economically meaningful square in the heart of metropolitan Shanghai) and how the practice of topical, site-oriented, artistic research has the capacity to portray a form of differential thinking. In both *Shelter 07* and *Translocalmotion*, artists Tiong Ang and Jeanne van Heeswijk produced site-oriented works researching both locations from diverse perspectives.

The objective of *Shelter 07* was to draw attention to the history of the Dutch city of Harderwijk. To achieve this goal, the genealogical significance of the name Harderwijk, 'an elevated place offering a safe shelter to refugees in troublesome times', serves as the starting point for this exhibition in public space. The genealogical significance makes notions such as safety and freedom inextricably bound to Harderwijk's history. But how did that connection arise? To investigate that question further, eight artists were invited to produce research projects related to a number of locations significant for the history of Harderwijk. The artists were asked to develop specific proposals, underscoring the above problematic issues in an artistic form. Interestingly, in their research projects, a number of related concerns and topics emerged.[3]

As a location for his intervention, Tiong Ang chose the former lodge of the duty officer of the colonial yard depot, the building where volunteers for the Dutch East Indies were recruited. The lodge is located next to a monumental gate that, thanks to the house of ill repute once situated just outside, seamlessly connects two former literary worlds of bourgeois escapism: the reality of Keetje Tippel, a famous woman of easy virtue, recorded by Neel Doff; and the contours of colonial reality, sketched by Multatuli in Max Havelaar. Tiong Ang's intervention shows that connection, by presenting two works in a parallel mode at that location: a painted portrait of cultural critic Multatuli (the first Dutchman who, already in the 19th century, openly denounced the hypocrisy of bourgeois morality and colonialism) and a video work where film footage of Keetje Tippel and Max Havelaar smoothly alternate.



3 *Shelter 07* took place from June 1 through August 31, 2007 on various locations in the city of Harderwijk. Besides work by Tiong Ang, Jeanne van Heeswijk, and Lara Almarcequi, artists such as Gijs Frieling, Job Koelewijn, Mieke Van der Voort, Ginette Blom, and Irene Kopelman also participated. Parallel to the *Shelter 07* presentations in the public space, the 'Catharinakapel' (former University of Harderwijk) served as the source of *Shelter 07* information during the summer of 2007, supplying information about the participating artists, the artistic research projects, the work processes and the historicity of the chosen locations. For more details: http://www.e-flux.com/shows/view/4310 (consulted 08.08.2011).



Jeanne van Heeswijk extensively investigated the historical archive of the city of Harderwijk. Based on that investigation, Van Heeswijk developed a series of posters placed on the bricked-up windows of old houses around the church square, retelling last century's lingering tales: how the symbolic poet Rimbaud lost his identity as a poet during his stay in Harderwijk, and vanished in the grand myth of the foreign legion; how the first big stream of (Belgian) refugees found temporary shelter during World War I, in camp Harderwijk; and how the rumours circulated that missing passports popped up during the transformation of the AZC (Refugee Centre) Jan van Nassau Barracks into luxury condominiums, as proof that its former inhabitants found shelter there with a new, safe identity. Thus, three different tales show how viewing the location of 'Harderwijk' as shelter contributes to a more fluent awareness of the usually locally mediated concept of identity.

In order to understand site specificity as a medium, Lara Almarcegui employed an archaeological method eliciting that which precedes space—the granting of room. On the Blokhuisplein, a historical location renowned for its straightness and power—specifically because of the bordering rampart and the impregnable fortress (the Blokhuis) of the Duke—she created a fallow field presenting a temporary autonomous zone, as a dysfunctional, undefined, and unfounded space escaping the grid of geography. The compelling frame of abstract space was literally broken open, while Lara Almarcegui's spatial practice replaced it by a abandoned piece of ground, a place 'without certainty or determinacy, but with flux and changeability, existing outside the city's effective circuits and productive structures' (Sola-Morales Rubio 1995: 119). At the same time, this differential place was able to shelter the experience of a total freedom of interpretation.

Translocalmotion also intended to examine the conditions of human life in dynamic urban environments, including socioeconomic conditions, and the logic of mobility and its subsequent cultural implications. Could conditions related to the current form of human movement and urbanization, and the cultural implications as reflected by and from topical visual art, perhaps be described as a *migratory aesthetics*?[4] That is, an aesthetics that provides support for the visibility of marginalised groups and issues—an aesthetics which, contrary to the *relational aesthetics* of the 1990s, no longer concentrates on

47

--

4 The concept of *Migratory Aesthetics* pointing to visual thinking of the 'the experience of being out of place' was introduced by Sam Durrant and Catharine Lord (2007)

the actual creation of social environments for intersubjective meetings,[5] but rather adopts the form of a *documentary aesthetics* revealing all components related to mobility, such as arrival, change, combination, departure, deterritorialisation, displacement, encounter, interface, location, loss, memory, movement, passage, reconnection, relocation, reterritorialisation, revisiting, separation, and transformation. Yet it is also an aesthetics of mapping other phenomena connected with today's culture of mobility, such as the effect of newcomers on public space; it is an aesthetics stressing that indeed the artistic reflection of the multifaceted culture of mobility gives way to a more fluid form of perception, i.e., a plurality of sensory experiences that both transform and modify the way we perceive the world.

To research these topical issues, the curatorial team decided to deploy the immediate surroundings of the Shanghai Art Museum as a starting point for their endeavour. *The People's Square* actually functions as a microcosm of the complex dynamics affecting the current issue of mobility. If you take a closer look at *The People's Square*, you will find issues of migration and transition, traces of ultra-modernist urban planning, and manifestations of the power of the topical rhetoric of capitalism. In short, *The People's Square*, as a microcosm, may hold great potential for artistic inquiries and artistic research projects. Thus, the curatorial team of the Shanghai Biennale treated *The People's Square* as a location of knowledge transfer, connection, meeting, and exchange. It is exactly from this perspective of knowledge transfer that the artists invited for the *Seventh Shanghai Biennale: Translocalmotion* were commissioned. The artists worked on a series of interventions at *The People's Square*. These interventions articulated *The People's Square* as a showcase for all the topical issues in the shanghainese society: migration, global issues etc. This connection between local issues and global perspectives was presented to a local audience.[6]

48

5 Nicolas Bourriaud has redefined certain site-specific practices as 'relational', or having a 'relational aesthetic', where the emphasis is on 'a parallel engineering, on open forms based on the affirmation of the trans-individual' (Bourriaud 2002: 49). Relational practices aim at the formal construction of space-time entities that may be able to elude alienation, the division of labour, the commodification of space, and the reification of life.

6 *Translocalmotion* took place from 8 September through 16 November, 2008 in and around the Shanghai Art Museum. More context-responsive contributions came from Kim Sanggil, Ricardo Basbaum, Lonnie van Brummelen & Siebren de Haan, Suchan Kinoshita, and Mariana Castillo Deball. The closing event of this *biennale* consisted of a presentation of *The Shanghai Papers* (Balkema and Liping 2008): a publication in which all participating artists further contextualised their research. See also: www.e-flux.com/shows/view/5789 (consulted 08.08.2011)

5)

6)

Fig. 5) Installation view of Jeanne van Heeswijk, *Alles van God*, 2007.
Fig. 6) Lara Almarcegui, intervention at Blokhuisplein, 2007.

For example, Tiong Ang's project *Models for (the) People* employed the historical map of *The People's Square*—the 1930s map where the building of the Shanghai Art Museum still functions as the clubhouse for the equestrian sporting club. In those days, the building was a specific location where entertainment created a clear awareness of a collective identity. That form of constructed identity, as Tiong Ang's dialogic exploration shows, seems to have been replaced in *The People's Square* by today's logic of mobility and the more fragmented experience of the sort of collectivity that a karaoke bar creates. In the Shanghai papers Tiong Ang states:

> *Models for (the) People* is a range of disparate images juxtaposed in both sequential and spatial environments. Video images, paintings, objects, songs and words in three languages are united in a display that generates a *contradictory space,* where differentiation and mutual contestation rule. All these images carry with them both the moment of desire and that of opportunity. The work alludes to cinematic estrangement, the collision of cultures and trades, the alienating impact of exoticism, and it parallels with our multifaceted society as a succession of displacements. (Balkema and Liping 2008: 6)

Such an experience is characterised by repetition and difference, based on an ongoing confrontation with various stereotypical systems of classification; for example, the English colony in 1930s Shanghai versus the current colonisation of Africa by China.

A different approach is demonstrated by the artistic strategy of re-charting the unmapped, where static, geographic registers and representational systems equalising location and identity suddenly appear to be able to articulate unexpected perspectives. For example, Jeanne van Heeswijk developed her individual topography *Shanghai Dreaming-Holding an Urban Gold Card* by randomly selecting a number of locations on Shanghai's city map. At these locations, she recorded talks with people working there, about their ideals and dreams.

> This collection of migrant workers' stories will form a map of Shanghai based on a web of mobility by which the fulfilment of your dream generates change in the city. Personal symbols of progress are extracted from these stories to demonstrate the power of the productive individual. Symbols of dreams of fortune arising out of migrant workers' personal initiatives form a new shared language. (Ibid,: 102)

These identity-based stories are dissociated from their location through diverse media ranging from daily papers to t-shirt texts, and then connected with other locations and persons.

The installation *DeriVeD* by Hito Steyerl could also be described as an artistic project of remapping. The methodology of this work is formed by a psycho-graphical mapping process of *The People's Square* as an unofficial but com-prehensible film archive. On the one hand, The People's Square has been the setting for many films made by classic film directors such as Antonioni; on the other hand, The People's Square has a number of locations where immigrants sell DVD bootleg copies of (these) films. That is a micro-economic activity giving the square an additional connotation as a location for distributing its own imaginary narratives. 'The DVDs move on a stage of globalization which is characterized by moving images and sounds, by errant desires, structural misunderstandings and meandering meanings' (Ibid.: 85). By mapping these hidden flows of desire and moving images, *DeriVeD* offers—entirely in line with *Translocalmotion's* documentary aesthetics—a deterritorialising experience characterised by open-endedness, new connections, pluriform categories of perception, and a contingent understanding of the public domain.

The complex of relationships within these installations, or interventions based on artistic research, reinterprets the specific history of a certain location in a dynamic way. The material found during research appears to function indeed as a medium, i.e., as a mediator or vector between a specific location and viewer. Both *Shelter 07* and *Translocalmotion* show that themes or subjects 51
such as today's migratory aesthetics appear to be able to be deployed as places of artistic research, turning them into the medium of a topical art practice searching for the most adequate spaces, locations, and places—posing issues such as mobility and migration. In *Translocalmotion*, the curators expected

> the artistic research projects to provoke a series of redefinitions of topical urban conditions in non-disciplinary modes. In varied ways and different media, the participating artists will explore and document the aesthetic dimension of mobility by means of their own singular artistic strategy. In forms such as mapping the traces of micro-economic activities, documenting the new faces of the urban landscape, and depicting personal narratives, the Seventh Shanghai Biennale will produce new ways of understanding modern-day mobility. *Translocalmotion* proposes a chance to review and remap our world from different viewpoints within expanded geographies. (Slager 2008: 62)

With this description, the curators clearly connoted the concept of context-responsive investigations. As stated above, that concept entails a form of research as spatial practice focusing on generating differential places. That is, a research by artists taking the context as impetus to mobilise all medial aspects of the site—such as the set of circumstances, geographical location, historical

facts, and groups of people—through interconnections; and ultimately to articulate a discursive narrative. We clearly noticed that form of research in Tiong Ang's and Jeanne van Heeswijk's projects. Projects meticulously tracing and mediating the continuous tension between power and desire through micro-political strategies. Projects departing from structured, abstract spaces such as a colonial barracks, an ultra-Calvinist church square, or a party-ideological people's square—and next contextualising them as multitudinous places,[7] through discursive detours of cinematic reflection, placing billboards, or distributing t-shirts. Instead of dreaming about a constructed purity or harmony, as is common in classsic site-specific art, art in context-responsive projects aspires to achieve a particular and non-essentialist locality at that very site, both acknowledging and cherishing internal conflicts and inherent plurality of views.

...

7 Negri and Hardt connect the notion of people on the move with the demand for a new democracy. 'The multitude must be able to decide if, when, and where it moves. It must have the right also to stay still and enjoy one place rather than being forced constantly to be on the move. The general right to control its own movement is the multitude's ultimate demand for global citizenship' (Hardt and Negri 2000: 400).

--

References

Balkema, Annette W. and Xiang Liping. 2008. *The Shanghai Papers*. Ostfildern: Hatje Cantz.

Bourriaud, Nicolas. 2002. *Relational Aesthetics*. Dijon: Les presses du réel.

Durrant, Sam and Catharine Lord (eds). 2007. *Essays in Migratory Aesthetics: Cultural Practices Between Migration and Art-making*. Special issue of *Thamyris* 17.

Hannula, Mika. 2010. 'Embedded, engaged and excited' in *maHKUzine. Journal of Artistic Research* 8 (Winter 2010): 14-16.

—2009. *Politics, Identity and Public Space: Critical Reflections in and through the Practices of Contemporary Art* (Series in Art Research and Public Space 1). Utrecht: Utrecht Consortium.

Hardt, Michael and Antonio Negri. 2000. *Empire*. Harvard and London: Harvard University Press.

Kwon, Miwon. 1997. 'One Place After Another: Notes on Site Specificity' in *October* 80: 85-110.

—2004. 'The Wrong Place' in Doherty, Claire (ed.) *From Studio to Situation.* London: Black Dog: 29-41.

Krauss, Rosalind. 2000. *A Voyage on the North Sea: Art in the Age of the Post-Medium Condition*. London: Thames & Hudson.

Lefebvre, Henri. 1991. *The Production of Space*. Oxford: Wiley-Blackwell.

Mueller, Andreas. 2009. 'Dutch Artistic Research Event' in *maHKUzine. Journal of Artistic Research* 6 (Winter 2009): 14-16.

Sola-Morales Rubio, Ignasi de. 1995. 'Terrain Vague' in Davidson, Cynthia C. (ed.) *Anyplace*. Cambridge: MIT Press: 118-123.

Slager, Henk. 2008. 'Research-based practices' (Curatorial Text) in FANG, Zengxian and Jiang Xu (eds). *7ᵗʰ Shanghai Biennale: Translocalmotion* (Exhibition Catalogue). Shanghai: Shanghai Shuhua: 61-65.

53

AESTHETIC OF RESISTANCE?[1]
Hito Steyerl

Artistic research as discipline and conflict

What is artistic research today? At present no one seems to know an answer to this question. Artistic research is treated as one of the many practices which are defined by their absence of definition, constantly in flux, lacking coherence or identity. But what if this view were indeed misleading? What if we actually knew more about it than we think?

In order to discuss this proposition, let's first have a look at current debates around artistic research. It seems as if one of the most important concerns is the transformation of artistic research into an academic discipline. There are discussions about curriculum, degrees, method, practical applica-tion, pedagogy. On the other hand, there is also substantial criticism towards this approach. Basically, it addresses the institutionalisation of artistic research as being complicit with new modes of production within cognitive capitalism: commodified education, creative and affective industries, administrative aesthetics, and so on. Both perspectives agree on one point: artistic research is at present being constituted as a more or less normative, academic discipline.

A discipline is of course disciplinarian; it normalises, generalises, and regulates; it rehearses a set of responses, and in this case trains people to func-tion in an environment of symbolic labour, permanent design, and streamlined creativity. But then again, what is a discipline apart from all of this? A discipline may seem oppressive, but this is also precisely its purpose: to keep something under control. It circumscribes a suppressed, avoided, or potential conflict. A discipline hints at a conflict immobilised. It is a practice that channels and exploits that conflict's energies, and incorporates them into the 'powers that be'. Why would one need a 'discipline' if it wasn't to discipline somebody or something? Any discipline can thus also be seen as a response to conflict.

Let me give an example: a project I recently completed, called *The Building*. It deals with the construction history of a Nazi building on the main square in Linz, Austria; it investigates its background, the stories of the people who built it, and the materials used in the building. The construction was partly done by foreign, forced labourers; and some of the former inhabi-tants of the site were persecuted, dispossessed, and even murdered. During

1 This text was first published in *maHKUzine. Journal of Artistic Research* 8 (Winter 2010: 31-37).

the research, we also learned that some of the building stones were actually produced in the notorious quarry of concentration camp Mauthausen, where thousands of people were killed.

There are at least two different ways of describing this building. The stone used for the building can be seen as having been shaped to fit the paradigm of neoclassicist architecture; this would be the official description given on the building itself. Or, it could be described as having been most likely shaped in concentration camp Mauthausen by a stone mason who was likely a former Spanish Republican fighter. The conclusion is obvious: the same stone can be described from the point of view of a discipline, which classifies and names; or read as evidence of a suppressed conflict.

But why would this very local project be relevant for a reflection about artistic research in general? Because parts of this building also coincidentally house the Linz Art Academy. This building is a location where artistic research is currently being integrated into academic structures: there is a department for artistic research inside this building. Thus, any investigation of the building might turn out as a sort of institutional meta-reflection on the contemporary conditions of artistic research.

Questions arise: where is the conflict, or rather what are the extensive sets of conflicts underlying this new academic discipline? Who is currently building its walls, using which materials, produced by whom? Who are the builders of the discipline, and what are their associations?

Discipline and conflicts

So, what are the conflicts, and where are the boundaries? Seen from the point of view of many current contributions, artistic research seems more or less confined to the contemporary metropolitan art academy. Actual artistic research looks like a set of art practices by predominantly metropolitan artists acting as ethnographers, sociologists, product or social designers. It gives the impression of being an asset of the technologically and conceptually advanced First World capitalist, trying to upgrade his population to function efficiently in a knowledge economy, and as a by-product casually surveying the rest of the world. But if we look at artistic research from the perspective of conflict, or more precisely of social struggles, a map of practices emerges, which spans most of the 20th century and also most of the globe. It becomes obvious that the current debates do not fully acknowledge the legacy of the long, varied, and truly international history of artistic research, which can be understood in terms of an aesthetics of resistance.

Aesthetics of Resistance is the title of Peter Weiss' seminal novel, released in the early 1980s, which presents an alternative reading of art

history through an account of the history of anti-fascist resistance from 1933 to 1945. Throughout the novel, Weiss explicitly uses the term 'artistic research' *(künstlerische Forschung)* to refer to practices such as Brecht's writing factory in exile. He also points to the 'factographic' and partly 'productivist' practices in the post-revolutionary Soviet Union, mentioning the documentary work of Sergei Tretjakov, among many others. Thus he establishes a genealogy of aesthetic research, which is related to the history of emancipatory struggles throughout the 20th century.

Since the 1920s, extremely sophisticated debates about artistic episte-mologies were waged—over terms such as 'fact', 'reality', 'objectivity', and inquiry—within the circles of Soviet factographers, cinematographers, and artists. For factographers, a fact is an outcome of a process of production. The word 'fact' comes from *facere*, to make or to do. So in this sense, a fact is made or even made up. This should not come as a surprise, in this age of post-structuralist, metaphysical scepticism. But the range of aesthetic approaches which were developed as research tools almost 100 years ago is stupefying.

Authors such as Vertov, Stepanova, Tretjakov, Popova, and Rodchenko invent complex procedures of investigation, such as the 'cine-eye', the 'cine-truth', and the biography of the object—'photomontage'. They work on human perception and practice. and actively try to integrate scientific attitudes into their work. And scientific creation still flows as a result of many of their inventions. In his autobiography, Roman Jakobson describes in detail how such avant garde art practices inspired him to develop his specific ideas on linguistics.

Of course, throughout history many different approaches to this type of research have existed. We could also mention the efforts of the artists employed by the FSA (Farm Security Administration), in creating essayistic, photojournalistic inquiries during the Great Depression in the US. In these sorts of cases, the artistic researcher must ambivalently let their work be co-opted by state policies, to varying degrees and with unique consequences: around the time Tretyakov got shot during the Stalinist terror, Walker Evans had a solo show at the MoMa.

Another method of artistic inquiry, which is based on related views of conflict and crisis, is the essayistic approach. In 1940, Hans Richter coined the term 'film essay' or 'essay film', as a means of visualising theoretical ideas. He refers to one of his own works, from as early as 1927, called *Inflation*—an extremely interesting experimental film about capitalism running amok. Richter argues that a new filmic language must be developed to deal with abstract processes such as the capitalist economy. How does one show such abstractions—how does one visualise the immaterial? These questions have been reactualised in contemporary art practice; but they have a long history.

The 'essay as filmic' approach also embraces the perspective of anti-colonial resistance. One of the first so-called 'essay films' is the anti-colonial film-essay *Les statues meurent aussi* by Marker and Alain Resnais, about racism in dealing with African art. The film was commissioned by a magazine called *Presence africaine* that includes as its editors people like Aime Cesaire or Leopold Senghor, main theoreticians of the so-called 'negritude' movement in the 1930s. Only a few years later, Theodor Adorno's text *The Essay as Form* appeared, in which he ponders the revolutionary characteristics of the essay as a subversive method of thought. To Adorno, the essay means the reshuffling of the realms of the aesthetic and epistemological, undermining the dominant division of labour.

And then we enter the whole period of the 1960s, with its international struggles, tri-continentalism, and so on. Frantz Fanons slogan, 'we must discuss, we must invent', is the motto of the manifesto *Towards a Third Cinema* written by Fernando Solanas and Octavio Getina in 1968 in the context of dictatorship in Argentina. The relationship between art and science is also explicitly mentioned in Juan Garcia Espinosa's manifesto *For an Imperfect Cinema*. Other methods of artistic research include situationist derivation, worker inquiries, constructivist montage, cut ups, biomechanics, oral history, deconstructive or surrealist anthropology, the diffusion of counter-information, and aesthetic journalism. Some of these methods are more easily absorbed into the art mainstream than others. Especially strongly dematerialised practices, with pronounced modernist features, are quickly absorbed into information capitalism because they are compressed, quick to absorb, and easily transmitted. It is no coincidence that many of the practices mentioned here have been dealing with classical problems of documentary representation from very different perspectives: its function as power/knowledge; its epistemological problems; and its relation to reality, and the challenge of creating a new one. Documentary styles and forms have forever grappled with the uneven mix of rationality and creativity, subjectivity and objectivity, and the power of creation and the power of conservation.

It is no coincidence either that many of the historical methods of artistic research are tied to social or revolutionary movements, or to moments of crisis and reform. From this perspective, the outline of a global network of struggles is revealed, spanning almost the whole 20th century—a network which is transversal, relational, and (in many, though far from all cases) emancipatory.

It is a coincidence, however, that Peter Weiss' *Aesthetics of Resistance* also mentions the main square of Linz: the site of *The Building*. He describes a scene in which members of the International Brigades in Spain listen to a broadcast of the enthusiastic reception for Hitler and the German troops in

Linz' main square in March 1938. But Weiss' protagonist notices a very small (and entirely hypothetical) moment of resistance, pointed out by a radio journalist: some of the windows on the square remain unlit; and the journalist is quick to point out that the flats of the Jews are located there. Actually, research showed that one of the Jewish families living there had already dispersed to three different continents, and two members of the family had been murdered. One of the latter was a person named Ernst Samuely who supposedly was a communist. After many ordeals, he joined a Jewish partisan group on the Polish border, before disappearing. So, if we look at the Linz building from this point of view, we see that it dissolves into a network of international routes and relations, which reveal oppression but also resistance: it exemplifies what Walter Benjamin once called 'the tradition of the oppressed'.

The perspective of conflict
If we keep applying the global and transversal perspective to the debate around artistic research, the temporal and spatial limitations of contemporary metropolitan debates are revealed. It simply does not make any sense to continue the discussion as if practices of artistic research do not have a long and extensive history well beyond conceptual art practices—one of the few historical examples ever mentioned (albeit very rarely). From the point of view of social struggles, the discontinuous genealogy of artistic research becomes an almost global one, with a long and frequently interrupted history. The geographical distribution of artistic research practices also dramatically changes from this perspective. Since some locations were particularly affected by the conjunction of power and knowledge which arose with the formation of capitalism and colonialism, strategies of epistemic disobedience had to be invented.

A power/knowledge/art—which reduced whole populations to objects of knowledge, domination, and representation—had to be countered not only by social struggle and revolt, but also by epistemological and aesthetic innovation. Thus reversing the perspective, focusing on discipline as an index of conflict, also reverses the direction in which art history has been written as an account of peripheral artists copying and catching up with Western art trends. We could just as well say that many contemporary metropolitan artists are only now catching up with the complexity of debate around reality and representation that Soviet factographers had already developed in the 1920s.

Specific and singular
In all these methods, two elements collide: a claim to specificity, clashing with a claim to singularity. What does this mean? One aspect of the work claims to participate in a general paradigm, within a discourse that can be shared

and which is manufactured according to certain criteria. More often than not, scientific, legalistic, or journalistic truth procedures underlie these methods of research. Their methodologies are pervaded by power relations, as many theorists have demonstrated.

On the other hand, artistic research projects in many cases also lay claim to singularity. They create a certain artistic setup, which claims to be relatively unique and produces its own field of reference and logic. This provides it with a certain autonomy, in some cases an edge of resistance against dominant modes of knowledge production. In other cases, this assumed singularity just 'sexes up' a quantitative survey, or to use a famous expression by Benjamin Buchloh, 'creates an aesthetics of administration'.

While specific methods generate a shared terrain of knowledge—which is consequently pervaded by power structures—singular methods follow their own logic. While this may avoid the replication of existing structures of power/knowledge, it also creates the problem of the proliferation of parallel universes, which each speak their own, untranslatable language. Practices of artistic research usually partake in both registers, the singular as well as the specific; they speak several languages at once.

Thus, one could imagine a semiotic square, which would roughly map the tensions that become apparent during the transformation of artistic research into an academic and/or economic discipline.

SPECIFIC

SCIENCE/ART HISTORY PUBLIC DEBATE/
 COUNTERINFORMATION

DISCIPLINE RESISTANCE

ART MARKET/ AESTHETIC AUTONOMY
CREATIVE INDUSTRIES

SINGULAR

Of course, this scheme is misleading, since one would have to draw a new representation for every singular point of view investigated. But it shows the tensions that both frame and undermine the institutionalisation of artistic research.

Artistic research as translation

The multi-linguality of artistic research implies that artistic research is an act of translation. It takes part in at least two languages, and can in some cases create new ones. It speaks the language of quality as well as quantity, the language of the singular as well as the specific, use value as well as exchange value or spectacle value, discipline as well as conflict; and it translates between all of these. This does not mean that it translates correctly—but it nevertheless translates.

At this point, one should emphasise that this is also the case with so-called 'autonomous' artworks, which have no pretence whatsoever of partaking in any kind of research. This does not mean they cannot be quantified or become part of disciplinary practices; because they are routinely quantified on the art market, in the form of pricing, and integrated into art histories and other systems of value. Thus, most art practices exist in some mode of translation, but one that does not jeopardise the division of labour established between art historians and gallerists, between artists and researchers, between mind and senses. In fact, a lot of the conservative animosity towards artistic research stems from a feeling of threat due to the dissolution of these boundaries; and this is why often in everyday practice artistic research is dismissed as neither art nor research.

But the quantification processes involved in the evaluation or valorisation of artistic research are slightly different than traditional procedures of quantification. Artistic research as a discipline not only sets and enforces certain standards, but also presents an attempt to extract or produce a different type of value in art. Apart from the art market, a secondary market develops for those practices that lack fetish value. This secondary value is established by quantification and integration into (increasingly) commodified education systems. Additionally, a sort of social surplus embedded into a pedagogical understanding of art comes into play. Combined, they create a pull towards the production of applied or applicable knowledge/art, which can be used for entrepreneurial innovation, social cohesion, city marketing, and thousands of other aspects of cultural capitalism. From this perspective, artistic research indeed looks like a new version of the applied arts, a new and largely immaterial craft, which is being instituted as a discipline in many different places.

Radiators

Let me at the end come back to the beginning: we know more about artistic research than we think. And this concerns the most disquieting finding of the project around *The Building* in Linz. It is more than likely, that after the war, radiators were taken from the now abandoned concentration camp

61

Mauthausen and reinstalled into the building. If this plan—documented in the historical files—was in fact executed, then the radiators are still there and have quietly been heating the building ever since. A visit with an expert confirmed that the radiators have never been exchanged in the Eastern part of the building; and, moreover, that some of the radiators were used when installed around 1948. Also, their make corresponds to that of the few radiators visible in photos of KZ Mauthausen. Of course, radiators were not in use in the prisoners' barracks; but they were in some work rooms like the laundry, the prisoners' office, and the prisoners' brothel where female inmates from another concentration camp were forced to work.

What do we make of the fact that the department for artistic research (its administrative office located in *The Building*, according to the website) might find itself being heated by the same radiators that were mute witnesses of the plight of female inmates in the concentration camp brothel? To quote from the website of the Linz art academy, 'artistic-scientific research belongs to the core tasks of the Art University Linz, and artistic practice and scientific research are combined under one roof. The confrontation and/or combination of science and art require intense research and artistic development in a methodological perspective, in the areas of knowledge transfers and questions of mediation. Cultural Studies, art history, media theory, several strategies of mediation as well as art and Gender Studies in the context of concrete art production are essential elements of the profile of the university.'

What are the conditions of this research? What is the biography of its historical infrastructure and how can reflecting on it help us to break through the infatuation with discipline and institutionalisation and to sharpen a historical focus in thinking about artistic research? Obviously not every building will turn out to house such surprising infrastructure. But the general question remains: what do we do with an ambivalent discipline, which is institutionalised and disciplined under such conditions? How can we emphasise the historical and global dimension of artistic research, and highlight the framework of conflict? And when is it time to shut down the lights?

AHAMKARA:
PARTICULES ÉLÉMENTAIRES OF FIRST-PERSON CONSCIOUSNESS[1]
Sarat Maharaj & Francisco Varela

Sarat Maharaj: One of your striking contributions to neuroscience and consciousness studies is your focus on the 'view from within'—on how the mind ticks from inside its own activity. You have referred to this as the 'first-person' standpoint. Its 'second- and third-person' counterparts, if we may speak with such brittle distinctions, tend to look at mental processes and experience 'objectively.' How does the 'first-person' stance—the mind tackling its own streaming flux, its own procedures and operations—come about in your approach; what are its origins?

Francisco Varela: The honest answer is that it was related to my interest in Buddhism picked up in 1974. I left Chile after the *coup d'etat* in 1973, the Pinochet story. I went to the U.S. and that time—1974—was a bit of a crisis for me. My whole world was gone. I took a job at the University of Colorado, in Boulder, as a neuroscientist because I needed something. I ran into this very interesting person from Tibet called Chogyam Trungpa. He had come 65 to the West as a young man, studied at Oxford and migrated to the States in the early '70s. He was a pioneer in bridging traditional Tibetan Buddhism and the West. He died in 1987. I met him early in 1974. He was so perceptive. I talked about my personal life—because like I said, I didn't know what to do—and he had tremendous advice. Most of all, he said, 'Why don't you try and work a little bit with your own mind? Just think about who you are. You know, sit down for a while and look at it.' He began to teach me basic Buddhist *Siddhi* or *Shama* meditation. I fell in love with it. That was really the beginning of understanding that the first-person emphasis is an attainable, doable strategy. It teaches you things you don't know; and you actually get to know who you are in clearer ways. That's really the origin. For years, it was a separation of personal/professional life. Then for seven or eight years, I was a complete meditation fanatic.

--

1 The recording of this interview was arranged and conducted by Hans Ulrich Obrist. It took place at the Hôspital Pitié-Salpêtrière, Paris on 11 September 2000. It was first published in Obrist (2003).

SM: I was wondering if we could say that the experience of exile and emigration—or the sense of trauma itself, of rupture and melt down—might have contributed to your sensing the creative potential of the 'first-person' stance, to the value of its force?

FV: My feeling is that trauma gave me an open state of mind. I grew up in a milieu in Chile where we had the idea of re-inventing the Southern continent, what we call 'America.' *[Laughs]* At the time, the most obvious thing for a young person was to take a 'left' position, with a heavy dose of Marxism. I was fascinated by science. My interests were in Western philosophy. I was 'rationalist' through and through, a materialist-rationalist, as you would expect from somebody with that background. With the *coup d'état*—I mean, for people who haven't been through such an experience—what it shatters takes us way beyond the rational mind. To see a fascist regime all of a sudden crop up in the middle of the street is as if society's been turned inside out—all of the incredibly dark, mysterious sides of the human mind made visible. The suffering and violence, friends being killed, and the rest is shattering. For the first time I had the experience of saying, 'I don't understand a thing; I don't know anything. What is this? I'm a complete nincompoop when it comes to understanding all of this; what is human life, who am I?' That was the road that I was on when I came to Boulder. Meditation seemed sane, because it didn't mean learning a new idea or reconstructing any interpretation: it meant just being there and observing in a fundamentally naked sense who I was—something I realised I didn't know. Maybe if I had decided to stay on in the United States after my PhD or if I had never been through that trauma in Chile, I may never really have developed that open-mindedness.

Hans Ulrich Obrist: But you didn't stay long in Chile, and soon you emigrated to Europe... There have been successive exiles in your life. I'm wondering to what extent have these been 'voluntary or involuntary' to follow Jonas Mekas' distinction?

FV: When I returned from the U.S., I tried to build my life in Chile; but I realised I couldn't. In 1985–86, I decided on Europe. That is voluntary exile—because nobody pushed me. There was no Pinochet behind my ass to do that. In my case, the first exile is the one that counts. If it is involuntary, then it's a totally different flavour from when, for other reasons, you decide to migrate: curiosity, love of diversity, or whatever. I have always felt I am an exile, because I was robbed of the possibility of actually making my life in my country as I wanted to—robbed forever.

SM: What you say suggests how displacement intersects not only with shifts in thinking but also with the production of other modalities of consciousness. To tie this to what Hans Ulrich is asking us, I find my own journey out of the Apartheid State adds up to a series of moves in and out of the registers of 'voluntary/involuntary exile'. Because of our Indian background, we were subjected to 'internal exclusion' in South Africa, officially classified 'alien' in the context of the British Empire. Then, with the Apartheid Republic, we were labelled 'non-white of Indian origin' with second-class citizenship in a racist state. Leaving South Africa in the 1970s, I became stateless, then given refugee status in Britain. These moves seem to mix—not only into perpetual uprootedness—they also churned up mental turbulence, a heightened quest for other modes of thinking. An anomaly that bugged me was the feeling that it did not seem possible for me to voice my abiding interest in Hindu-Buddhist philosophical systems of enlightenment and liberation—especially the *Nyaya-Vaisheshika*—if only as some kind of half-felt counter position to Euro-epistemics. It seemed at odds with historical materialist views on liberation. My interest felt subterranean even in England. How to square rationalist-materialist models of social-political transformation—to liberation ideology—with philosophical elements that had been de-legitimated as 'non-rational,' as 'mystical-primitive' by Euro-centric notions of consciousness.

FV: Did you also suffer discrimination of Apartheid at the time, not as a black person, but as someone of Indian descent?

SM: As the struggle against Apartheid grew—and later informed by the Black Consciousness Movement—'non-whites', whatever their 'colour', came together to see themselves as 'Black'. Apartheid was bad news for everyone, but Africans suffered under every repressive law. They were subjected to violence from the time the first Dutch settlers set foot in the country, through the era of colonial pacification, to Apartheid. They were dispossessed of 87% of their land, forcibly removed, dumped on patches of land called 'Bantustans', and plugged into a vicious circuit of migratory labour between black townships and white cities. Indians were mainly brought over during British colonial rule, impoverished workers for the sugar plantations and mines, on an indenture-ship scheme introduced soon after the abolition of slavery—perhaps, a modern, wretched version of it. They stayed on after the indentureship period eking out a living largely through market gardening, eventually working their way up. But they were severely restricted by the colour bar—the Job Reservation Act spelled out what kinds of work they were allowed to do and what jobs or

professions were for 'whites only'. They were also swindled again and again under the Group Areas Act. As soon as they had built up an area of land, it was declared for 'whites only' and they were expropriated. Gandhi had come to South Africa as a smart English-trained lawyer to help a muslim trader. Soon enough, he was propelled into action with the poor indentured community. His 18-year stay amongst them forms the crucible of his practice of *Satyagraha* or 'truth-force'—the production of consciousness and self-understanding in the struggle against racial discrimination.

FV: So when you decided to leave, it was because of the pressure of this very discriminatory life that was imposed at that time?

SM: Apartheid was in full institutional spate by then, by the mid-1970s: racial segregation in all aspects of everyday life, according to ethnic boxes devised by the Race Classification Board. There were separate live and work areas for the different race groups—such as Zulu, Xhosa, Venda, Sotho, 'people of mixed descent,' etc. Through the segregated schools and universities, the regime hoped to train obedient staff for the Bantustans. I went to a university for non-whites of Indian origin. Voicing criticism through teaching and visual artwork, participating in awakening consciousness through plays, performances, and satirical revues, eventually made it impossible to continue there.

FV: I see. Did this engagement with the 'political-rational' have to be kept apart from explorations in what was seen as 'para-rational' forms of thinking?

SM: I suppose the latter sprang from a hazy awareness of residues of traditional Indian culture that the indentured memory had somehow stored. Apartheid had a stake in re-ethnicising the various racial groups it had cooked up. Post-1960, Indian philosophy was offered for study at the segregated university for Indians in Durban alongside Western thought, excluding taboo thinkers of the period such as Marx, Mao, and Marcuse. What passed as Indian thought was not exactly active engagement with 'the technologies of introspection'. More a parroting of a glorified, 'essentialised' version meant to inculcate in us a sense of 'Indianness'. With this political drift, engagement with it remained under a cloud. It was side-stepped and treated as compromised. Its potential to place under critique the political-rational hardly counted. Perhaps too late, it came to be seen as a gap in prevailing models of liberation, as purely political-institutional transformation.

 I wanted to connect this to the moving sessions of the Truth and Reconciliation Commission in South Africa today, where we have had to learn

to listen—often in between painful, unspeakable lines—to ordinary people recounting their personal ordeals of the Apartheid years. These episodes showed that the search for 'truth and reconciliation' has to go beyond legalistic frameworks. Juridical understanding has to be 'supplemented'—with the resonance Derrida gives the word—by other dimensions, that is, explorations in personal consciousness, our ability to tussle with difference and heterogeneity, even with the 'otherness' of the 'enemy.' It meant stepping into the scene you describe as 'heterophenomenology.' This seems like an urgent quest today—an ethics of difference.

FV: What you say is very interesting because I was in Chile a few weeks ago, and through my son-in-law, I met some younger people. I was astounded that a good part of their discourse was their rediscovery of what they call the 'politics of intimacy', which I thought was a beautiful term—including the life of the spirit in their essential values. They even used the word 'spirituality', which would have been totally unthinkable for where I was coming from in politics. It seems to me to converge with what you are saying. We spent more than half of the time talking about what is 'spiritual life,' what does it mean, what actually are the pragmatics, what are the actual hands-on things you can do? I was deeply touched. My generation seems to have missed that completely. Now, at this point in my life, I thought it was just something individualistic. But they seem to be thinking naturally of putting these two things together: the private-public. This is a consciousness reborn out of difficult times—very naturally, after 25 years of dictatorship, or after how many long years of Apartheid.

HUO: What are the ways in which you see the ideas of working through first-person consciousness and elements of 'new spirituality' making themselves felt in South Africa?

SM: Within institutions and their limits, it is seen in the Dutch Reformed Church's 'apology' to South Africa or in the work of Desmond Tutu's Anglican Church. These efforts are sacramental events—'lustrations'—public enactments of the desire for purification, forgiveness, for getting ready to reconcile; couched in symbol, icon, ceremony, the regulated lingo of religion; if also in a wordless syntax. Beyond this, we have the reflections of Albie Sachs, a Justice of the South African Constitutional Court and a dogged opponent of Apartheid (Sachs 2002). The regime tried to kill him off with a bomb that wrecked his body, damaged his eyesight. He probes the limits of the juridical using Gandhi's 'Experiments with Truth' to expand modes of truth-telling to supplement the institutional-juridical.

69

HUO: These truth-telling modes seem to take in Gandhi's practices such as *Ahimsa* (non-violent action), *Satyagraha*, passive resistance, and civil disobedience.

SM: Some of his 'experiments' were a bit scandalous to over-delicate Victorian tastes, since they touched on sexual energy, body relationships, testing yourself in the face of difference, a kind of somatic plugging into otherness. There is perhaps a rough parallel with Francisco's more systematic notion of 'embodied knowledge' (Maturana and Varela 1998). It is in this spirit that Sachs maps 'existential, phenomenological and dialogic' modes of truth-telling to fill in what the rationalist-juridical model leaves out or rather tags on as 'spirituality' in an instrumental way as officially sanctioned activity. Gandhi perhaps relates to what you develop as 'embodied, enactive' rather than abstract knowledge, and to your distinction between 'know what'—living by ready-made moral rules, as opposed to 'know-how'—uncertainties of ethical creativity.

FV: Is that happening as a marginal thing, or more in the mainstream of political renovation in South Africa?

SM: The mainstream focus is on socio-economic urgencies rather than trauma and therapy or their implications for processes of liberation. A managerial attitude prevails: first-person investigations are seen to be done and over with; vented in controlled, channelled fashion, through due processes of the Truth and Reconciliation apparatus. Now people are expected to settle down, become regular citizens.

FV: But it doesn't have to be about trauma. It could also be about taking it as an explicit part of reality. This is what I liked about the 'kids' in Chile. It wasn't so much about going back to traumas that are still there as about the non-separability of the politics of intimacy and the pragmatics of the real.

SM: Some do link pragmatics with experiments with truth and self. They're testing it in their own way, inventing their own lingo. It's not so much a single movement, but rather, a crop of impromptu intelligences, patched-together ways of coping. You see a group of women who were machinists in a clothes factory. They lived a particular demeaning drill under Apartheid. Democracy might have arrived formally, but they still have to make sense of it beyond abstract government declarations. No less for formally-educated Albie Sachs, who also has to string together tools for self-understanding. It is not about

simply mulling over trauma, but about mental-emotional devices for making sense of how it is, that even though Apartheid is dismantled many of its features hang on, that we've gone through truth-telling, yet we find ourselves stuck with many troubling modes of thinking from the old dispensation.

FV: That's very interesting to me to hear about South Africa, because it is coming out of a dreadful, traumatic period. There are things in Chile we didn't have to deal with, fortunately, like the tremendous racial diversity and racial tensions. But the tensions are more of the right/left kind.

HUO: I think this conversation is progressing well because there are not only some very interesting points in your biographies which kind of cross of course, but also common elements between your respective works and approaches towards knowledge. I remember discussing with Sarat the contribution that you did, Francisco, for the exhibition I organised together with Barbara Vanderlinden ('Laboratorium,' various venues throughout Antwerp, 1999). Maybe we should examine this now.

SM: As with several of Hans Ulrich's projects, 'Laboratorium' gave us models and propositions for seeing-thinking-knowing. I was delighted to come across 71
your 'portable, subjective laboratory'. You seemed to situate it, if I remember correctly, as the 'triple braid'—neuroscience, phenomenology, introspective technologies. The last term takes in Zen, Yoga, Transcendental Meditation, and the vast Abhidharma corpus that over several centuries elaborated and documented techniques of first-person consciousness.

FV: I'm engaged now in giving flesh to the neuro-phenomenology idea. It is not treated as abstract, but through concrete examples of how we can go beyond the phenomenological-natural opposition; how seeing the natural can be phenomenological, and vice versa. In other words, that what we call personal experience is really not all that personal. There is always the public in the private; or first-person is also third-person. The insight comes from traditional, more spiritual practices. But it doesn't have to carry 'spiritualistic' connotations. On the other hand, when you work with the brain, in the end the images and the measures you get are very subjective. They belong to interpretation by a community that can only interpret them anyway because of their own experience. So there is a false dichotomy of first/third-person. Theoretically, the program is pretty much sketched out.

 How to implement it? One attempt is a simple perceptual task. You must have seen random-dot stereograms, where if you cross your eyes a little

you see the third dimension. It's striking. You actually do see 3-D, although there is nothing there but random dots—a very strong phenomenological experience. If you subject somebody to a number of these random dots and ask a simple question, 'Just tell me when the 3-D pops up by pressing on a button', then you have a perfectly standard psychology experiment. At the same time, we registered what was going on with the subject way before they would see the 3-D pop up. There was a long period where nothing seemed to be happening. Then the stimulus would be presented. Another innovation was to let the subject, after each time they see something, record a phenomenological account saying, 'Well, in fact, when the stimulus came, I was really thinking about something else', or 'I was half asleep', or 'No, no, that was really good; that was brilliant'.

You have repetitions, but also full, detailed accounts. Their first-person expression can actually be sorted out from third-person data. This is because you can say, 'Let's take all the moments in which the person was completely distracted, thinking about something else; and separate them from ones where he says he was totally present, very prepared. All hangs on the time before the stimulus. We have what we call 'phenomenological clusters'. The first-person actually constrains the way you treat the third-person. What you see when you look at third-person data on the brain are that they are two completely different things—when the subject reports being totally prepared, and the opposite. That's not surprising in itself, had it not been for the fact that typically in the classical experiments this is not done at all. Everything mixes. We have in the brain means for sustained preparation that makes it possible to see; it is a sophisticated personal-individual strategy, what you do to be prepared. You activate an approach to something that is endogenous, belonging to you before you see anything in the world.

We even worked with a long-time meditator, an extraordinary person called Mathieu Ricard. Does the name ring a bell? He trained as a scientist. But he left to become a personal assistant to one of the greatest Tibetan masters in this century, Dilgo Khyentse, for twenty years. Mathieu really knows that tradition and is a highly developed meditator. We had Mathieu come and do exactly the same experiment.

HUO: He came to the lab?

FV: He did because we're friends. I said, 'Mathieu, I need you.' When you compare the ordinary Joe with Mathieu in the strategy, it's incredible. Mathieu has no distractions. He is so totally steady. You can see it in his electrical activity. The protocol is totally different for somebody like him, where you can actually

see the importance of the first-person development. There is no way to con-fuse the highly trained first-person explorer from just a regular person. Those examples allow us to see that clearly. You know: first-third, it's all mixed up. You cannot really separate what you see from the real data that comes from the first-person. But these distinctions are made on the analytical plane.

HUO: The area that you are exploring now, Sarat—visual arts practice as a kind of 'non-knowledge'—does it overlap with the modes of knowing that Francisco is describing? Could you talk a little about it, and how you've come to be investigating it?

SM: I'm afraid my efforts are not as clearly testable as Francisco's. For 'non-knowledge' I use the Sanskrit term avidya. The word 'vidya' means 'to see-know.' It gives us the Latin 'video' ('to see') and the modern English 'video' as in VCR. When we attach the prefix '*a*' to it, we normally mean to signal something like its opposite—'ignorance.' But '*a*' can also neutralise rather than negate—as we find with in-between, indeterminate terms such as typical<atypical>untypical or moral<amoral>immoral. The middle term highlights the shortfalls of the binaries 'knowledge/ignorance'—but it ques-tions the assumption that by knowledge we only mean the full-blast variety, such as that of the established disciplines. *Avidya* or non-knowledge, contrary to appearance, is not anti-knowledge—unless we imagine it as exciting stuff like anti-matter. It is more a *détournement* of ready-made knowledge systems, a flip-over and displacing of structured data and information, dissolving them as they try to settle and fix into institutional disciplines. Within knowledge systems, the learning-creating process centres on transfer and transmission of what's already known. It is about tracing-repeating-reproduction; and representation of ready-made, canonical elements. Avidya is more about pro-duction, about generating new forms of think-feel-know, about first-person creativity, unknown circuits of consciousness. It treats visual-art-practice thinking today as an unscripted condition where anything might happen—verging on Francisco's challenge to absolutist first-third-person dividing walls.

73

FV: For me this implies a widening process. The first-person stance doesn't so much invalidate science or classical objectivity; it is about a larger under-standing of objectivity, where it's not only your view from the outside, manipulating measures that constitutes objective knowledge. These interact with first-person accounts to become inter-subjective, to become knowledge. In that sense they would be objective; although in principle, in their way of access, they are subjective. In fact, I don't like the word 'subjective.' It's just

another mode of access to something like a base where we build objectivity—if by that we mean what can be made stable in inter-subjective dynamic.

SM: I play on the paradox of visual arts practice as knowledge production that is at the same time non-knowledge. This back-to-front speak is partly to provoke us into probing precisely what knowledge systems leave out as 'invalid' method, evidence, and practice—the 'murky non-knowledge fog' around 'clear-cut knowledge.' In the knowledge-systems league table, contemporary visual arts often ends up at the bottom, a 'leftover' because it 'fails' to cough up an all-encompassing, rigorous account of its foundations, axioms, and methodologies. Today it's a strength that visual arts practices are often not able to spell this out in advance. It's more likely that their principles and procedures get thrashed out in the process of doing the practice. This links with Francisco's querying first-third-person boundaries not to undermine objectivity, but to rethink it—not least to ask how the sense of such borders originate and get fixed in the first place.

FV: How would you put, more positively, what is the knowledge that artists produce? Say of a painter: we know it is not a kind of organised, rational belief; but how would you describe it? Is it kind of a know-how? What would be, in other words, the content of *avidya*?

SM: That's the tough bit. Speaking of 'know-how', Gilles Deleuze refers to Henri Bergson's celebrated swimming example to ask if we can ever learn to swim from a theoretical account? More likely, it seems being plunged into water forces us to come to grips with it. Otherwise, I suppose, we are truly sunk! We might possibly never get the hang of it through a theoretical exposition that tells us how swimming is like walking-in-liquid. The know-how springs from 'just doing it'—hit-or-miss trying, tinkering, sticking things together to see if they work, a kind of non-sequential, assemblagist logic.

FV: But shouldn't we wonder whether when an artist builds up his or her thinking in the painting process is it at all of the same nature as, say, swimming? The latter kind of know-how is very clear, it is bodily knowledge—it is so ancestral to learn how to cope with your body, of not having it as part of consciousness. Maybe the difference of art knowledge lies in the fact that it's less about coping with the world, more this imaginary activity, event?

SM: To speak of art practice as 'know-how' is simply a ruse, I would imagine, for jump-starting an exploration of why it is not reducible to it. For art, it's also about conscious invention, creativity that is paradoxically both 'destructive/

de-constructive'. It's like a dissolvent sprinkled on prevailing conceptual structures and conceptualising processes—let alone the acidic, eat-away effect it has on the crust of convention, taste, fixed ways of doing and defining art.

FV: Right. How come it is not possible to theorise it, even for a painter?

SM: Is the drift of twentieth century visual arts less a know-how than a highly conceptual affair—even during periods of muscular anti-conceptual rhetoric? But what do we mean by 'conceptual' in this context? I stop short of lumping artistic endeavour either with know-how or with regular concept-knowledge structures. What's the chink in-between? Non-knowledge? This is not easy to map in terms of broad principles, because it resists hard-hat conceptualisation.

FV: Against know-how, and against conceptual consciousness?

SM: Against both. That's why, with non-knowledge one should think beyond the Renaissance-painting model. Today, the contemporary visual art setup is a spread of indeterminate practices. We face the prized possibility, to use Adorno, that 'anything can count as art even if does not look like it'. We can hardly figure what form the art event might take in advance of its making. But from installations, situations outside the museum-gallery circuits, through to experimental events and improbable contraptions—we have a range of practices that style themselves as 'conceptual'. Strictly speaking, they are reducible neither to know-how or dexterity, nor to concept-systems.

FV: No, they cannot be reduced to 'know-how'. But there's no 'concept' category either.

SM: That's why I prefer to see them as 'indeterminate modes', as 'non-knowledge'. Should we speak here of the 'conceptual against itself', or use something like Deleuze's phrase, the 'non-conceptual conceptual'.

FV: Non-knowledge is a form of knowledge manifest in actions and inventions like the painter-practitioner's. That's why I feel to think it through as 'non-knowledge' might somehow limit our grasp of its particular quality. Is this not a kind of knowledge better grappled with as *prajna*?

HUO: In this context, Francisco, could you tell us a little about how encounters or dialogues with artists or individuals might have led you to look at what kind of knowledge or thinking art practice is?

Fig. 1) Looking for Varela's Lab in the Hôspital Pitié-Salpêtrière, Paris on 11 September 2000.

2)

Liste des spécialités	Chefs de service	N° Bat	Localisation
ANATOMO-PATHOLOGIE	Pr LE CHARPENTIER	85 et 17	Bâtiment universitaire - RDC Unités INSERM - 17 Bâtiment amphithéâtre RDC.
BACTERIO	Pr HURAUX	89	Bâtiment de la pharmacie 2° étage
BIOCHIMIE	Pr DELATTRE	89	Bâtiment de la pharmacie 1° étage.
BIOCHIMIE	Pr FOGLIETTI	10	RDC- 1° et 2° étage.
BIOCHIMIE MEDICALE	Pr LEGRAND	13	Bâtiment Benjamin Delessert RDC
BIOLOGIE DES URGENCES	Pr GUILLOSSON	12	Bâtiment Gaston Cordier - 1° étage.
CARDIOLOGIE	Pr THOMAS	65	Bâtiment Rambuteau - Consultation et Hospitalisation.
CENTRE DE MOYEN ET LONG SEJOUR	Pr LAPLANE	51	Centre de moyen et long séjour - Hospitalisation 1°, 2°et 3° étage.
CHIRURGIE GENERALE ET DIGESTIVE	Pr CHIGOT	20	Bâtiment Husson Mourier - Consultation 1° étage - Hospitalisation 1° et 2°étage.
CHIRURGIE GYNECOLOGIQUE	Pr BLONDON	54	Pavillon Antonin Gosset - Consultation S-S - Hospitalisation RDC.
CHIRURGIE GYNECOLOGIQUE ET OBSTETRIQUE	Pr DARBOIS	18 et 19	Maternité et Pavillon Siredey.
CHIRURGIE ORTHOPEDIQUE ET TRAUMATOLOGIQUE	Pr SAILLANT	12	Bâtiment Gaston Cordier - Consultation 6° étage - Hospitalisation 6° et 7° étage.
CHIRURGIE THORACIQUE ET CARDIOVASCULAIRE	Pr GANDJBAKHCH	12	Bâtiment Gaston Cordier - Consultation 2° étage
		11 et 41	Hôpital de jour - Hospitalisation (2° étage Secteur Ambroise Paré)
CHIRURGIE VASCULAIRE	Pr KIEFFER	54	Pavillon Antonin Gosset - Consultation S-S - Hospitalisation 1° étage.
COPROLOGIE	Pr GOBERT	41	Bâtiment de la Force
DEPARTEMENT D'ANESTHESIOLOGIE ET REANIMATION	Pr CORIAT	47	Pavillon de l'enfant et de l'adolescent - 3° étage
DEPARTEMENT D'ANESTHESIOLOGIE ET REANIMATION		12 et 70	Bâtiment Gaston Cordier - S-S et 1° étage - Pavillon BABINSKI
DIABETOLOGIE	Pr THERVET	15	Pavillon Larochefoucault-Liancourt - Consultation 2° étage - Hospi 1° et 2°étage.
ENDOCRINOLOGIE - METABOLISME	Pr TURPIN	13	Pavillon Benjamin Delessert - Consultation 1° étage - Hospi RDC et 1° étage.
ETABLISSEMENT DE TRANSFUSION SANGUINE	Pr FOURNEL	66	Pavillon Laveran - RDC.
EXPLORATIONS FONCTIONNELLES NEUROLOGIQUES	Pr BOUCHE	62	Cliniques de neurologie Paul Castaigne - 1° étage.
EXPLORATIONS FONCTIONNELLES NEUROLOGIQUES	Pr WILLER	89 et 70	Bâtiment de la pharmacie (3° étage) - Pavillon BABINSKI
EXPLORATIONS FONCTIONNELLES RESPIRATOIRES	Pr ZELTER	65	Bâtiment Rambuteau
FEDERATION DE NEUROLOGIE	Pr AGID	62	Cliniques de neurologie Paul Castaigne - Consultation RDC
FEDERATION DE NEUROLOGIE	Pr LYON-CAEN	62	Hospitalisation au 3°, 4° et 5° étage.
HEMATOLOGIE	Pr BINET	66	Pavillon Laveran - Consultation 1° étage - Hospitalisation 2° étage.
HEPATO-GASTRO-ENTEROLOGIE	Pr OPOLON	64	Cliniques médicales - Consultation RDC supérieur - Hospi 3° et 4° étage.
HISTO-EMBRYOLOGIE	Pr POIRIER	13	Pavillon Benjamin Delessert 1° étage
IMMUNOCHIMIE	Pr MUSSET	89	Bâtiment de la pharmacie - entresol
IMMUNOLOGIE	Pr GLUCKMANN	82	Pavillon C.E.R.V.I - 1° étage
IMMUNOLOGIE CELLULAIRE ET TISSULAIRE	Pr DEBRE	82	Pavillon C.E.R.V.I - 3° et 4° étage
INFORMATIQUE MEDICALE	Pr DE HEAULME	13	Pavillon Benjamin Delessert
INFORMATIQUE MEDICALE - BIOSTATISTIQUE	Pr BOISVIEUX	66	C.H.U 91 Bld de l'hôpital 75651 Paris.
MALADIES INFECTIEUSES PARASITAIRES ET TROPICALES	Pr BRICAIRE	66	Pavillon Laveran - Consultation 3° et 4° étage - Hospi 3° étage - HDJ 5°
		64 et 41	Bâtiment des cliniques médicales 3° étage - Ambroise Paré 3° étage.
MEDECINE GENERALE	Pr BOUSQUET	2	Cour des consultations RDC
MEDECINE INTERNE	Pr PIETTE	15	Pavillon Larochefoucault-Liancourt - Consultation RDC - Hospi RDC et 1° étage.
MEDECINE INTERNE	Pr HERSON	64	Bâtiment des cliniques médicales - Consultation 2° ét - Hospi 1° et 2° étage.
MEDECINE NUCLEAIRE ET BIOPHYSIQUE	Pr ANCRI	20	Bâtiment Husson Mourier - RDC
MEDECINE NUCLEAIRE	Pr AURENGO	2	Cour des consultations - Consultation et Hospitalisation RDC
MEDECINE NUCLEAIRE		70	Pavillon BABINSKI
NEPHROLOGIE	Pr JACOBS	12	Bâtiment Gaston Cordier - Consultation et hospitalisation 3° étage
		56	Pavillon de la grille - Centre de formation de dialyse à domicile
NEUROPATHOLOGIE	Pr HAUW	62 et 70	Cliniques Paul Castaigne (salle Raymond Escourolle) - Pavillon BABINSKI
NEUROCHIRURGIE	Pr POIRIER	70	Pavillon BABINSKI
NEUROCHIRURGIE	Pr PHILIPPON	70	Pavillon BABINSKI
NEUROIMMUNOLOGIE	Pr SCHULLER	89	Bâtiment de la pharmacie - 5° étage.
NEUROLOGIE	Pr C. PIERROT-DESEILLIGNY	62	Cliniques Paul Castaigne - Consultation 2° étage - Hospitalisation 1° et 2° étage.
NEUROLOGIE	Pr BRUNET	30	Division Mazarin - Consultation RDC - Hospitalisation RDC et 1° étage.
		70 et 47	Pavillon BABINSKI - Pavillon Risler - Consultation.
NEUROLOGIE	Pr DEROUESNE	62	Cliniques Paul Castaigne - Hospitalisation 3° étage.
NEURORADIOLOGIE	Pr MARSAULT	70	Pavillon BABINSKI SCANNER et IRM
	Pr CHIRAS	62	Cliniques neurologiques Paul Castaigne (SCANNER et IRM)
O.R.L	Pr SOUDANT	70 et 41	Pavillon BABINSKI - Bâtiment de la force - Division Ambroise Paré - 1° étage.
ONCOLOGIE MEDICALE	Pr KHAYAT	44	Division Jacquart - Consultation, hospitalisation et hôpital de jour.
OPHTALMOLOGIE	Pr LE HOANG	70	Pavillon BABINSKI
PARASITOLOGIE ET MYCOLOGIE	Pr DANIS	66	Pavillon Laveran - 4° étage
PEDIATRIE ET GENETIQUE MEDICALE	Pr BOURILLON	70	Pavillon de l'Enfant et de l'adolescent
PHARMACIE-TOXICOLOGIE	Pr THUILLIER	89 et 70	Bâtiment de la pharmacie - Pavillon BABINSKI
PHARMACOLOGIE	Pr PUECH	41	Bâtiment de la force - Division Saint Vincent de Paul et Ambroise Paré
		89	Bâtiment de la pharmacie entresol.
PHYSIOLOGIE - MEDECINE DU SPORT	Pr PERES	2	Cour des consultations
PNEUMOLOGIE - PHTISIOLOGIE	Pr DERENNE	65	Bâtiment Rambuteau - Consultation - Hospitalisation 1° et 2° étage.
PSYCHIATRIE ADULTE	Pr ALLILAIRE	58 et 57	Bâtiment Philippe Chaslin RDC - Bâtiment Pinel
		41	Bâtiment de la Force - Division Clérambault 1° étage.
PSYCHIATRIE ENFANT ET ADOLESCENT	Pr BASQUIN	14	Pavillon Charles Quentin RDC et 1° étage.
RADIOLOGIE GENERALE		47	Pavillon de l'enfant et de l'adolescent
	Pr GRENIER	2 et 12	Cour des consultations Premier Sous-Sol. Pavillon Antonin Gosset (échographie...)
		43 et 54	Division Montyon (ostéo-articulaire) - Pavillon Antonin Gosset (échographie...)
	Pr GRENIER	68 et 65	Unité de stomatologie - Bâtiment Rambuteau -
		53	Bâtiment anc.pharmacie (SCANNER)
RADIOTHERAPIE	Pr BAILLET	54 et 41	Pavillon Antonin Gosset - Bâtiment de la Force
REEDUCATION NEUROLOGIQUE	Pr E. PIERROT-DESEILLIGNY	86	Bâtiment de rééducation neurologique
		13	Bâtiment Benjamin Delessert - Hospitalisation 1° et 2° étage.
RHUMATOLOGIE	Pr BOURGEOIS	9	Pavillon Layani - Consultation.
SANTE PUBLIQUE - ECIMUD	Pr BRUCKER	41	Bâtiment de la Force - Division Saint Vincent de Paul 3° étage
STOMATOLOGIE ET CHIRURGIE MAXILLO-FACIALE	Pr GUILBERT	68	Bâtiment de stomatologie - Consultation RDC - Hospitalisation 1° et 2° étage
STOMATOLOGIE ET PROTHESE MAXILLO-FACIALE	Pr BERTRAND	68	Bâtiment de stomatologie
UNITE MOBILE D'ACCOMPAGNEMENT ET DE SOINS PALLIATIFS	Pr DESFOSSES	27	Maison des Soins Palliatifs
URGENCES CEREBRO-VASCULAIRES	Pr RANCUREL	62	Bâtiment Paul Castaigne - Consultation RDC - Hospitalisation 4° étage.
URGENCES CHIRURGICALES	Pr BENAZET	12	Bâtiment Gaston Cordier RDC et 1° étage.
URGENCES MEDECINE	Pr DAVIDO	12	Bâtiment Gaston Cordier - Urgences RDC - Service Porte 1° étage.
UROLOGIE	Pr CHATELAIN	12	Bâtiment Gaston Cordier - Consultation 4° étage - Hospitalisation 4° et 5° étage.
VIROLOGIE	Pr HURAUX	82	Bâtiment C.E.R.V.I 4° étage.
Centre de Détection et de Prévention de l'Athérosclérose	Pr TURPIN	13	Bâtiment Benjamin DELESSERT
Centre de Dépistage Anonyme et Gratuit	Pr HERSON	64	Bâtiment des cliniques médicales Rez-de-chaussée supérieur.

Services administratifs

31	Division Lassay :	Cour du marché :
	Direction générale - Direction de la Communication - RDC	42 Direction de la communication - Central courses - Vaguemestre - Reprographie-Badges - Sécurité sociale
	Direction des services économiques 1° étage	74 Standard téléphonique
	Direction des finances (fournisseurs - budget) 1° étage	7 Bâtiment Raymond Poincaré :
	Direction de la formation et de la qualité 2° étage	Direction de l'accueil et de la clientèle RDC
	Direction des ressources humaines 3° étage	Direction des Affaires Médicales (gestion et paie du personnel médical) 1° étage
	Direction de la stratégie 3° étage- 2° étage	Admissions Pitié - Frais de séjour - Renseignements - État civil - Tutelles RDC
	Direction des soins infirmiers 3° étage	Service des relations avec le public RDC
45	Sécurité générale anti-malveillance 3° étage	Division Hemey :
	Admissions Salpêtrière RDC	D.E.T.S.I 2° et 3° étage - Centre de Tri Labo RDC
70	Régie principale-traitements externes-successions RDC	Admissions BABINSKI

Fig. 2) Looking for Varela's Lab in the Hôspital Pitié-Salpêtrière, Paris on 11 September 2000.

FV: For me these encounters are a little like 'happenings'. I run into people like you; then something happens. I do not have a systematic thing about it all. That's how I feel, like a chick put into a pen other than the one it's used to. I feel like hen out of my pen. *[Laughs]* I don't really have a story or a theory.

What I do know is that artistic imagination somehow cannot be that different from the scientific or the philosophical. Perhaps, in this sense, it's not so much a form of non-knowledge, because it manifests itself in production, right? Now what would it be? Let's go back to Sanskrit, or to a Buddhist term: *prajna*, because in Buddhism *avidya* is ignorance in a most basic metaphysical sense, right? *Prajna* is a form of intelligence, but a non-conceptual one; it is intelligence without the negation I sense in *avidya*. We all have *prajna*: it's intelligence that happens when you let go of fixated ideas. Basically, that's how it manifests itself; it's the moment when you can just allow yourself to forget, suspend, put into parentheses. (If you want, not unlike the idea of the phenomenological reduction.) It's to put into suspense, and *poum*! there is a tiny light that comes out, which is a manifestation of *prajna*. I'm always fascinated by that quality. It is neither know-how, which is too low somehow; nor is it conceptual. There is no term for this in the West. Cognitive science has none either. At best, it's sometimes called 'pre-conceptual or pre-linguistic or prenoetic'. That's very flattening. It just signals what 'comes before'—but not what it is.

SM: For this, I've used the term 'aconceptual.' For me it mirrors the neutralising prefix *'a'* in *avidya*. It flags up non-knowledge as 'non-negation,' as switched into neutral gear. Essentially, I am using *avidya* to signal something close to what you are referring to. This becomes a little clearer if we unpack *prajna*. The word Sanskrit roots are *para-gyana*. The prefix *'para'* is familiar to us in common words such as paraphrase, paranoid. To this is added *gyana*, familiar to us in *gnosis*, which gives us the word 'knowledge'.

Para-gyana means 'above, beyond, around' knowledge—not concept-structure knowledge or scholarly learning, but the flash of intuition-intelligence. What you speak of from the Buddhist route overlaps with *avidya*, as developed in my slightly wild etymology. But I think both of us are signalling not something anti-conceptual or sub-conceptual or pre-conceptual, but rather a mode of consciousness that is *aconceptual*.

FV: Which would be *prajna*.

SM: *Prajna* would be the ideal term. But the hint of negation, I retain—by perversely using *avidya* to give it an edge. This has partly to do with applying

it provocatively in the art/culture context. It's to say that if visual art is seen as a demoted, lesser form of knowledge, we'll call it 'non-knowledge'. The provocation is nudged on a little by Duchamp's mind-boggling question, 'How to make a work of art that is not a work of art?'

FV: How can you make a work of art that is not art? What a question!

SM: Not so much a negation, but a non-negation. Perhaps more a *détournement* rather than sheer annulment.

HUO: This morning you were struck by a remark of the Dalai Lama, which you somehow linked to John Cage. I thought this an interesting moment to connect with this discussion.

SM: I think it sprang from the book you were glancing through: Hayward and Varela (1992). The distinction crops up between roughly Hindu thinking or Vedanta, and its structural-conceptual twin: Buddhist thinking, or roughly speaking, the Nyaya-Vaisheshika traditions. They are like two halves of the same thing. The former has a logocentric drift—it speaks of fullness, presence, self, metaphysical essences. The latter, in counter-terms: of emptiness, no-self, non-presence, non-affirmation of ultimate reality. Mirror images!

FV: This is your classic Buddhist-Hindu debate, right? *[Laughs]*

SM: Absolutely! On the one hand, Buddha's celebrated, sceptical words about defining 'ultimate reality': '*neti, neti, neti*'—'not this, not that, not this'—is a kind definition by negation, by deferral; or, we may say, by Derrida's *différance avant la lettre*. 'Ultimate reality' is *nirvana*; burnout of consciousness, nothingness, or *sunyata*. On the other hand, in Vedanta, ultimate reality is defined by affirmation '*Tat vam asi*,' or 'Thou art That.' The self aspires to become one with *sat-chit-ananda* or the inundating fullness of truth-consciousness-bliss.

I was saying to Hans Ulrich, I was struck by John Cage's relationship with this tradition of mirror opposites. His writings show he was tuned into these ideas through [L.C.] Beckett. Also through Daitzu Suzuki and Ananda Coomaraswamy. At any rate, Hindu-Buddhist traditions of self/no-self, empty-full consciousness provided him with non-binary grist to the mill for his approaches to 'music'. This, at times, seems to be neither silence nor sound; neither noise nor music; but indeterminate sonic construction—music/ non-music, silence-sound, noise-non-noise.

FV: Perhaps it's a work of art but not a work of art! But this guy is something else. He knew all that?

SM: In his own terms. Formally, through L.C. Beckett's writings, the Coomaraswamys, through Daitzu Suzuki's seminars at Harvard.

HUO: That's incredibly interesting. As we discussed this morning, it would be great to trace these links between Cage, the Coomaraswamy, Suzuki, and Duchamp.

SM: The East Coast mob!

FV: Did Duchamp ever point out what he felt was his most successful art that wasn't art? Did he have examples?

SM: I must say I can't quite imagine him even suggesting one. Perhaps the project he secretly worked on, *Etant donnés* (1946-66), comes close. He was working on it when it was assumed he had stopped doing art. Does it look like he was doing something that wasn't?

At the time *Etant donnés* was revealed, I suppose, it didn't quite look like art at all. A strange, strip-show peephole through which we see, somewhat brusquely, a full-frontal nude in a landscape, with a motorised, moving waterfall. It became a model for what is today taken for granted as 'installation': a genre that is neither the nude nor landscape, neither painting nor sculpture, neither diorama nor film—but takes in all elements. *Neti. Neti, Neti?* Maybe now it has become very much of 'Art'—exactly what he had sought to avoid. He was trying to manoeuvre between practices, between fixated ideas of art/non-art, knowledge/non-knowledge—the space of *prajna?*

FV: That's very close to my heart because that's basically your thread of Ariadne—into your own growth in the Buddhist context. The symptom is, you see, this *prajna* growing or not. Then you can tell whether you're making any progress (if there is such a thing). Trungpa always said we all have *prajna*, every human being. But most people have 'baby *prajna*'—a potential that has to develop. I feel when somebody is acting from the basis of *prajna*, you can see it. There is a quality to it—intelligent spontaneity. But this can easily degrade into, you know, 'goofy golf,' as they say in America.

HUO: Can you expand a bit on the notion of this kind of spontaneity?

FV: I feel 'intelligent spontaneity' is what you see in the beginnings of improvisation, the moment when everybody is suspended. You see Keith Jarrett, all of a sudden, getting into his piano or the Indian drum, a moment of pure passion. When an individual acts, in my experience—individuals who have highly-developed minds—they often tend to be like that. It's almost like *prajna*, I feel. It has a smell to it. It stops your mind—the very first symptom is that it attempts to stop your mind. It happens a lot in the Dalai Lama's company. He's a brilliant *prajna* guy. When you enter in conversation, oftentimes you find yourself listening with full intent, so your conceptual mind just stops. His *prajna* has brought up your own. A mutuality. It's like affection calling out affection—that can just sort of melt you down. You become affectionate. It's similar to that.

HUO: So it happens in conversation?

FV: In conversation. In encounters, but usually in conversation. It's a very interesting thing everybody notices with the Dalai Lama. I took my wife to the meeting with him last March. She isn't particularly Buddhist. After two days, she said to me 'I've never been with somebody like that. There is something very unusual there.' And she said exactly like I did, 'My mind stops.' [Laughs]

81

HUO: Could it be accounted for by experiments, such as those that you mentioned today? What exactly happens at the moment 'mind stops'? Could you not do an experiment while somebody speaks with the Dalai Lama?

FV: With the Dalai Lama, it is too hard. That's why I bring people like Mathieu Ricard. Eventually I do want to do that. For he's the kind of person that can get himself in a position where there is no stream of conceptual thinking. Whatever he does is in terms of *prajna*. This would be not unlike the 3D perception experiments we spoke of; but maybe that's too flat, too simple, too poor a performance to relate to the experience of 'the mind stops.' Slowly, we want to get there.

SM: Are elements of consciousness always only knowable 'at one remove'— through some mode of representation, sign-system, or medium that has to relay them? Is a sense of immediacy and presence strictly impossible? Are we trapped in the prisonhouse of language, where there is no direct, unmediated access to experience?

FV: I don't really believe that we are always speaking through representation, or living the moment through it. I think the first-person approach, the hands-on,

actually doing, exploring mind—and what you find through it—shows that the living present has a depth which is just that. It's not representing anything. Within that living present, we can also have a discourse or a narrative: who you are, what you're doing, whatever. In that sense, of course, linguistically mediated, it has the quality of representation.

But I think I have a generic problem with 'representation'. The word almost means anything. The content of my experience is not a representation of anything. It's a *presentation*. You might say that language can represent something through its semantic links. That's very much the logician's view. There you have items in language; it's about semantic correspondence. That might be fine for logic; but human language is inseparably linked to emotions, to the body. Even psychoanalysis is about how language is so totally embedded in the constant going-on of the emergence of mind, for us to speak of presentation rather than a representation. But to see all linguistic occurrences—a dialogue or discussion—as representation, seems to me to be phenomenologically poor. If that is the issue, I really don't see it that way. It seems more true of the tradition of seeing language as a semantic object.

SM: I'm tussling with the issue, but I haven't the glimmer of an answer. Leaving aside language as representation, what if we say that whatever emerges has to have a signifying system, a vehicle to articulate it. It sort of 'stands in' for the experience, and conveys it to the mind.

FV: Why couldn't it just articulate what it articulates? Suppose you take language as something with which we couple with the world. It follows there is no representation. It is what it is. We are moving in and with the world.

The sign system is good for signifying objects. When it comes to language and interpersonal interactions, what you have is a *coupling* with another person, a dance of coordination of action. Language sits in there. Why does it have to stand for something else?

SM: I suppose, because we normally say that a language has repeatable signs and signifiers of some sort, counters and units that 'stand-in' for something—an external delivery system to put across experience. However, you are speaking of language as *coupling* with the world, an interactive system.

FV: The repetitiveness and syntaxity of language should not imply that it has to stand for something else. The syntax I understand; it's the semantic argument I don't get. It does not seem to me to be necessary, unless one has a view of reality that needs knowledge to be some form of semantic mirroring. But what

if knowledge is the shaping of your actions in the world? That sense comes from action, not from representing anything. Let's put away the syntax. The semantics is more a pragmatics: meaning is in what it does, rather than what it stands for: as you know, a well-developed argument in pragmatic linguistics.

SM: The level at which language as a system of signs comes in—is that at the level of narration, depiction, and description?

FV: At that level, I have in mind language in all of its glory and power. You can coordinate; you can describe; you can do injunctions; you can be performative. But in none of these do you need the idea that there is a standing-in for something. Rather: an effective, pragmatic capacity to change; coupling with the other; and coordination, like when I say, 'Let's go'.

HUO: The question that comes to mind is: where is the link to systems of coordination and control. I recently re-read Gordon Pask, in terms of cybernetics. I mean, how far is this linked to cybernetic theory?

FV: One link is what Gregory Bateson pleaded for: language as a performative look. His brilliant example is the double bind of the 'schizophrenic' mother and child in language. The mother says, 'Don't do this.' Yet the phrase can convey quite the opposite in another form of language—body language, usually. The double bind idea was already there in the early days of cybernetics. Gordon Pask is second generation. He introduced the fundamental notion of language as conversation—what ethno-methodologists like Garfinkel and others took up later. Their point was not to isolate language as a set of sentences you look at printed on the page, but to treat it as a mode of coupling. Therefore, the conversational dimension is essential—to study language is to look at conversations between people. Now Gordon's theory was incomprehensible! But his insight was absolutely right. Have you read his books on conversation theory?

HUO: No. But I came to it actually via Richard Hamilton and Cedric Price, because there were connections there.

SM: As Hans Ulrich says, Hamilton and others around the Independent Group in the '50s in Britain had glanced at Norbert Wiener's cybernetics. Two views of language and representation were at play. In Hamilton's Pop Art of the '50s, we see a version of the deconstructionist stance—decoding signs, symbols of contemporary style, fashion, ads, mass culture—the 'mythologies of

83

everyday life' as Roland Barthes put it. This is language as semiotic system—a 'chain of substitutes' representing/signifying elements and experiences of the world. Alongside, was Wiener's model of systems of communication as transformative processes—language and representation as intrinsic to shaping activity in the world. Is something of this the drift of the 'funhouse' that Hamilton, with John MacHale and John Voelcker, put together for the *This is Tomorrow* show (Whitechapel Art Gallery, 1956)? Their 'crazy house' was a machine for the production of new feeling, thinking and action—not just a matter of unpacking representation. In this context, Derrida's view—his 'origin of geometry' stance of the '50s—seems a drastic throwing into doubt of the notion of 'self-presence', by showing how signifying systems leave us and our language experience always at 'one remove'. Quite a scuffle all round over language and representation.

FV: I've always been a little puzzled about Derridian *différance* though I have read him only partially and recently more than before. I'm always very impressed: he's so damned, unbearably smart. They shouldn't let people as intelligent as him walk around like that. *[Laughs]* His stuff on *différance* has something reactive about it—to be a little critical of how he treats 'immediacy'. In his early, long commentary on the origin of geometry, how can you not agree? He drives the nail all the way through. But having done that, he seems, more recently, to take a more balanced position. Because it's not that immediacy is totally impossible. Rather it's always on the run, you cannot rest on it, it will always pull itself away. That seems to me very different from always falling into a linguistic interpretation. The life of language and meaning can indeed seem constantly to pull you along. You cannot nest in any particular present moment. It's not absolute that *différance* would be the only place where one could be. It's perhaps better to think of *différance* as dynamics of all present moments. That's my reading. I'm not so sure he would disagree all that much today with that.

SM: The tendency has been to whittle down his thinking to saying that he is speaking of either presence or absence—when his drift is the *undecidable*. It's becoming more apparent that we have to probe 'immediacy and presence' on several fronts. From one position, it appears we can't be here and now, because we are always dispersed into there and then. The elusive sense of 'self- presence' has always flitted on. But this way of speaking has pitfalls. It suggests some sort of ready-made substance, some entity that is fugitive—uncatchable—maybe but an entity, no less. As you say, through *différance* perhaps we need to look at temporality. For me this would be duration, the continuous stream of becoming, each moment passing into and becoming its other, a ceaseless production

of difference. What net of representation, concept-language, sign-system can ever hope to catch its flow and flux except at a brutally reductive price?

FV: Therefore, I say the sense of 'now' does have a depth to it, which is what gives it sight of 'immediacy.' This is exactly where the preconceptual can come in, or what you call the *aconceptual.*

SM: Derrida himself remarks that his 'concepts' are not strictly concepts—perhaps more image-ideas? Might he have even used 'non- conceptual' to signal this? Generally, he seems to suggest that *aconceptual* devices come closer to capturing any sense of presence- absence. The issue remains that at some level we do feel powerfully an experience of 'self-presence'; of 'being on the spot'; the persistence of a sense of self and identity, to which 'I' have recourse, and which 'I' can get hold of; the ego's activity or *ahamkara* as the Sanskrit goes—elements of everyday first person consciousness. But dissecting through linguistics—it is not something easy to sustain in analytical terms.

FV: There is another way that I'm trying to understand this through Derrida. These are just progress notes. Let's take the question of time. You have the Husserlian account of specious present, retention, protention. However, that stays in a single individual sphere: it's just the individual, the *conscious* individual at that. But there are the two spheres, which are not of the same nature. One is what I call the 'philogenetic' or 'preconceptual', which is everything that comes with your entire bodily inheritance—emotional life, conscious and unconscious life, that is going to shape that present and move it along, give it a dynamic. The other is inter-subjectiveness, the social, distributed nature of the self that language is going to pull, in all senses that it normally does. Husserl's analysis is missing both of those. Somehow it is incomplete, all of the non-conceptual—or aconceptual—and preconceptual are missing. He only has the conceptual parameter. In that sense, I think Derrida is right. If you reduce things just to the point of measurable language, it's oversimplifying. I think the three levels have to be kept: the philogenetic; the ontogenetic—which is where you are in the 'immediacy'; and this Derridian de-centeredness of the subject. One day, maybe when I retire, I want to write on the phenomenology of time—to put these three together. It's a bit daunting.

HUO: So far an unrealised project?

FV: Yes. You see, this is art that isn't art! *This* is my little Duchamp-like box. *[Laughs]*

..

References

Hayward, Jeremy W. and Francisco J. Varela. 1992. *Gentle Bridges: Conversations with the Dalai Lama on the Sciences of Mind.* Boston: Shambhala.

Maturana, Humberto R. and Francisco J. Varela. 1998. *The tree of knowledge: The Biological Roots of Human Understanding* (tr. R. Paolucci). Boston and London: Shambhala.

Obrist, Hans Ulrich. 2003. *Interviews. Volume 1.* Milan: Edizioni Charta: 539-559.

Sachs, Albie. 2002. 'Different Kinds of Truth: The South African Truth and Reconciliation Commission' in Enwezor, Okwui (ed.) *Experiments with Truth. Documenta 11, Platform 2.* Kassel: Hatje Cantz: 43-60.

EXPERIMENTAL SYSTEMS:
DIFFERENCE, GRAPHEMATICITY, CONJUNCTURE[1]
Hans-Jörg Rheinberger

At a symposium devoted to the structure of enzymes and proteins, held in
1955, Paul C. Zamecnik talked about his laboratory's attempts to integrate
amino acids into proteins in test tubes. When, in the discussion to follow,
Sol Spiegelman referred to his own experiments on the induction of enzymes
in yeast cultures, Zamecnik responded as follows: 'We would like to study
induced enzyme formation, too; but that reminds me of a story Dr. Hotchkiss
told me of a man who wanted to use a new boomerang but found himself
unable to throw his old one away successfully' (Zamecnik et al. 1956).[2] This
remark is insightful concerning the auto-feedback character which is typical
of experimentation in the research process. It expresses a fundamental experi-
ence of scientific work. The more familiar a scientist is with *his* experimental
set-up, the more effectively *its* inherent possibilities open up. Formulated
paradoxically, the more an experimental system is tied to the skill and experi-
ence of the researcher, the more independently it develops. The subject enters
into a kind of inner connection to its object.[3] The boomerang is an image of
this relationship, which can also be called 'virtuosity'.

Alan Garen once asked Alfred Hershey what a scientist's dream of hap-
piness was, and the latter replied: 'To have one experiment that works, and
keep doing it all the time.' As Seymour Benzer reports, the first generation
of molecular biologists referred to this situation as being in 'Hershey heaven'
(Judson 1979: 275).

François Jacob's autobiography, which contains a reflected record of a
research process matched by only few scientists' own testimonials, contains
the following sentences: 'In analyzing a problem, the biologist is constrained

1 This text is a shortened version of the second part of Rheinberger (1992). For this version, the
 extensive scientific-historical part in the 'Konjunkturen' (Conjunctures) section was abridged
 and the transitions smoothed out. The text in its present form has been translated into English
 for the first time. For a broader development of the same thoughts see Rheinberger (1997).

2 The symposium was part of a Research Conference for Biology and Medicine of the Atomic
 Energy Commission, sponsored by the Biology Division, Oak Ridge National Laboratory,
 Gatlinburg, Tennessee, April 4-6, 1955.

3 What Lacan formulated for the sciences 'conquered' by structuralism also applies here:
 'The subject is, as it were, internally excluded from its object' (Lacan 2006: 731).

to focus on a fragment of reality, on a piece of the universe which he arbitrarily isolates to define certain of its parameters. In biology, any study thus begins with the choice of a 'system.' On this choice depend the experimenter's freedom to manoeuvre, the nature of the questions he is free to ask, and even, often, the type of answer he can obtain' (Jacob 1988: 234).

The contexts in which these three quotations stand could hardly be more different. They speak of experimentation in light of familiarity, satisfaction, and analytic constraints. But they all converge in one respect: they suppose an *experimental system* to be the smallest functional unit, to be a scientist's working unit. This has consequences for the theory and history of science. When asked what drives the research process, it is advisable to begin by characterising the experimental systems, their structure, and their dynamics, and not with an original, unavoidable primacy of theory (however it is formulated).

Should one rather speak of *experimental reasoning* then? If everything depends on the choice of a 'system'—the experimenter's room to manoeuvre, the scope of the questions that he can ask, and the kind of answers he can receive—then even the expression 'experimental reasoning' might still be misleading. The expression's grammatical structure presupposes 'reasoning' as the *genus proximum* whose specific difference consists in that it is being guided by an experiment. But what is at issue is the exact opposite: a movement oriented through instrumental boundary conditions *in* which reasoning is torn into the game of material entities. Gaston Bachelard called the instruments of science '*theories materialised*'[4] (Bachelard 1984: 13). He formulated it more sharply later: 'Contemporary science thinks with/in its apparatuses' (Bachelard 1951: 84, trans.). Thus, it is the 'scientific real' itself in its 'noumenal contexture' which is 'able to define the axes of experimentation' (Bachelard 1984: 13, trans. altered). At issue is the *writing game*, the tracing game of science. The expression alludes to Wittgenstein's discussion of the 'language-game'. 'I shall,' says Wittgenstein, 'call also the whole, consisting of language and the actions into which it is woven, a "language-game"' (Wittgenstein 1953: 5). We cannot retreat behind this *interweaving*. 'Our mistake is to look for an explanation where we ought to look at what happens as a "proto-phenomenon". That is, where we ought to have said: *this language-game is played*' (Ibid.: 167). Thus, I am not looking for a 'logic' of the relationship between experiment and theory.[5]

4 As a mirror image of this, one could refer to theories as 'machines idealised'.

5 In the classic formulation of Karl Popper: 'The theoretician puts certain definite questions to the experimenter, and the latter, by his experiments, tries to elicit a decisive answer to these questions, and to no others. All other questions he tries hard to exclude' (Popper 2002: 89).

Nor am I speaking of theories, experiments, and instruments as relatively autonomous, intercalating layers of a scientific whole that manifests itself in postponements, side-shifts, extensions, and abortions (cf. e.g. Galison 1988). My remarks concern, rather, that which can be irreducibly regarded as the *experimental situation*: a situation that offers technological conditions for the existence of scientific objects, differential reproduction of experimental systems, conjunctures of such systems and graphematic representation as the decisive aspects of the practical production of what one might call 'epistemic things.' What is meant by this?

To illustrate these considerations, I will cite an episode from the experimental history of protein biosynthesis: the laboratory production of transfer ribonucleic acid in the 1950s. This molecule would go on to occupy a central place in the scaffolding of molecular biology. It formed the bridge between DNA, which stores genetic information, and proteins, which realise its biological function. It was among the levers with which the genetic code could be deciphered. The history of the early test-tube production of this nucleic acid as soluble RNA has to be viewed, however, against a biomedical, bioenergetic, and biochemical background, which initially had nothing to do with these later events. It is not a matter of the usual history of a 'discovery,' but of what Foucault would have called the 'archaeology' of what today is called transfer RNA.[6]

Experimental systems

First, though, I would like to provide a few methodological and conceptual clarifications. How should an *experimental system* be understood? In traditional philosophy of science[7], experiments are normally viewed as singular instances, as staged tribunals that are organised and conducted in order to corroborate or refute theories. Some time ago, though largely

6 '...what I am attempting to bring to light is the epistemological field, the episteme in which knowledge, envisaged apart from all criteria having reference to its rational value or to its objective forms, grounds its positivity and thereby manifests a history which is not that of its growing perfection, but rather that of its conditions of possibility; in this account, what should appear are those configurations within the space of knowledge which have given rise to the diverse forms of empirical science. Such an enterprise is not so much a history, in the traditional meaning of that word, as an "archaeology"' (Foucault 1994: xxi). The concept of the 'archaeology' of knowledge is discussed in detail in Foucault (1969).

7 Cf. Popper (2002), footnote 5. The idea of the experiment as the test of an hypothesis is, however, still virulent in more recent social constructivist approaches which explicitly deny the naked experiment the ability to decide on controversies in science (cf. e.g. Collins 1985).

without success,[8] Ludwik Fleck argued convincingly, based on an historical analysis of biomedical research practice, that experimenters, contrary to the conventional views of philosophers of science, deal with everything except individual experiments. 'Every experimental scientist knows just how little a single experiment can prove or convince. To establish proof, an entire *system of experiments* and controls is needed, set up according to an assumption [...] and performed by an expert' (Fleck 1979: 96, emphasis added). According to Fleck, in research we do not deal with individual experiments, nor, as a rule, with a clear-cut relationship between theory and experiment, but rather with a complex experimental arrangement set up in such a way that it produces knowledge that we *do not yet have*. And even more important: we deal with experimental systems which normally do *not provide clear answers*.

> If a research experiment were well defined, it would be altogether unnecessary to perform it. For the experimental arrangements to be well defined, the outcome must be known in advance; otherwise the procedure cannot be limited and purposeful.[9] (Ibid.: 86)

Thus, experimental systems can be regarded as the smallest functional units of research; they are set up in order to give answers to questions that we are not yet able to formulate clearly. In a typical case, an experimental system is, in Jacobs' words, a 'machine for making the future' (Jacob 1988: 9). It enables one in the first place to generate questions that can be answered. It is a vehicle which serves to materialise questions. It cogenerates, if you will, the phenomena or material delineations and the concepts they embody. A single experiment, on the other hand, as a sharp procedure for testing a sharp idea, is in no way the simple, elementary unit of experimental science, but rather the degeneration of an elementarily complex situation.[10]

8 Discussion in theory and history of science about the experiment and the experimental practice of sciences has actually only been taken up intensively in the last ten years, although less so here in Germany than in the Anglo-Saxon countries and in France.

9 The chapter 'Observation, Experiment, Experience,' from which these quotations were taken, is today still an unsurpassed masterpiece of describing a research activity in the biosciences.

10 Here I take up an idea that Gaston Bachelard formulated for the objects of contemporary physics as follows: 'In very general terms simple always means simplified; we cannot use simple concepts correctly until we understand the process of simplification from which they are derived' (Bachelard 1984: 138, trans. slightly altered).

Reproduction and difference

So asking questions and giving answers within such an experimental system is an inherently open and inconcludable game. It is quite possible and common that a scientific object—and this applies even more to its ultimate transformation into a technological one[11]—is not even conceivable at the time an experimental setup is established. But once a surprising outcome has emerged and is sufficiently stabilised, it is difficult to avoid the illusion of a logical path of thinking, let alone a teleology of the experimental process. I would like to quote François Jacob again:

> How does one trace a path chosen for research work? [...] How does one re-create a thought centred on a tiny fragment of the universe, on a "system" one turns over and over to view from every angle? How, above all, does one recapture the sense of a maze with no way out, the incessant quest for a solution, without referring to what later proved to be *the* solution in all its dazzling obviousness? (Ibid.: 274)

The construction principle of a labyrinth consists precisely in the fact that the already existing walls determine the space and the direction in which new walls can be added. A labyrinth cannot be planned. It builds itself. It forces one to proceed by 'groping' and 'grasping' (Ibid.: 255, among other places).

An experimental system owes its temporal *coherence* to its reproduction, and its development depends on whether one manages to *produce differences* without destroying its reproductive coherence. Together, these two factors make up its *differential reproduction*.[12] The construction process is dominated by a kind of probing movement which with regard to the scientific object can be described as a *'jeu des possibles'*[13] (Jacob 1982) or a '"game" of difference' (Derrida 1976: 23-24 and elsewhere). I would like to suggest that it is precisely the way in which it is 'falling prey to its own work' that makes the scientific enterprise

93

11 On the relationship of scientific objects or epistemic things and technological objects or technical conditions cf. Part IV 'Das "Epistemische Ding" und seine technischen Bedingungen' (The 'Epistemic Thing' and its Technical Conditions) in Rheinberger (1992).

12 The concept of reproduction is complex. Here it does not mean so much the restoration of something used, nor the repeatability of a process as often as one likes (i.e. the 'reproducibility' of results), but rather keeping a movement going that enables an experimental system to be 'productive'.

13 The title of this 'Essai sur la diversité du vivant', 'Le jeu des possibles', refers to the 'bricolage' of the evolutionary process as well as to the historical process of the sciences. Insofar as the scientific dynamic is at issue, the 'possible' has to be taken in both senses: on the one hand it is that which never will have existed because things always turn out differently than expected; on the other hand, 'one always has to have decided what is possible' (Jacob 1982: 22, trans. altered).

similar in a certain sense to what Derrida called 'the enterprise of deconstruc-tion' (Ibid.: 24). To play this game productively requires *'Erfahrenheit'*[14] (Fleck 1979: 96) on the part of the experimenter, something that can perhaps best be paraphrased using the paradoxical expression 'acquired intuition'.[15]

We can conclude from what has just been said that one never knows exactly where an experimental system will lead. As soon as one knows exactly what it produces it is no longer a *research* system. An experimental system in which a scientific object gradually takes on contours in the sense that certain signals can be handled in a reproducible way, has to simultaneously open windows in which new signals are visible. Once it is stabilised in one respect, it can and *must* be destabilised in another in order to arrive at new 'results'.[16] Stabilisation and destabilisation are interdependent. In order to remain productive, an experi-mental setup has to be sufficiently open to produce unforeseeable signals and to let new technologies, instruments, and model substances seep in. If, on the other hand, it becomes too rigid, it stops being a 'machine for making the future'; it degenerates into a testing facility geared to production of standards or replicas. Thus, it loses its immediate function as a research tool. As a stable subsystem it can, however, be integrated into other, still productive experimental systems and thus contribute towards producing new results in an indirect way. The transformation of former research systems into stable, technical sub-systems of other research arrangements lends the experimental process its specific material kind of growth and information storage. On account of the same mechanism, however, it also produces an historical burden. Usually, due to this mechanism, 'new objects' have to be brought to light by 'old tools'. In the long term, however, a degenerated research system is completely replaced by technological systems which embody the current, stabilised knowledge in a more efficient form. Thus, the historian of science normally deals with a 'museum of abandoned systems' and must in the very first place reconstruct the context in which they made sense at all. So an experimental system begins its life as a research set-up, is subsequently transformed into a technological system, and finally is replaced.

94

14 *'Erfahrenheit'* is not simply 'experience.' Experience connotes an ability to judge. *Erfahrenheit* —experiencedness—is a form of practice in which this ability displays itself.

15 It numbers among the attempts to do justice to the 'surplus' of scientific action, to what lies beyond all methodological axiomatisation. Cf. e.g. Michael Polanyi's 'tacit knowledge' (Polanyi 1967) or San MacColl's 'intimate observation' (MacColl 1989).

16 In the everyday language of the laboratory scientist the 'result' is the unit with which the productivity of an experimental system is expressed. The 'result' is usually not the scientific statement concluding a programme, but rather a brickstone whose place in the mosaic still has to be found.

To remain a research system, such an arrangement must therefore be set up 'differentially'. If it is organised in such a way that the production of differences itself becomes the organising principle of its reproduction, then one can say that it obeys the kind of subversive, displacing movement Jacques Derrida referred to as *'différance'*[17] (Derrida 1976: 23). In this sense, differential reproduction lends science, or better, individual research systems, their own internal time and turns the process into an 'historial' one (Ibid.).[18]

Representation

How does that which I provisionally termed the 'writing game' take place within a research system, with its formal dynamic as a machine for producing the future? This leads us to the problem of *representation*. But what does 'representation' mean?

Here 'representation' is generally to be understood in the sense in which German technical chemistry language uses the term in conjunction with the process of production, characterisation, isolation, and purification of a substance. We will see that such a usage of the term leads to a fundamental undermining of its classical connotation, namely being something that stands for something else.[19] Within the framework of a given experimental system, a scientific object is revealed within a space of material representation and brought to articulation. One certainly misses the specific nature of the procedure if one considers it simply as the 'theoretical' representation of a 'reality' of whatever kind.[20] What *practically* occurs in a research process is the realisation, i.e. production of

95

--

17 In *The Différance* the term is paraphrased as follows: 'We will designate as différance the movement according to which language, or any code, any system of referral in general, is constituted 'historically' as a weave of differences' (Derrida 1982: 12).

18 Cf. the detailed Part III 'Historialität, Spur, Dekonstruktion' (Historiality, Trace, Deconstruction) in Rheinberger (1992).

19 The problem of 'representational' thinking has a long history in what today is called 'Post-structuralism'. For orientation cf. Bennington and Derrida (1991), among others the chapters entitled 'Le signe' and 'L'écriture': 26-63.

20 An experimental system embodies a knowledge horizon which can only be handled by manipulating the system itself. Subsequently the arrangement of its significant units can be transformed to an arrangement *of a second order*—to a graphic, algebraic, or other arrangement on paper (or in a calculator). And this is not simply an abstractive doubling process. It is itself again a representation in the sense of a purification, a selection, which can retroactively have an effect on the arrangement of the *first order*. Since moreover the arrangement of the first order has more signification possibilities than the arrangement of the second order expresses, other second order arrangements also have the possibility in principle to have an effect on a given experimental system.

scientific objects with the help of things that can already be viewed and handled as sufficiently stable material forms of knowledge. In turn, a realised scientific object itself becomes a tool, a technical construct, which makes it possible to form new research arrangements. It is incorporated in the process of the realisation of that which one does not yet know. The only proof of its scientific form, or character, is the fact that, and only the fact that, it promises to change an already modelled piece of nature which the technological arrangement embodies at the present moment. This process is in no way target-oriented from the very outset. It has to be 'felt out' by those processes that Jacob described as 'the abortive trials, the failed experiments, the false starts, the misguided attempts' (Jacob 1988: 281). Ultimately, the only guide through this landscape, as Goethe would have said, is 'the kind of procedure itself' (Goethe 1962: 315). The latter alone produces the hints to which direction one can turn, and where one has to change direction.

Representation: so what happens when the experimenter produces a chromatogram using a DNA sequence gel and a series of test tubes to which round filters are assigned; with which, in turn, a count of radioactive decay can be correlated? All of these 'epistemic things'[21] are objects of experimental interpretation. They embody certain aspects of the scientific object in a palpable form that can be handled in the laboratory. It is the arrangement of these graphematic traces or graphemes, and the possibility of pushing them around in the space of representation, that comprise the experimental writing game. It is out of these units that the experimenter composes his 'model'.[22] How are the graphemes constituted? A polyacrylamide gel in a biochemical laboratory, for example, is at the same time an analytical tool for separating macromolecules and a graphematic pattern of components that are made visible as coloured, fluorescent, UV-absorbing, or radioactive spots. It *is* the scientific object, the realised model, which in turn is compared with other such models, to find out whether it 'fits'. So the comparison here is not between 'nature' and its 'model', but rather between different graphematic traces that can be produced. That which conveys to us a sense of certainty

21 Cf. the more detailed Part IV 'Das "Epistemische Ding" und seine technischen Bedingungen' (The Epistemic Thing and Its Technical Conditions) in Rheinberger (1992).

22 Astonishingly, to date there has been little acknowledgement in theory of science of the role played by dealing with model components, say, in the development of the alpha helix structure of proteins by Linus Pauling and the DNA double helix by Watson and Crick. Such models occupy the position of experiments where the comparison between different experimental representations is not or not yet possible. An experimental system always implies a model which in turn has to be made explicit by a further experimental system.

of *one* 'reality', which we *ascribe* to the scientific object studied, is nothing else than this kind of fit. The scientific real is a world of traces.

The production of 'inscriptions'[23] is neither a purely arbitrary process nor completely dictated by the material, technical conditions and instruments of the respective system. In the process of production and differential reproduction in experimental systems, there is a constant interplay between presentation and absentation. And this is the case because every grapheme is the suppression of another. In any attempt to show or strengthen 'something', at the same time an effort is inevitably made to make 'something else' disappear. It is like playing with wedges. When you drive in one, you drive out another. In an ongoing research process, one normally does not know which of the possible signals should be suppressed and which strengthened. This means that for a shorter or longer period the presentation/absentation game has to be kept reversible. One must ensure that the research object can oscillate between different interpretations, i.e. realisations.

Conjunctures

A research system can lead to a point that can be referred to as a *conjuncture*. In this context, conjuncture means: the emergence of an extraordinary constellation.[24] A conjuncture is characterised by an 'unprecedented event' that leads to a larger recombination or reorganisation between or in given representational spaces. It can give the entire experimental system a new orientation, and above all it can form interfaces between different experimental systems.

The preparation of a soluble, small ribonucleic acid in the cell-free protein biosynthesis system of Paul C. Zamecnik, Mary L. Stephenson, and Mahlon B. Hoagland at the Collis P. Huntington Memorial Hospital of Harvard University in Boston meets all the criteria of a major conjuncture.

..

23 Bruno Latour and Steve Woolgar distinguish between machines that 'transform matter between one state and another' and apparatus or 'inscription devices' that 'transform pieces of matter into written documents' (Latour and Woolgar 1986: 51; cf. also Latour 1987: 64f.). It is often not possible to clearly distinguish between the two. What is a polyacrylamide gel? It transforms matter; it divides molecules; and it produces an inscription, for example a series of blue spots. Perhaps one has to go a step further and view the totality of the experimental arrangement—including both kinds of machines—as a graphematic activity. A written table or a printed curve is then only the recorded form of a preceding graphematic disposition of pieces of matter produced in the experiment.

24 The term is neither identical with that of an 'anomaly' nor with that of a 'paradigm' in Thomas Kuhn's sense. It does not designate confusion in an old thought pattern nor the latter's replacement by a new one, but an experimental event.

This RNA emerged as an unheard-of event. The molecule was found as something that had not been looked for, and it changed the entire representational space from a representation of intermediate metabolic products in protein biosynthesis to a representation of the genetic information transfer from the DNA to the proteins of the cells. It produced one of the seams between classical biochemistry and molecular biology in the sense of molecular genetics.[25]

I cannot elaborate on this interesting example from the history of science here. I have discussed the path of soluble ribonucleic acids to protein biosynthesis as conjuncture in more detail elsewhere[26] and instead would like to conclude here as follows:

I have tried to develop the following lines of reasoning: First, the conditions of experimental knowledge production cannot be reduced further than to that which, in scientific vernacular, is termed an *experimental system*. The scientific object is constituted within its technical boundary conditions. Second, an experimental system must be able to *reproduce itself differentially* to function as an arrangement for producing 'epistemic things' whose possibilities lie beyond our current state of knowledge, i.e. in order to serve as a 'machine for making the future.' This does not simply mean that it has to permit displacements within the process of investigation; rather, it has to be organised such that the production of differences brings about the reproductive orientation of the entire machinery; the system has to be *'différant'*.[27] Third, I have made a case for viewing the experimental system as a structure that plays out its dynamics in a representational space in which material graphemes or graphematic traces are articulated and unknotted, shifted and replaced.[28] Finally, I have suggested that events which can be referred to as *conjunctures* lead to individual experimental systems being linked to an experimental superstructure or an experimental network. The local condensations of this superstructure, or the 'places' in the economy of scientific practice, represent those knots around which research communities and eventually scientific disciplines develop.

English translation: Burke Barrett

25 The 'narrow conception' of molecular biology is based on the notion of genetic information transfer and puts 'protein-nucleic acid relations at the heart of biology' (Olby 1990: 504, 510, trans.).

26 In the original German text (Rheinberger 1992) a 12-page, scientific-historical, case-studies section follows here. The editors and I thought this part was not very important for artistic research issues and therefore dispensable.

27 Cf. footnote 17.

28 Knorr Cetina et al. (1988: 91, trans.) speak of 'laboratory as a sign process'.

References

Bachelard, Gaston. 1984. *The New Scientific Spirit* (tr. A. Goldhammer). Boston: Beacon Press.

—1951. *L'activité rationaliste de la physique contemporaine*. Paris: Presses universitaires de France.

Bennington, Geoffrey and Jacques Derrida. 1991. *Jacques Derrida*. Paris: Seuil.

Collins, Harry M. 1985. *Changing Order: Replication and Induction in Scientific Practice*. London: Sage Publications.

Derrida, Jacques. 1982. *Margins of Philosophy* (trans. A. Bass). Chicago: University of Chicago Press.

—1976. *Of Grammatology* (trans. G. Ch. Spivak). Baltimore: Johns Hopkins University Press.

Fleck, Ludwik. 1979. *Genesis and Development of a Scientific Fact*. Chicago: University of Chicago.

Foucault, Michel. 1994. *The Order of Things: An Archaeology of the Human Sciences*. New York: Vintage Books Edition.

—1969. *L'archéologie du savoir*. Paris: Gallimard.

Galison, Peter. 1988. 'History, philosophy, and the central metaphor' in *Science in Context* 2 (1): 197-212.

Goethe, Johann Wolfgang. 1962. 'Der Versuch als Vermittler von Objekt und Subjekt' in id. *J. W. Goethe, Die Schriften zur Naturwissenschaft, Erste Abteilung: Texte* (8). Weimar: Hermann Böhlaus Nachfolger: 305-315.

Jacob, François. 1988. *The Statue Within: An Autobiography* (tr. F. Philip). New York: Basic Books.

—1982. *The Possible and the Actual*. Seattle: University of Washington Press.

Judson, Horace Freeland. 1979. *The Eighth Day of Creation: Makers of the Revolution in Biology*. New York: Simon and Schuster.

Knorr Cetina, Karin et al. 1988. 'Das naturwissenschaftliche Labor als Ort der 'Verdichtung' von Gesellschaft' in *Zeitschrift für Soziologie* 17: 85-101.

Lacan, Jacques. 2006. *Écrits: The First Complete Edition in English* (tr. B. Fink). New York: W.W. Norton and Company.

Latour, Bruno. 1987. *Science in Action*. Cambridge: Harvard University Press.

Latour, Bruno and Steve Woolgar. 1986. *Laboratory Life*. Princeton: Princeton University Press.

MacColl, San. 1989. 'Intimate observation' in *Metascience* (7): 90-98.

Olby, Robert. 1990. 'The molecular revolution in biology' in Olby, Robert et al. (eds) *Companion to the History of Modern Science*. London and New York: Routledge: 503-520.

Polanyi, Michael. 1967. *The Tacit Dimension*. London: Routledge.

Popper, Karl. 2002. *The Logic of Scientific Discovery*. London: Routledge.

Rheinberger, Hans-Jörg. 1997. *Toward a History of Epistemic Things. Synthesizing Proteins in the Test Tube*. Stanford: Stanford University Press.

—1992. *Experiment-Differenz-Schrift. Zur Geschichte epistemischer Dinge*. Marburg/Lahn: Basilisken-Presse.

Wittgenstein, Ludwig. 1953. *Philosophical Investigations*. Oxford: Basil Blackwell.

Zamecnik, Paul C. et al. 1956. 'Mechanism of incorporation of labeled amino acids into protein' in *Journal of Cellular and Comparative Physiology* 47 (Suppl. 1): 81-101.

PRECARIOUS EVIDENCE:
NOTES ON ART AND BIOLOGY IN THE AGE OF
DIGITAL EXPERIMENTATION

Hannes Rickli

Based on audiovisual laboratory measurement records, this paper outlines the transition from 'hypothesis-driven' to 'data-driven' research from the perspective of an artist interested in the aesthetics and materiality of epistemological processes. How does comprehensive digitisation affect their perception?

1991

In the summer of 1991, I happened to visit a research laboratory for the first time, at the University of Neuchâtel in French-speaking Switzerland. Two years later, the experimenter handed me a copy of a videotape labelled *13.10.1991—Varroa 2 mins. running against test tube, stimulus starts at 12:02:28.* Little did I know at the time that a long-term art project would result from watching the three-hour video protocol of a behavioural biology experimental system investigating the odour orientation of the *Varroa jacobsoni*, a parasitic bee mite. Looking back, it was probably sheer coincidence that at the time Hans-Jörg Rheinberger, a molecular biologist and historian of science, was writing *Experiment-Differenz-Schrift* (Rheinberger 1992),[1] a small book that has since won high acclaim. Rheinberger conceived of the knowledge produced in laboratories as 'a tracing game.'[2] This notion, which captures the instrumental production of 'graphematic traces,' enabled me to place audio-visual laboratory artefacts in a larger context. Crucially, Rheinberger argued that rather than reproducing the investigated phenomenon—nature—in the experimental system, it was instead such traces that brought it forth in the first place, namely, through differential shifts, translations, and recombinations. My own interests as a practising artist concerned the concrete experimental activities, the trial-and-error and the attrition-forming part of scientific experiments, as well as their reciprocal alignments of time, space, media, apparatuses, and animals: while these various constituents of the scientific experiment somehow seemed embedded in the resulting videograms, they

101

1 A reworked version of the second part of this small book is published in the present volume pp. 89-99.

2 See Hans-Jörg Rheinberger's contribution to the present volume p. 90. There, he argues, that 'at issue is the *writing game*, the tracing game of science'. Originally published in Rheinberger (1992: 23, italics in original).

no longer appeared in the scientists' publications. This difference unlocks the potential for telling 'other' stories about the production of knowledge than those appearing in published scientific texts or scientific communication. Narrating such local micro-stories, moreover, presupposes that laboratory procedures somehow manifest themselves in one kind of material form or another and become tangible as leftovers of the research process.

The 'practical turn' underway in scientific research over the past thirty years has focused on the research process itself. In parallel to the studies on laboratory practices undertaken by sociologists like Bruno Latour, Karin Knorr-Cetina, and others, the history of science has reconstructed experimental procedures from a wide range of source material, including the private estates of researchers and scientists, laboratory records, notes, sketches, and photographs—that is, an array of leftovers and protocols that are typically omitted from research publications. The concept of the material trace is central to such work, not only because of its indexical character but also because of its physical connection with material objects and actual events. The inherent surplus thereby becomes productive. Depending on how the trace is turned, these discarded materials and traces open up other interpretative spaces:

> It is in the nature of [...] material, graphematic entities that they contain the possible conditions of *surplus* or spillover. Not only do they contain more but also other possibilities of action than those assigned to them at any particular moment. (Rheinberger 1992: 56, Italics in original)

In my art, I use the surplus signs of these video protocols to reactivate the material, aesthetic, and subjective dimensions of experimentation suppressed by the sciences.

2007
Almost twenty years after my first laboratory visit, I initiated an artistic research project, *Spillover. Videograms of Experimentation.*[3] The project draws on my somewhat random collection of video recordings made by measuring

3 *Spillover: Videograms of Experimentation* was a research project pursued at Zurich University of the Arts from 2007 to 2010. Comprising five parallel studies conducted in art, scientific research, media studies, and art history, Spillover examined discarded laboratory video materials. Project partners included three research laboratories, based in Helgoland, Austin/Texas, and Zurich, as well as the Max Planck Institute for the History of Science, Berlin. For details, see online at: http://www.ifcar.ch/index.php?id=59 (consulted 10.08.2010).

1)

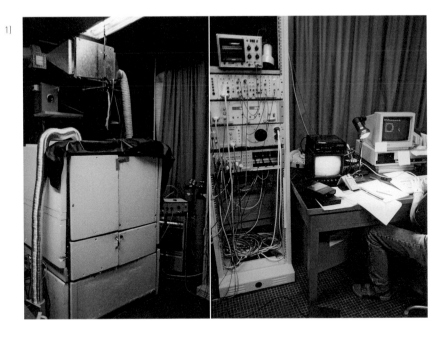

Fig. 1) *Locomotion compensator* (*Kramerkugel* system). Climatic chamber (temperature 32°C, humidity 70%); control rack; foot pedal on floor for releasing stimulus; video monitor and recorder, DOS computer (l. to r.).

cameras and microphones in various behavioural biology experimental systems. Initial analysis of the archival material reveals that the above-mentioned tape, *3.10.1991—Varroa 2 mins. running against test tube, stimulus starts at 12:02:28*, includes features that recur in other videograms.

Therefore, I shall provide some background information on the experimental setup: to combat a parasitic bee mite called *Varroa jacobsoni*, which migrated to Switzerland from East Asia in the late 1980s, plans were underfoot to develop a biological mite trap. Specifically, the chemical composition of an attractant had to be invented and corresponding animal tests conducted. The testing facility was a so-called 'Kramerkugel,' a spherical locomotion compensator that had been developed by the Max Planck Institute for Behavioural Physiology, located at Seewiesen in Germany, for the observation of silkworm moth behaviour and the phonotaxis of crickets. The spherical apparatus was housed in a box located approximately at chest height and fitted with thermal insulation styrofoam panels and ventilation tubes *(see Figure 1)*. Beside it stood a shelf with electronic steering equipment, switches, regulators, and oscillators. On a desk stood a DOS computer with a monochrome green screen, a video monitor and a VHS recorder, notepad and writing utensils, computer printouts, and so forth. In a laboratory darkened with brown curtains lay tools, adhesive tape, various containers for mites and bee larvae, and glass bulbs containing fluids. Inside the box, a measuring camera was mounted above a free-standing plastic globe measuring fifty centimetres in diameter. The camera registered the movements of a laboratory animal released at the globe's north pole, and subsequently transmitted the data to two servo motors. Simultaneously with the measured running motion, the motors rotated the globe in a negative direction so that the animal constantly remained at the north pole, although it was covering dozens of metres on the globe's surface. The apparatus first had to be adjusted to the small arachnid's running behaviour, whose shell measures one millimetre and weighs about one fiftieth of a cricket. The experimenter then had to develop a technique for extracting mites from the chitinous plates of live honey bees using a retouching brush and tweezers without damaging them, in order to subsequently apply the same precaution to affix a lightweight, reflective foil onto their dorsal shield for the camera to recognise them as they moved 'naturally'[4] across the now-virtual surface. It took several months to successfully calibrate the chemical, mechanical, electronic, media, and animal components.

4 On the problem of observation under 'natural' circumstances, see Hoffmann (2011).

The process was interrupted time and again by defective machinery, the passivity of the mites due to adverse weather conditions or electromagnetism, funding difficulties, and so forth. Since the 'arena'[5] of events could not be observed from outside the box, they were surveyed on two levels: 1) the DOS monitor displayed the numerical series of the servo motors as a list, or the computer represented the figures concurrently with the animal's movements as a two-dimensional map, on which its trajectory became a trace that could be printed out later; 2) an infrared video camera focused on the globe's north pole and thus on the laboratory animal *(see Figures 2 and 3)*. The video signals were transmitted to the outside of the arena and served to monitor the interior area during the experiment, and to retroactively count out the sequences, such as antennae movements, stored on the magnetic tape. Beneath the camera a glass tube was fitted to emit an odorous stimulus into the arena, which the experimenter seated at the desk triggered with a foot pedal. After several months he approached a positive composition of the attractant, which one Sunday afternoon prompted him to label the videotape with the comment *3.10.1991—Varroa 2 mins. running against test tube, stimulus starts at 12:02:28.* Another several months later, once a reasonably stable fit between the run marks and chemistry had been achieved, and the data sets had been transferred into statistics, represented as diagrams, and published in the experimenter's doctoral dissertation, the tape was no longer needed and was left to the present author, a practising artist.

Admittedly, this retrospective account casts no light on the circumstances described above. Thus, it explains neither the reasons underlying the actions undertaken nor the calibration procedures. The latter make themselves felt negatively in that the behaviour of the experimenter, globe, and animal sometimes lacks coordination, and thereby causes the mite to be abruptly catapulted out of the system. Following Rheinberger, the recording can thus be read as a trace:

> In the process of production and differential reproduction in experimental systems, there is a constant interplay between presentation and absentation. And this is the case because every grapheme is the suppression of another. In any attempt to show or strengthen "something", at the same time an effort is inevitably made to make "something else" disappear. (p.97. Originally published in Rheinberger 1992: 31)

5 With regard to 'representation,' Rheinberger (1992: 29) observes that 'within the framework of a given experimental system, a scientific object is unfolded within a space of material representation and brought to articulation,' (p.95) The term 'arena' was used by behavioural biologists in conversation with the present author.

105

Fig. 2] *Interior of climatic chamber.* Servosphere, Ø 50 cm, set into hole in tabletop; sensor camera in
housing over the north pole; infrared video camera on tripod. Tabletop: glass flask for filtering
wind; glass flask with stimulant; aluminium wind pipe, Ø 36 mm; stimulant nozzle attached to
piece of wood; air suction hose (l. to r.).

00-47-34-04.13.10.91.varroa.tif 01-52-38-11.13.10.91.varroa.tif

01-53-24-04.13.10.91.varroa.tif 01-53-43-09.13.10.91.varroa.tif

01-54-02-05.13.10.91.varroa.tif 01-55-24-03.13.10.91.varroa.tif

Fig. 3) *13 Oct. 1991*, Label: 'Varroa 13 Oct. 91—start of stimulus 12:02:28. 2 min. running toward pipe'.
Kramer servosphere. 9–13 Oct. 1991. VHS, b/w, mute, 2:29:28 (videostills).

Although the videogram was produced for the sake of data generation, it does not present data, but instead exhibits experimental activity. It displays everything that is aesthetic about the research process, and thus everything that is perceptible by the human eye and ear. The trace reveals precisely that which is obliterated as scientific activity evolves: concrete objects, spatial constructions, temporal sequences, lighting conditions, gestures, and manual actions. Precisely this twofold character of the trace, which cannot be wholly controlled by the producers, interests me as an artist. As long as videograms are physically present, their surplus signs open up ways of reading that reach beyond research. Its production of media turns the laboratory into a typical space, which following Siegfried Kracauer could be interpreted as a 'spatial image':

> Every typical space is brought forth by typical social circumstances, which express themselves in that space without the inference of consciousness. Everything denied by consciousness, everything otherwise deliberately overlooked, is involved in its construction. Spatial images are the dreams of society. Wherever the hieroglyph of any spatial image has been deciphered, there the basis of social reality is present. (Kracauer 1990: 186, translation of a text originally published in: Frankfurter Zeitung, 17. Juni 1930)

During the *Spillover* research project, non-intentional, material trace production was dropping out of the research process increasingly. With increasing digital storage and processing, indexicality is disappearing. Interestingly, this process is occurring precisely at a time when the history of science is focusing its exploration of the cognitive process on the trace, and philosophy is rediscovering the trace as an 'orientation technique and knowledge-art [Wissenskunst]' (Krämer, Kogge and Grube 2007).

Between 1995 and 1998, Steven N. Fry from the University of Zurich's Institute of Zoology developed an experimental system for the videographic exploration of goal-navigation in honey bees. To identify recurrent patterns in thousands of goal-approach flights, the bees were trained to fly independently from outside the laboratory building into the arena, which measured approximately 2.4 metres, thus recording themselves. At the same time, they used various landmarks to visit the food site, and to subsequently leave the laboratory again after locating the feeding station, which was disguised as a bowl containing sugared water. The experimenter's presence was no longer required for the entirety of the experiment, but instead he could delegate observation and recording to the video system. In 2005, I was able to rescue from a refuse container the videotapes, which contained over forty-four hours

of raw material gathered over a period of eighteen months of experimental activity, just before their disposal.

Fry developed procedures and processes that further automated the video system and the evaluation of a growing amount of data. Nevertheless, he appears on various occasions in the videograms; for instance, while training the bees,[6] while assisting them during search flights by using his outstretched hand as a second landmark inside the arena and then pulling away the cover of the feeding station attached to the invisible thread as soon as a bee approached the goal, or when reconstellating the landmarks, or indeed when rebuilding the arena. Forming part of our current research cooperation, Fry's current experimental system studies the behaviour of black-bellied fruit flies.[7] In a wind tunnel coupled with a virtual reality environment, the optical feedback system guides free-flying *Drosophila melanogaster* to a position desired by the experimenter. There, a high-speed camera measures the changes occurring in the body position of the insects during their split-second acceleration. Since the various positional data are measured and correlated simultaneously, the system neither stores nor evaluates images, but instead numerical series.

Falling out of the process

Our partner laboratory on the North Sea island of Helgoland adopts an alternative method for programming data collection, selection, and navigation. Here, the fish ecologist Philipp Fischer is investigating the acoustic communication of the red gurnard, Trigla lucerna. The actual object of investigation is the codfish, which has become almost extinct in the North Sea. Since this fish only rarely produces sounds and (possible) communicative units by means of percussive contractions of its swim bladder, its sound production is difficult to observe. Therefore, the somewhat more sound-active gurnard is used as a reference fish for devising automated algorithmic pattern recognition, a so-called 'bioacoustic filter'. Connection with a video system permits round-the-clock registration of the visual correlation between fish sounds and behaviour, in an aquarium measuring 2 x 2 metres, over a period of several months. Whenever the programme registers a relevant event, the system deletes the entire previously 'void' sequence. What remains is a series of pre-programmed sequences. The above example illustrates that the computerised economisation of data

6 Before measurements could be carried out, the bees learned how to fly from the entry hole on the rostrum into the arena to search for food on the opposite side. This was achieved by providing sugared water at the entry hole at increasingly greater intervals.

7 'Drosophila flight control lab'. Online at: http://fly.ini.uzh.ch/joomlas/ (consulted 10.08.2010).

16 8. 9¹, V ¹², eight 5 min., Vein Kot (Kot 1, 11)

Fig. 4) *Running path.* Test without stimulus; start in the south (arrow); duration of trial 5 min. (16 Aug. 1991)
(computer printout, 1991).

5)

STATISTICS
INTER.=Ä 1, 600Ü Tot.Vec= 600 Tot.Tim=120.00
SAMPLE RATE = 2 1/2 CA = 60 MODE = SAM

PARAMETER	SUM	AVERAGE	SD	MAX
X mm	12.80	0.02	0.23	0.70
Y mm	-225.30	-0.39	0.23	0.40
LENGTH mm	277.61	0.48	0.17	1.10
ANGLE dg (abs)		26.82	29.10	5729.58
ANGLE dg (rel)		3.18	39.46	
T.A. dg (abs)		15.88	14.94	5730.00
T.A. dg (rel)		0.33	21.81	
1/2 CA dg (abs)		18.39	17.04	
1/2 CA dg (rel)		5.61	24.45	

VEC_DPT	225.66 mm
VEC_DPT_ANG	3.25 dg
DG_RECT	81.29 %
No Move Time	4.20 s
>0 & <PL Time	0.00 s
UWind Time CA	¬102.40 s
UWind Leng CA	247.85 mm

PAS 5, Deiz 20

PA 0252. 13 *1208t*

Fig. 5) *Running path*. Start in the east; stimulus after 20 sec. (from solid line); wind from the west;
 duration of trial 120 sec., running length total 277.61 mm, of this 247.85 mm in the direction of
 stimulus source for 102.4 sec., no-move time 4.2 sec. (computer printout, 1991).

production faces various kinds of material- and media-related resistance. It seems extremely difficult to make reliable distinctions between noises and signals in acoustic pattern recognition. Thus, it took almost four years until the first experiments involving a bioacoustic filter could be conducted in open North Sea water.[8]

Rheinberger refers to the observation that an 'epistemological revolution' is currently taking place in connection with the rapid development of bioinformatics:

> The claim is that we are facing a transition from hypothesis-driven to data-driven research. That is, to put it succinctly: traces are no longer generated and evaluated in the light of possible phenomena, but generated and pooled as data ponds and streams in order to help to possibly bring to light facts that are still unheard of. What this new primacy of data means for our understanding of traces on the one side and facts on the other, I have no concluding answer. Have we perhaps returning to the original meaning of these words? The data are there. [...] The facts have to be made. (Rheinberger 2010)

Is the history of science in danger of losing its research objects if the traces left behind by research activities lose their indexical character and evaporate on storage disks and pre-sorted databases? Will this happen even before that history manages to make the transition from the 'world of traces' to the 'world of data', as the example of analogue videograms suggests, which are meanwhile disposed of permanently?[9] How does this altered frame of reference affect art? Does art also face a 'crisis of the documentary,' as film scholars,

8 See also Rickli (2009: 49-63); see further Hoffmann (2011).

9 In contrast to photography, which the history of science has studied in great depth (see Geimer 2002), the instrumental moving image has hitherto received no attention. Similarly, media studies have only recently begun researching 'commissioned films' (see the themed issues of the specialist journal *Montage/av* (14 and 15), 2005 and 2006). In conjunction with the *Spillover* research project, and in cooperation with an exhibition entitled *Hannes Rickli – Videogramme*, held at the same time at the Helmhaus Museum Zurich, the Institute of Media Studies at the Ruhr University Bochum hosted the first international conference ever dedicated to this phenomenon: *Latente Bilder – Erzählformen des Gebrauchsfilms* (Collegium Helveticum/ETH Zürich, 10-12 September 2009). For programme details, see online at: http://www.ifcar.ch/index.php?id=15&sub=51&lang=d (consulted 10.8.2010).

for instance, have observed?[10] Art looks back on a long history of objects that have fallen out of functional coherence. Dadaism, for instance, deployed the withdrawal of function as a tactic, as Raoul Hausmann remarked in 1970. The 'anti-cultural action,' he further observed, transforms the object, and 'anti-art deprives things and materials of their usefulness, and equally of their concrete and civic meaning; it overturns classical values and makes them semi-abstract' (Hausmann 1977: 10ff, trans.).

While a tendency to escape from the real through abstraction existed in the early twentieth century, the real now seems threatened as digitisation looms ever closer on the horizon. As Beat Wyss observes:

> Art history chiefly concerns the study of objects that became unusable and therefore aesthetic. Currently, analogue media like film and photography are being ousted from the practice of communicating through images. They are left to the discretion of art history, which is tasked with preserving their indexical character. Film and photographic images are reproducible, of course. Nevertheless, something has occurred that Walter Benjamin could not have dreamed of. Photography and film have become auratic in claiming to be a vera icon of the real. It is matter of protecting this aura against possible transgressions by digital image production. (Wyss 2000: 73, trans.)

113

Whereto and whereby can the data streams pervading all areas of life beyond the laboratory be diverted in order to reconnect them with the concrete world and show how they bring forth and influence realities?

Experimentation

How can art oriented toward the documentary deal with references that have become abstract? How can it observe the non-concrete and find new forms, in order to shift the non-concrete into the sphere of perception? Should it perhaps, as Jean-François Lyotard suggests, 'conduct its own experiments' and 'set up strange machines that render audible and tangible that for which ideas and materials are lacking'? (Lyotard 1986: 70, trans.) Could it return, once again, to the laboratory, Kracauer's 'typical space,' in order to use its own instruments and programmes to trace and filter out the hidden aesthetic layers of contemporary experimentation, just as they are involved both in

--

10 'Current film studies discusses the "crisis of the documentary" in terms of how referentiality, given "virtual" digital technology, docutainment, and constructivist analyses, can remain productive as a category that does not lose itself in the "fictitious".' (Bergermann 2009: 53, trans.)

the reassortment of data whose availability has become indeterminate and in the development of reference systems? What would be meant by a 'work' of art under these conditions: the programme, the cooperation with scientists, the bringing together of various discourses? Or should documentary art also produce its own objects and make facts, whose aesthetic effects it then seeks to observe? Traces can also become productive where they are absent—perhaps precisely because they are absent.

References

Bergermann, Ulrike et al. (Working group for Media Studies and Science Research). 2009.
 '"Hot Stuff": Referenzialität in der Wissenschaftsforschung' in Segeberg, Harro (ed.)
 Referenzen. Zur Theorie und Geschichte des Realen in den Medien. Marburg: Schüren: 53-81.
Geimer, Peter. (ed.). 2002. *Ordnungen der Sichtbarkeit. Fotografie in Wissenschaft, Kunst und
 Technologie.* Frankfurt/M.: Suhrkamp.
Hausmann, Raoul. 1977. 'Dada empört sich, regt sich und stirbt in Berlin' in Riha, Karl and
 Hanne Bergius (eds) *Dada Berlin: Texte, Manifeste, Aktionen.* Stuttgart: Reclam: 3-12.
Hoffmann, Christoph. 2011. 'Eigenleben. Zur Erforschung "natürlicher Systeme"' in Rickli,
 Hannes (ed.) *Videograms. The Pictorial Worlds of Biological Experimentation as an Object
 of Art and Theory.* Zurich: Scheidegger & Spiess.
Kracauer, Siegfried. 1990. 'Über Arbeitsnachweise' in Mülder-Bach, Inka (ed.) *Schriften* (5.2).
 Frankfurt/M.: Suhrkamp: 185-192.
Krämer, Sybille, Werner Kogge and Gernot Grube (eds). 2007. *Spur. Spurenlesen als Orientierungs-
 technik und Wissenskunst.* Frankfurt/M.: Suhrkamp.
Lyotard, Jean-François. 1986. *Philosophie und Malerei im Zeitalter ihres Experimentierens.*
 Berlin: Merve.
Montage/av. Zeitschrift für Theorie & Geschichte audiovisueller Kommunikation 15. 2006.
 Marburg: Schüren.
Montage/av. Zeitschrift für Theorie & Geschichte audiovisueller Kommunikation 14. 2005.
 Marburg: Schüren.
Rheinberger, Hans-Jörg. 2010. 'From Traces to Data, from Data to Facts'. Paper presented at
 Internationales Kolleg für Kulturtechnikforschung und Medienphilosophie (Bauhaus-
 Universität Weimar, 26 May 2010).
—1992. *Experiment-Differenz-Schrift. Zur Geschichte Epistemischer Dinge* (Experiment-Difference-
 Writing. On the History of Epistemic Things). Marburg/Lahn: Basilisken-Press.
Rickli, Hannes. 2009. 'Livestream Knurrhahn' in Bippus, Elke (ed.) *Kunst des Forschens. Praxis
 eines ästhetischen Denkens.* Zurich and Berlin: Diaphanes.
Wyss, Beat. 2000. 'Das indexikalische Bild. Kultur nach der Schrift' in Huber, Jörg (ed.) *Darstellung:
 Korrespondenz.* (Interventionen Band 9). Zurich: Institut für Theorie der Gestaltung und Kunst (ith).

Weblinks

http://fly.ini.uzh.ch/joomlas/(consulted 10.08.2010).
http://www.ifcar.ch/index.php?id=59 (consulted 10.08.2010).
http://www.ifcar.ch/index.php?id=15&sub=51&lang=d (consulted 10.8.2010).

BOUNDARY WORK
Henk Borgdorff interviewed by Michael Schwab

In a recent text in the Zurich Yearbook of the Arts (Borgdorff 2010) you mention the concept of 'boundary work' in relation to artistic research. Could I ask you to expand on your ideas?

I borrowed the concept from Thomas F. Gieryn (1983). I did not study his work in detail and just stumbled across the concept of 'boundary object', which actually is the term he uses—I use 'boundary work' in the article to highlight the negotiations that are required along the boundaries, but I think the more challenging concept is 'boundary object', which is an object that changes its ontological and epistemological nature depending on the context in which it is used. This is especially interesting along the borderlines between different disciplines, within academia, for instance.

'Boundary object' means that an object has some meaning in a certain research environment and another meaning in another research environment. Moreover, in the sociology of science, where the concept is used, it also has a role to play between academic disciplines *per se* and fields outside academia. This is interesting for artistic research, because artistic research places itself on the border between academia and the art world. As a consequence, artistic research as boundary work has two contexts: one context is academia, which means that artistic research has to acknowledge that it is part of academia and its ways of doing; the other context is the art world, where artistic research has to be relevant for things which happen within the 'real world' outside.

Taking this into account, what impact does a concept such as 'boundary work' have on artistic research as a discipline? Is artistic research a discipline; or rather, can it be a discipline if it operates with 'boundary objects'?

The notion of 'discipline' has become contested not only in the case of artistic research but also in the case of other areas of contemporary research. When you ask a question about 'disciplines', you really enquire about traditional disciplinary academic research, while a lot of advanced academic research nowadays challenges the notion of 'discipline'—it is post-disciplinary or trans-disciplinary. Artistic research is more something that represents this kind of border violation than being a new discipline alongside other art-related disciplines.

Part of the notion of 'discipline' is the way in which it safeguards its borders through, for example, reviewing processes or the adherence to certain modes of writing. Is such safeguarding also challenged through the advanced concept of 'boundary work'?

There is a misunderstanding here. When I say that artistic research is not a discipline in the usual sense of the word, I am referring to the old concept of scientific research as organized in specific scientific disciplines, which is not the case with artistic research. This does not mean that it is not disciplined—that there is no quality assurance or refereeing process, although no one at the moment knows how to do that in the best possible way. I am just referring negatively to the old concept of what is called 'mode-1 science', which is disciplined and organized in a homogenous way—chemistry laboratories in Helsinki or Barcelona, for example, all look the same, the quality of their research is exclusively assessed by disciplinary peers, i.e. academics. This is not at all the case in artistic research: it is more heterogeneously organized, more diversified, with a form of extended peer-review, which in our case means that both academics and artists judge the quality and the direction of the research and even the research agenda at large. This character makes it an example of 'mode-2 knowledge production', although I will not say that artistic research always is mode-2 knowledge production (I have written extensively about this elsewhere [2009])—there are all kinds of problems attached to that. To answer your question briefly: yes, it is not a discipline in the usual sense of traditional, disciplinary academic research; but academic customs, like quality assurance through a refereeing process, are still in place.

Can boundary works be reviewed in the same way as other types of objects? Normally, when you are reviewing something, doesn't it have to have some form of identity? In other words, is there not a potential methodological problem when reviewing processes refer to a shifting object, so that the way you would talk about it has to adapt in some form or other?

I don't think so. The fact that the object is floating, or not a real object at all if looked at on closer inspection, is not a problem within academia. Not even the different perspective: for instance from the artist's side, towards the same phenomenon—compared to an academic looking at the same object—creates a problem. Once an object is approached in order to review its research quality, academic discourse is already prescribed, making no difference whether the reviewer is an artist or not. The whole point rather is that the borderline between artists and researchers is being blurred. The moment you are refereeing

or judging the quality of an artwork as research, you brand it within academic discourse. However, there are two other things I want to stress that relate to the concept of 'artistic research' as boundary work: artistic research is a good example of a form of academic research in which the context is not just the disciplinary environment of university-based research—the outside world, in this case the art world, plays a central role in formulating the research agenda, formulating the direction the research has to take, evaluating the outcomes of the research, and assessing the quality of the research. Thus, artistic research has two contexts that make artistic research a very good example of modern contemporary academic research, where more and more people realize that the quality of academic research is not assessed only within the boundaries of university institutions. The second aspect has to do with the blurring of art and other life domains. The text I published in Zurich has to do with the boundaries of what art is and what the realm of knowledge and research is, and also what art is in comparison to our moral stance or to issues of daily life. I think that artistic research is an opportunity to address specifically the interrelationship between what is at stake within art and other domains of life. In artistic research projects, things are articulated that bear on who we are, where we stand, what our relation is to other people and the environment. In that sense, artistic research is also transdisciplinary research, because it reaches out to the wider community, making it relevant to the discussion around 'mode-2 knowledge production'.

When you say that the 'boundary work' is not a real but a floating object, what are the implications in relation to the work's materiality? Are there particular modes that bring out the 'boundary work'? How can a 'boundary work' appear, and how might it be threatened?

The starting point is: there is no work—at least not in a strict ontological sense. Artworks become concrete only in specific settings, contexts. Artworks and artistic actions acquire their status and meaning in interchange with relevant environments. The art world is one such environment; academia is another. It all depends on what you are looking for. The research context might invite us to identify a work as 'work', either material or immaterial. Again, it all depends on the issues addressed, the questions raised and the methods used. There are no particular modes that bring out the 'boundary work', but the 'research mode' will bring out the work on this side of the boundary; the 'market mode', for instance, on the other.

There are two aspects I am interested in when it comes to artistic research and the question of boundary work: one aspect is the discipline—it sounds very

119

much like artistic research is a transdisciplinary exercise that transgresses all possible disciplines; the other aspect is that the boundary work as you describe it might equally lack identity, and that only by pragmatically accepting provisional identities such as 'artworks' can we even talk about it. Does a 'boundary work'—in spite of its floating or shifting character—have a stable identity that functions as a point of reference within different contexts; or are there more complex ontological consequences to be drawn from the concept of 'boundary works'?

The distinction I make in the essay *The Debate on Research in the Arts* (Borgdorff 2006) between an ontological, an epistemological, and a methodological question served a mere heuristic aim: to differentiate between different aspects of research in the arts, which one might encounter in this emerging research field. In fact, there is no such a thing as an 'ontology of artistic research' independent of its epistemology and methodology. Identifying a research object is always at the same time an epistemic act, i.e. knowing at least roughly the kind of knowledge the object might convey or embody; and a methodological act, i.e. knowing how to get access to the knowledge the object is said to convey or embody.

In your question you refer to 'a boundary work', thereby already more or less objectifying the 'object' of research. In my essay *Artistic Research as Boundary Work*, I emphasis the more active use of the term: the work to be done, both on the border of art and academia and on the border of art research and other life domains. Precisely because no sharp boundaries can be drawn between art on one side and academia and other spheres of life on the other, research in art has to acknowledge that its 'objects' are fuzzy, preliminary, contingent on the project at hand. One might say that the epistemological core of the artistic research program is empty, or at least crowded and heterogeneous—terms used by Helga Nowotny et al. (2001: 179) to describe the new production of knowledge—and dependent on the specific perspective or the 'implication' of the research project. This fuzzy epistemology of artistic research is in line with recent investigations into the history and epistemology of science. Hans-Jörg Rheinberger's notion of an 'epistemic thing' tries to capture something of the contingency inherent to research in science:

> As long as epistemic objects and their concepts remain blurred, they generate a productive tension: they reach out into the unknown and as a result they become research tools. I call this tension "contained excess". François Jacob speaks of a "play of possibilities". (Rheinberger 2010: 156)

The artistic research program is a case in point where from the start we acknowledge that the research 'object' or 'issue' does not have a fixed identity—which invites, in principle, unfinished thinking. Especially due to the non-conceptual content of artistic research—the fact that what is at stake here can only partially be 'captured' discursively—it evades any definitive epistemological 'grip' while at the same time opening up a possible perspective on what we do not yet know. 'Artistic things' are epistemic things *par excellence*; they create room for that which is un-thought. In *The Debate...* I made a distinction between scientific facts, social facts, historical facts, and artistic facts in order to highlight the *sui generis* nature of the object of research in the arts. As with the distinction between ontology, epistemology, and methodology I would like to play down that distinction. There are no such things as basic artistic facts on which the edifice of the artistic is build. The realm of the artistic is historically and systematically contingent on where and how it is constituted. Here, we can learn something from Science & Technology Studies, e.g. the Actor-Network-Theory, where the artistic realm is a network and something which is performed through the active involvement of its acteurs, both human and non-human. To paraphrase Bruno Latour: the artistic research program is a program to 'reassemble the artistic', which in itself is an unfinished project. 121

If the 'artistic' is a project-to-come, what are the characteristics of 'artistic research' that make it different from other forms of research?

When it comes to discriminating or demarcating artistic research from other advanced mode-2 forms for knowledge production, I would simply say that there are two features, which are characteristic of artistic research when compared to other approaches. Firstly, there are methodological prescriptions; and you could say that artistic research takes place in and through the making of art, making it distinct from, for instance, humanities research into the same issues. Secondly, there is the outcome of artistic research, which, partly at least, is art. I say 'partly', because people differ in opinion about the amounts to which discursive aspects might be added to the artistic outcome. For sure, if there is no concrete practice or artwork as a part of the outcome of an artistic research project, then in my opinion it could not count as artistic research. Here we have two criteria, which discriminate artistic research from other advanced forms of knowledge production that might address the same issues: one is that it is in and through creating or performing that the research is done; and the other is that the outcomes of artistic research are partly also concrete artistic products—artefacts, installations, compositions, and so on.

In this case, would you not worry about the potential impact of art market structures on artistic research, i.e. what is counted as art or artwork in the market? Does artistic research then not have to buy into limited forms of art making, whilst the more advanced or more ephemeral practices (which might not necessarily produce a work or anything identifiable as such) would actually be disadvantaged? Would we not rather expect the opposite; namely, that artistic research if anything would mount a challenge against any traditional definition of art and its objects?

Yes, I see the danger, but then again, I think that with the introduction of artistic research we have created—and we are still creating—a free space also in opposition to the demands of the market, to the creative industries, to the daily strains of production—a free space for 'material thinking', to use the term of Paul Carter. As a consequence, I am not that afraid that the whole endeavour of artistic research will be in one way or another corrupted by the demands of the market. I think on the contrary that it might be the case that in performing artistic research we can have some influence over what counts as art, and as an interesting prospect not only within academia but also within the art world. That is rather optimistic, I think; but it might be the case that in the future not only our understanding of what academia is might change, but also that of art.

So, you see artistic research as having a strategic role in these transformations?

Well, this is a part of the side agenda. It is not the first thing I think about, but it might add some extra benefits. Whether to call it 'strategic' or not, I am not that sure.

References

Borgdorff, Henk. 2010. 'Artistic Research as Boundary Work' in Caduff, Corina, Fiona Siedenthaler and Tan Wälchli (eds) *Art and Artistic Research* (Zurich Yearbook of the Arts 2009). Zurich: Scheidegger & Spiess: 72-79.

—2009. *Artistic Research within the Fields of Science* (Sensuous Knowledge 06). Bergen: Bergen National Academy of the Arts.

—2006. *The Debate on Research in the Arts* (Sensuous Knowledge 03). Bergen: Bergen National Academy of the Arts.

Gieryn, Thomas F. 1983. 'Boundary Work and the Demarcation of Science from Non-Science' in *American Sociological Review* 48 (December 1983): 781-795.

Nowotny, Helga, Peter Scott and Michael Gibbons. 2001. *Re-Thinking Science: Knowledge and the Public in an Age of Uncertainty.* Cambridge: Polity Press.

Rheinberger, Hans-Jörg. 2010. *An Epistemology of the Concrete: Twentieth-century Histories of Life.* Durham and London: Duke University Press.

THROUGH THE LOOKING GLASS
ART AND SCIENCE AT THE TIME OF THE AVANT-GARDE:
THE EXAMPLE OF WASSILY KANDINSKY'S WORKING METHOD
IN HIS SYNTHETIC ART
Sabine Flach

Avant-Garde as an experimental culture

We do not (only) want that science develops and flourishes in our world. We want first, and above all to organise and structure our entire perception of the world, of our social conditions, of our artistic, technical and social culture, accordingly to the principles of science. (Punin 1920, according to Douglas 2004: 31)

This statement, formulated by the art historian Nikolai Punin in his 1919 lecture, characterised a tendency in the artistic culture that would become symptomatic of the members of the avant-garde: working on an art and on a conception of art that was new, universal, anti-naturalistic, and anti-idealistic. It refused the traditional procedures and methods used to govern the iconographic archives of the past. It also rejected the teleology of the conventional historiographic ideas on the development and replacement of the codes and motifs of iconography. This new approach to art—or rather a result of this search for a new art—was associated with the (re-)discovery the life sciences and its methodology, as an analogy and a reference point for the artistic practice.

The program of the avant-garde artists was based on an attempt to achieve a systematic and complete study of artistic culture. This program had to be accomplished by an analysis of the methods and mechanisms of the artistic production as a whole, and at the same time an analysis of the art pieces themselves. The goal of this research was the modernisation and the founding of a new art, which through the levelling of the traditional conventions and cultural techniques would overcome the habits of perception. The research aimed at an elementarisation, i.e. a return of the artistic production to its basic structures and unity, in order to test their efficiency (cf. Groys and Hansen-Löve 2005).
In 1926, Kazimir Malevich wrote:

The academic naturalism, the naturalism of the impressionist, the cézanism, the cubism etc.—are in a way nothing else than a dialectic method, which in itself cannot determine the intrinsic value of the work of art. A figurative representation—in itself (the figurative being the goal of the representation) is something that has nothing to do with art… (Malevich 1980: 66)

This search for the basic elements of art was used for the elucidation of the modalities of perception. The novelty was that art itself was the conductor of the transformation of these modalities of perception into an object of research. As Ivan Kliun said: 'Art is the agent of the artistic influence on our psycho-physical system, and—considering the role it played in our culture—it is a very strong agent. Artistic creation and artistic perception.' (Kliun, according to Karassik 1991, 45).

In this case—here is my argument—the avant-garde was an *experimental culture* which would establish a new *aisthesis*, in order to emancipate the perceptive abilities of humans from the traditional representations and artistic systems, in favour of unexpected combinations and the fusion of senses: art became an experiment, in which the senses and modalities of perception would be extensively analysed. At the same time, the relations would be investigated not only with the new pre-formed techniques of visualisation (cf. Flach 2005), but also in the interest of the knowledge of the physiological and psycho-technical theories of perception, which were closely connected with the concepts of the immaterial, the pre- and unconscious, the non-visible and the sensitive. This occurred along with the process of abstraction, which can be considered as a *constitutive device*, and consequently as the *missing link* of the interference between science and art. In that sense, abstraction would become a key phenomenon for the understanding of this new art and its efforts to access a *new vision*.

This new vision meant neither the naturalistic rendition of the environment nor the simple representation of its visual appearance. Rather, it linked in a new vision, the sense of sight with all the other senses, for the 'general development of perceptual abilities of mankind' (Matjuschin, according to Karassik 1991: 44).

Another perspective would be the investigation of mental images—or processes of imagination, fantasy, twilight sleep, or dreams—and their links with the question of the function of perception, associated with the functions of the brain and nerves. The conviction was that natural phenomena that existed beyond the perceptive abilities of the eye were met by the development of ever more sensitive recording devices. This process went hand in hand with the rediscovery of intuition as a skill genuinely constitutive of art. This skill was lacking after the natural and life sciences, with the analytical attitude that characterised the 19th century, sought to eradicate it. This 'intuitionalism' was more sensitive and pre-rational than irrational, arbitrary, or emotional (cf. Groys and Hansen-Löve 2005: 237). Thus the artist became a *révélateur*, unveiling the concealed material world and—this is crucial—representing it by abstraction. One of the consequences of this abstraction was the creation of

a 'genuine interpretation of reality', which implied a specific mode of aware-
ness, providing legitimacy to the new art. Art did not consist any longer in
the restitution of a normative teaching of the *Mimesis*; instead it was drawing
attention to the radical changes in its relation to reality.

These innovations in the arts emphasised changes in perception, and
reorganised the relation between aesthetics and *Aisthesis*, as well as estab-
lishing art as a science. They were understood not only as a renunciation to
the paradigm of the imitation of nature, but as a new spirit, a synchronic
combination of artistic processes, scientific discoveries, and cultural and
media technologies.

The prevalence of abstraction as the link between art and science—
after its successful introduction in the practice of visual arts and aesthetic
theory—is essentially an institutional phenomenon. In Western Europe,
the Bauhaus or the group De Stijl could be considered as centres of innova-
tion. In Russia, experimental and innovative work was conducted at the
High Artistic and Technical Workshop (VChUTEMAS); at the Institute for
Artistic Culture in Leningrad (GINChUK); and at the Russian Academy of
Artistic Sciences (RAKhN), an art laboratory focusing on constructivism or
organic realism in the sense of bio-aesthetism.[1] In the course of this research,
elementary colours, *Faktur*, shape, materials, and light were exhaustively
analysed as components of the perceptual parameters of humans *(fig. 1)*.
These institutions directed their efforts towards research on *aisthetic* and
aesthetic practices, to create a connection between a new cultural meaning
and a new culture of knowledge. Their goal was primarily to establish art as
a field of research, producing its specific *knowledge*. This was realised by the
choice of their own working methods, materials, specific forms, and aspects
of concrete space-time relationships.

Nicolai Punin, head of the 'general methodology' department at the
Institute for Artistic Culture (GINChUK), stated:

> Artistic activity operates with measuring and is measured, like any other practice
> intending at producing knowledge. If these conditions are not met, producing
> knowledge is not possible. Art is often nothing else but the science of the aesthetic
> phenomena. (Punin 1919, according to Karassik 1991: 40)

127

1 Vysšie [Gosudarstvennye] Chudožestvenno-Techničeskie Masterskie; Gosudarstvennyj Institut
 Chudožestvennoj Kul'tury; Rossiskaja Akademija Chudožestvennych Nauk. On the term
 'bio-aesthetism' cf. Groys and Hansen-Löve (2005: 264).

Such self-conception of artistic practice made it possible for Kasimir Malevich
to declare:

> These kind of pretentious artistic methods has nothing to do with a scientific
> approach, especially when the old conception of the painter is disappearing and is
> replaced by the painter as a scientist. (Malevich, according to Schadowa 1978: 26)[2]

The program of the GINChUK aimed at a *scientific foundation of the arts*,
developed in research departments, each with different tasks and goals.
For this purpose, five departments were created: 1. the department for the
culture of painting, led by Malevich; 2. the department for the culture of
materials, with Tatlin at its head; 3. the department of organic culture, under
the direction of Matyushin; 4. the department of general methodology, led
by Punin; and 5. the experimental department, headed by Mansurov. The
task of the department of general methodology was 'to gather the individual
efforts to develop a theory of the new art' (State archives for literature and
art, according to Karassik 1991: 45). The content and methodology of the
artist-scientist activities included the preparation and development of precise
and objective research methods. It was crucial that these methods were based
on reliable experimental analysis, in order to be presented in a conclusive
and clear form. The declared goal of this research effort was the founding of
a *universal artistic methodology*, because 'analytically and integratively, art
history can be considered as resulting from a cultural invention' (Punin 1929: 41).
This research would be made available to other cultural and scientific fields,
to promote a global clarification of the psycho-physical skills and to optimise
these skills.

These experiments—on the sense of space, the perception of color,
shape, and dynamic processes—were used as an exercise to help people
express the connections between sensations, without relating to the usually
associated representations. They also investigated the methods, painting
procedures, and systems of art.

With focusing on the *design* and investigation of colour-and-form
values, abstraction became a method and a practice of elementarisation,
halfway between art and science. It was clearly stated in the administrative
report of 1927/28 about the institution:

128

2 Originally, the quote is from Malevich's notebook, which is held at the Malevich Archive at the
Stedelijk Museum in Amsterdam. Cf. Wiese (1980).

Fig. 1) GINChUK. Department for Organic Culture, ca. 1925 (from Klotz 1991: 121).

Fig. 2) Wassily Kandinsky: On the working method of synthetic art. Excerpts. 1927 (from Kandinsky 2002a: 4).

Researches on the impact of the image on visual perception has demonstrated:
a) the importance of the first and second complementary colour in an interactive
system of two colours, b) the role played by displacements in the reception of colour
combinations, c) the creative power of a colour can be approximatively deduced from
its colour reflexions in the eye, d) the law of the closed circles in the perception of
colours, e) the role played by movement in the reception of colour combinations.
(State archives of literature and art, according to Karassik 1991: 55)

The 'Russian Academy of Artistic Sciences' or RAKhN[3] (then renamed
GAChN), was founded in 1921 in Moscow. Wassily Kandinsky was its Vice
President and Director of the psycho-physical department[4]. He saw it as
a 'laboratory for the integration of arts and sciences' (Pogodin 1997: 47),
in which 'the general character of contemporary aesthetics' should be
understood as a 'precise field of knowledge'; and 'the history of art and art
criticism' should be considered 'sciences'. The conceptual guidelines of the
institute were: 1. a commitment to German science in art theory (K. Fiedler,
A. Hildebrandt, W. Worringer); in psychology as developed by W. Wundt
and the Leipzig school; and in the philosophy of Husserl and phenomenol-
ogy, 2. an experimental working process organised in laboratories, 3. the
founding of an art history understood as an evolution of forms, and 4. the
analysing of neurophysiological relationships between perception and space
(cf. Barck 2002).

130

The objective of the collaborators of the institute—the *rakhnovtsy*—was
to formulate a theory of artistic creativity for an *experimental science of art*.
The RAKhN's art theory had to be founded on a scientific base, so that
the connections between the art and life sciences—from an artistic point
of view—could be explored. 'The task now confronting the Academy is to
acknowledge and use artistic experiment as a special method—and this has
not been applied in the past' (Anonymous 1926: 211).

According to the working methods established at the Institute for
Artistic Culture, the Russian Academy for Art Sciences was also organised
in departments. Shortly after, an artistic-scientific comity was founded,
which in addition to the conceptual and organisational work of the Institute,
decided on the main research of its departments: the Physico-Mathematical

3 Founded in Moscow on 13th of October 1921 by decision of the People Commissariat for Education
 (NARKOMPROS), directed by A.V. Lunatscharski, later named GAChN: States Academy for
 Artistic Sciences. The RAKhN published its own Journal, the *Iskusstvo* (Art).
4 The president of the RAKhN was Petr Kogan.

and Psycho-Physical department, directed by Kandinsky; and the Sociology department—under the authority of Vladimir Friche—and the department of Philosophy, both directed by Gustav Spet. Within these large areas, sub-projects focused on specific questions of literature, music, architecture, theatre and—Kandinsky´s specialty—visual arts.

The program of both institutions was built around the exploration of perceptual modalities, in which a particular effort of research was dedicated to methodological tools. To *define and communicate* the *non-measurable* factors *of artistic culture* was one of the main problems that the institutions had to solve to reach their goal. This had to be done with the condition that every specific artistic practice would *not* be merged with science, but science applied to the analysis of each art's proper instruments. Consequently, artistic research aimed to explore specific artistic methodologies which, *at the same time, would be used in the experiments.*

The 'synthetic art' method of Wassily Kandinsky

(Fig. 2) Wassily Kandinsky directed the Psycho-Physical department of the Russian Academy for Art Sciences. He described it as a 'synthetic laboratory for studying the work of art in all its interdisciplinary connections, especially with the psychological sciences—psychology of perception, psychopathology and psychoanalysis' (Misler 1997: 150). Its main goal was to conduct basic research on the psychological dimension of artistic experience and on struc-tural aspects. He stressed that:

> The tasks of the department are determined by (our) investigation of artistic phe-nomena within their synthetic interrelationship starting with the *elements*, moving through *construction*, and ending with *composition*. For the most part, the *positive* and *empirical* method is being applied here. (Ibid.: 152)

Kandinsky's research activities—which he would continue to develop at the Bauhaus after he left Moscow—emanated from his *Plan for the Psycho-Physical Department of the Russian Academy of Artistic Sciences*, in which

> The department sets as its tasks to disclose the inner, positive laws on the basis of which aesthetic works are formed within every sphere of art and, in connection with the results obtained, to establish the principles of synthetic artistic expres-sion. This task can be reduced to a number of concrete objectives: (1) the study of artistic elements as the material from which a work of art is formed, (2) the study of construction in creation as a principle whereby the artistic purpose is embodied, (3) the study of composition in art as a principle whereby the idea of a work of art

is constructed. The work of the department must be carried out in two directions: (a) a series of lectures based on the established program and (b) experimental research. (Kandinsky 1923, according to Bowlt: 197)

In *The Primary Elements of Painting*, Kandinsky described his research activities as follow: 'We should note that all works (of art) contain certain constant elements and we cannot imagine a work of this or that art without them. They are what I call primary elements' (Kandinsky 1919, according to Misler and Bowlt 1997: 166). A substantial part of the scientific work of the year 1922-23 was dedicated to the methodological approach: 'a psychological approach, inasmuch as the research will concern the psychology of artistic creation and perception' (Kandinsky 1923, according to Bowlt 1988: 198). The questions raised by contemporary psychology—as well as psychoanalysis and Gestalt psychology—were the main focus of the Russian Academy for Art Sciences. In this respect, Kandinsky's program was not an exception, rather he organised the research of the department—on the basis of his conception of synthetic art (Kandinsky 1980: 45)—like a laboratory, where the art piece would be examined from an interdisciplinary perspective. The objective was to explain the influence of art on human perception in regard to psychological sciences like cognitive psychology, psychopathology, and psychoanalysis.

In March 1921, Wassily Kandinsky published *On the working method of synthetic art*[5] which was used as a conceptual manifesto[6]. Accordingly, the basis of synthetic art had less to do with the object of art—the person who perceives art—than with an exploration of the subject, i.e. the artist himself. It should also include a detailed analysis of the materials. Furthermore, experimental laboratory work acquires an exceptional importance, with appropriate methods that Kandinsky outlined: 'the observation of simultaneous and alternating effects of two elements of different arts can be most accurately realised in the laboratory' (Kandinsky 2002a: 6).

Kandinsky defined synthetic art as 'an art created by means of various arts' (Ibid.). In addition, synthetic art could overcome the differences and specialisation of art and science, which were particularly marked in the 19th century. Kandinsky criticised art as pure reference to the appearance of nature, its principle of the reproduction of nature, which meant that art did not go beyond the simple mechanical imitation of nature. Instead of an

5 Published for the first time in German with a commentary by Karlheinz Barck (2002).
6 In 1927 Kandinsky wrote 'UND. Einiges über synthetische Kunst' in *i10. Internationale Revue* (1): 4-10 cf. Kandinsky (1927).

autonomous art, as Kandinsky stated, art depended on representation. For Kandinsky, the notion of synthesis was synonymous with the notion of the age of the *'Großen Geistigen'*. He included in this complex concept an 'optimisation' of the senses of human beings: 'the great age of the spiritual, which only a few have the presentiment and even fewer can see, will go through many developmental moments. The current moment has, among many others, the task to open peoples' eyes wide, to sharpen the sense of hearing, to free and develop all the senses and to reunite the living with the *élan vital*' (Kandinsky 2002b: 628).

Kandinsky never blindly associated art and science; rather, he chose to draw the attention to what linked them, according to *converging phenomena*, which *positively transformed* the developments of the 19th century, before *completing* and *using* them.

> We should also utilise the legacy of the last century (analysis = decomposition) and simultaneously, with the synthetic approach, deepen and complete it in order to perceive and create (synthesis = link) a living and organic link in what seemed territories away from one another. Then [...] the rigid atmosphere of the "whether-or" would be replaced by the flexible and lively atmosphere of the "and"—analysis as a means of synthesis. (Kandinsky 1955a: 115)

On the basis of a 'bigger or a maximised abstraction' (Kandinsky 2002a: 6), it should not be about examining works created by different arts *together*, but works in which the elements of the arts are connected by the principle of *parallel motion*. Therefore *design* intended as *contrasting* is the focus of synthetic art, meaning that one art form assists, interprets, and accentuates the other. In the words of Kandinsky: 'The principle of [...] arithmetical addition is to strengthen a means of an art with the parallel means of another art or arts' (Kandinsky 2002a: 5).

An artistic science based on synthetic art comes with the following possibilities: 'an application of the elements of each art on the basis of its affinities in general; the implementation—after the principle of parallelism—of powerful design methods, with which each art constantly operates in its own field, i.e. the principle of *contrasting*' (Kandinsky 2002a: 6). From this statement, Wassily Kandinsky derived the following tasks:

1. the analytical study of the properties of the individual elements of the respective arts,
2. the study of the principle of the combination of elements and finally the laws of these combinations within and outside a work—that is, the design issue,

3. the study of the individual elements as well as the design principle, according to the overall organising aspect of the compositional idea of the work. (Kandinsky 2002a: 6)

In the second part of the study of the elements of art, the focus must remain on the exploration of the works, 'in the sense of their analytical decomposition and examination, to define why, in a given work, this, or any element should be implemented' (Kandinsky 2002a: 6f.). The study of the properties of the elements aims at precisely specifying their psycho-physical effect on the person. The way to appropriately explore these aspects, Wassily Kandinsky recommended, was 'to perform laboratory work [...] and strictly [apply] laboratory procedures, since they are more flexible and easier to control.' To conduct these experiments, Kandinsky gathered professionals from various disciplines for a productive collaboration. This search for an exploration of the 'empiricism of subjectivity'[7] demanded the adoption of a common language. The 'empiricism of subjectivity' combined sensory-physiological components with questions about the perception of art.

For Kandinsky, this work was inextricably linked with design issues, as in each particular work elements were not used separately but combined. For him, a central question was also the 'knowledge of materials and elements', which should have been researched alongside the 'Basic elements of painting. Its nature and meaning' to use the title of his lecture dated from the first of September 1921.[8] The reason for this was, for Kandinsky, that:

> until today, the prevailing thesis—which was disastrous—stated that to "decompose" art would inevitably lead to the decay and the death of art. This thesis was stated by ignorants, underestimating the exposed elements and their primary strength. (Kandinsky 1955b: 11)

The goal of this *decomposition and exposition* of the elements of art was the investigation of their effects on the senses, which could be combined with research on the physical, psychological, and physiological dispositions of human beings. Kandinsky emphasised that the purpose of the *process* of emergence of a scientific or artistic work was the 'investigating method' (Kandinsky 2002a: 8),

134

7 I borrowed this expression from the works of Jan Evangelista Purkinjes (1951: 28).
8 A previous version of this lecture was held at the INCHUK on the 2nd of June 1920. The original title was: *Osnovnye elementy zhivopisi*.

as he called it, and not the final product. Abstraction, as part of an elementary and analytical investigation, is for Kandinsky the moment which can reveal the internal connections between art and science. This specific connection between art and science produced the synthetic thought developed by Kandinsky.

In conclusion
Kandinsky—whose working method was emblematic of the avant-garde movement—showed that the methods of artistic knowledge were characterised by the development of *primary elements*. These could be explained by the postulate of modern abstraction, which involved the use of *elementary forms*. Art had to get rid of the obsolete imitative method. A typical aspect of these elementary methods and theories was that they did not remain confined to the field of art. In the contrary, after being developed in the field of art, they became a part of the knowledge of the sciences of life. A methodological tool was developed alongside the artistic activities to validate the basic research on conceptual models. Kandinsky's theory represents an aspect of an explicitly artistic knowledge that should be constitutive of the comprehension of this knowledge. Abstraction can be understood as a reaction to the epistemological crisis and upheavals of representation. In this sense, abstraction is nothing more than a phenomenon of the visual arts and 135 a theory of the aesthetic. For the scientific investigation of the relationship of complex phenomena oscillating between art and science, it can be said that an *abstract turn* (cf. Flach 2006), beginning in the second half of the 19th century, reached a decisive climax in the experiments of the Russian avant-garde and its institutional practice.

References

Anonymous (A. Sidorov). 1926. 'Akademiia khudozestvennykh nauk' in *Nauka i iskusstvo* (M) (1), according to Misler, Nicoletta. 1997. 'A Citadel of Idealism: RAKhN as a Soviet Anomaly' in Misler, Nicoletta and John E. Bowlt (eds). *Experiment. A Journal of Russian Culture* (3): 15.

Barck, Karlheinz. 2002. 'Die Russische Akademie der künstlerischen Wissenschaften als europäischer Inkubationsort' in *Trajekte. Zeitschrift des Zentrums für Literaturforschung* 4: 4-8.

Flach, Sabine. 2006. 'abstrakt / Abstraktion' in: Barck, Karlheinz et al. (eds) *Ästhetische Grundbegriffe. Historisches Wörterbuch in sieben Bänden* (7). Stuttgart: Metzler: 1-40.

—2005. 'Experimentalfilme sind Experimente mit der Wahrnehmung' oder: Das Sichtbarmachen des Unsichtbaren. Visualisierungstechniken im künstlerischen Experiment am Beispiel der Arbeiten von Leopolod Survage, Vikking Eggeling und Walter Ruttmann für die UfA' in Becker, Sabine (ed.) *Jahrbuch zur Kultur der Weimarer Republik* 9. Munich: Edition Text und Kritik: 195-221.

Groys, Boris and Aage Hansen-Löve (eds). 2005. *Am Nullpunkt. Positionen der russischen Avantgarde*. Frankfurt/M.: Suhrkamp.

Kandinsky, Wassily. 2002a. 'Über die Arbeitsmethode der Synthetischen Kunst' in *Trajekte. Zeitschrift des Zentrums für Literaturforschung* 4: 4-8.

—2002b. Untitled text (Today, in an acute form...) answer to a survey, according to Zimmermann, Reinhard. *Die Kunsttheorie Wassily Kandinskys* (2). Berlin: Mann.

—1980. 'Rückblicke' in Roethel, Hans Konrad and Jelena Hahl-Koch (eds) *Wassily Kandinsky. Die Gesammelten Schriften* (1) (Autobiographische, ethnographische und juristische Schriften). Bern: Benteli: 27-50.

—1955a. 'Pedagogy of Art' in Max Bill (ed.) *Essays über Kunst und Künstler.* Stuttgart: Hatje: 113-117.

—1955b. *Punkt und Linie zur Fläche. Beitrag zur Analyse der malerischen Elemente.* Bern: Benteli.

—1927. 'UND. Einiges über synthetische Kunst' in *i10. International Revue* 1: 4-10.

—1923. 'Plan for the physicopsychological Department of the Russian Academy of Artistic Sciences', according to *Iskusstvo. Zhurnal Rossiiskoi Akademii khudozhestvennykh nauk (Art. Journal of the Russian Academy of Artistic Sciences)* (1, R69): 415-416, according to the English translation in Bowlt, John E. (ed.) 1988. *Russian Art of the Avant-Garde. Theory and Criticism 1902–1934.* London: Thames and Hudson: 196-198.

—1919. 'Die Grundelemente der Form' in Staatliches Bauhaus Weimar (ed.): *Staatliches Bauhaus Weimar,* (Weimar 1919, 1923).

Karassik, Irina. 1991. 'Das Institut für Künstlerische Kultur. GINCHUK' in Klotz, Heinrich (ed.). *Matjuschin und die Leningrader Avantgarde* (Catalogue of the correspondent exhibition. ZKM Karlsruhe). Stuttgart and Munich: Oktogon: 40-58.

Klotz, Heinrich (ed.) 1991. *Matjuschin und die Leningrader Avantgarde* (Catalogue of the correspondent exhibition. ZKM Karlsruhe). Stuttgart and Munich: Oktogon.

Malevich, Kazimir. 1980 (1926). *Die gegenstandslose Welt* (Reprint ed. S. von Wiese). Mainz and

Berlin: Kupferberg.

Misler, Nicoletta. 1997. 'Vasilii Kandinsky at RAKhN' in Misler, Nicoletta and John E. Bowlt (eds)
 Experiment. A Journal of Russian Culture (3): 14-30.

Misler, Nicoletta and John E. Bowlt (eds). 1997. *Experiment. A Journal of Russian Culture* (3).

Pogodin, Fedor. 1997. 'Toward a New Science of Art' in Misler, Nicoletta and John E. Bowlt (eds).
 Experiment. A Journal of Russian Culture (3): 40-50.

Punin, Nikolai. 1929. 'Abteilung für die neuesten Kunstströmungen. Gründung und Aufgaben'
 in *Rechenschaftsbericht des Russischen Museums für 1927*, Leningrad: s.n.: 41, according
 to Karassik, Irina. 1991. 'Das Institut für Künstlerische Kultur. GINCHUK' in Klotz, Heinrich (ed.)
 Matjuschin und die Leningrader Avantgarde (Catalogue of the correspondent exhibition.
 ZKM Karlsruhe). Stuttgart and Munich: Oktogon: 40–58.

—1920. 'First Cycle of Lectures for the In-Service Training of Drawing Teachers', according
 to Douglas, Charlotte. 2004. *Wilhelm Ostwald und die Russische Avantgarde* in Papanikolaou,
 Miltiadés. *Licht und Farbe in der Russischen Avantgarde. Die Sammlung Costakis aus dem
 Staatlichen Museum für zeitgenössische Kunst Thessaloniki* (Catalogue of the correspondent
 exhibition. Martin-Gropius-Bau, Berlin and Museum Moderner Kunst Stiftung Ludwig,
 Vienna). Cologne: Dumont: 30-40.

—1919. 'Maß der Kunst' in *Kunst der Kommune*, according to Karassik, Irina. 1991. 'Das Institut für
 Künstlerische Kultur. GINCHUK' in Klotz, Heinrich (ed.) *Matjuschin und die Leningrader
 Avantgarde* (Catalogue of the correspondent exhibition. ZKM Karlsruhe). Stuttgart and
 Munich: Oktogon: 40-58.

Purkinjes, Jan Evangelista. 1951. *Opera omnija, Band V.* Prague: s.n.: 27-54.

Schadowa, Larissa A. 1978. 'Das Staatliche Institut für Künstlerische Kultur (GINCHUK) in
 Leningrad' in *Probleme der Geschichte der sowjetischen Architektur. Sammelband
 wissenschaftlicher Artikel* 4: 26

States archives for literature and art, Leningrad (LGALI:F.244, Op.1, D.33, L.43ob), according to
 Karassik, Irina. 1991. 'Das Institut für Künstlerische Kultur. GINCHUK' in Klotz, Heinrich (ed.)
 Matjuschin und die Leningrader Avantgarde. (Catalogue of the correspondent exhibition.
 ZKM Karlsruhe). Stuttgart and Munich: Oktogon: 40–58.

Wiese, Stephan von. 1980. 'Vorwort. Zwei Standpunkte: Kasimir Malewitsch und das Bauhaus'
 in Malevich, Kazimir. 1980 (1926). *Die gegenstandslose Welt* (Reprint ed. S. von Wiese).
 Mainz and Berlin: Kupferberg: V.–XIX.

137

ALLEGORY, ARCHITECTURE AND 'FIGURAL THEORY'
Penelope Haralambidou

'This book is a defense of the eye' writes French philosopher Jean-François Lyotard in the introduction to his complex work *Discours, Figure* (1971: 11). Lyotard defends the eye against a philosophical tradition denigrating visual perception, by establishing the notion of the 'figure', which he links to phenomenology, images/drawings, and the experience of seeing. He sees the 'figural' as a violating force, which works to interrupt established structures in both the visual and the discursive realm.

In my practice-led research, the violating and transgressing force of 'figure' takes the guise of allegory, an artistic and literary trope, which I have used as a research method. Allegory, a figurative mode of representation that says one thing (in Greek *agoria*, speaking) and means another (*allos*, other) demonstrates reciprocity between visual and verbal: words are often treated as purely visual phenomena, while images are offered as a script to be deciphered.[1] In accordance with my training as an architect, Lyotard's notion of 'figure' materialises into the 'allegorical architectural project'. The allegorical architectural project is the design of an imaginary building that uses architectural drawing and making as tools for defining and thinking through the research question: challenging the underlying syntax of established conventions for imagery and codes for representation in the visual arts.[2] Projection and prediction—preceding that which it describes—traditionally, and still perhaps, distinguishes architectural drawing from representational drawing in art; its extrapolative but also organizational traits, however, are pertinent in practice-led research beyond architecture.

In *Anatomy of Criticism*, Northrop Frye asserts that all commentary is allegorical interpretation, and points to the formal affinities of allegory with criticism (1990: 89). Although using architectural design as a method, the focus of my research extends to an analysis of work from other disciplines: art, cinema and music, as well as architecture. Therefore, I use architectural drawing and making—the language of describing buildings—to articulate something 'other' *(allos)* than the construction of a building. Consequently,

--

1 For more on the literary and artistic trope of allegory, see Angus Fletcher (1965) and Craig Owens (1980: 70).

2 For an in depth analysis of my definition of the allegorical architectural project, see Haralambidou (2007a and 2007b).

the allegorical architectural project disengages the architect from the con-
struction site; it assumes the disruptive and creative role of Lyotard's 'figure'
and in combination with 'discourse' becomes a vehicle for critical analysis.
Blurring the distinction between two fields of architectural endeavour,
drawing (in terms of the architect as designer) and theoretical enquiry
(in terms of the architect as writer), my research practice explores the potential
of architectural design as 'figural theory'. Inspired by Lyotard's philosophical
ideas, my work is also a 'defense of the eye' that critically probes the role of
the visual in defining conceptual models of creative knowledge.

 An example of 'figural theory', as described above, is *The Blossoming
of Perspective*, an ongoing project investigating the underlying arrangement
of *Given: 1ˢᵗ the waterfall, 2ⁿᵈ the illuminating gas...*, 1946–66, an enigmatic
assemblage by French artist Marcel Duchamp (Haralambidou 2003). *Given*
has not ceased to puzzle visitors since it was first open to the public in 1969,
shortly after Duchamp's death. Standing in front of an old weathered door
in a darkened, empty room, the viewer engages through two peepholes
with an unexpected—often described as pornographic—eerie scene: in the
open landscape and bathed in light, a recumbent, spread-eagled, and face-
less female nude is holding a gas lamp, while in the background, a waterfall
silently glitters.

 The title of the work, which Duchamp developed in secret for twenty
years, reads as a mathematical equation, a problem or a riddle requiring
a solution Furthermore, in his notes, he alludes to the 'allegorical appear-
ance' of the scene. Duchamp has offered no explanations of *Given*, but has
famously stated that 'the creative act is not performed by the artist alone; the
spectator brings the work in contact with the external world by deciphering
and interpreting its inner qualifications and thus adds his contribution to the
creative act' (Lebel 1959: 77-78). Given the waterfall and the illuminating gas,
therefore, Duchamp directly invites the viewer to contribute to the creative
act by determining the hidden meaning behind the allegorical setting and
even conclude the incomplete title.

 Drawn by the unresolved riddle of Duchamp's call for interpretation,
and taking as a starting point Lyotard's linking of *Given* to linear perspective
(Lyotard 1990), in *The Blossoming of Perspective* I allegorically constructed the
research question in the form of an imaginary building. Entitled *The Fall*, this
building would sit in the landscape depicted behind the nude figure in *Given*;
it would link *Given* with *L.H.O.O.Q.*, 1919, Duchamp's infamous defacement
of Leonardo da Vinci's *The Mona Lisa*, c. 1503–1507, by offering the female
figure a fictional identity: that of a fallen woman (Haralambidou 2007c). This
'figural' redrawing of Duchamp's work had a twofold purpose. It aimed to

1)

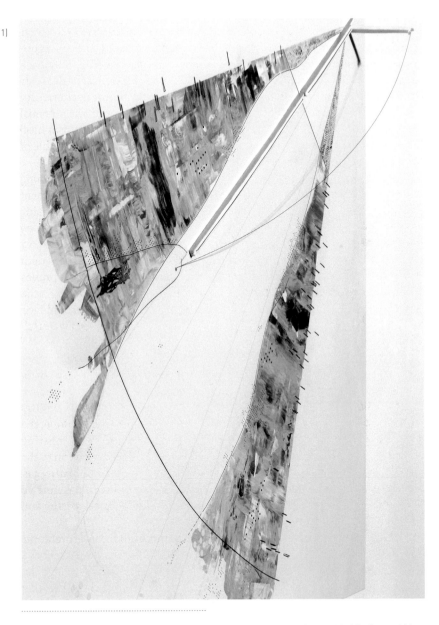

Fig. 1) Penelope Haralambidou, *The Fall*, mixed media on board, 2004. Sited behind the figure of Mona Lisa, in a void between the two visible sides of the depicted landscape, my design—the architectural structure of The Fall—comprises a tower supporting Mona Lisa's balcony, a long corridor leading to the door in Given, and a sinuous trajectory tracing the female figure's fall.

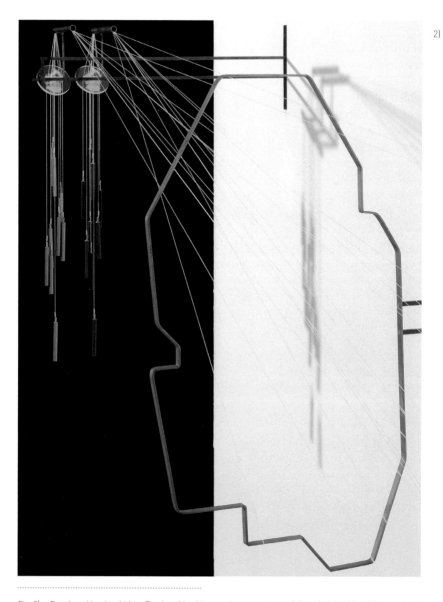

2)

142

Fig. 2) Penelope Haralambidou, *The Act of Looking*, steel, perspex, waxed thread and acid etching on nickel silver, 2007. The Act of Looking, a full-scale three-dimensional drawing of Given, gives material substance to the act of looking through the first interface awaiting the viewer: two peep holes on a weathered Spanish door. The piece is a ghost image of Duchamp's assemblage, where all the main constituent elements—door, wall, nude body, and illusionary landscape—lose their materiality.

unravel the perceptual and psychological spaces embedded in the structure of the artwork, while at the same time pursuing the primary focus of the research: a questioning of the Renaissance schema of perspective construction. *The Fall* allegorically encapsulated the research hypothesis, a set of ideas, which, although complete and intuitively convincing within the narrative structure, I accepted as an unresolved enigma that I felt compelled to decipher. The ensuing research through text and drawing aimed to interpret, verify, and expand the intuitive links established by the allegory. Duchamp's term 'blossoming' came to suggest an expansion of the Cartesian understanding of space, and led to a study of stereoscopy and binocular vision—the overlooked 'other' eye—pointing to an alternative visual schema (Haralambidou 2007d).

Therefore, I would like to suggest here that the importance of the allegorical architectural project, and the construction of the design enigma, is paramount within the boundaries of a research project in visual practices, as a method of grasping meaning beyond analytical discourse. This is especially valuable in research focusing on representation and drawing, which is for art and architecture what language is to literature. The difficulty of interrogating the architecture of visual thinking can be resolved by working through a figurative parable or an allegorical narrative in the form of an imaginary building.

143

--

References

Fletcher, Angus. 1965. *Allegory: The Theory of a Symbolic Mode*. Ithaca: Cornell.

Frye, Northrop. 1990. *Anatomy of Criticism: Four Essays*, Harmondsworth: Penguin.

Haralambidou, Penelope. 2007a. 'The Fall: The Allegorical Architectural Project as a Critical Method' in Rendell, Jane et al. (eds) *Critical Architecture*. London: Routledge: 225-236.

—2007b. 'The Allegorical Project: Architecture as Figurative Theory' in Anstey, Tim, Katja Grillner and Rolf Hughes (eds). *Architecture and Authorship: Studies in Disciplinary Remediation*. London: Black Dog Publishing: 118-129.

—2007c. 'Given: The Tower, the Corridor and the Fall...' in id. (ed.) *The Blossoming of Perspective: A Study*. London: DomoBaal Editions: 5-7.

—2007d. 'The Stereoscopic Veil' in *Architectural Research Quarterly* 11(1): 118-129.

—2003. *The Blossoming of Perspective: An Investigation of Spatial Representation*. PhD thesis. University of London.

Lebel, Robert. 1959. *Marcel Duchamp*. New York: Grove Press.

Lyotard, Jean-François. 1990. *Duchamp's TRANS/formers* (tr. I. McLeod). Venice, CA: Lapis.

—1971. *Discours, Figure*. Paris: Klincksieck.

Owens, Craig. 1980. 'The Allegorical Impulse: Toward a Theory of Postmodernism' in *October* 12: 58-80.

PSYCHO - ACTIVE - ACOUSTIC EXPERIENCES
Florian Hecker & Sónia Matos

Thus in a sense nature is independent of thought. By this statement no metaphysical pronouncement is intended. What I mean is that we can think about nature without thinking about thought. I shall say that then we are thinking "homogeneously" about nature. [...] Of course it is possible to think of nature in conjunction with thought about the fact that nature is thought about. In such a case I shall say that we are thinking 'heterogeneously' about nature. (Whitehead 1920: 3)

Section I

From psychoacoustics to the work of polymath Alfred North Whitehead our contribution will attempt to mobilize ways in which an artistic logics of fabrication might challenge some of the proposed discussions—particularly that of sound and spatiotemporal measurement—further exploring unconcealed paradoxes.

Auditory experience is intimately embedded in particular techniques of psychoactive fabrication. This same logic is by no means purely materialistic[1]; it conceals a world of various geographic, ecological, cultural, and historical dimensions. Such entanglement bears the invention of instruments such as the ear phonautograph, already proposed in the early 19th century. To activate this device, the user would speak into a 'mouth-like' structure further channeling the acoustic vibrations into its auricular counterpart. This conversion of the sounds of human speech was further translated into graphical representations of sinuous patterns, providing a very particular and mechanized model of human auditory perception (Sterne 2003: 31-33). A technique that was

--

1 'Materialism' should be understood here under the rubric of Alfred North Whitehead (1925). "There persists, however, throughout the whole period the fixed scientific cosmology which presupposes the ultimate fact of an irreducible brute matter, or material spread throughout space in a flux of configurations. In itself such a material is senseless, valueless, purposeless. It just does what it does do, following a fixed routine imposed by external relations which do not spring from the nature of its being. It is this assumption that I call 'scientific materialism'" (Whitehead 1925: 22).

further strengthened by an ancient Pythagorean[2] and harmonic legacy where auditory sensitivity can be translated into a body of formal equations. Today, largely relinquished to bodies of historical investigation, the ear phonautograph stands as an entry-point into the further development of a very particular conceptualization of auditory aesthetic and scientific experimentation. If prior attempts to mechanically reproduce the auditory fabric would situate in the mouth—or the activity of musical instruments—the locus of sonic production[3], the further transference of sound from the mouth, or the instrument, to the ear would provide new degrees of conceptual-abstraction. Finally, hearing could be studied devoid of any source or context while emphasizing the idea that hearing occurs through a simple excitation of sound waves at the level of the ear's cochlea (Ibid.: 33), an intuition that would further influence the development of auditory and perceptual experimentation.

Such historical association lies at the heart of a bifurcation between two oscillating empirical methodologies. On the one hand, a cognitive ramification that is most concerned with the 'what' of auditory perception and, on the other, a scientific and technical ramification that is largely concerned with the 'why' of various auditory experiential accounts. While the first approach entails the ways in which 'perceiver' and 'perceived'— resembling an old dichotomy between 'subjects' and 'objects'—correlate to each other, the second approach further strengthens this delineation by carefully inspecting the properties of both entities (Blauert 1997: 1). If, on the one hand, one might enumerate and measure the qualities of sound as it is physically and materialistically conceived it is also possible to reverse this metric operation by—in a Gestalt style—questioning the ways in which psychophysical phenomena is perceptually (meaning here structurally)

2 This same interrelation can be figured in Pythagoras harmonic universals, where the vibrating quality of a string (the wave like structure) and the perceived quality are in strict quantitative correlation, where length of string and quality of tone (now conceived as quantity) obey to pre-established ratios, most visible in the further development of the Western musical tempered scale but also in the development of particular instrumental appropriations of sound as in the Fourier transform. Here, a sound was perceived through a particular reading of pitch as that which is composed by various Fourier sine waves (that bore a harmonic ratio in themselves). By calculating their fundamental frequency one could locate the fundamental pitch further relegating timbre to a secondary role (Wishart 1996: 46-51).

3 In fact, before Bell engaged in the creation of the telephone he engaged with other experiments. This included the creation of a talking machine, a project that was highly influenced by his father a speech teacher who had created "a remarkable system of symbols for depicting the actions of the vocal organs in uttering sounds [...] a universal alphabet [...]" (Lastra 2000: 19-28).

organized. The development of psychoacoustic research is by no means foreign to this articulation. Here, it seems relevant to ponder and ask: how does one make sense of the auditory-experiential world? To further dwell into the proposed articulation, psychoacoustic research directs our attention towards two unequally studied phenomena: the phenomena of 'primitive segregation' of sound or innate and the phenomena of 'schema based organization' of sound or learned patterns of organization (Bregman 1994).

The previous demarcation seams to 'ring a bell', a similar distinction can be found within the autonomous project of linguistics when referring to language in the 'narrow sense', the 'deep' and 'innate structures' and the 'faculty of language in the broad sense', its perceptual qualities (Chomsky et al. 2002). And while the 'faculty of language in the narrow sense' represents "[...] the abstract linguistic computational system alone, independent of other systems with which it interacts, and interfaces" (Ibid.: 1571), the 'faculty of language-broad sense' can only capture the qualities of "[...] two other organism-internal systems, which we call 'sensory-motor' and 'conceptual-intentional'" (Ibid.: 1570). This same method further extracts the situated, contextual and messy (or the Pythagorean 'inharmonious' qualities (Whitehead 1925: 35)) while delineating the skeletal features of language. In fact, further deploying such informational intuition[4], while confining an understanding of language to that of 'code', one that has a formal and stable existence prior to its performative qualities. Returning to auditory research and experimentation, psychoacoustician Albert Bregman (1994) further elucidates: so it seems that

> there is provocative similarity among the three examples: the syntactical, the visual, and the auditory. In all three cases, the perceivers are faced with complex shaping of the sensory input by the effects of various simple features, and they must recover those features from their effects. Transposing the linguistic vocabulary to the field of psychoacoustics, one might say that the task of the perceiver is to parse the sensory input and arrive at a new complex structure. In some sense the perceiver has to build up a description of the regularities in the world that have shaped the evidence of our senses. (Ibid.: 34)

147

--

4 The informational intuition is in line with the idea of human cognition as information processing.
 "A human information processing approach to cognitive development attributes development
 change to the development of general purpose mechanisms, knowledge acquisition, and their
 interaction. In contrast to modularity theories, the emphasis is on general purpose cognition—
 the general problem solving part of the mind. The general mechanisms posited derive from adult
 cognitive theories and the overriding metaphor is mind as machine" (Smith and Thelen 1994: 37).

To further complicate this conceptual departing point and within this matrix of both innate and learned schemas, psychoacoustics divides perception of a flow of sound—while resembling a Cartesian coordinate system—and where 'horizontal' and 'vertical' processes of auditory segregation take place. Where, for example, the 'horizontal process' of auditory organization entails the analyses of aural sequential integration (frequency), connecting "[...] events that have arisen at different times from the same source [...]" using "[...] changes in the spectrum[5] and the speeds of such changes as major clues to the correct grouping" (Ibid.: 31). In this sense, both 'vertical' and 'horizontal' processes of auditory perceptual organization are in fact closely related to the melodic organization found in Western classical music (based on the equal-tempered scale):

> Musicians speak of a horizontal and vertical dimension in written music. By horizontal, they refer to the groupings across the pages that are seen as melody. By vertical, they refer to the simultaneous events that form cords and harmony. These are the same two dimensions as the ones called sequential and simultaneous. (Ibid.)

Here, the Gestalt principles are put into good use. From 'similarity', 'good continuation', 'common fate' and 'closure' (Moore 2003: 290), perception meets its visual counterpart in an organized and coherent whole. Whether one speaks of the auditory 'event, stream or object'[6], its organization further celebrates the true meaning of the German word commonly understood as pattern[7]—one that is mentally and coherently recreated while drawing all necessary elements of sensory input (Bregman 1994: 19). However and

148

5 Here, it is important to understand that within the field of psychoacoustics the 'spectrum' of a sound corresponds "to the distribution of frequency of the magnitudes (and sometimes the phases) of the components of the wave"; one that is "represented by plotting power, intensity, amplitude or level as a function of frequency" (Moore 2003: 404).

6 Within the psychoacoustic community there are strong disagreements when attempting to determine which term best describes human perception of sound. There is the idea of sound as 'stream' (Bregman 1994), the idea of sound as object or 'objecthood' (Kubovy and van Valkenburg 2004: 124) and the idea of sound as 'event' (Blauert 1997).

7 Here it is crucial to present a more concise description of the Gestalt movement. As suggested by Rudolf Arnheim in an interview: "Gestalt psychology was basically a reaction to the traditional sciences. A scientific experiment was based primarily on breaking down its object into single parts and defining them. [...] By contrast, the Gestalt psychologists [...] emphasized that there are common connections in human nature [...] in which the whole is made up of an interrelationship of its parts and no sum of the parts equals the whole" (Arnheim and Grundham 2001).

as all coherence and common sense—the Greek doxa—one will find its corresponding aberration, deception, unrecognizability, one that resists precise rules of categorization—the paradoxa—the unresolved nature of physical and perceptual phenomena. While psychoacoustics will see in such paradoxes mere stubborn exceptions aesthetic experimentation will rather point towards unforeseen opportunities for radical physiological and psychological subversion.

Section II
Such methodological endeavor opens space for pertinent aesthetic experimentation particularly while rendering some perceptual experience and impressions as 'unsound', this considering that they represent a deviation from a physically isolated and coherent structure. To a certain extent, this formalization presupposes a very concrete structuralization of both time and space, further elucidating what mathematician and philosopher Alfred North Whitehead (1961) would count as absolute representation of both phenomena as they are conceived without any ecological reference, independent of any event 'in' time and 'in' space. In fact, it has been the methodological separation of both elements that has further instigated the ideal of formal clarity; a dismantling of our perceptual experience no longer considered as unified and conglomerate phenomena (Ibid.: 41-44). As with the autonomous project of linguistics, a psychoacoustic approach will propose, to a certain extent, a rather complicated premise, the idea that the subject mentally 'builds' a hierarchical informational gestalt, one that always departs from a given, isolated and innate syntax (Slaney 1995). Even though some would recognize that both innate and learned schemas cooperate (Bregman 1990: 402) they are rarely explored as emergent phenomena (not reducible to lower level properties) or even as paradoxical or contradictory to common sense; one that challenges a sense of definability, common inclination for those who poke the universally translatable and disciplined phenomena.[8] To defy such common sense and disciplined perceptual organization it seems relevant to present interesting psychoacoustic paradoxes as more recently discovered by psychologist Diana Deutsch. In an illustration presented by this same author, one is confronted with a very particular 'musical' pattern where:

149

--

8 This reading resonates with Matthew Fuller's account of "[...] art's paradoxical self-formulation as a discipline or mode of activity involving training and a notion of the inheritance of historical dynamics crossing generations, but one which is also always exploding out of itself, that is predicated upon breaking its boundaries, and at the same time on the production of boundary objects for the understanding of things that will never be disciplined" (Mills s.d.).

[…] two tones, spaced an octave apart are alternated repeatedly at a rate of four per second. The identical sequence is played over headphones to both ears simultane-ously, except that when the right ear receives the high tone the left ear received the low tone, and vice-versa. The tones are sine waves of constant amplitude, and follow each other without amplitude drops at the transitions. So in fact the listener is presented with a single, continuous two-tone chord, with the ear of input for each component switching repeatedly. (Deutsch 1974: 18-19)

Through this precise and mathematically controlled experiment the listener is most often immersed in an aesthetic illusion that defies the expected (meaning here coherent) perceptual outcome—an interlacing of high and low tones. Unexpectedly, the listener is immersed in a perceptual illusion ranging 'a single tone that switches from ear to ear while the pitch shifts between high and low, or, in some cases remains the same; from the perception of a low tone that shifts from ear to ear, while the pitch proceeds with a semitone of difference to a constant high tone in one ear. Others seem to perceive pitches that gradually change as the sequence of high and low tones progresses. The countless illusory descriptions accumulate finally rendering one of the most curious experiments: when the headphones are reversed the listener seems to hear the same thing, the high tone still appears as phantom experience on the right ear and vice-versa (Ibid.).

Deutsch's experiments are—at minimum—strikingly amusing and, more fundamentally, they seem to challenge the established doctrines of perceptual organization where categorization follows a well-established matrix of universally coordinated attributes. To give continuity to the previ-ous example, the researcher also presents the 'tritone paradox' (Deutsch 1986). An auditory and perceptual illusion that was discovered when submitting distinct individuals to the auditory perceptual test of Shepard tones, "two tones that are related by a half-octave (or tritone) are presented in succes-sion" (Ibid.: 1) providing the illusion of audible movement. What is most interesting about the discovered paradox is that this same movement will be rendered as ascending or descending in correlation to the listener's spoken language. In the case of Deutsch's experiment, North American Californian speakers would perceive an ascending tone while speakers from the South of the United Kingdom would perceive a descending tone. And returning to the perceptually similarities between the 'syntactical, visual and auditory' (Bregman 1990: 35), it seems their interrelations not only indicate profound structural similarities but also potential, largely unexpected and synergetic outcomes. Hence, philosopher Gilles Deleuze's discussion in *The Logic of Sense* (2004b): "the power of the paradox therefore is not all in following the

other direction, but rather in showing that sense always takes on both senses at once, or follows two directions at the same time" (Ibid.: 88), where reality always takes on the sweep of illusion and the categorical, the unrecognizable.

Here, the idea of structure along the lines of topological spatio-temporal organization becomes pertinent, one that denies the almost 'naturalized' attempt to fragment all our experience into a serial delimited and measurable symbolic entities, the idea of topological object/space challenges exactly this same impossibility. In this sense, while a classical harmonic scale is based on serial structural organization of space, the Euclidean space defined by abstracted and formal-logical relations (as it is informed by Pythagorean mathematics), the topological space implies new spatio-temporal dimensions where movement can no longer be rendered as imperceptible. Only through this situated spatial-temporal transformation might one understand a classic example borrowed from the field of topology: when considering a plastic medium such as a blob of rubber, it is important to consider that this same blob (with the same physical properties) might at once be a sphere and once a cube (Wishart 1996: 83). There is structural transformation between a blob of rubber and a cube, however there is more flexibility, specifically when comparing to the Euclidean space/object[9] and its matrix of organization and transformation. Taking on board both doxa and paradoxa, it seems that distinct spatio-temporal experiences are then at play—informed through distinct degrees of techno-aesthetic appropriation and embeddedness, the possibility of deforming classical perceptual organization.

With similar hypothesis in mind atomic physicist Niels Bohr was able to demonstrate in *Atomic Physics and Human Knowledge* (1958) that within a modern representation of the physical theory of light—a similar paradox can be thought for sound (Roads 2001: 49-50)—one could either conceive such natural phenomena as a wave or as a particle, known in Physics as the wave-particle duality. One can find in this brief passage, that intrinsic to the wave-particle duality were in fact opposing philosophical intuitions inherent to the designed experimentations. In this sense, Bohr's work was able to take this discussion even further while providing the analyses of the light wave-

151

9 Further discussion of how an Euclidean conception of space has impacted the development of Western scientific thought, particularly the idea of structural phenomena as stable and predictable phenomena (as in Newtonian physics), can be found in Brian Rotman's *Ad infinitum—the ghost in Turing's machine: taking God out of mathematics and putting the body back in: an essay in corporeal semiotics* (1993) and in Alfred North Whitehead's *The Interpretation of Science, Selected Essays* (1961).

particle through a 'Gedanken' (thought) experiment that established the very idea that this same distinction is solely dependent on the nature of measuring apparatuses (Barad 2007: 97-131).

Within the domain of physics, this breakthrough proposed a new understanding of the makings of scientific knowledge, one that could no longer be conceived along the lines of a *Characteristica Universalis*[10] as proposed by Gottfried Leibniz. Rather, the making of knowledge was now considered intrinsic to the very nature of representations and measuring apparatuses. Following a reading of Pythagorean cosmology through the words of Alfred North Whitehead (1925) as presented above, the very nature of a measuring apparatus had to be considered as both inclusive and exclusive, where conceptions of the harmonious (the sound, the accurate, the cogent) and the inharmonious (the unsound, the ambiguous, the abnormal) can now be understood within particular ecologies that are composed by distinct resources and intuitions. Here, taking the human-body, its very nature as that which does not preclude the idea of an 'originary technicity'[11], apparatuses can no longer be conceived as a mediating gesture, one that provides a simple contact with particular bodies of knowledge, rather the measuring apparatus becomes intrinsic to a body of knowledge as such.

Section III

This entails a profound subversion, a profound reversal of our understanding of categorization, mental representation, or coherent perceptual experiences in and by themselves. And to give continuity to Bohr's physical intuitions, it is possible to envelop and deform the canons of classical perceptual organization

--

10 To recall the words of 17th century mathematician, philosopher and inventor Gottfried Leibniz in *Universal Characteristic*: "there is an old saying that God made everything in accordance with weight, measure and number. But there are things that cannot be weighed [...] there are also things that cannot be measured. But there is nothing that cannot be numbered. And so number is, as it were, metaphysical shape, and arithmetic is, in a certain sense, the statics of the Universe, that by which the powers of things are investigated" (Leibniz 1989: 5).

11 The concept of 'originary technicity' as part of current discourse within the field of philosophy of technology, can be understood through a close reading of Adrian Mackenzie's 'Transductions. Bodies and Machines at Speed' (2002). Working closely with the work of Jacques Derrida, Bernard Stiegler, amongst others, MacKenzie further emphasizes the main thesis of Derrida: "The natural, originary body does not exist: technology has not simply added itself, from outside or after the fact, as a foreign body" (Ibid.: 5), Mackenzie further adds: "One tack we could take on this quasi-concept of originary technicity is to say that it concerns the status of the body as a body. It may not be possible to think of a body as such because bodies are already technical and therefore in some sense not self-identical or self-contained" (Ibid.: 6).

while further mobilizing an ecological reading of representation in itself. In fact, now salvaging a previous notion of 'subjects' and 'objects'—that Whitehead (1961) so politely contested—Bohr's wave-particle duality is more than a contestation against the accurate representation of physically measurable and coherently defined phenomena, it provides a more profound and onto-logical rupture, this considering that it no longer envisions possible degrees of separation between subjects and objects (Barad 2007: 138), perceiver and perceived. Even though not referring to the work of Bohr, Whitehead (1961) would further contest:

> What I am essentially protesting against is the bifurcation of nature into two systems of reality, which, insofar as they are real, are real in different senses. One reality would be the entities such as electrons which are the study of speculative physics. This would be the reality which is there for knowledge; although on this theory it is never known. For what is known is the other sort of reality, which is the byplay of the mind. Thus there would be two natures; one is conjecture and the other is dream. (Ibid.: 41)

This is what paradoxes achieve, once they disturb and disrupt Platos' 'theater of representation' they expose, emancipate and so to say fracture what Deleuze (2004b) has presented as the (im)possibility of any 'logic of sense'. The 'becoming-mad' of Alice's wonderland, where both the Hatter and the March Hare fall towards the side of unexpected insanity once they suppress time, the precise degrees of measurement that stubbornly reduce qualities to fixed and immutable points (Ibid.: 91). Returning to an early presentation of psychoacoustics coordinates and classically defined structural organization of auditory experience—the doxa—and its unexpected correlatives—the paradoxas—as presented by Deutsch's auditory illusions, the foreseeable organization and, on the other hand the 'becoming-mad' of both Hatter and Hare are thus two faces of the same coin. And if psychoacoustic experimenta-tion is mostly concerned with the 'conditions that must be fulfilled, inside and outside an organism in order for a particular object to appear in the sensory world' (Blauert 1997: 1), illusion, paradoxes and hallucinations do not take such separation for granted. To rephrase Foucault in *Theatrum Philosophicum*: "Phantasms do not extend organisms into the imaginary; they topologize the materiality of the body" (Foucault 1980: 170), redirecting any attempt to coherently stratify the real or truthfulness while re-enacting the nondeceptive qualities of perceptual experience.

 This same tension between doxa and paradoxa is in consonance with the shift from a passive to an active approach to perception, particularly as it draws

from a philosophical problem already posed by Plato in the *Allegory of the Cave* (Cottingham 1996: 63). This allegory presupposes that the real world contains forms (or ideas) that cannot be truly known through situated experience, one could only grasp their reflections (Ibid.). In fact, the only way to pass beyond reflection—in the attempt to access the real truth of these forms—is through the deployment of the instruments of reason—the doxa. Transposing this same allegory to contemporary discourse this will imply a spatial metaphor, the idea that cognition is not a direct temporal process. Here, the brain—the organ of reason—is responsible for converting the information provided through sense perception into coherent and stable representations. In similar vein, throughout an individual's life, cognition will amount to a collection of representations that can be further deployed whenever necessary, static representations devoid of any process of 'individuation'[12]. In this sense, the dogmatic reading of emergence will always position the process of individuation as departing from an agent as fully formed being. What is left abeyant is the very idea that individuals, agents or beings already take part in their own transformative capacities. This renders the impossibility of defining any subject or object prior or after its own process of individuation, opening, once again, the confusing byplay of both reality, distorted or illusory perceptions.

154 To set another and yet entirely distinct example, when relegating the presented information into a reliable neurological account this will amount to the idea that distinct patterns of neurons when triggered will average out noise, here represented by the 'excessive' bits of information, creating a clear interconnected pattern that 'matches' the 'correct version' of the required representation (Freeman 2000a). Such interpretation provides an intrinsic limitation this considering that in real-time experience the distinction between information (the figure) and noise (the background) is not clear cut, particularly when we consider that our experience is in constant temporal flux and not prone to dissection into discrete spatial-temporal instances or absolute durations (Bergson 1911: 87).

12 Gilbert Simondon's in *The Position of the Problem of Ontogensis* (Gilbert Simondon, translated by Gregory Flanders) further elucidates: 'Such an individuation is not the meeting of preexisting form and matter that exist as previously constituted, separate terms, but a resolution springing from a metastable system that is filled with potentials: form, matter and energy pre-exist in the system. Neither form nor matter suffices. The true principle of individuation is mediation, generally supposing an original duality of orders of magnitude and the initial absence of interactive communication between them, followed by communication between orders of magnitude and stabilization' (Ibid.: 7).

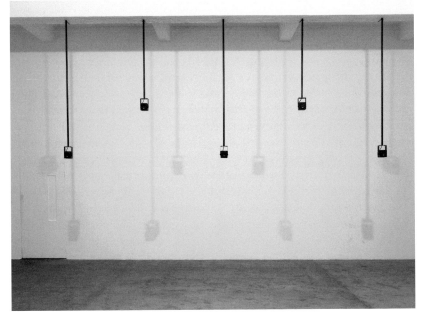

Fig. 1) *Auditory Scene (5 fold) 2010*, 5 channel computer generated sound loudspeaker system powder-coated steel ceiling mounts duration: 4 min 30 sec, dimensions variable. Installation view: Chisenhale Gallery, London 11 February–28 March 2010.

It seems relevant to reverse the proposed intuition and consider the work of ecological psychologist James J. Gibson (1966), particularly as expressed in the idea that 'we do not hear, we listen' (Ibid.: 83). With this reverse of intuition what is implied is that due to the complex process of individuation we do not simply receive raw (externally organized) sense-information, we are rather in a constant state of exploration, seeking for informational cues within a given and already individuated milieu (as opposed to external environment). This invites us to present the anti-thesis to Plato's 'Allegory of the Cave', and introduce Aristotle's conception of 'action' as the necessary condition for distinguishing raw sensation from directed perception (Freeman 2000a). It is this directed and active perception that constantly envelops listeners in a psychoactive fabric, where tensions between doxa and paradoxa allow one to resist any sense of definability.[13]

Section IV

2 x 3 Kanal (2 x 3 Channel) (2009) is a sound piece that contains two separate three-channel compositions, one rotating clockwise and the other coun-terclockwise, while creating an audible movement that simultaneously circumscribes the piece's three outward-facing loudspeakers. Depending on one's acoustic focus, the perceiver will either hear one or the other part of the work or a mix of the both. This perceptual conflict—one that concerns the intensities of auditory and spatial movement—is dramatically intensified. Such sensorial interrelation recalls James J. Gibson's (1966) 'active-listen-ing'—celebrated in the idea that 'one does not hear one listens'—also briefly described above. In this sense, this piece 'dramatizes' the idea that perceptual information pickup is an active process. The second half of this piece offers yet another perspective on spatial movement and perceived localization.

13 In *Emotion is Essential to All Intentional Behaviors*, Freeman (2000b) further explicates: 'A major cleavage that fuels debates on the nature of mind derives from the ancient Greeks: Is perception active or passive? According to Plato it was passive. He drew a distinction between intellect and sense, both being immaterial and belonging to the soul. The intellect was born with ideal forms of objects in the world, and the senses presented imperfect copies of those forms. For each object the intellect sought the corresponding subjective ideal form through the exercise of reason. Thus the experiences from the world of objects and events were passively impressed onto the senses. According to Aristotle it was active. There were no ideal forms in the mind. The organism moved in accordance with its biological destiny, which was initiated by the Prime Mover (God). The actions of the intellect were to define and seek objects with its sensorimotor power, and with its cogitative power to construct forms of them by abstraction and induction from the examples that were presented by the senses' (Ibid.: 210).

2)

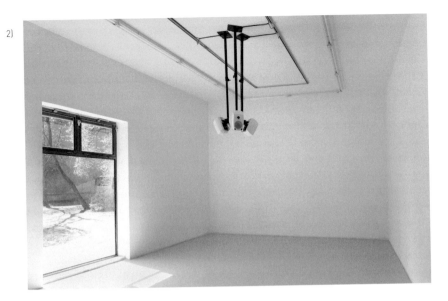

Fig. 2) *2 x 3 Kanal* 2009, 3 channel electroacoustic sound DVD-A player loudspeaker system, duration: 19 min 10 sec,, dimensions variable. Installation view: Galerie Neu, Berlin 23 April–24 April 2010.

A seemingly constant upward raising high pitch sound object gets juxtaposed to a sequence of tones in the style of Diana Deutsch's (1986) *Tritone Paradox*. This adds to the here discussed horizontal rotations further vertical dimensions, while questioning the role of the analytical—yet musical—topographies of the Cartesian structuring suggested by Bregman (1994).

Auditory Scene (5 fold) (2010) is a five-channel piece that further explores the perceptual organization of a sequence of tones that change according to the position of the visitor. Five streams of short tone pulses form a pattern, which, at first, seems to second and confirm the zigzag structure of the visual Gestalt of the installation. Once the listener focused on the spatial location of an individual loudspeaker, one particular auditory stream seems to appear, one that further strengthens the audio-visual 'contract' (Chion 1994) between the physical sound source and the perceived sound source. A bond that is ruptured at various moments throughout the piece, particularly when a reconfiguration of the pattern shakes and unbalances these qualities of the audible Gestalt, such as 'similarity', 'good continuation, 'common fate' and 'closure' (Moore 2003: 290). It is this very oscillation between the emergence and submergence of sonic streams and events that opens the path to another notion, namely the one of sound as 'event' (Blauert 1997). With this in mind,

it seems relevant to, once again, redirect our efforts towards the work of Gilles Deleuze (2006), particularly when referring to both Whitehead and Leibniz in the exploration of such notion as the 'event'.[14] According to the philosopher, firstly there is 'extension':

> Extension exists when one element is stretched over the following ones, such that it is a whole and the following elements are its parts. Such a connection of whole-parts forms an infinite series that contains neither a final part or a limit [...]. The event is a vibration with an infinity of harmonics or submultiples, such as an audible wave [...]. (Ibid.: 87)

Further 'exploring' the words of the philosopher, here, the 'extension' takes the form of an entanglement, of one tone to the next, a synthesis that always appears in combination with the audible reflections from the gallery space. This same knot further reworks what psychoacoustics would denominate as

14 This passage, particularly concerning the work of Gilles Deleuze (2006) in the *Fold*, was largely informed by a reading of TJ Demos text *Encountering the Unheard* (2010).

a spray of acoustic 'localization blur'[15] and discrete sonic events, discrete tones that are the building parts of this whole pattern.

The discussed psychoacoustic fabric—spanning both Gestalt perceptual organizational principles (Bregman 1994) and Deutsch's (1974, 1986) perceptual illusions—offered points of departure in the depiction of the sound pieces presented above. However, such depiction is not in consonance with what, earlier on, Whitehead (1920) described as a 'homogeneous approach', the very idea that we can think about perceptual phenomena—Whitehead's 'nature'—without thinking about the contradictions that such systematization presupposes in and by itself, this considering that it is thought of. In opposition, and in fact more in accordance with the suggested 'heterogeneous' approach, the proposed aesthetic experimentation is line with what Deleuze (2004a) described as the method of 'dramatization'. A handy concept that yields potential in the further depiction of the multidirectional feedback spikes that are sent out between such a conceptual ping-pong that interweaves both doxa and paradoxa. In fact, Deleuze states that it is within the different spatio-temporal properties—the creation of particular times and spaces—that concepts emerge; concepts that otherwise would not be able to form new articulations. It is this coexistence of Alice's double notions, one that is in line the 'the philosophical past theory of primary and secondary qualities',[16] that makes 'dramatization' a useful tool, one that actualizes—here to use the proper Deleuzian term—and makes experientially and materialistically viable an 'Idea' that might in fact grabble with the uncertainties of experientially contradictory phenomena.

159

15 "'Localization blur' is the smallest change in a specific attribute or in specific attributes of a sound event or of another event correlated to an auditory event that is sufficient to produce a change in the location of the auditory event." (Blauert 1997: 37)

16 As Quentin Meillassoux (2008) points out in his recent book 'After Finitude': "the terms 'primary quality' and 'secondary quality' come from Locke, but the basis for the distinction can already be found in Descartes" (Ibid.: 1) and they refer to the what Alfred North Whitehead (1961) would denote as the method of bifurcating nature into two distinct qualities of nature. While the "primary qualities are its shape, its degree of hardness and cohesiveness, is massiveness, its attractive effects, and its resilience. Our perceptions of nature such as color, sound taste and smell, and sensations of heat and cold form the secondary qualities. These secondary qualities are merely mental projections which are the result of the simulation of the brain by the appropriate nerves. Such in outline is the famous theory of primary and secondary qualities in the form of in which it has held the field during the modern period of science. It has been of essential service in directing scientific investigation into fruitful fields both of physics and physiology" (Ibid.: 13).

And to rephrase Deleuze (2004a) himself: "This status of the Idea explains its logical value, which is not the clear and distinct, but rather as Leibniz sensed the distinct-obscure" (Ibid.: 94). The so called 'distinct-obscure' appears here in the form of a phenomenological gap, particularly at the level of the sound element in itself; a polymorphism that creates a conflict between what Gibson (1966) would have denoted as 'hearing' and 'listening'—the 'homogenous' versus 'heterogeneous' accounts also proposed by Whitehead (1920). In fact, such aesthetic experimentation attempts not only to expose the entanglement between real and illusory perceptual categories explored throughout but also the 'phenomenological gap', a fault-line within the traditional categorizations of 'auditory events' (Blauert 1997), 'auditory objects' (Kubovy and van Valkenburg 2004) or 'streams' (Bregman 1994). Challenging these tendencies, that see the only possible interrelation between (auditory) objects as residing in their common holistic destiny, instead such pieces celebrate their most singular character, their dynamic materiality—

> [...] a feature that allows them to participate in events, unleashing their forces within transient "wholes," without ever exhausting their infinite potential as abstract objects. As in philosopher Graham Harman's (2005) "neo-occasionalism", for which objects perennially withdraw from contact, only ever interacting with the interior of a third object, without this relation ever exhausting their real, autonomous being. (Hecker et al. 2009)

This, void, fault-line or gap, between what has been earlier described as the classic doxa and paradoxa appears equally significant between the terrains of Deutsch's (1974, 1986) musical illusions and Albert Bregman and Stephen McAdams (1979) *Hearing Musical Streams*. Where, in the latter, the authors speak about timbre as the "psychoacousticians multidimensional wastebasket" (Ibid.: 34), an open-air field where categories from musical psychology and traditional psychoacoustics never manage to settle down, to provide a name, a classification of experiential phenomena—in a spatial and synthesized manner—of what can only be best qualified as 'hallucinatory' (Mackay 2010: 11). Such altered perspective allows us to reconfigure the multiple streams and events, reflected and diffracted doubles of this work. In fact, we should point out here that despite all such micro references borrowed from the histories of post-war composition and psychophysic research what is most important is to further poke the immediate and experiential character of auditory phenomena.

..

References

Arnheim, Rudolf and Uta Grundham. 2001. 'The Intelligence of Vision: An Interview with Rudolf Arnheim' in *Cabinet* 2: 95-100.

Barad, Karen. 2007. *Meeting the Universe Halfway: Quantum Physics and the Entanglement of Matter and Meaning.* Durham: Duke University Press.

Bergson, Henri. 1911. *Creative Evolution* (tr. A. Mitchell). New York: Random House.

Blauert, Jens. 1997. *Spatial Hearing.* Cambridge, MA and London: MIT Press.

Bregman, Albert S. 1994. *Auditory Scene Analysis.* Cambridge, MA: MIT Press.

Bregman, Albert S. and Steven McAdams. 1979. 'Hearing Musical Streams' in *Computer Music Journal* 3(4): 26-43.

Chion, Michel. 1994. *Audio-Vision: Sound on Screen* (tr. C. Gorbman). New York and Chichester: Columbia University Press.

Chomsky, Noam, Marc D. Hauser and Tecumseh Fitch. 2002. 'The Faculty of Language: What Is It, Who Has It, and How Did It Evolve?' in *Science* 298: 1569-1579.

Cottingham, J. (1996). *Western Philosophy: an Anthology.* Oxford: Wiley-Blackwell.

Deleuze, Gilles. 2006. *The Fold.* London: Continuum Press.

—2004a. 'The Method of Dramatization' in id. *Desert Islands and Other Texts* 1953-1974 (ed. David Lapoujade). Los Angeles and New York: Semiotex(E) Foreign Agents Series: 94-116.

—2004b [1969]. 'Twelfth Series of the Paradox' in id. *The Logic of Sense.* London: Continuum International Publishing Group: 86-94.

Demos, TJ. 2010. 'Encountering the Unheard' in Gaensheimer, Susanne (ed.) *Florian Hecker: Event, Stream, Object.* Cologne: Verlag der Buchhandlung Walther König: 55-60.

Deutsch, Diana. 1986. 'An Auditory Paradox' in *Journal of the Acoustic Society of America* 80: 93.

—1974. 'An Auditory Illusion' in *Journal of the Acoustical Society of America* 55: 18-19.

Foucault, Michel. 1980. 'Theatrum Philosophicum' in id. *Language, Counter-Memory, Practice: Selected Essays and Interviews* (ed. Donald F. Bouchard). Ithaca: Cornell University Press: 165-193.

Freeman, Walter J. 2000a. 'Brains Create Macroscopic Order from Microscopic Disorder By Neurodynamics in Perception' in P. Århem, C. Blomberg and H. Liljenström (ed.) *Disorder versus Order in Brain Function: Essays in Theoretical Neurobiology.* Singapore: World Scientific Publishing Co: 205-219.

—2000b. 'Emotion is Essential to all Intentional Behaviors' in M. Turner and I. Granic (eds) *Emotion, Development and Self-organization: Dynamic Systems Approach to Emotional Development.* Cambridge: Cambridge University Press: 209-235.

Gibson, James J. 1966. *The Senses Considered as Perceptual Systems.* Boston: Houghton Mifflin.

Harman, Graham. 2005. *Guerilla Metaphysics.* Chicago: Open Court.

Hecker, Florian, Robin Mackay and Sónia Matos. 2009. *Event, Stream, Object.* Vienna: TBA 21.

Michael and David van Valkenburg, 2004 'From Gibson's Fire to Gestalts' in Neuhoff (ed.), *Ecological Psychoacoustics.* London: Elsevier Academic Press: 113 - 147.

161

Lastra, James. 2000. *Sound, Technology and the American Cinema. Perception, Representation, Modernity.* New York: Columbia University Press.

Leibniz, Gottfried Wilhelm. 1989. *Philosophical Essays.* Ed. by Roger Ariew and Daniel Garber. Indianapolis: Hackett Publishing: 5-10.

Mackay, Robin. 2010. 'These Broken Impressions' in Gaensheimer, Susanne (ed.) *Florian Hecker. Event, Stream, Object.* Cologne: Verlag der Buchhandlung Walther König: 11-12.

Mackenzie, Adrian. 2002. *Transductions. Bodies and Machines at Speed.* New York: Continuum.

Meillassoux, Quentin. 2008. *After Finitude.* London: Continuum.

Mills, Simon. s.d. 'Matthew Fuller. Interview by Simon Mills'. Online at: http://www.framejournal. net/interview/5/matthew-fuller (consulted 23.05.2011).

Moore, Brian C. J. 2003. *Introduction to the Psychology of Hearing.* Cambridge: University Press Cambridge.

Roads, Curtis. 1998. *The Computer Music Tutorial.* Cambridge, MA and London: The MIT Press.

Roads, Curtis. 2001. *Microsound.* Cambridge, MA and London: The MIT Press.

Rotman, Brian. 1993. *Signifying Nothing: the Semiotics of Zero.* Palo Alto: Stanford University Press.

Simondon, Gilbert. 2009. *The Position of the Problem of Ontogenesis.* (G. Flanders, Trans.). Retrieved 02, 03, 2010 from Parrhesia: a Journal of Critical Philosophy website: www.parrhesiajournal.org/parrhesia07/parrhesia07_simondon1.pdf

Slaney, Malcom (1995). *A Critique of Pure Audition.* Paper presented at the International Joint Conference on Artificial Intelligence Montreal, Canada.

Smith, Linda and Esther Thelen. 1994. *A Dynamic Systems Approach to the Development of Cognition and Action.* Cambridge, MA: MIT Press.

Sterne, Jonathan. 2003. *The Audible Past.* Durham, NC and London: Duke University Press Books.

Whitehead, Alfred North. 1961. *Interpretation of Science, Selected Essays* (Vol. 117). Liberal Arts Press Book.

—1925. *Science and the Modern World.* New York: The Free Press.

—1920. *The Concept of Nature: The Tarner Lectures Delivered in Trinity College, November 1919.* Cambridge: Cambridge University Press.

Wishart, Trevor. 1996. *On Sonic Art* (Contemporary Music Studies 12). New York: Routledge.

162

--

Weblinks

http://www.framejournal.net/interview/5/matthew-fuller

THE LANGUAGE OF THE BIRDS
Raqs Media Collective

I) Bird-Man

Birds have wings on their bodies. Human beings have winged minds. Like a bird in flight that considers its own shadow floating unattached to itself, the human considers its own shadow produced by the optical accident of being borne aloft between the stars and the earth, between light and matter, between incandescence and life.

And an artist does not simply consider or study consciousness; she uses it as her material, shapes it and makes it reflect back on itself in everything she does.

An image of a human figure with a bird's head drawn seventeen thousand years ago on the walls of a shaft in the Lascaux Cave in southern France may well be one of the earliest extant self-portraits of the artist as researcher.[1] He is seen, relatively diminutive, ithyphallic, perhaps prone, near an aurochs—a giant, extinct ox. Not hunting, not really doing anything; just being, considering, looking at the ox. Next to him is a small bird, impaled on a stick. A line scratched nearby perhaps represents a broken lance, or the trajectory of a meteor. Perhaps the bird-man is dead, or injured, felled by the aurochs. Perhaps he is just looking beyond the horn of the aurochs into the sky, doing what can be done only when one is not doing anything in particular—inhabiting an imagined world, making a world out of one's own experience of being alive.

The scene in the Lascaux shaft has excited a great deal of wonder and scholarly attention ever since it was discovered. It has been interpreted as the depiction of a failed hunt, a portrait of the agony of death (both the aurochs and the bird-man have been depicted as dying), and as an illustration of an ancient shamanistic ritual. Recent archaeo-astronomical research and speculation even has it that the bird-man, aurochs, and bird configuration on the Lascaux cave wall is a prehistoric depiction of a fragment of the cosmos. Computer modelling of the sky over Lascaux at the time when the images were produced suggest that if a person at Lascaux in the ice age were to draw lines between the eyes of the birdman, the aurochs, and the bird, he would get a diagram of an asterism known as the 'Summer Triangle' comprising the stars Vega, Deneb, and Altair in the constellations of Lyra, Cygnus, and Aquila.

1 For more on caves, shamans, bird-men, birds, and stars see Lewis-Williams (2004), Magli (2009), and Rappenglück (2004, 2005, and 2009).

The person who drew this configuration may or may not have also been an upper Palaeolithic astronomer, but the image does intrigue us into thinking that the artist-birdman may well have been a stargazer, whose frequent scans of the night sky might have prompted inner explorations of his own subjectivity, imagining flight and the experience of being suspended between worlds. Perhaps what we see on the wall of the cave is the record of his research about himself, an aurochs, a bird, and the universe. The image may be an anticipation of death or a celebration of life, or both, because it is only recently in human history that death has been taken to be the termination of human life, and not just another vestibule, or portal to a different state of being. The cave at Lascaux is the cosmos, and the bird-man an early cosmonaut.

The Lascaux Bird-Man is a precursor to an endless series of images and representations of human beings with beaks, wings, and feathers found across a vast array of cultures; which inevitably signals: a shaman, the human desire for transcendence, the capacity for reflection, and the uncanny sense of an affinity between birds, beasts, and people.

This desire to see further in space and time than our embodied, earth-bound existence allows for—to imagine ever-greater arcs of possibility—produces an almost automatic conceptual identification in all cultures between being human and bird. Ascending birds survey an expanding horizon. Almost everywhere, the artist-researcher-shaman, a bird-man-woman, or man-woman-bird, flies, gets too close to the sun, founds flocks, sings untried songs, learns new languages, forages further afield in the mind than most, and—like the songbird that migrates across enormous distances—discovers routes and itineraries that connect human experiences at a planetary level.

It is said that the Hèrmes, the most artful of the Greek gods, taught himself the alphabet, and was thus able to give humanity the gift of writing, by discerning the patterns inscribed into the sky by flocks of migrating cranes. Artists are forever speaking and reading in the language of the birds, and it is not for nothing that some of the most interesting work that they do is sometimes dismissed as 'hermetic' by those too philistine to read what gets written by birds and stars in the heavens.

II) Double take

A decade or so ago, we had written an essay on the place of research in documentary practice that seems strangely resonant today, as we consider the role of research in the making of art (Raqs Media Collective 2000). In the passage that follows, taken from that essay, *Frame of Mind*, we retrieve once again the shaman as a practitioner of research in art.

What is it that distinguishes the attentiveness of the documentarist at work from the attention that all of us pay to the world in an everyday sense? What marks the difference between the two acts of looking at life?

Perhaps a tentative answer to this question could be—it is the porous line that separates looking from looking again at the world, and it is this line which also separates our negotiations as individuals from our engagements as filmmakers It separates looking and searching within our field of vision, from the act of looking again, searching again. From re-search. Can we then suggest that the act of re-search is always an invisible and silent corollary to the act of filming that which we look at anyway?

[…] If we remove from research its respectable institutional connotations its images of while coated investigators in laboratories or the ethnographer-hunter-gatherer of facts in the "field", can the word "research" then be claimed as a significant motivation for all those who have gambled with the "real" every time they let light into their lens? Can documentary filmmakers then be seen as the last living claimants of the heritage of shamans, (rather than as visual anthropologists who make shamans the objects of their study) by virtue of their pursuit of a second sight within the sphere of the real and peopled and ordinary and material world?

Can we, then, make the imaginative leap to say that research for the documentary film which begins before a film is even conceived and doesn't end (in a sense) even when it has been made, is a form of "second sight", redolent with all the intuitive, supra-sensory and associative turns of the phrase?

What a documentary film can do is open for its audience the leaves of another aperture on to this world. It asks us to bring our situatedness in our world into contact and dialogue with at least two other such senses of location, that of the filmmaker and that of the subject who is filmed. Thus, it sets off a chain of refractions and resonances by positioning one set of realities (that of the audience) against other, alternate realities.

By asking us to look at the way someone (the filmmaker) looks at the world, a documentary film is only asking its viewer to look again at what s/he may have taken for granted. But this reiteration of vision is at a heightened and conscious level. In other words, witnessing a documentary film can, through its insistence on a double take on reality, make us aware of awareness itself. It can make us doubt, take pleasure in, as well as experience the intensification of that awareness. By framing the real, by holding the real in the custody of its images and sounds, the documentary film can disturb our deepest and most dearly held ontological assumptions.

However, can this disturbance not constitute the first step in a tentatively transcendent consciousness that yet remains rooted in the material and experiential everydayness of the world that it contemplates? If we were to imagine a frame in our mind through which we see the world, as if we were looking out of a window, then perhaps research can shift the lines and alter the boundaries of this frame that we have in our mind.

The filmmaker and the film-viewer orient themselves from different vantage points on to the same frame. The filmmaker seeks out, screens what s/he desires to show from the reality s/he sees, and transforms this desire into something that s/he can throw with light onto a screen. The film-viewer sees this assemblage of images and sounds on the screen and then looks again at the world which has been refracted through this fragment of representation. The filmmaker has "looked" again at reality with "second sight" in order to fashion an image of it. The viewer comes away from this image to look again at reality as a result of the experience that the filmmaker has offered in the film. Both are transformative acts of research/looking-again, bracketing either ends of a transmittable experience of reality. That is why it is possible to say that the act of research in a documentary film does not end with its making. It only gets transposed onto a different register.

III) The injured ox and the lament of the sarus crane

Over the past year, we have been pre-occupied with the making of *The Capital of Accumulation* (Raqs Media Collective 2010). The work is an installation featuring a 50-minute long video diptych, accompanied by two vitrines containing an extant and an imagined book. It posits an oblique narrative concerning the relationship between the metropolises of Warsaw, Mumbai, and Berlin—in counterpoint to Rosa Luxemburg's exceptional critique of global political economy, *The Accumulation of Capital* (Luxemburg 1990).

168

In making this work, we found ourselves undertaking a singular reading of contemporary political economy: of the relationship between capitalism's accumulative drive and the realities of decay, displacement, and disappearance that shadow processes of expansion, especially in cities. We were also returning, in a sense, to the history of our own two-decade-long engagement with Rosa Luxemburg's *Accumulation of Capital*, a text that has had a key heuristic role to play in the evolution of our own sense of the contemporary world.

The Capital of Accumulation registers this move, partly through the conceit of an imaginary eponymous book (which inverts the title of the original text) that is ostensibly being written by a fictional woman with a name—*Luxme Sorabgur*—that reads as an Indian-sounding anagram of Rosa Luxemburg.

Positioning the fictional Luxme Sorabgur in a temporal dimension that stretches backwards from now to the early twentieth century allows us to reiterate Rosa Luxemburg's question about 'how capital continues to reproduce itself', and to play with the possibility of several kinds of attempts at an adequate response.

Luxemburg answers the riddle of the 'missing body' of the expanded reproduction of capital in the language of political economy, by referring to the relation that capital has to its 'outside'—to persisting 'pre-capitalist' forms.

We, for our part, are enabled by Luxme's numinous presence in the work, to answer our queries partly in the language of birds. This allows us an elliptical, allusive commentary on the three cities themselves, on Luxemburg and her legacy, as well as on the possibility of a radical renewal that can take us away from capitalism.

The 'Language of Birds' is a term used in various esoteric traditions to describe a 'natural' hermetic code of signs and auguries that were apparently the common medium of communication between birds, beasts, and human beings in the Garden of Eden before the fall.[2] King Solomon, who can be regarded as a shaman-sovereign, is said to have been given the ability to understand the language of birds and a sense of 'the abundance of all things'. In this sense, an adept at the language of birds is a person who has the ability to make meaning out of the mystery of the world, and of nature.

For our purposes, we can take the language of birds to mean a vocabulary of practice that makes it possible to draw meaningful connections from amidst an eternal abundance of detail. As if, to name a cluster of objects, or make images of them, were not merely to describe or list the things in themselves in an ordinal sense, but to create a cardinal web of connections between those objects and their environment; between things and their affects, shadows, or mirror-images; between information and mental states; between a body or bodies and a matrix of interwoven histories.

When we began researching the project that would culminate in *The Capital of Accumulation* we had with us a supposition, a set of bare facts, and a hunch.

The supposition was that our reading of Rosa Luxemburg's legacy would have something meaningful to say about the contemporary dynamics of capital in cities like Bombay, Berlin, and Warsaw. The bare facts were few, sketchy and not very well connected: that Rosa Luxemburg spent her life in Warsaw and Berlin; that Berlin and Bombay shared a tenuous history through the transcontinental movement of people who worked in the early film industry; that Berlin, Bombay, and Warsaw were all cities shaped by the cataclysmic forces of the twentieth century; and that we had in our library an esoteric twenty-year old abridged edition of *The Accumulation of Capital* published by a worker's political self-education group in Faridabad, on the outskirts of Delhi. The hunch was that somewhere in Warsaw there was an abandoned industrial facility named after Rosa Luxemburg. This is all that we had, to begin with.

169

--

2 For an introduction to the history of the concept of the secret language of birds, see Nozedar (2006).

Throwing these few fragments together repeatedly, as if they were moves in a long-winded dice game, and watching to see what patterns would form when the dice fell, was the first step in our research. Out of this game emerged the figure of Luxme Sorabgur, a might-have-been-latterday imaginary inter- locutor to Rosa Luxemburg, the author of a book that re-arranged the terms of reference of the *Capital of Accumulation* to bring them in line with the realities of the first decade of the twenty-first century.

The second step lay in determining that there was in fact a gigantic aban- doned factory in Warsaw's industrial district called the Rosa Luxemburg Elec- tric Light Bulb Factory. Once this was known, it became imperative, in a sense, to undertake a reading of the Faridabad edition of the *Accumulation of Capital* in the ruins of the Rosa Luxemburg Electric Light Bulb Factory in Warsaw.

The third step occurred through a series of uncanny coincidences. Even as we were beginning our preliminary investigations in the early summer of 2009, researching the life and death of Rosa Luxemburg, marvelling at her interests in botany and birds, we began to hear reports of a forensic analyst, Dr. Martin Tsokos at the Charité Hospital in Berlin, who was claiming that it was likely that a hitherto anonymous decapitated and preserved cadaver kept as a teaching specimen in a vitrine in the Charité morgue may well be the actual

remains of Luxemburg herself (Tsokos 2009). Here, staring us in the face, was a speculation that somehow seemed to embody a strangely corporeal analogy to the question of the 'missing body' left in the wake of the accumulation of capi- tal. Our interest in one 'missing body' had led us to another. And it was pos- sible that the second 'missing body' was the remains of the author of the first.

Tsokos based his speculations on the rumour that 'Luxemburg had never left the building' which had been passed down through generations of students and doctors at the Charité. He claimed that the body that had in fact been buried (and which in turn had since disappeared, after the desecration of Luxemburg's grave by the Nazis) was in fact not Luxemburg's, but that of another anonymous drowned woman. He suspected that the body in his cus- tody at the Charité had a much greater resemblance to what is known about Luxemburg's physique and posture, based on photographs and anecdotal sources. He was joined in his quest by an historian passionately devoted to Luxemburg's political legacy, Dr. Jurgen Schuhtrumpf, who, when he met us in Berlin, would neither deny, nor confirm Tsokos' speculations, but did show us slides of Rosa Luxemburg's herbarium—her meticulous collection of plants cultivated during prison sentences, which was now being considered as a possible repository of residual DNA from her person.

We traced the herbarium, which had travelled across continents before finally coming to rest in its current location in the Polish State Archives. The

herbarium did not yield any materials for DNA matches; but looking at them, and handling them, opened a window to a different Rosa Luxemburg. Here was a woman passionate about plants, birds, animals, and nature—who could write movingly of an animal's pain, or wonder at the migration of birds. While standing in the spot where a plaque marks her assassination by the Landwehrkanal in Berlin, we realized how close we were to the zoo. It seemed probable that the only notional witnesses to Luxemburg's last moments on the night of January 15th in 1919 would have been the animals in the nearby Berlin zoo. We had to find a voice for them—a voice with which we could allude to her anger at the way in which capital denudes and destroys nature. We found a letter that she wrote from Wroclaw prison agonising over the way in which an injured Rumanian ox was being pushed beyond its capacity by its cruel master. Those words became the basis of the chorus spoken by the animals of the Berlin zoo in memory of the assassination of Rosa Luxemburg in the *Capital of Accumulation.*

And thus, we were confronted with the appearance of much more than a hitherto missing body. It was anecdotally known to us that Rosa Luxemburg, like many early twentieth-century intellectuals, regardless of her personally sceptical philosophical orientation, would occasionally amuse and entertain herself and her companions with *planchettes* and self-consciously ironic forays into the *demi-monde* of mediums and contact with the deceased. In a strange twist of circumstances, it was beginning to appear as if by embarking on our project we had ourselves turned into mediums, who occasionally receive uncanny bursts of insight and communication from Luxemburg herself, relayed to us through the entirely imagined medium of Luxme Sorabgur—whom we found embodied in the form of a sari-clad statue of an Indian woman in the precincts of the Salon of Congresses in the Palace of Science and Culture in Warsaw. Rosa Luxemburg turned up to tease us in Berlin; and Luxme Sorabgur stood in front of us, of all places, in Warsaw. Somewhere around this time, we met an artist in Warsaw, Agnieszka Kurant, who happened to be a great-grandniece of Luxemburg herself. She suggested that we meet her granduncle, a Dr. Kasimierz Luxemburg, who at 97 years of age was still alive and lucid, in Vilnius, Lithuania. She seemed to think that the forensic analyst in Berlin had been interested in his DNA. When we met him, he said he still saw her in his dreams, in Warsaw.

We are not here suggesting that there was anything occult about the process of research and creation that this work involved; but we are aware of the fact that our encounters with the details that began to accumulate—in photographs and letters, in archives, prisons, forensic laboratories, hauntingly abandoned factory floors, and the streets of three cities—led to the

formation of several patterns. Other figures began to emerge. From a photo-
graph kept in a vitrine in a silent watchtower that remains in Woltersdoft
near Berlin, emerged the figure of an Indian prisoner-of-war turned radical
activist, turned film extra and animal trainer. We found out that there were
indeed such people who, we speculated, could become in our narrative
someone like Dada Amir Haider Khan also known as Haider *Inquilabi* (Haider
the Revolutionist), an Indian/Pakistani scarlet pimpernel who was active
in several radical left and anarchist *milieux* in Europe and North America,
and who, it is said, had met Karl Liebknecht, Clara Zetkin, and indeed, Rosa
Luxemburg (Khan 2007).

 The Capital of Accumulation stages a meeting between Haidar *Inquilabi*
and Luxme Sorabgur in a place called 'The Cafe Universal' (yes, there is such
a place—in Ballard Estate in the Fort area of Bombay).

 Their encounter begins with allusions to chess, and to the memory
of a political meeting masquerading as an ornithological congress.[3] Haider,
we think, speaks in this instance, through us, in the language of birds:

> **Haider:** And how many times must I sit at the Cafe Universal in anticipation of
> your arrival, Luxme, with bulletins and chess pieces, practising melancholic moves
> against invisible friends and adversaries while I wait.
>
> **Luxme:** And there's always an unfinished game spread open for your pleasure.
>
> **Haider:** Like in Zimmerwald. I sat in the Cafe Voltaire. Rosa was in prison. I was
> her anonymous messenger.
>
> **Luxme:** Remember Zimmerwald?
>
> **Haider:** I can never forget our Ornithologists Congresses. One time, Rosa asked me
> to do birdcalls, she knew of my gift. She wanted to play a game, to see if the birds
> of a middle European forest would respond to the voices of their Indian comrades.
> I sang the arcing lament of the Great Indian Sarus Crane. Rosa reminded everyone
> present, as only she would, that it's proper name was Grus Antigone Antigone.
> She asked if anyone could discern in the voice of the Sarus crane an echo of the
> first defiance of the citadel, the law of the state. She said we should never let them
> claim the memory of our defeats as the chronicle of their victories. Like Antigone,
> she said, we should watch over our dead. We should insist on our own account
> of their passing.

--

3 For more on Zimmerwald Conference, see International Communist Current (2005). For the Orni-
thological 'cover' of the Zimmerwald Congress, see Kuhn (1998). For more on Rosa Luxemburg's
interest in ornithology, see Sheasby (2001).

Luxme: You pretended to be ornithologists to fox the secret police of fourteen countries, but the dadaists at the next table thought you were freemasons, and you thought that they were snake oil salesmen.

Haider: I played chess. I beat Ilyich.

Luxme: Enough reminiscence, grand master Haider Inquilabi. Let's get down to business.

Haider: So! make your move.

Luxme: I have decided to stop letting myself be turned into stone.

Haider: That's easier said than done, you know.

Luxme: Some would say that it's easier done than said. And enough's been said already.

Haider: Someone needs to write "What is to be Undone".

Luxme: I am in my time, you are in yours, we have almost a century between us on this table.

Like the distant flock of white birds that keeps appearing and disappearing over the skyline over Warsaw as Haider and Luxme recall Zimmerwald, the central conceptual concerns and questions of the work rise and fall like the crest of a wave during this dialogue. It is the patience of research—of looking again and again for resonances in the shot, collected, and found material; of reading; and then speaking in the language of birds—that enables us to recover disparate elements like the chess game, the Sarus crane, bodies that ask for burial, the unlikely history of Haider *Inquilabi*; and bring them all together in one place.

What follows from this gathering is the possibility of an imagined constellation, a cluster of stars revealed by a procedure similar to what Hermes did when he read the writing of birds in the sky, or what would have happened when someone followed an imaginary line drawn between the head of a scrawled bird-man, a bird and an aurochs in the cave at Lascaux seventeen thousand years ago.

IV) A conference of birds

The thirteenth-century Persian poet, alchemist, perfumer, and mystic, Sheikh Farid-Ud-Din Attar of Nishapour wrote a verse allegory *Mantiqa't Tayr* that is variously translated into English as 'The Language of the Birds' or 'The Conference of the Birds' (Attar 1984). Remembering Attar's poem, even if in inadequate paraphrase, could be one way to close these considerations on the relationship between searching and practice, research and art.

The poem chronicles a conference of birds who meet to choose their king. The *Hoopoe*, wisest amongst them, tells them that they have no need to choose a sovereign, they have one already, the *Simurgh*, a mythical, benevolent, magical giant bird that lived on the Mountain of Kaf. The gathered

birds, inspired by the Hoopoe's guidance, resolve to fly to see the Simurgh. On the way several birds drop out. Finally, only thirty birds, assisting each other over the long haul, make it to their final destination. Upon arrival, the Hoopoe reveals to them that the Simurgh (now read *seh-murgh*, or thirty birds) is nothing other than their own gathering. The birds only need to know themselves to find their true sovereign.

Every allegory has unpredictable uses; and nothing prevents us from purloining the 'Conference of the Birds' for the purposes of our current concern. The relationship between acts of research and the making of an artwork can be seen as being analogous to the tie between the predicament of the thirty birds and the Simurgh of the fable. Research is the summation of flight paths, of the thirty birds, the 'cranes passing in great numbers with a twittering flight of the birds of passage' as they make their way to the mountain of Kaf to meet their sovereign. The work of art is the Simurgh, which can only be recognised when the acts of research, 'the cranes and twittering birds', reflect on themselves, on the solidarities forged during their flight between different kinds of knowledge, reasoning, discovery, and intuition—and understand the import of the migrations that their passages map between continents of details.

174

But to do this we need to be bird-men, and speak in the language of the birds.

— END —

References

Attar, Farid-Ud-Din. 1984. *The Conference of the Birds* (tr. Dick Davis). London: Penguin 1984.
International Communist Current. 2005. 'Zimmerwald Conference 1915: Revolutionaries
 against the Imperialist War'. Online at: http://en.internationalism.org/wr/290_zimmerwald.html
 (consulted 01.04.2011).
Khan, Amir Haider. 2007. *Chains to Lose: Life and Struggle of a Revolutionary: Memoirs of Dada Amir
 Haider Khan* (ed. Hasan Gardezi). Karachi: Pakistan Study Centre, University of Karachi.
Kuhn, Rick. 1998. 'Marxism and Bird Watching'. Canberra: Australian National University. Online at:
 http://www.anu.edu.au/polsci/birds/marxbird.htm (consulted 01.04.2011).
Lewis-Williams, David. 2004. *The Mind in the Cave: Consciousness and the Origins of Art*. London:
 Thames & Hudson.
Luxemburg, Rosa. 1990. *The Accumulation of Capital* (Special Abridged Edition). Faridabad:
 Kamunist Kranti.
Magli, Giulio. 2009. *Materials and Discoveries of Archaeoastronomy from Giza to Easter Island*.
 New York: Springer.
Nozedar, Adele. 2006. *The Secret Language of Birds*. London: Harper Element.
Rappenglück, Michael A. 2009. 'Heavenly Messengers: The Role of Birds in the Cosmographies
 and the Cosmovisions of Ancient Cultures' in Rubiño-Martín, José Alberto, Juan Antonio
 Belmonte, Francisco Prada and Anxton Alberdi (eds) *Cosmology Across Cultures*
 (Astronomical Society of the Pacific conference series 409). San Francisco: Astronomical
 Society of the Pacific: 145-150.
—2005. 'The Cave as a Cosmos: Cave Art, Cosmography and Shamanism in the Upper Paleolithic'
 in *Iskusstvo i ritual lednikovoi epochi* (Art and Ritual of Ice Age). Lugansk: YP Vega: 126-144.
—2004. 'A Palaeolithic Planetarium Underground—The Cave of Lascaux (Parts 1 & 2)' in
 Migration & Diffusion: An international Journal 5 Nos. 18 & 19: 93-119.
Raqs Media Collective. 2010. *The Capital of Accumulation* (art project). Produced by the Goethe
 Institute Warsaw & Mumbai as part of Promised City.
—2000. 'Frame of Mind: Researching for Documentaries' in id. (ed.) *Double Take: Looking at the
 Documentary*. New Delhi: Public Service Broadcasting Trust.
Sheasby, Walt Contreras. 2001. 'Marx at Karlsbad' in *Capitalism Nature Socialism* 12 (3)
 (September 2001): 91-97.
Tsokos, Michael (with Veit Etzold & Lothar Strüh). 2009. *Dem Tod auf der Spur: Zwölf spektakuläre
 Fälle aus der Rechtsmedizin (Death and its Trace: Twelve Spectacular Forensic Cases)*. Berlin:
 Ullstein TB-Verlag.

175

Weblinks

http://en.internationalism.org/wr/290_zimmerwald.html (consulted 01.04.2011).
http://www.anu.edu.au/polsci/birds/marxbird.html (consulted 01.04.2011).

LOGIC OF BLINDNESS
Marcus Steinweg

Experience can only be had blindly.
Heiner Müller (2008: 412)

In his *Logic of Scientific Discovery*, which first came out in 1934, Karl Popper lays out the foundations of his *epistemology of the modern natural sciences*, as the subtitle of the first edition of the German original indicates. Important sections concern the principle of falsifiability of empirical-scientific theory systems.[1] Attacking a position Popper calls 'conventionalism', the *Logic of Scientific Discovery* denies the possibility of an irreversible verification of scientific propositions by contesting the 'existence of *ultimate explanations*' (Popper 2002: 452); in the few pages dedicated to the arts, he says of the artist that, though the latter 'may freely choose a certain *form*' (Ibid.: 450), this choice ultimately remains contingent. There is no place beyond contingency in the sciences, philosophy, or the arts. The logic of scientific discovery turns out to be one of contingency. Art, as an art of discovery, has to do with the affirmation of contingency, just like any scientific experiment. The point is to 177 entrust oneself to a certain ignorance and blindness, to affect all knowledge with a constitutive not-knowing, with its blindness, its dizziness and the irreducible remainder of disorientation.

Agamben writes: 'How it is we do not know something is no less important and perhaps even more important than our ways of knowing' (Agamben 2010: 189). An 'art of ignorance' would open the subject up toward the sphere of the incommensurable that Agamben calls the 'zone of ignorance' (Ibid.: 191); and he does not hesitate to affirm the ideal of a harmony 'with what we fail to apprehend,' which would amount to 'finding the right relation to ignorance' (Ibid.). As so often, Agamben argues in favor of embracing a fundamental impotence:

> Nothing makes us so poor and so unfree as the alienation from impotence. Someone who is separated from what he can do can still offer resistance, still possesses the

1 Popper also calls this the "principle of the continual correction of error"; see his 1964 preface to the German edition (Popper 2003: ix); the English translation of the book has appeared under the title *The Poverty of Historicism* (Popper 2002).

ability to desist. He who is separated from his impotence, by contrast, loses first and foremost the ability to resist. Just as only the injurious awareness of what we cannot be vouches for the truth of what we are, only the radiant manifestation of what we cannot do or abstain from doing lends consistency to our actions. (Ibid.: 80)

We should not confuse the injury Agamben speaks of with a narcissistic wound giving rise to resentment; far from confirming an imaginary integrity, an intact potency, a stable knowledge and ability—by making a cut or incision, it names the originary contamination of the subject that consists in its instability and contingency. We may also speak of the imperfectionism of our realities, faculties, and achievements, theoretical as well as practical.

Perfectionism would be narcissism. It would imply a lack of willingness—should we not speak of a want of courage?—to engage with the point of inconsistency of mundane presences to the extent that it marks their visible or invisible, dramatic or imperceptible, unsettling or amusing, affirmed or repressed fissuredness. What sort of image of thinking might be adequate to this general inconsistency?

We expect thinking to lead from darkness into light. That is the self-conception of the enlightenment. Whether in philosophy, in art, or in the sciences: the twentieth century has begun to complicate this imperialism of light (one name for this complication is *deconstruction*). Not in order to slide into the esoteric and irrational; but in order to initiate a thinking that accounts for the blindness of the subject, with a more precise conception of enlightenment, subjectivity, and reason. 'If enlightenment does occur, it does so not through the establishment of a dictatorship of lucidity' Sloterdijk writes (1989: xxv–xxvi). A dictatorship neither of lucidity nor of opacity, since all knowledge remains after all dependent on ignorance, as lucidity is dependent on opacity, and meaning on its absence.

'It is not enough,' Nietzsche says in a fragment unpublished during his lifetime,

> that you understand in what ignorance humans as well as animals live; you must also have and acquire the *will* to ignorance. You need to grasp that without this kind of ignorance life itself would be impossible, that it is a condition under which alone the living thing can preserve itself and prosper: a great, firm dome of ignorance must encompass you. (Nietzsche 1968: 609)

The philosopher of active forgetting turns out to be an apologist for active ignorance, which we must not rashly confuse with a reactive irrationalism. Nietzsche seeks to contain the naïve traits of the religious belief in reason and

knowledge; he insists that knowledge is not everything, that ignorance is not in opposition to it, that the subject must muster the willingness to integrate its blind components into an enlarged conception of itself. An enlargement that conciliates it with its inconsistencies, with its ignorance as well as the limitations of its consciousness, with itself as a subject of blindness, before psychoanalysis finally studies the conception of a subject complemented by its unconscious and the attempt to describe it in its openness toward an entity that speaks within it as it speaks and decides for it before it can appropriate its own decisions.

The topics of ignorance as well as the unconscious (which are by no means identical: the unconscious is the knowledge of which I do not know, whereas the ignorance Nietzsche speaks of is to be the object not only of my knowledge but also and even of my will) evoke a certain expropriation of the subject, a sort of ontological poverty that limns its outlines as naked life or empty *cogito*, or in brief, as a *subject without subjectivity*. The subject of idealism defines itself by its partaking in a universal we-subjectivity; the subject of Christianity knows itself to be the *ens creatum* of a *creator*; the subject without subjectivity, by contrast, is an originarily decapitated subject. Open to the above as well as the below, without *telos* or foundation. Its hyperbolism marks this openness, which makes it border the infinite. At all historical moments, philosophy confronts itself with the infinite components of the subject until—in the phase of its development that is the critique of metaphysics—it finally holds out the prospect of a conception of enlightenment expanded by this infinity: a *new enlightenment*, as Nietzsche puts it, a new subject and a different reason that acknowledge their hyperbolism. A thinking that retains its opacity as it enacts the conflict of the 'night of the world' with the 'light of reason', of closure with opening (cf. Žižek 1997: 96).

It is part of the subject's normality to transcend normal circumstances. That is the meaning of Kant's formula about metaphysics as a 'natural predisposition' (Kant 1997: 104). We may also say: perversion against nature as naturalness or abnormality as normality. We move within the precinct of the 'human', but this is a humanity that does not exclude the inhuman. To the contrary, it maintains an opening toward the inconsistency not only of the 'humanisms' but of all ideas and concepts that seek to grasp what is authentically human, by severing it from what is allegedly external (or inauthentic) to man, be it his animality with all its imaginable semantic connotations or his tendency to aggressively subject himself to strenuous exertions that bring him in touch with his (non-external) outside. The subject obviously exists only as a hyperbolic animal. Forever and everywhere does man reach beyond

himself.[2] He does not content himself with the possible. He wants the impossible and so creates new possibilities. He resists his enclosure into established concepts and realities. He overshoots his objectivity. The philosophies of existence since Kierkegaard have insisted that the real of the subject marks a disturbance that is irreducible to abstract concepts. Philosophy has never been anything but the attempt to tailor concepts to what defies the concept, not in order to abolish it but in order to preserve its intensity in the concept.

What does *intensity* mean? When do we use this word? Lyotard, for instance, has defined intensity as an incommensurable energetic value. This enables him to identify the 'production of concepts' in a representative discourse with an 'attenuation of intensities' (Lyotard 1978: 15). Intensity is what resists being channeled. It defies the attempt to instrumentalise it as well as any *limited economy*. Like Bataille's 'heterogeneous', it marks the point of resistance that needs to be affirmed, by a thinking that allows itself to be enraptured by it into experiences from which it cannot emerge unaltered. Intensity drives thinking to excess; it renders thinking itself intense, headless and precipitate, precise and blind. The dream moves one to imagine an intense theory, with intense concepts. It is the dream of a language and a thinking that are no longer the antagonists of life and the libidinous intensities, by slowing them down and stopping them as they confine what is incommensurable in them into concepts—hence the reproach that was, all too simplistically, leveled against Hegel. Instead of being reproductive like the Owl of Minerva, this thinking is to be productive, hyperbolically turned toward an uncertain future without abdicating as thinking, without renouncing concepts and the rigour of their disposal in more or less consistent constellations. The dream of intensity is the dream, itself intense, of a philosophy that would be different from the one that exhausts itself in reproductive commentary and professorial paraphrase. The dream of entire generations of philosophers who attempt to wrest philosophy from its history, the forever recurring dream that threatens at any time to jolt thinking out of its academic slumber in order to lead it to its critical point. Intensity disrupts historic filiation, destroys the great continuities to which people ascribe causal necessity, which they consolidate into unified blocks that construct coherencies and identities at the price of reductive simplifications, in order to offer pedagogical assistance to the subject, promising it orientation by providing it with consistencies. These consistencies always serve to reinforce the fabric of fact, just as the experience of intensity begins

2 See Sloterdijk's remarkable studies on this issue (2001: 255-74).

to unravel it. Intensity offers resistance to the terror of the doctrines as well as the dictatorship of tradition. It opposes what Heiner Müller (2008: 369) calls the 'total occupation by the present,' which implies an 'effacement of the past' and an 'effacement of the future.' That is Müller's version of the critique or deconstruction of the metaphysics of presence and its conception of time, which subordinates everything to the primacy of the given and elevates any contingency (including that of the past) to the status of a necessity, that is to say, of something against which resistance will inevitably be futile.

Deleuze has given 'intensity' an ontological turn. He relates it to Nietzsche's eternal recurrence and to the chaos or abysmal ground, which is to say, to the indifference-value of reality. Intensity points to a momentum that defies reconciliation or balancing. It is disparity and difference; it indicates 'the unequal in itself' (Deleuze 2004: 298). As such it designates (in Lacanian terminology) the *real* of reality, the precarious point where it defies internalization. We can think Deleuze's *difference of intensity* in conjunction with Derrida's *différance* and Heidegger's *ontological difference*. It marks the rift that is part of the constitution of reality, like Lacan's *lack*, like Adorno's *non-identity*. Though these philosophical and psychoanalytical registers are glaringly divergent, though their temperatures (negative, diagnostic, affirmative, etc.) differ widely, they obviously agree in pointing out a universal boundary or void, a resistance that remains their shared vanishing point. Being open to possibilities is one thing. But being open to the ruin of the optional texture demands that the subject approach a resistance that can easily trip it up by evoking that subject's *truth* (its real), the ontological inconsistence of its reality (cf. Žižek 2007: 154). Opening toward closure is opening toward an inconclusiveness that propels the emergence, amid the possible and the familiar, of the *unfamiliar* or *impossible* or *differently possible*. Possible beyond the possibilities, so unexpected that it is experienced as danger rather than opportunity. True opening is opening toward unfamiliarity and absence. It is the act of breaking through the optional texture toward its implicit outside. Not opening toward the world *as* it is as a world of fact, but opening toward its pure existence. The subject extends itself toward this outside, which opens up its possibilities by delimiting them. It *is* nothing but this self-extension. Only thus does it exist, as primordial excess or originary self-transcendence. Instead of drawing from itself the ground of its certainties and constituting itself as stable self-consciousness and transparent *cogito*, it immerses itself in a water without ground:

> It immerses itself in it without immersing itself. It neither bathes nor swims in the depths (of which, incidentally, it is afraid.) But it immerses its thoughts in this unthinkability that is the obscure, closed, and nonetheless movable mass of the

ductile and plastic water. This "I" that arrives on the edge of the lake arrives at once from the mountains and from the woods: the lake opens before it like a crater (that is perhaps its antiquity), like a very old rift of the earth in the domain of its solid rock and its oldest vegetation. This is a mouth at once open and closed, in which the previous state of the world manifests itself: a state without transcendence, without form, all in all without expression. Or it is like an eye that does not see, an eye that is turned toward the sky that reflects itself in the water—the sky, and not the "I." (Nancy 2009: 164)

The picture Nancy paints of the world evokes the ontological difference Heraclitus, Nietzsche, Heidegger, Fink, Axelos, and Deleuze have described as innocent becoming and indifferent play, as the naked dynamism of *There is*.[3] This picture reaches into the thinking of the present via Levinas and Blanchot; it must measure itself against the incommensurable, must be able to be the sea and at once the empty sky. Within the horizon of this horizonlessness, the subject—as the 'indefinite subject of the anonymous,' as René Schérer puts it (2008: 10)—seizes its indefiniteness as the condition of a possible self-articulation.

In a text that imparts to the subject the experience of the water and its banks, Nancy approaches the 'point' where 'delimitation and opening become indistinguishable' (Nancy 2008a: 10). The water rests in a basin, delimited by soft beaches and bare rocks. Water that unmasks the inconsistency of the logos, its aquatic origins and essential fluidity (cf. Steinweg 2002). In a text written in 1963, Foucault traced the line separating reason from insanity along the distinction between islands or continents and limitless oceans, reminding us that, at least within the occidental horizon, the water reflects the hyperbolism

3 The point of departure is Heraclitus's fragment no. 52: 'Time [*aion*] is a child playing draughts; the kingship is a child's' (Heraclitus 1889: 103). A Heraclitean play Deleuze describes as 'the unconscious of pure thought': 'game—without rules, with neither winner nor loser, without responsibility, a game of innocence' (Deleuze 2001: 71). Nietzsche already refers to this fragment in *The Birth of Tragedy from the Spirit of Music* (Nietzsche 1999: 114). Heidegger translates as follows: 'The *Geschick* of being, a child that plays, shifting the pawns: the royalty of a child,' and comments: 'The Geschick of being: a child that plays. In addition, there are also great children. By the gentleness of its play, the greatest royal child is that mystery of the play in which humans are engaged throughout their life, that play in which their essence is at stake. Why does it play, the great child of the world-play Heraclitus brought into view in the aión? It plays, because it plays' (Heidegger 1991: 113; cf. Mascolo 1993: 91ff.). Kostas Axelos is the author not only of *Le Jeu du Monde* (1994), but also of *Héraclite et la philosophie: la première saisie de l'être en devenir de la totalité* (1992).

of any thinking, which must leave its firm footing on dry land in order to be able to leave itself behind for the limitlessness of its outside (Foucault 1963). The aquatism of reason consigns it to an experience that, although it jolts itself out of it, is essential to it, as it is necessarily tied to unreason as the medium of its mobility. 'The question must no longer be one of deciding between the finite and the infinite, between delimitation and opening' (Ibid.), Nancy says, as though to remind us that there is no alternative to the *originary contention* between *léthe* and *alétheia*, between clearing and concealment.[4] This opening reaches into a closure that is forgetting and blindness. A minimum of light attests to it, an almost-nothing-of-evidence. Heidegger named it *disclosedness* or truth of being. Even the originary forgetting requires exposure to this light in order to manifest itself, however vanishing this manifestation. The concealed harbours unconcealedness. It becomes apparent in the latency of withdrawal, in an absence that is *there*. It is this 'inseparable bond between concealedness and unconcealedness,' the thinking of a 'disclosedness' that 'discloses not the bright light of insight' but 'an impenetrable darkness' (Agamben 2005: 49–89), that imparts orientation to our meditation on an originary impossibility.

What does it mean to affirm the impossible? Is the affirmation of the impossible an affirmation of difference? At issue, in any case—that at least is what the imperative of the critique of identity demands—is the readiness to
receive something unexpected:

> In affirming the impossible, we do not dialecticize it, we do not domesticate it, we do not transform it into the possible, and yet we also do not fall into the trap of nihilist despair. (Nancy 2008b: 56)

We do not transform it into the possible, but we affirm it, we give it a little air and afford it a presence that is otherwise unattainable to it. A riven presence, but a presence and an object of possible affirmation! If, then, the goal is, as Nancy writes elsewhere, to introduce '*into* the world' this '*withdrawal* that is the heterogeneous,' to introduce, in other words, what remains 'absolutely foreign to the fettered order of the world (of use and exchange),' what accordingly has no place in it and so cannot breathe, that does not mean indulging a passing romantic fancy or an idealistic temptation that refuses to face the facts—i.e., economic reality. It means not avoiding

4 The originary contention that coincides in Heidegger's thinking with the differential compossibility
 (*diaphora*) of world and earth (cf. Heidegger 2002: 1–56).

the Nietzschean legacy of 'agitation,' to accept it into oneself in order to draw from it the impulse to introject the impossible into the possible, the heterogeneous into the homogeneous, the improbable into the probable (Nancy 2008c: 76). It means, moreover, being fully aware that the possible has long been shot through with the impossible, the homogeneous with the heterogeneous, the probable with the improbable: the incommensurable is of this world, it is already taking place in it, this world exists only as opening, as incommensurable or impossible totality.

And that is exactly what it means to *expierence*, this appreciation of an immeasurable distance between two orders that are joined in conflict.[5] The order of differential value assessment and the order of the indifference of value are not in themselves as incompatible as it may seem. They delimit each other without being mutually exclusive. They are identical under the aspect of difference. Difference drills a hole into identity, as does the incommensurable, as does the void, as does the sky without god. All efforts henceforth point in the direction of 'inscribing elsewhere in here,' as Nancy writes, of 'having, in the world, the experience of what is not of this world, without being another world for all that' (Nancy 2008c: 78). Which is another way of delineating the introjection of the impossible into the possible or the redefinition of reality. The fabric of fact disintegrates in this experience in order to manifest itself as what it is, a collective phantasm resting on conventions whose function is to generate consistency. In ontological terms, the inscription of elsewhere in the here and now of constituted reality possesses is strictly *a priori*, i.e., it is equiprimordial with that reality. And yet the concept of introjection hints at an active-creative experience that corresponds to the affirmation of the incommensurability-value of the established value models. With a glance at Bataille, Nancy can call it '"inner" experience,' a phrase he immediately qualifies by adding that it is 'not at all the fact of some interiority qua subjectivity'; rather, it correlates to an exteriority he locates in an 'outside of the outside,' for it opens not a 'beyond-the-world' (nor a 'behind-the-world') 'but the truth of the world' (Ibid.: 79). As an interval between presence and absence, it is distraction into the nowhere, transcendence within immanence, hole within being, exodus that loses its way in this world, a flight across (*survol*)

184

5 The reader will remember that Heidegger gives identity to think as 'the close relation of *identity and difference*,' which must not be subsumed entirely either under identity or under difference. See Martin Heidegger (1969: 21).

that remains in contact with what it flies across,[6] a step into an outside that is taking place here and now, affirmation of absence as presence, touching the untouchable, reception and welcome of what is allegedly *epékeina tes ousías*, beyond being, as reality's blind spot.

The demystification of the world has led to the mystification of demystified reality. Enlightenment has engendered its own obscurantism; facts are now the new religion. They bring consistency and reliability. That is the meaning of the word and its function: to guarantee familiarity. The opening toward the incommensurable, by contrast, is an opening toward the unfamiliarity-value of the world, toward an inconsistency that comprises its *contingency* and its *becoming*, its *invisibility* and its *eluding* our grasp, its *defying* our control and its *insignificance*. In his *Aesthetic Theory*, Adorno quotes the passage from Hegel's lectures on aesthetics where the earlier philosopher says of the artist that, 'as a free subject,' he attempts 'to strip the external world of its inflexible foreignness' in order to impress 'the seal of his interiority' on it so that he can reencounter 'in the shape of things only an external realization of himself' (Hegel 1975: 31). The 'effort to do away with foreignness,' Adorno writes, touches upon the fundamental operation of the enlightenment, which renders commensurable to man what remains incommensurable (Adorno 2004: 106). The dialectic of commensurability and incommensurability pervades the concept and history of the enlightenment itself, which—as a sort of a negative dialectic—enacts the conflict between two elements that defies speculative conciliation. Because the incommensurable remains incommensurable, remains foreign and unfamiliar, it must appear as such in the work of art as the latter not merely acquiesces to, but actively expresses, its irreducibility to the known and familiar. That is the meaning of the word 'appearance'—Adorno speaks of an *apparition kat' exochén*, 'appear[ing] empirically yet [...] liberated from the burden of the empirical' (Ibid.: 107): it denotes the emergence of the incommensurable from the field of commensurable fact. We might also speak of the *event* that disrupts the order of being. In any case, the incommensurable presents as a rift in the structure of reality without marking the irruption of an absolute outside. It articulates the truth of reality that, excluded from it, at once evokes its fundamental trait. It is a non-integral element to which the pre-rational consciousness—or what

6 That is the meaning of the *survol*, the 'flying-over,' in the thinking of Deleuze and Guattari (see the translators' introduction in Gilles Deleuze and Félix Guattari (1994: ix–x) on the difficulties of translating this term into English). Instead of fleeing reality, the subject intensifies its contact with it by distancing itself from it.

Adorno calls 'the preartistic level of art'—affords access, whereas it possesses no immediacy of any kind, acquiring negative apparency only through the mediation in the artefact that is the work of art. We might speak of an aporetic organisation of the work of art to which each sentence of the *Aesthetic Theory* seeks to be adequate. Where Adorno begins in the affirmative register, he ends the thought critically; where a sentence begins with a negative, delimiting, or subversive turn, it ultimately opens in affirmative fashion toward what it has rejected. The same holds for the work of art Adorno defines in many such sentences. It is affirmative and subversive at once. It approves and negates. It is empirical and yet not empirical. It captivates, but not from outside. It seduces, but to reflection. It reflects, yet blindly, etc. The work is aporetic because it draws its intensity from an opening toward a boundary it affirms instead of transgressing it. Its artificiality conveys what it denies, the 'shudder as something unmollified and unprecedented.' It surpasses 'the world of things by what is thing-like in [it], [its] artificial objectivation' (Ibid.: 107–8). It remains forever committed to the impossible, as the possible collaborates with what is, with power, with authorities. The work, by contrast, requires the affirmation of the unknown and the pact with contingency. At the same time it must not dissipate its energy in esotericism, in magic and obliviousness toward reality. Part and parcel of it is the knowledge that what is possible in sublimity belongs to reality as its impossible, as its boundary and inconsistency, as what is repressed or nameless in it, as its implicit outside: that is, as that in it which eludes.

186

References

Adorno, Theodor W. 2004. *Aesthetic Theory* (tr. R. Hullot-Kentor). London: Continuum.
Agamben, Giorgio. 2005. *Nymphae*. Berlin: Merve.

—2010. *Nacktheiten*. Frankfurt/M.: Suhrkamp.

Axelos, Kostas. 1994. *Le Jeu du Monde*. [1969] Paris: Éditions de minuit.

—1992. *Héraclite et la philosophie: la première saisie de l'être en devenir de la totalité*. [1962] Paris: Éditions de minuit.

Deleuze, Gilles and Félix Guattari. 1994. *What is Philosophy?* (tr. G. Burchell and H. Tomlinson). London: Verso.

Deleuze, Gilles. 2004. *Difference and Repetition* (tr. P. Patton). London: Continuum.

—2001. *The Logic of Sense* (tr. M. Lester and Ch. Stivale). London: Continuum.

Foucault, Michel. 1963. 'L'eau et la folie' in *Médecine et Hygiène* (613, October 23): 901-906.

Hegel, G. W. F. 1975. *Aesthetics* (1) (tr. T.M. Knox). Oxford: Oxford University Press.

Heidegger, Martin. 1969. Identity and Difference (tr. J. Stambaugh). Chicago: Chicago University Press.

—1991. *The Principle of Reason* (tr. R. Lilly). Bloomington, In.: Indiana University Press.

—2002. 'The Origin of the Work of Art' in *Off the Beaten Track* (tr. J. Young and K. Haynes). Cambridge: Cambridge University Press: 1-56.

Heraclitus. 1889. *The Fragments of the Work of Heraclitus of Ephesos on Nature* (tr. G. Patrick, ed. I. Bywater). Baltimore: Murray.

Kant, Immanuel. 1997. *Prolegomena to Any Future Metaphysics. With Selections from the Critique of Pure Reason* (tr. G. Hatfield). Cambridge: Cambridge University Press.

Lyotard, Jean-François. 1978. *Intensitäten* (tr. L. Kurzawa and V. Schäfer). Berlin: Merve.

Mascolo, Dionys. 1993. *Haine de la philosophie. Heidegger pour modèle*. Paris: J.-M. Place.

Müller, Heiner. 2008. *Heiner Müller, Werke 11, Gespräche 2: 1987-1991*. Frankfurt/M.: Suhrkamp.

Nancy, Jean-Luc. 2008a. *Die Annäherung*. Cologne: Salon.

—2008b. *Philosophical Chronicles* (tr. F. Manjali). New York: Fordham University Press.

—2008c. 'An Experience at Heart' [2002] in *Dis-Enclosure. The Deconstruction of Christianity* (tr. B. Bergo, G. Malenfant and M. B. Smith). New York: Fordham University Press: 75-80.

—2009. 'Das liegende Auge' in Woznicki, Krystian (ed.) *Vernetzt*. Berlin: Verbrecher: 161–165.

Nietzsche, Friedrich. 1968. *The Will to Power* (tr. W. Kaufman and R.J. Hollingdale). New York: Vintage.

—1999. *The Birth of Tragedy and Other Writings* (ed. R. Geuss and R. Speirs). Cambridge: Cambridge University Press.

Popper, Karl. 2002. *The Poverty of Historicism*. London: Routledge.

—2003. *Das Elend des Historizismus* [1960]. Tübingen: Mohr Siebeck.

Schérer, René. 2008. 'Homo tantum. Das Unpersönliche: eine Politik' in Nancy, Jean-Luc and René Schérer. *Ouvertüren. Texte zu Gilles Deleuze* (tr. Ch. Dittrich). Zurich: Diaphanes: 7–30.

Sloterdijk, Peter. 1989. *Thinker on Stage: Nietzsche's Materialism* (tr. J. O. Daniel). Minneapolis: University of Minnesota Press.

—2001. *Nicht gerettet. Versuche nach Heidegger.* Frankfurt/M.: Suhrkamp.

Steinweg, Marcus. 2002. *Der Ozeanomat. Ereignis und Immanenz*. Cologne: Salon.

Žižek, Slavoj. 1997. *The Plague of Fantasies*. London: Verso.

—2007. 'Materialism, or the Inexistence of the Big Other' in *lacanian ink* (29): 141-159.

THE SUBLIME AND BEAUTY BEYOND UNCANNY ANXIETY

Bracha L. Ettinger

By *beyond the Freudian 'uncanny' anxiety (Unheimliche Angst* [Freud 1955])
I mean: beyond the fatal association between daunting and haunting aesthetic
phenomena and the affect of anxiety. Experiencing Beauty, experiencing the
Sublime, imply—I am convinced—that *primary* affects *other than anxiety*
are encountered too, affects that are also connected, like anxiety is, to the
early human states of helplessness. They hint at a state that an even more
archaic 'helplessness' (if such an expression should apply here at all) would
have evoked—once upon a time, before it had evoked anxiety—a silent
overwhelmedness of the pre-I, an oceanic feeling of-with-in the unity of
self and (m)Other, self and Cosmos, self and a primary sense of being alive
(Freud 1961), which *not only* was not connected to anxiety, and not only was
sometimes connected to undifferentiated bliss, but which, also, had involved
other primary affects, affects that bring about the experience and emotion
of *wondering-admiring and amazement* and also accompany them—as
originary emotions-experiences—during a process of *differentiating-
in-jointness* within such a unity. This silent overwhelmedness allows for some
apprehension of the shared space and continuity, not the cut, between I and
non-I, when the I is in differenciation from, and in co-birthing with, the non-I,
the pre-maternal (m)Other. Once a continual contact has taken place-time-
duration, psychic sharing and continuity *continue to occur,* in some aspects,
at a certain level: continuity and a vibration of shared psychic strings. The
partial-I, and then the subject that evolves from it, works through traces of
this vibration, looks for the resonance of its frequency, where the wonder-
ing relates to passivity and admiring to activity along and around the same
affective arousal of amazement. Thus, the other (for the I) is an entity that
begins, not in abjecting, rejecting and splitting. The other, to begin with, is not
the site of rejected psychic materials, but of continuity and a shared affective
trembling. Beauty—this last barrier before the emergence of the Death Drive
in life, or the revelation and admittance of the occurrence of death, the last
barrier before the horror of death (Lacan 1992)—is also *the last barrier from the
knowledge of non-life as pre-birth.* This beauty overwhelms and amazes. And
precisely by this affective touch it gives me a passage to another world while
offering me access to my own non-subjective futures and non-subjectivised
pasts. The true work of art echoes this beauty of the pre- and post-subject.
 I ask myself the question: Is it indeed Angst, or is it just, or mainly
Angst, with which I, as an artist, open myself to the Other and the Cosmos,

risking, like Eurydice, my own fading and disappearance again and again? What is the Thing or what are the things that overwhelm me so, and how is this amazement connected to art? And what is art anyway? And how do I know something by 'artworking'? There is this human condition described in Hebrew by the word 'de'aga' with its verb *'lid'og'* (and its root 'd.a.g') that means to worry and have concern for, to take care for and about. I am concerned and involved as I take care; I care for your needs while I worry about you. But do I necessarily *take care* of whomever and whatever worries me? When do worry and care meet? What is this worry-caring to which I give a time of my soul, which moves me to artworking and gives my life a sense of a sense in-by an *oeuvre*? And what kind of care-worry moves the viewer to participate in the affective sphere that an *oeuvre* creates?

Consider and seize the passive force of a mixture of affective strings of compassion and awe, even without their connectivity to any object, to any supposed cause of their arousal. I think of this mixture as a psychic *concerned arousal, an arousal in concerning.* Arousal, not anxiety. Something arises both in itself while being with-and-versus something, and as a response during an encounter. We take it for granted that any mother, any father, knows this arousal, and we register this on the account of responsible adulthood. I suggest something else: that this arousal is primary, that the infant is exposed to it originarily as an affective way to know the other, whether (m)Other or Cosmos. If the capacity for this arousal is lost, the subject is in trouble; a careful distinction between arousal and anxiety is therefore needed. *Concerned arousal of compassion in awe-full amazement* is close in kind to anxiety, but it is different from it. It doesn't alert me to a danger for myself; it doesn't push me to flight, even if it raises my defences to an extent. It calls me to transgress my subjective boundaries while it signals that in fact my boundaries have already always been transgressed, and that on certain levels they are only a fiction. To en-compass-worry and to awe-wonder-care—these are two affects that call upon me to slip out of my self, but not into infinite oceanity. These two affective ways to know the other, the (m)Other and the cosmos, serve also to differentiate between non-I and I. They know in one another. And I therefore structure a level of the other within and with-out, a non-I, accordingly—contrary to the position of Sigmund Freud, and to that of Melanie Klein (which corresponds to his view): that the other is primarily structured as what the self rejects and detests (Freud) and that the first subjective position is schizophrenic-paranoid (Klein) and emerges out of an undifferentiated fusion with the world (autistic symbiosis). The two affective arousals: compassion and awe, these non-rejecting affects, I consider, then, to be just as primary as anxiety. They work to keep proximity through processes of differenciating

and differentiating, to prevent or suspend rejection. They signal arousal of *anima* in the being, a psychic breath of the spirit. When the spirit is aroused, adjoined with fascinance, what can appear to the senses as beauty and to the spirit as sublime has already offered itself as some enigma to the psyche, between arousal and anxiety.

Together with uncanny compassion and uncanny awe, and even as a reaction to those affects, uncanny anxiety is often experienced; and indeed, not only is it difficult to distinguish between those affects when they are mixed in different doses, but it is also difficult to extract them in their special uniqueness once they are followed by anxiety. And yet, it is important to extract them from the reservoir of the anxiety into which such different affects are gathered, to distinguish between them and to allow their effects to direct us both at an emotional level and in comprehending, thinking aesthetics and, finally, also, Ethics. Compassion and awe are gathered together because with compassion, the shadows of compassion also arise; shadows that turn between disgust and pity, contempt and sadistic or masochistic traits that form the possibility to humiliate. And so the chord that links compassion to its shadows is coiled. Compassion and awe are being gathered together because with awe, the shadows of the awe arise too, shadows that turn between fear, shame and envy, affront and sadistic or masochistic traits. And so the chord that links awe and its shadows is coiled too. The chords are coiled around-inside the subject. They oppress the subject first of all on their own account, but also because of the guilt concerning those shadows. Thus, beyond-anxiety uncanny affects are channelled toward anxiety. These shadows fall—or are projected—onto the present, disappearing and *a priori* lacking object, which realises whatever the psyche is missing in the other to which it is referring. Anxiety follows when self-relinquishment turns into surrendering. Suddenly—self-relinquishment can turn into flight or fight. When one is swimming inside such a reservoir, it is difficult to distinguish between vulnerability and fragility, fragilization and self-fragilization (Ettinger 2009). It is difficult to distinguish between free self-relinquishment and surrendering out of frailty. When the shadows of the affects are projected onto the other of the I, the vulnerability of the other becomes transparent: the subject does not apprehend it any more; the subject moves in the world as if it were on its own. In a similar way, we are unaware of the frequencies and vibrations of the Cosmos—out of a similar kind of blindness but on a non-personal level, a blindness that is translated into fear from (our own) death and a negation of (our own) death, which are at the same time fear and the negation of all futures. If one is not flooded by the contact with these shadows and does not look for 'causes' to be blamed for their appearance, either in the inside

or in the outside, the borderlinking by en-compassing alongside fascinance becomes creative and reveals Beauty, and the borderlinking by being filled with awe with fascinance reveals the Sublime. The capacity for en-compassing and being awe-full beyond anxiety allows us to dignify the other and the Cosmos, both at the level of the subject ('inside', the interiorised others) and in the world *per se*. A return of the capacity to respect goes together with the placement of respect at the site of the other and in the space of the cosmos.

We need a careful distinction not only between anxiety and uncanny anxiety, but also between uncanny anxiety and the uncanny beyond-anxiety, when approaching the enigma of the aesthetic experience and that of the ethical route. For this, an attunement and attention is required, which reason is limited to describe precisely because limits are inherent to reason. There is a fluidity between compassion and awe as there is a fluidity between the beautiful and the sublime; there is also fluidity between their shadows. But when speaking of beauty and sublimity in art and of the affectual musicality of drawing and painting—and in hinting with Lacan, with Kirkegaard, with Kant and with Socrates and his Diotima that the question of beauty infiltrates the field of ethics and, even more, that the ethical space is already transgressed at the level of the spirit—we admit that for the artist, in the field of art and on the level of the spirit, what brings forth awe and compassion also attracts and gives rise to beauty. We contribute to culture but at the same time create a debt toward the spirit, and in that sense betray art if and when we limit ourselves to expressing this complexity solely by conceptual discourse.

Wondering-admiring and being amazed while worrying for whatever arouses the experience of the awesome by which you are stirred, during artworking: an *Uncanny awe*. This kind of awe concerns both the process of work, which is poietic, poetic and also aesthetic, and the act of viewing, which is more clearly aesthetic but is not purely such, due to the participation offered by art when it does work—a participation in the same affective atmosphere in which it was birthed. The Freudian *Unheimliche Angst* arises primarily on the aesthetic plane as it addresses a sensuous experience and the effects of getting in contact with artistic products: poetic writing, drawing, paint-ing. Artworking—the artistic process—was not Freud's first concern when articulating the uncanny. My use of the expression 'aesthetic' does not intend an experience of viewing and listening conceived as a passive perceiving of what arrives from the outside. Or rather, there is another kind of passivity that I intend. Passivity in a matrixial borderspace and bordertime (Ettinger 2006d) is an affectual attuning in arousal: an active passivity, a special Eros. The aesthetic for me encompasses the creative-poietic producing as well as the effects of participating in, while perceiving an artwork; processual poetic

moments as well as the contact with an *oeuvre*, a *chef-d'oeuvre*—master-piece—even, I dare say, which calls for an engagement over a duration of time, which inspires and initiates. The idea of inspiration moves me to the sphere of before and beyond sensing, before and beyond perception, before and beyond the sensual, to an Eros of the m/Othernal heart-beat and breathing transmitted beyond the senses, in proximity, an Eros of my own heart-beating, and an Eros of the breathing of the m/Other transmitted beyond the senses, an Eros of my own breathing—breathing and heartbeating with-in different kinds of beyonds where the now is in contact with the unexpected adjoining thereafter, stretched from near or far. These thereafters-beyonds do not represent transcendence in a 'religious' way, in relation to the unreached-for, but a call for overtures to the holy in the human, to a search for meaning through access to the Cosmos beyond the perceptive span and to what is found in the future of the real in the here-now, and in the virtual futures of past encounters, but here and now. The question of the holy arises—the human desire to encompass, to feel awe, to respect and wonder-admire, with or without the existence of God, this crazy desire in the human soul not to ignore the fact of its separation while also not ignoring its autistic core in the individual, to address *adjoinment* with the inside core of the outside while the autistic spiral coils inside and im-presses itself upon the self and the world, working through what I call one's *autistic resistance* until the autistwork works through an unknown jointness in its edge's working. (Formal religious organisations exploit this dimension, but we should not turn our back to it altogether when we refuse this exploitation and this organisation. The aesthetic and the ethical are deeply connected to the uncannies of awe and compassion and to the human capacity for self-relinquishment.)

193

The Freudian *Uncanny* is based on weaning, separation and castration anxieties. Lacan has identified in all clarity that anxiety does not stem from the state of separation but from a state of encounter hinted at after the separation has already taken place, which is then identified with symbiosis, with the maternal body and with psychic death. This symbiosis-death is identified with the feminine linked to the mother. For this reason, the articulation I have made of the difference between non-life, or non-living-yet, and death has been very important in my eyes, and I have dedicated much writing (Ettinger 2006c) to articulating the link between the pre-maternal femininity and the pre-life condition (that is not death in life) and to the idea of differentiation in jointness with a maternal subjectivity which is not symbiosis. In Lacanian terms, anxiety addresses symbiosis and the subjective cut via the cause of desire which is forever lacking: *objet a*. Anxiety connects to the helplessness of the infant, to the series of weanings the infant must pass through, to an enormous

net of notions and concepts that deal with cuts, lacks, holes, losses, splittings and rejections of which the *abject* as a rejecting tendency is neither the last nor the least. When I suggest thinking through an uncanny produced by and relating to those other affects that for me are primary and major, I also suggest ways to think on art, and on another kind of art-critique that will put forward a self-requirement for self-fragilization, an autistic pact to work for life from the difference between non-life and death and from the difference between the phallic femininity in-for men and women and the matrixial femininity in-for men and women. Such a critique would not be supported by splitting mechanisms and would not support them either: the lacking object of its search would not be the flip-side of the subject or its shadow, but linking, continuity and resonance in the cosmos and in the Other by which it has already been transformed. A conceptual frame alone is not able to deal with the specificity and uniqueness of an artwork in terms of such continuity and resonance. (After all, as long as a creation is called 'art', even when the halo has left her, like a reproduction—we have to think on what account and why it was specified as art). To fragilize oneself without helplessness in a search for the holy that is not a search for submission and religiosity—one that calls upon art to get involved in a particular way—you enter this time-space as long as you care-wonder-amazed-admire even in criticality. Just observing, even a painting, is not enough. If you feel observing while wonder-caring, continue to observe; you are at a threshold of *adjoining in self-fragilization*. When resistance adjoins this self-fragilization while fascinance is still maintained, a horizon opens. The horizon of Art. Art beyond the pleasure principle scratches the reason of-in culture.

Beyond Uncanny anxiety, then: wonder-worrying the awesome (awestricken and not meditating on or thinking about the awesome) as well as en-compass-caring while *fragilizing one's self* worry-wondering in amazement—with such overture to Other and Cosmos and such pointing toward a horizon, the idea of Beauty that originates is linked to an idea of a Sublime. An idea of love arises here too, but not of a sentimental kind. And with the artistic thing—love intermingled with resistance. Wondering and worrying: not a passive-submissive or religious *replique*: *Communicaring* in self-fragilization, not a passive feeling of compassion on the one hand and communication on the other hand. Fragilization and resistance, then: continuity and resonance in re-spect, a passage from such Eros into its Ethics.

The encounter-event is an occasion for borderspacing and borderlinking. There is no promise that borderlinking will occur and create a specific kind of atmospheric alliance for each participant. Encounter-eventing resists both the unique, sole subject with its narcissistic core and coherent Ego

(*à la* Freud) and the endless unstitching and fluidity (*à la* Deleuze and Guattari [1987]), chaos or entropy. It is possible to access a virtual web of traces that function as threads still connected to strings of archaic co-emergence with the (m)Other and the Cosmos. Encounter-event is inseparable from what is inspired and felt between partial-subjects in borderlinking, but the potential for resistance to either fragmentation or self-freezing is there too, if we accept, precisely, the risk of a momentary overture of the subject's limits, felt as 'me' by self-fragilization, while still keeping an 'internal' move of re-spect.

Primary affective compassion and primary affective awe arise (Ettinger 2006a) during being-with and becoming-with the Other and the Cosmos sensed as an outside that enters my limits either without impingement (from outside) or without rejection (from inside). Even alone, I am not alone when those affects arise; I am with my archaic non-I(s), pulled to the outside and to future non-I(s) by my most internal core. You can call this being-pulled "Love". *Primary affective compassion saturated with fascinance is a precursor to the capacity for experiencing Beauty. Primary affective awe saturated with fascinance is a precursor to the capacity for experiencing the Sublime.* Here, however, a Beauty moves toward the Sublime and a Sublime moves toward Beauty, intermixed with knowledge without rejection or fusion at either aesthetic pole, when our cognition and our defences are suspended for a while, in respect. Affectual fascinance binds transsensing with sensing and the sensual to the archaic Eros before sexuality. Affected suspension brings the before and the after into the *beyond* in the here-now. The entry of awe and compassion into the poietic-artistic aesthetical field calls for modes of criticality that lean on dwelling and resonating-with whatever arrives over a duration of such a suspended time, what I name *implicated criticality*. Art and art criticism, which lean on conceptual tools or aesthetic judgements alone miss this dimension, or rather: this dimension, as generous as it is, manifests its resistance and evades them. Implicated criticability involves entwinement. There is a thinking-feeling in the worrying-caring wondering-admiring. An active knowledge, an inscribing knowledge, a knowledge concerning an attraction that is not based on needs or self-defence. A non-paranoiac knowledge beyond anxiety and reasoning, that gives you string-wings.

I feel-think-know-care-worry in-by working in uncanny compassion. Beauty crystallises itself as I keep wondering on the threshold of some failed harmony. Without harmony, without expectation, without claiming symmetry, to attend to something that will not reach the level of the social, with-in sorrow, without resolution. I feel-think-know-care-worry in-by working in uncanny awe. This carries and gives birth to an experience of the Sublime as I am wondering, swerving toward something awesome, almost reaching the

195

beyond of me with no equivalence, what I can't reach, something that does not give in to the human and yet reaches the human and doesn't burn me. I can grasp something of it as long as I transgress the limits of my individual psyche. Something is struggling to breathe in the co-affective processing of the trembling of a transjective string (Ettinger 2005 and 2006b). When the effect of the sublime infiltrates from the overwhelmed individual subject into its transsubjective web, those measures of failure, swerving, disharmony and difference are contained and maintained as a part of an overture whose price is indeed also anxiety.

Beauty bends toward the sublime and is working-through not by some hints of possible future happiness (Freud, Nietzsche) in a harmony already felt and expected to reach future formulations, but as a wandering arousal that might be painful, which emerges from a *direct contacting* with the wounds and the scars of the world, with the traces of the outside when they scarify me and I sense the overwhelmedness of the Other and the Cosmos *in their difference* from me, while circumventing my narcissistic investment in my-self. By *direct contacting* I mean the beyond-sensing that still scarifies in a borderlinking-pregnance, in participation-beyond-identification, participation-before-identification and even participation-beside-identification and beyond identity, which doesn't involve appropriation and allows neither fusion nor assimilation, nor abandonment or reject. Something is discerned and sifted; endlessness is discerned from the Thing, which something is concerned with. With it I am con-cerned, 'do'eget': interested, involved, affected, connected, related, implicated, solicitous, caring, attentive to, considerate of—and also worried, anxious, upset, perturbed, troubled, distressed, uneasy, apprehensive, not passive but aroused. (Con-cerned is taken from the French *concerner* or late Latin *concernere* (in medieval Latin *'be relevant to'*), from con- (expressing intensive force of uniting) + *cernere* 'sift, discern', all included in the Hebrew word *de'aga* in a similar way.) Art works inside a paradoxical in-different con-cern. The kernel of the things in the world is in-different to the subject. We must therefore imagine borderlinking along strings, without recognition and without confirmation. And a wondering joy that is not joyful but traumatic bursts forth, a joy that doesn't indicate narcissistic gratification or fulfilments of wishes and needs. Art invents, treasures and creates threads in which the vibration of such strings is saturated and inscribed, traces of joint trembling, and grasps bare sorrow by the same touch. Art is a means to get access to such strings only as long as you are being transformed by it and affected by its hidden *Unheimliches*. Art is generosity in precisely this sense—not necessarily a happy generosity, not a promise of happiness, since its promise is to con-cern and in-volve you by anxiety,

awe and compassion in trauma or joy alike, producing trauma and joy and tracing and transmitting whatever is transmitted, in horror and grace alike. Transsubjectivity in life and in art is always revealed to the subject as a shock when not negated, refused or repressed. An arousal of *anima* disturbs the Psyche as it is sensed beyond the senses in the unconscious that is stretched between some I(s) and non-I(s) (without becoming a collective or global Unconscious). Primary compassion arises as a shock to the Psyche. The *uncanny compassion* carries and gives birth to experiencing joy while we are traversing the enigmatic and traumatic becoming-with the (m)Other and the Cosmos *in their vulnerability*. Primary awe arises as a shock to the Psyche. The *uncanny* awe carries and gives birth to experiencing joy while traversing the enigmatic and traumatic becoming-with the (m)Other and the Cosmos in their overwhelming horror and splendour. Vibrations that turn into sounds, lines and color-lights include the shadows that also turn into sounds, lines and overcolor-lights and undercolor-lights. If this is how you approach an artwork, something inspiring will occur. Even dust and ashes, cinders of traces of a burnt memory within zones of oblivion are ready for an encounter-event, which turns into uncanny objects or links, and subjectivises us as long as we keep connecting with-in it. The unexpected plays here. What works doesn't stop to amaze. The oeuvre works as it amazes. What doesn't stop to amaze shocks. Art offers this shock as a gift to the field of culture and society, as well as to civilisation, all of which is not this generous. Civilisation shouldn't be confounded with art, even though it uses it and tries to offer it. Art is traumatizing and joy-filling. Society and culture can't control awe and compassion, though they can use and abuse them, and though they can manipulate their shadows and derivatives. Being non-manipulable, they are invisible as such (unused) to a civilisation whose paranoid attitude has become generalised and transparent, a civilisation that turns every thing and every affect into an object to use. The right and obligation of a living artist is to intensify each time anew the difference between art and culture (and art-critique is a part of culture, though critique is a part of art) while broadening each time the boundaries of culture.

1)

198

Fig. 1) Bracha L. Ettinger, *No Title – Sketch* n.1, 1985. Mixed media on paper, 25.5 x 20 cm.

2)

199

Fig. 2) Bracha L. Ettinger, *No Title – Sketch* n.2, 1985. Mixed media on paper, 27.3 x 23.1 cm.

3)

200

Fig. 3) Bracha L. Ettinger, *No Title – Sketch* n.8, 1989. Mixed media on paper, 26 x 26 cm.

4)

Fig. 4) Bracha L. Ettinger, *Fliegerbilder* n.3, 1986-1987. Mixed media on paper, 28 x 25 cm.

5]

202

Fig. 5] Bracha L. Ettinger, *Fliegerbilder* n.4, 1986-1987. Mixed media on paper, 25.5 x 25 cm.

This woman with the shaven head—does she remind you of someone? A woman disgraced. Graceful. To see the humiliation and to see the beauty of the world without humiliating, in respect. She could be your mother or your daughter, or mine; she could be you or me or your sister. Is she beautiful? She might sit in the same position as the Mona Lisa, but looking closely you feel this curve, the turning of her head downwards, her face distorted—by what? Is this the horror of shame? Is she ashamed for someone else or just surviving? If you judge her, you know nothing of her. If you pity her, you know nothing about her. You see-know something only if you give yourself to it-her, reaching transcendence of the objectal in the image. Such is the work of painting. How can critique be carried without judgement of the kind that falsifies all critique? What kind of critique can awe and compassion allow? You can withdraw even from your self, can't you? Resistance is first of all to your self as the unique, and to the endless self-fluidity. Anxiety combined with awe and compassion allows a different kind of critique—different from the reactive criticality that splits and follows anxiety alone, uncombined in that way.

203

She is seemingly crazy—but is she? Or is the world chaotic or simply overwhelming for her, she who is expecting death, watching horror, accepting death, being rejected, between two deaths, betrayed or betraying, intensive and helpless. She doesn't want to look at us. She looks at us. She looks away. When she turns her back she refuses objectality. When she looks down she refuses subjectality. Some forms of turning one's back, some forms of looking down, of withdrawing, indeed offer life. And that's what happens when she resists your objectalising of her, and in this precise same move, but only if you self-fragilize yourself to the extent of letting her vulnerability touch you. She doesn't ask anything from you, she doesn't ask you anything, yet she calls you to meet her where both she and you transcend her objectality, and where you lose your own boundaries. Such is the call emanating from painting, from drawing, when the process reaches primary affects and works from those combined time-space-body-anima moments to bring you to the proto-ethical zone of the aesthetic field. To understand betrayal and to connect the beauty of the world without betraying; to understand shame and to connect to the beauty of the world without shaming; to hallow in re-spect.

When she looks at us, she sees without returning our gaze. She is gazing at us and at eternity, and we are seized by an instant of eternity, be it loss, languishing or wandering. Wondering and worry-caring still. Wondering and worry-caring again. Now it is us who are looked at and called upon—but what for? But why? And how can you approach this particular eternity with a critique and still join with-in it?

To paint is to wonder. To connect the beauty and to contact the cruelty of the world without cruelty, in re-spect. A last time-place-duration of wondering. To paint is to dare wondering. Softness of light-darkness of halo. Resonance returns into life by the musicality of things. This woman, sometimes mother figure, in all its apparitions, has always haunted me. She has haunted me from before my memory began—and so I have recognised her. She daunts me from and in this time-space where fascination, awe, anxiety and compassion arise together—before guilt, before shame, before action, before reaction, before cognition, and even before abjection and disgust. She haunts me though her traces have functioned from with-in me from before I even knew that such is also anybody's virtuality, anybody's possibility, mine or not mine. I keep knowing her as long as I access the Other and the Cosmos through those affects. And I keep losing her when splitting mechanisms get stronger and these affects get diverted into fear, shame and blame intermingled with submission, which give birth to a freezing fascinum.

I always knew that I could be her. And I have always thought: I would not have survived, that's for sure. Yet, there is no identification here—only initiation and inspiration. That's where the halo re-enters art that seemingly has come after it. The halo returns to the oil paint.

Impossible to join eternity in implicated criticality without some copoiesis. You are called to respond, yet you are free. In fascinance—and you are free. The aesthetical moment that works to enhance the emergence of a future ethical moment plays on a virtual string. Harmony is not attained; the spiral swerving always continues. An ethical imperative will enter when you are in encounter, yet free.

6)

205

Fig. 6) Bracha L. Ettinger, *Atypical Psychosis*, 1990-92. Ensemble III Drawing 5, mixed media on paper, 20.1 x 22.3 cm.

7)

Fig. 7) Bracha L. Ettinger, *Metramorphosis*, 1989-1990. Ensemble II drawing 2, mixed media on paper,
27.2 x 27 cm.

8)

207

Fig. 8) Bracha L. Ettinger, *Hundert Deutsche Fliegerbilder aus Palastina (Hundred German Aerial Photos of Palestine)*, 1989. Ensemble V drawing 3, mixed media on paper.

9]

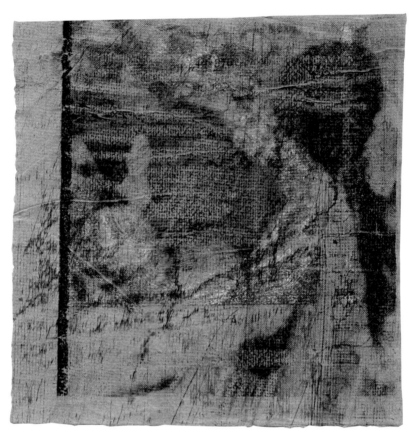

208

Fig. 9) Bracha L. Ettinger, *No Title – Sketch* n.7, 1989. Mixed media on paper, 26 x 25 cm.

10)

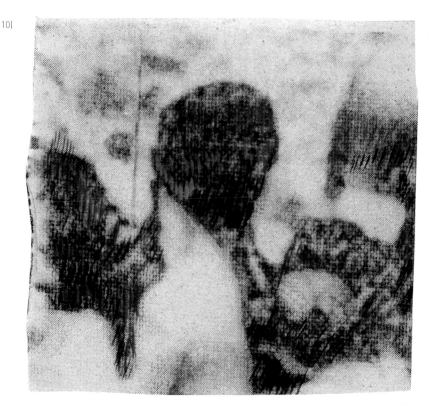

209

Fig. 10) Bracha L. Ettinger, *Matrixial Borderline*, 1990-1991. Ensemble I drawing 5, originally composed in polyptych, mixed media on paper, 18.3 x19.4 cm.

Fascinance is pregnant with potential and virtual responsiveness-openness
to otherness that is intrinsically and paradoxically related to the I with-in
a matrixial string. There is here a metaphysical overture to the possibil-
ity of joining that is beyond me. I and non-I are a loom; we are webbing.
A dimension of the holy in the human comes forth. *Fascinum*, on the
contrary, is reactive, it can be manipulated, it freezes life (Lacan 1981) as it
exploits the search of the isolated subject for submission to a power stronger
than itself, turn ing the potential for self-fragilization and transformation
into masochism. Abolish the possibility for fascinance—and you wake up
with *fascinum* and its effects.

 Co-responding-with by way of feeling uncanny awe and uncanny com-
passion means feeling a kind of joy—not sadistic and not masochistic—even
in sorrow. Live with-in sorrow. A life drive. To love the anonymous elements,
to individualise them, to create specific links and recognise the borderlinking
to them—this is a long process that I referred to in my *Matrix Halala Lapsus
Notebooks* around 1990 (Ettinger 1993). It demands that we restart again at each
encounter-event; it calls you to always-again reach a threshold of a beginning-
toward-life, even though you are already within a net of strings, even when
the process is already a few years' process, even though you feel that you
know your non-I(s) and carry-vibrate with their deads. Each time you begin
to paint, the painting begins you and you unknow again. Each time you look,
it looks at you and you unsee. The particularity of the processual *innocentia* of
painting is that it is innocence after the end of innocence, innocence without
naivety, still possible in a world where innocence alone is not possible since
we are impregnated with transmitted traces of crimes and traumas, and where
innocence per se is not even wished for, as we must work for ethicality that
uses memory. Yet, there is an autistic *innocentia* that unknows and knows.
No working of art and no love and no worry-caring is possible without that
kind of innocence, insensitive to paranoia. A non-reactive kind—the autistic
in openness, a paradox. With the kind of circulation of traces in the matrixial
space, we are slowly and each time in a shock becoming responsible for traces
of events in which we didn't participate, traces of events we didn't cause,
engagements with the turning-into-life of sounds we didn't produce while
producing new sounds, visions and traces. So talking about love, like talking
about innocence, vulnerability of the other together with self-fragilization
of the self, and working with people in conversation, and painting with
archive photos, is an invitation. Invitation also to rethink—beyond splitting
mechanisms—shame, guilt, evil, death, deception of the other, deception
by the other and self-deception, betrayal of the other, betrayal by the other
and self-betrayal, languishing, hope, hopelessness and helplessness, cruelty,

humiliation, grace, solace. Helplessness of being born, helplessness of dying. Deception, betrayal, shame—which are today much more repressed than acts and feelings of aggression and of sexuality.

Uncanny awing carries and gives birth to the experience of the Sub-lime not out of narcissistic identification with the immensity of the cosmic outside or the interiorisation of such immensity but by borderlinking to the intensity and vibration of the cosmic that remains out of the reach of my Ego and personality, and yet allows me, through poetic artworking and aesthetic wondering, to resonate with it, to connect to its frequencies to such an extent that this resonance reaches the level of the archaic resonance in me. This archaic resonance is directly linked to past and missed future horizons that now edge the present-presence: to a net of virtual strings.

Uncanny en-compassing and awing mobilise particular kinds of Eros and Thanatos—an Eros of languishing-longing that is not sexual and a Thanatos of languishing-withdrawing that is not aggressive—which labour to pass a glimpse of that mysterious zone in the human which resonance offers: initiation and inspiration. Beauty inclined toward the Sublime transports kinds of non-cognised non-conceptual knowledge and sorts of unverified truths about the nature of the connecting strings. A truth of being touched. The notion of being-artist enters here: the difference between art and other productions in-of culture, the difference of moments of art. Perhaps music can serve us here: I think of the musicality of painting. When it works to wonder, it does the working when it is played. When you are touched by the vibrations and have some knowledge of this touch, you keep wondering-admiring in a worry-caring way, engaged in a time out of time. You care-worry because you realise that you are in touch with a failing world, but you are also lost inside it for a moment of eternity. This is, I think, what Marguerite Duras means by the expression *"endless thing"*. Artworking offers, if I use her expression, some endless thing I will never know. Painting as transcendence of the subject and the object alike still remains immanent in the matrixial dwelling with-in it, where uncognised knowledge of some endless thing manifests itself. Painting offers the forever elsewhere in a time-space duration of a with-in-between, where whatever could have happened but failed to happen can express itself, where you can see again yet for the first time what can't be seen any more once you have emerged out of transjectivity and what can't be seen by the eyes: your virtual and possible intersections with the Other and the Cosmos, and the time-space of intersection itself, which works as light cloud and spiral string, a spirit-string, a wave, a halo, the musicality of things, affected by the human *anima minima* (Lyotard 1995), a pulsating color-light cloud scarred in a thread that then treasures *memory of oblivion* of a string through which you

can almost *remember the memory of others and grow centuries older* (Duras again) and centuries younger. Painting and drawing and writing, scanning with light in light, over time, time and time over, painting still, drawing still, writing still, between conscious scribbling and unconscious drawing-writing, and encounter-eventing again, are the processing of—and the engendering of—affected forms, and the offering of words for such signals of some endless thing I will never know while I know in it from it. *Painting as halogram.*

The transcendence offered by the art object is specific and unique. It can't be generalised—and yet it is shared, and therefore I locate the transject both at the level of the subject, artist and viewer, and at the level of the art-work. This doesn't mean that artist and viewer are in the same position or in symmetrical positions *vis-à-vis* the artwork and *vis-à-vis* one another. Think of reciprocality without symmetry, in difference. You can be inspired while respecting the offer. But you can despise it too—we are dealing here with some very delicate routes toward knowledge, which evolve and dissolve in a spiral way. A neglect of the insights that emerge from these affective routes diminishes their effectivity. Despising is an option too, but it is important to realise that this leads to other kinds of knowing. Slowly, indeed, abjection and rejection, which are ways to know and create the Other as squalor and the Cosmos as ashtray, became more effective during the 20th Century in which squaluor invaded each splendour to a maximal degree. No wonder that some contemporary critique, which is reactive, revealed *and created*, in a circular reflectivity as by a magnifying mirror, more and more kinds of abjection and abandonment.

Painting is a transmission intersection. It is a wandering dwelling pregnant place that, in a duration of time, offers—again and again—a possibility for coemerging and cofading in borderlinking and borderspacing with enigmatic traces of different periods and materials, traces of the world from different times and sites. The same dwelling place can be stretched between different unconscious public and psychic times, and the same time-duration connects different unconscious public and psychic places. Art, as a time-place-duration-body where you dwell beside others and they dwell inside-outside you, where you are neighbouring a stranger affectively known, and allow the archaic mode of fascinance to take its course and work (on the one hand), while hinting at the possibility of witnessing (on the other hand) to what you didn't cause. Artworking allows the opening-up of a spiral evolvement that engages bordertiming and the borderspacing that are involved in transjective metramorphosis. In art, transsubjective and transjective encounter-events take place by way of a subjectivising experiencing with an object in itself, or a process, an other in itself, or an event, other individuals or

the Cosmos, through image or movement, sound or touch or word, but mainly behind and beyond them all, through affective transsensing and resonance, through direct knowing which differentiates human subjects and living beings from objects as it keeps working with both subjects and objects.

Working in the domain of what we officially call art doesn't promise Beauty or the Sublime. I call what opens this possibility, precisely: Art. Painting for me is the place-time-process where the outside with-in the inside inspirits a move whose result is in the visible, though that move doesn't arise from the visible. The move itself is fragile, and it fragilizes you. It doesn't surrender to your will, and you are not submitted to it. What you plan is never what painting plans for you, so you end up by not planning painting; you enter again and again the process, at the threshold of non-knowing. There is a difference between the photographic process, video, photography, or any art that starts with the lenses, and the painting process, which, like a sound or a voice, starts again and again from the invisible transsensed resonance—transsensed by a body-soul—to finally reach the audible or the visible. For this reason I see painting not only as relevant to our time, but also as a project that still has a long way to go. *A project that meets the now from a future auratic era.*[1]

213

--

1 Different versions of this essay were presented on five public occasions: 1. *Matrixial Transjectivity*. A keynote lecture at the conference *French Psychoanalysis and Literature*, University of South Carolina, 19 March 2010. 2. *Lightpainting and Com-pass(ion)*. Artist Lecture at Conference in exhibition *Alma matrix: Bracha L. Ettinger and Ria Verhaeghe*. Fundació Antoni Tàpies, Barcelona, 14 May 2010. 3. *Painting Still: Fascinance and Com-passion*. Visiting Artist Lecture at the Royal College of Art, London, 22 March 2010. 4. *Beyond Uncanny Anxiety. Uncanny Awe, Uncanny Compassion and Matrixial Borderlinking*. Lecture with installation and encounter-event at ICI Berlin, 12 Nov. 2010. 5. *Beyond Uncanny Anxiety. Yearly History and Theory Conference*, Bezalel Art Academy, Jerusalem, 28 Nov. 2010. The full text whose extracts are composing this essay is in print (without the images) in FLS (French Literature Series), Volume XXXVIII, 2011, under the title *Beyond Uncanny Anxiety. Uncanny Awe, Uncanny Compassion and Matrixial Transjectivity*. In print.

..

References

Deleuze, Gilles and Felix Guattari. 1987. *Thousand Plateaus: Capitalism and Schizophrenia* (tr. B. Massumi). Minneapolis: University of Minnesota Press.

Duras, Marguerite 1961. *Hiroshima Mon Amour* (tr. R. Seaver). New York: Grove Press.

Ettinger, Bracha L. 2009. 'Fragilization and Resistance' in Nauha, Tero and Akseli Virtanen (eds) *Bracha L. Ettinger: Fragilization and Resistance.* Helsinki: Académie Finlandaise des Beaux-Arts and Aivojen yhteistyo: 97-134.

—2006a. 'Fascinance. The Woman-to-woman (Girl-to m/Other) matrixial Feminine Difference' in Pollock, Griselda (ed.) *Psychoanalysis and the Image.* Oxford: Blackwell: 60-93.

—2006b. 'Gaze-and-touching the Not Enough Mother' in de Zegher, Catherine de (ed.) *Eva Hesse Drawing.* New York: The Drawing Center and New Haven: Yale University Press: 183-213.

—2006c [1994-1999], *The Matrixial Borderspace.* Minneapolis: University of Minnesota Press.

—2006d [1994]. 'The Matrixial Gaze' in id. (2006c): 41-90 (chapter 1).

—2005. 'The Art-and-Healing Oeuvre' in de Zegher, Catherine and Hendel Teicher (eds) *3 X Abstraction.* New York: The Drawing Center and New Haven: Yale University Press: 199-231.

—1993. *Matrix . Halal(a)—Lapsus. Notes on Painting, 1985-1992.* Oxford: Museum of Modern Art (MoMA). Reprinted in Coessens, Piet (ed.) 2000. *Artworking (Bracha Lichtenberg Ettinger: Artworking 1985-1999).* Ghent/Amsterdam: Ludion and Brussels: Palais des Beaux-Arts: 10-115.

Freud, Sigmund. 1961 [1929]. 'Civilization and its Contents' in id. *The Standard Edition of the Complete Psychological Works of Sigmund Freud* vol. XXI. London: Hogarth Press: 64-145.

—1955 [1919]. 'The Uncanny' in id. *The Standard Edition of the Complete Psychological Works of Sigmund Freud* vol. XVII. London: Hogarth Press: 219-252.

Lacan, Jacques. 1992. *The Seminar of Jacques Lacan Book VII: The Ethics of Psychoanalysis, 1959-1960* (ed. J.-A. Miller, tr. D. Porter). London: Routledge.

—1981 [1964]. *The Four Fundamental Concepts of Psychoanalysis* (ed. J.-A. Miller, tr. A. Sheridan). London: Norton.

Lyotard, Jean-François. 1995. 'Des traces diffractées' / 'Diffracted Traces' in Buci-Glucksmann et al. (1995): 6-31. Reprinted in *Theory, Culture and Society* (TCS) 21(1). 2004: 101-106.

FINE ART AND RESEARCH
Jonathan Miles

The judgement of taste is not cognitive.
(Kant 1968: 133)

Lacking strength, Beauty hates the Understanding for asking of her what it cannot do.
(Hegel 1977: 19)

In this paper I will attempt to connect philosophical ideas surrounding invention, presentation and sense in a chain that stands in contradistinction to method, representation and signification in discussing the research process. This is to make a gesture against the idea that the research process can take method, representation and signification as a given. I wish to point towards some of the intellectual problems in assuming such a posture and even suggest that this alternative set of schemas provides a more developed platform for understanding what is at stake in the research process.

The central question of the research process has invariably been identified as method. But what is 'method' in the context of the arts? Within the scientific process, method is of course central because of the need to repeat the discovery. In the modern period, René Descartes was able to assert that method was truth. This foundational status of method (and with it deductive reasoning) has been evident not only within the scientific process, but throughout the entire educational matrix.[1] Aesthetic theory originated in the mid-eighteenth century, in part as a corrective, or at least a challenge, to the authority of deductive reasoning, particularly in regard to its denigration of the function of sensibility and imagination. Immanuel Kant, in attempting to develop a complete theory of knowledge in his series of critiques, found

1 The educational structure as a whole is still based largely on Cartesian philosophy. The very birth of modernity and the rationalist orientation of knowledge with its construction of a stable thinking subject able to verify truth through a rationally constructed method are based on this model. On the level of method, it aimed to eliminate all sources of doubt through the construction of an authentic *cogito* able to identify rational understanding, viewing experience as a source of error, or as indistinct thought that cannot be consistently verified. As a structure of thinking, it has assumed the very transparency that it so painfully constructed in the first place, and in this respect, it is so efficient in its cultural reach and so deeply absorbed by the bureaucratic operation of the world that it appears to be beyond discourse itself. We might say that it is the shape of our world, its invisible ideology.

that without an account of aesthetic judgement and imagination, his theory of reason could not confront the gap between the subject and nature—that is, freedom and necessity. Throughout the entire development of modern philosophy, aesthetic theory has proved to be one of the most dynamic arenas of its overall discourse, because invariably it has dealt with difficult and relegated forms of knowing and perceiving. At the heart of this endeavour is not only the question, 'What is the work of art?', but also, what is it in regard to the whole spectrum of human cognition and sensibility?

A central claim within Kant's theorisation is that art is a-conceptual, which has fostered the suspicion that it is unable, by virtue of its constitution, to construct its own critical tribunal. Instead, as Theodor W. Adorno claimed, it has remained 'a priori helpless'. The desire to advance the idea of 'method' might in part be seen as an attempt to counter this suspicion, born out of art's seeming lack of cognitive claim, perhaps even as a gesture of compensation. As opposed to opening up a field of thought through the working of representation, which assures the harmony of concept and object, there is instead recourse to the faculty of imagination, the implication being that there is a deferral of representation within reflection. This is why Kant advances the idea that the work of art arouses a purely contemplative stance, a stance that is in part based upon the *ek-stasis* of thought—a figuring of thought rather than its actuality—that erases rational overtones and, instead, places it within the sphere of transcendental illusion. If the work of art has a revelatory character, it is predicated on its withdrawal from concepts and transcendental representation, which implies that it is its own event and escapes representation. Such consideration explains the autonomy of the work of art, because the work of art answers its own laws only if it is incommensurable and undecidable on grounds of theory, an insight that provides the link between the moral and aesthetic realms, as opposed to the realms of rationality found within the sciences. Even though the work of art might offer 'infinite interpretation', in the words of Friedrich Schelling, this points to the enigma of the work of art and marks its deficiency in comparison to the concept.

In the present text, I wish to advance the idea of a research process within this sector and to look at the questions this raises. To this end, it is necessary to posit the idea of invention in opposition to method. The art object is not a knowable object in a conventional sense, even though art-historical enquiry might sometimes have aspired to such knowledge. Indeed, this is the root of much art-historical discourse about its own methods. Although art repeats itself in all artworks, the central desire that motivates the production of art is for originality, a form of singularity that is anti-habitual, heterogeneous and eruptive. In fact, in the modern period, the work of art has acquired a

divided essence by virtue of being both a thing and a speculation that allows each individual work of art to disturb the historical lineage to which it nevertheless belongs. Research processes in art require a deep understanding of how our conceptual vocabulary has been formed. It is at this point that we find a relationship between the formation of both language and form within the work of art.

In 1984 Jacques Derrida delivered a lecture on invention at Cornell University (repeated at Harvard in 1986) called *Psyche: Inventions of the Other*. His first major proposition is that an 'invention always presupposes some illegality ... since it inserts a disorder into the peaceful ordering of things' (Derrida 2007: 1). Straight away this strikes a chord with the modern history of the work of art, but not with the idea of the academy. He then goes onto to discuss allegory as the 'invention of the other' (Ibid.: 3) and with this the idea that invention cannot be inherently private because it always has a public implication. Invention for Derrida implies originality and in turn a set of values associated with genius. In speaking of originality, he describes invention as 'the coming or the coming about of something new'. Invention does not take place without an 'inaugural event', understood to be 'the inauguration for the future of a possibility' (Ibid.: 5). The advent of invention thus requires social consensus in order to create validity for the future, which is why invention is 'susceptible to repetition, exploitation, reinscription' (Ibid.: 6). In this passage, Derrida sets up an enigmatic play between 'advent' and 'event', of future, adventure and convention. This co-extensivity between invention and the arrival of the future remains central throughout the text.[2] To be inventive implies the development of a 'reflexive structure', which is a projection 'forward' to 'the advent of the self'.[3] For Derrida, the process of invention 'involves an affirmation' linked to the coming of 'event, advent, invention' (Ibid.: 22f.). So invention 'gives rise to an event, tells a fictional story, and introduces a disparity or gap into the customary use of discourse, by upsetting the mind-set of expectation and reception that it nevertheless needs; it forms a beginning and it speaks of that beginning, and in this double, indivisible movement, it inaugurates. This double movement harbors the singularity and novelty without which there would be no invention' (Ibid.: 24).

2 Derrida notes in this regard that the Oxford English Dictionary defines invention as 'the action of coming upon or finding' (Ibid.: 6).

3 It should be noted that Derrida does not think of deconstruction as a method. For Derrida, deconstruction itself 'is inventive or it is nothing at all' for it does not 'settle methodological procedures, it opens up a passage way' (Ibid.: 23).

Through the advent of the modern period, invention came to be seen within the remit of method in order to marginalise irrational discoveries. For the purpose of determining this difference 'an analytical method' was developed, whose outcome was a 'logico-discursive mechanism' that enabled 'the connection of subject and predicate'. The implication of this is that 'invention is invented only if repetition, generality, common availability, and thus publicity are introduced or promised in the structure for the first time' (Ibid.: 34).

According to Derrida, the other main factor that has impacted on the understanding of invention is related to the imagination and the shift of its status in and after Kant. The idea of the productive imagination 'liberates philosophical inventiveness and the status of invention from their subjection to an order of theological truth or alternatively infinite reason'. Derrida links the rehabilitation of the imagination to the call of Schelling for a 'philosophical poetics' or for an 'artistic drive in the philosopher' (Ibid.: 41) in order that philosophy can invent new forms.

> It was an event and a sort of invention, a reinvention of invention. No one had said before that a philosopher could and should, as a philosopher, display originality by creating new forms. It is original to say that the philosopher must be original, that he is an artist and must innovate in the use of form, in a language and a writing that are henceforth inseparable from the manifestation of truth. (Ibid.: 42)

Yet a paradox arises, for if invention is not going to end up as 'a program of possibilities within the economy of the same', 'the only possible invention would be the invention of the impossible' (Ibid.: 44).

Many of the concerns of this discussion might be usefully employed in relation to research. With practice-based research, the possibility that is opened up is that both the works of art in question and the process of theorisation could in some way occasion the reworking of their relationship, which has little by way of established ground. In effect, it might be seen as a relationship that needs to be substantially invented. Schelling's call, as quoted by Derrida, promises to offer congruence between the pursuit of new forms of thought and the pursuit of new forms within the aesthetic sphere. This creates the potential for a sophisticated consideration concerning the nature of the in-between. I am taking this route because the idea of a research question posited within the two registers of theory and practice suggests an impossible final object in the form of a new type of knowledge. This impossible final object would consist of two separate subject positions: the one inside the work, the absorption of making; the other, outside of the work, a theorisation process ideally representing a mode of critical distance. On the level of the

subject, there is a further complication, or paradox, since the work of art in part finds its impulse within the subject and yet becomes a work by virtue of an erasure of the subject. To speak of the autonomy of the work of art is, of course, to imply that the work is autotelic.

Such considerations suggest that the research process might be meaningfully concentrated upon the actual methodological issues that are contained within the very notion of research in art as an expansion of art as intellectual endeavour. Some of the main issues of research pertain to the interface between the arenas of fine art, the applied arts, design and architecture. This question of trans-disciplinarity has profound institutional implications (even for the institution of 'art') that raise further questions of the image, the relationship between the sensible and the intelligible, between the sayable and visual, the play of presentation and representation, practical and theoretical knowledge, aesthetics and ethics, immanence and transcend- ence, bodily affects and space, gesture and language, method and invention, knowledge and non-knowledge, thinking and making, theories of vision, matter and form, questions that intersect philosophy, aesthetic theory, his- tory of disciplines and critical theory. To capture such complexities requires resistance to representational or calculative thought, marking a turn towards the issue of presentation that is proposed by the making of art. 221

In recent thinking about art, presentation has come to the fore in a number of interesting ways. In his book *Confronting Images* Georges Didi- Huberman raises questions about the way in which art history has constituted itself as a form of science that can postulate its object as completely knowable. He states that directing 'one's gaze to an art image … becomes a matter of knowing how to name everything that one sees—in fact, everything that one reads as visible' (Didi-Huberman 2005: 3). For Didi-Huberman, this implies 'the omni-translatability of images', and with it, 'a closure of the visible onto the legible' (Ibid.: 3). He suggests an alternative to neo-Kantian art history, whose object is both a thing of the past and a thing of the visible, with a com- mitment to the

> paradoxical ordeal not to know (which amounts precisely to denying it), but to think the element of not-knowledge that dazzles us whenever we pose our gaze to an art image. Not to think a perimeter, a closure—as in Kant—but to experience a constitutive and central rift: there where self-evidence, breaking apart, empties and goes dark. (Ibid.: 7)

Such an undertaking places thinking 'under the aegis of an examination of the "presentation" or presentability of the images to which our gazes are posed

even before our curiosity—or our will to knowledge—exerts itself' (Ibid.: 9). Essentially, Didi-Huberman develops ways of resisting the notion that the work of art is purely or primarily an object of representation. He asserts that presentation can equally mean figuring and disfiguring, which jeopardizes both certainty and mimesis. Didi-Huberman's critique of art-historical methodology undermines many of the paradigmatic structures of the discipline, which has the effect of opening up the work of art not only to other modes of theorisation but also to the ways in which artists think about the process of theorisation.

In *Critique of Judgement*, Kant (1968) develops the notion of presentation in order to understand the relationship between human freedom and the constraints of materiality in terms of aesthetic or sensible forms. In doing so, he makes a distinction between presentation and representation. Whereas representation schematises the powers of the subject, presentation acts to suspend the claims of the subject's powers over material forms. Presentation therefore extends the possible meanings of material forms and as a consequence embeds the self within a meaning-context. While the cognitive relation to nature is suspended within presentation, an insight into the subject's power is gained as part of the consequence of this suspension. Aesthetic presentation operates through a form of structural dislocation, firstly through the detachment of aesthetic judgement from practical and cognitive fields, which allows for art to be dissociated from functional contexts. Secondly, a relational structure is advanced in order to distinguish between the presentations of a material content from a relation taken from this content. Through the relation to a material form, ideas that might not be cognitively or practically determinable can be established. Thus, objects can be seen in significant and special ways; and material is in turn able to present more than its constitutive materiality in the form of moral feeling, such as when Kant refers to the tulip as a symbol of morality. In overall terms, the importance of aesthetic judgements lies in the work of presentation; disinterest is exhibited within presentation, because we take no interest in the actual concept of the object before us. Whereas representation appears as conception, view, image-loving thought, picture-thought and idea, presentation appears as exposition, exhibition, setting forth and depiction. Representation creates an image of the unitary moment, whilst presentation displays the journey of becoming. The question that is at stake here is to what extent does the idea of research require the operation of representation? Do we straightforwardly focus on method and connect the idea of research with representation, marginalising invention and presentation? In venturing forward, do we privilege theory over thinking?

In his book *The Honour of Thinking* Rodolphe Gasché develops the different ways in which various theorisation and thinking processes have evolved. In reference to Martin Heidegger and his privileging of thinking over philosophy, Gasché states that thinking 'is the counter-concept to both philosophical and scientific thought as representational and calculating thought' (Gasché 2007: 4). Whereas theory stands in contrast to praxis, thinking does not, for thinking attends to the object without discrimination, and in this respect can touch upon the 'unthought' of philosophy. The project behind the various essays that form the book is to examine the historical development of notions such as critique, criticism, theory and thinking. 'Theory', for example, as it has developed in the United States, especially in a literary context, is not just theory but a 'theoretical monster' (Ibid.: 149), since for Gasché this 'multiple theoretical discourse' has a link to a conservative flattening of the early Romantic project, which attempted to re-invent 'theory' from the Greek notion of *theoria*,[4] but was already eroded in its later manifestation. It is precisely because of its theological grounding, which theory has received from this interpretative tradition, that the autonomy of theory is not possible, because the link between the theological and the theoretical was implicitly established by the Romantics. According to such a position, all theory must necessarily yield to the law of intellectual intuition and in turn think and perceive syn- 223
thetically. This implies that 'theory is in essence aesthetic' in the 'sense of a sensible presentation' (Ibid.: 153). Thus, for a thinker such as Friedrich Schlegel, theory is also aesthetics and spiritual contemplation, combining intuition and concept within a poetic form of theory. Without a presentation, theory would simply remain abstract. Theory is 'the bringing together [of] what refuses to come together—the Absolute and sensible appearing, the individual and the universal', and this becomes the site of 'aporetic intensity' (Ibid.: 163f.) or in the later modern context, negative knowledge, which was foundational to spiritualised conceptions of art within modernity which carried through even to postmodern notions of the 'sublime'.

The Romantic theory of art is rooted in a distinct crisis of philosophical discourse, namely in Kant's model of presentation and in turn speculative prohibition. If, for the Romantics, philosophy was not able to figure the Absolute as a whole, then art, in assuming a speculative function, was the site of the presentation of ontology, the revelation of being. In fact, the revelation of being is linked to art, which is capable of revealing itself as Art; that is,

4 See the discussion, which links *theoria* to *thea* (seeing or looking at) and *theos* (god) (Ibid.: 200).

as higher form. This quasi-philosophical implication of art is the reason why it is also understood as criticism. Although this critical aspect of the Romantic enterprise was short-lived, it planted the seeds, even by virtue of a paradox or misrecognition, not only of conceptual art but also of practice-based research, since both operate on what may be seen as philosophical territory. In order to understand the particular juncture between early Romanticism and the blind spots in the later developments of modernity, more research is required. For instance, Alain Badiou develops his thesis on art's relationship to philosophy by citing the fact that modernity is based upon three predominant schemas: the classical, the didactic and the romantic (Badiou 2005). They not only provide a link to philosophy, but also constitute a form of saturation or 'disrelation' between art and philosophy. Thus what might be at stake within the question of research is an engagement with the very figures that inform such schemas, principally, issues such as art and truth.

In order to theorise what research in the arts might be, it is necessary to go beyond theory as an inherited form, making it necessary to risk the formal limits of what is understood by 'theory'. Transdisciplinary studies test the limits of theory and risk the loss of discrete form. At the same time, they occasion a mediation of the objects in question and the adequacy of theory, a mediation that implies understanding. Such undertakings are less interested in the question of existing contexts, particularly if they are historical, than in looking at ways in which the work itself is able to produce a context. In effect, understanding should be focused on the becoming of art, which in a contingent sense is the reframing of context. It is not necessary to dispense with historical contextualisation but it is necessary to create a relationship between the work of art and history that demonstrates the dynamics of both. This is not to place incongruence and difference over identity, but rather to privilege the possibility of new forms of synthesis,[5] revitalising in the process problems concerning the overall field.

In the last section of this paper I wish to dwell on the notion of 'sense' in Jean-Luc Nancy's writing. Sense concerns the idea of presentation before signification, and as such is a form of exposure to the fact that the subject is never present to itself, constituting instead an abyss of infinite repetition. In place of a general idea of the 'subject', Nancy posits the notion of singular beings, each with its own sense. The implication of this is that the body is a

5 The issue of new forms of synthesis relates mainly to the question of time, for time is not just joined moments but also a leap outside of them—which lends to time indefinite diversity (Cf. Faulkner 2006).

'body of sense', a localised site that produces its own spacing in the form of here or there. As such, each body interlaces with other bodies in movement; that is, with sense in circulation. The body is a sensing body by virtue of the spacing it produces and reproduces. The body 'exscribes' (Nancy 1993: 338f.); it is written out of itself and therefore is only available either in departure from itself or coming back to itself. The body exists as an empty position without ground. 'Body' is thus an entity that is constantly in the stage of a 'to-come', in which sense occurs as a form of ‚being-with'. Nancy's thinking about art in relationship to sense is that it 'is always exterior to or in excess of itself in the work of art' (Heikkila 2008: 151). He is especially concerned with art's coming-into-presence or presentation, which he argues is the reason why art can never be a question of representation. Art, like sense 'cannot be approached as anything present, for it is always coming' (Ibid.: 154). Thus the ground on which art arises is itself absence, and it is this absence that is modelled by art. Art emerges out of the space found between presence and absence. Hence art is both withdrawal and offering in equal measure. For this reason, Nancy sees the image as an empty place or the place of displacement where the 'image makes sense come out of absence' (Ibid.: 225).

In regard to artistic research, such thinking leads me to conclude a double impasse. On the one hand, a conflation between art and theory, as if criticism were inherent to art, is dangerous because it might repeat the theological romantic structure; on the other hand, a radical distinction between art and theory, as proposed by the academic apparatus, eradicates the intellectual tension required for thinking to occur. Instead, artistic research opens a potential of a third space within which what constitutes art and theory is being negotiated. In Nancy, this is precisely the function of his notion of sense as posited in-between sensibility and intelligibility. We do not, for instance, expect philosophy to stand in for art as its representative legitimation, as would be the case if one wrote, for example, a Deleuzian account of art to clarify one's making process, which would clearly ignore the questions that art might place against philosophy.

In this paper I have employed philosophical figures such as Kant, Derrida and Nancy not in order claim that what they say about art is necessarily an illumination of art. Rather, I have done so in order to explore what might be sayable in regard to the rhetoric of the research process. The potentiality of research precisely relates to the investigation of a whole number of striations that occur when placing different fields in relationship to one another. This is not to attempt to solve the age-long dispute between philosophy and art; rather, it is to deal with its fallout within metaphysical thinking about art—which goes back as far as the Ancient Greeks.

Perhaps we must always expect to lose our objects in the process of identifying them, and acknowledge that this feature is inherent in the ontological condition of the work of art. We are constantly faced with the breakdown of signification within the modernist context of art, so that language or material becomes *itself* and thus stops having meaning in any teleological sense. Because of this, words or things speak of themselves usually as an outcome of misuse or transgression of rules. In relationship to the work of art, the economy of writing might best inhabit a strange border region in which such loss is enacted in order to test presentation to its limit. As in the case of the sublime, where art suspends itself on the border of art (Nancy 2003: 211ff.), we might look towards the same gesture within the act of writing. Like art, writing requires the ability to formulate a relationship to research that is situated on its border. We are, after all, dealing with an object that is constituted as a multiple doubling: a thing that is also a speculation, a condition that has uncertain temporal indices and an entity that is both object and subject. This condition might lead us to conclude that the actual ground of the work of art is in fact a form of fiction, even if as fiction it is always in pursuit of the reality of a ground. For these reasons, art is a form of becoming. The formulation of research is necessarily aligned with this

226 fact, that the artwork is the basis of a subjective experience of something beyond it. Implied in this is a confrontation with the paradigms that attempt to establish regulative regimes through which structures of knowledge are assembled. Practice-based research in the Fine Art context will always give rise to controversy, since it is without ground in the proper sense; but this can be an opportunity, as opposed to a defect.

We are faced with extended problems relating to the probable disintegration of the foundational structures of modernity and the coherence that it projects, such as the bounded status of the work of art. The ground of research, which in our field is the idea of art and its historical context, is confronted not only with the fracturing of the experience of art but also with its character as vestige or trace. There is no coherent institutional theory able to develop a way through this situation, while a research process might at least develop some sensible or even gestural indices through which an examination is assembled. For Derrida, the idea of invention gives rise to the possibility of a novel world or new desire, that is coupled 'with a certain experience of fatigue, of weariness, of exhaustion' (Derrida 2007: 23). The seeming exhaustion of the figures of thought within contemporary art, and the possibility of a new structure of desire capable of inventing novel figures, is the basis of a dynamic research culture. In the words of Derrida, such a notion of research would be 'allowing the adventure or the event of the entirely other to come' (Ibid.: 46).

References

Badiou, Alain. 2005. *Handbook of Inaesthetics*. Stanford: Stanford University Press.

Derrida, Jacques. 2007. *Psyche: Inventions of the Other: Vol 1*. Standford: Stanford University Press.

Didi-Huberman, Georges. 2005. *Confronting Images: Questioning the Ends of a Certain History of Art*. University Park, PA: The Pennsylvania State University Press.

Faulkner, Keith W. 2006. *Deleuze and the Three Syntheses of Time*. New York: Peter Lang.

Gasché, Rodolphe. 2007. *The Honor of Thinking*. Stanford: Stanford University Press.

Hegel, Georg Wilhelm Friedrich. 1977. *Phenomenology of Spirit* (tr. A.V. Miller). Oxford: Oxford University Press.

Heikkila, Martta. 2008. *At the Limits of Presentation: Coming-into-Presence and Its Aesthetic Relevance in Jean-Luc Nancy's Philosophy*. New York: Peter Lang. Online at: http://ethesis.helsinki.fi/julkaisut/hum/taite/vk/heikkila/ (consulted 19.03.2011).

Kant, Immanuel. 1968. *Critique of Judgement* (tr. J.H. Bernard). New York and London: Hafner Publishing Co.

Nancy, Jean-Luc. 2003. *A Finite Thinking*. Stanford California: Stanford University Press.

—1993. *The Birth to Presence* (tr. Brian Holmes). Stanford: Stanford University Press.

Squire, Michael. 2009. *Image and Text in Graeco-Roman Antiquity*. Cambridge: Cambridge University Press.

227

Weblinks

http://ethesis.helsinki.fi/julkaisut/hum/taite/vk/heikkila/ (consulted 19.03.2011).

BETWEEN A ROCK AND A HARD PLACE
Michael Schwab[1]

1) A future history
In May 2016, after a 27-hour marathon meeting, a joint declaration of the
G15 heads of state was published, in which a 'Commission Regarding the
Credibility of Artistic Research' was announced. Section 5 of the declaration
reads as follows:

> After more than 25 years of subsidies and sponsorship of artistic research with little
> or no benefit to our cultures and societies, we, the signatories, install the *Commission*
> *regarding the Credibility of Artistic Research* in order finally to determine whether
> Artistic Research is: (1) possible and, if this is the case, (2) what kinds of results are
> to be expected from any investment in that sector.

The commission took up its work in early 2017 and consisted of a cross-section
of experts from different nationalities and cultural backgrounds, as well as
from different artistic disciplines and the sciences. It was, as one commentator
said, 'an ambitious enterprise that truly wished to get to the bottom of the
phenomenon', while another complained that the work of the commission
was a 'total mystery to the general public, who could not see any benefit in
throwing good money after bad'.

Although the commission's final report was expected in 2020, it was
eventually published, four years late, in 2024. It was clear that the delay meant
negotiations had gone badly, but no-one was prepared for what has since been
called a 'bombshell'. Paragraph 1 of the report states:

> Artistic research has no essence, identity or purpose. It is a completely artificial
> construct that has its roots in a number of minor institutional reconfigurations that
> took place around the turn of the century in combination with a market-driven
> desire to further capitalise on art. The work that has been carried out since does
> not fit purposefully into any register that our knowledge-driven societies offer, and
> when evidence of artistic research within knowledge economies could be found,
> this consisted of by-products, residues, deformations and appropriations; in short,

1 Thank you to the Orpheus Research Centre in Music [ORCiM] and to the Institute Y of Bern
 University of the Arts for supporting my research on artistic experimentation.

nothing that could not have been achieved through traditional, non-artistic research. The lack of evidence holds true even for traditional art-making, where artistic processes are at play, but where no difference exists between artists doing research and artists doing art, rendering the notion of "research" in this sector useless.

Paragraph 7 of the report answers the question as to whether or not artistic research is possible:

> Concerning the possibility of artistic research, the commission came to the conclusion that with regard to history, the phenomenon of "artistic research" must be considered possible in so far as "artistic research" has been operational for more than a quarter of a century. Despite this general, historical possibility the commission found no evidence that artistic research has any epistemological significance and concluded that, in the context of our present knowledge economies, "artistic research" is, in fact, an impossibility.

In stating this, the commission accepted a certain contradiction between historical and epistemological facts and, as a consequence, commissioned a sub-report that was attached to the commission's final report as Appendix A. This document is most interesting, since it attempts to answer the commission's second leading question, namely, 'What kinds of results are to be expected from any investment in that sector?' Appendix A to the *Report Regarding the Credibility of Artistic Research* states:

> Although artistic research does not add to or enhance knowledge, it is nevertheless not without relation to it. For example, in an analysis of 1,356 interviews conducted with so-called "artistic researchers" it was found that a large majority (namely 82%) were either "aware" or "very aware" of the impossibility of "artistic research" at the same time as believing this impossibility to be the driving factor of their work.

And later:

> Despite its epistemological impossibility, "artistic research" as it is carried out today radically challenges the concept of knowledge upon which our public order is based. It attempts to create pockets in which this order is suspended, and claims that in such suspension lies not only the future of artistic research but also the future of our society. Although far from being contagious, artistic research has to be considered virulent and revolutionary.

2) Counting as

Back in the year 2011, those questions that may be asked as part of a future report have of course already been raised. What may be different in the year 2014 is a certain urgency and conclusiveness, with which on a political level such questions might require answers, while today such urgency does not exist, allowing for a multitude of possible identifications of a practice 'into', 'through' or 'for' something to count as research.

While in 1993/4 Christopher Frayling focused on the 'into', 'through' and 'for' in his seminal paper 'Research in Art and Design' (Frayling 1993), his 2006 foreword to Katy MacLeod's and Lin Holdridge's reader 'Thinking Through Art: Reflections on Art as Research' makes clear that the 'as' has recently attained more prominence (MacLeod and Holdridge 2006). In fact, in the title, as well as in their own introduction, the 'as' and the grammatical construction around it are essential. In relation to the 'as', the introduction references Stephen Melville's catalogue essay for the exhibition *As Painting: Division and Displacement* (Melville 2001), which in discussing how something can count as painting, stresses that 'counting' is a historically situated activity that always has to be done anew, while 'painting' in itself has no 'essence outside of history' (Ibid.: 1). Thus, the identity of painting is achieved every time something counts as painting. Crucially, every modernist painting 'counts', since the painting in counting as painting constructs and re-constructs both the concept of 'painting' and itself as painting. Melville describes the painting's own counting itself as painting as an instance when 'matter thinks' and 'substance refigures itself as relation' (Ibid.: 8), which is both a relation of something to itself and to the world as the world in which this something counts, i.e. matters.

The idea that a painting can think is perhaps not unrelated to Jacques Rancière's notion of the 'pensive image', which he defines using the same grammatical construction of the 'as'. Here, a painting counts as art only if a thought can be provided in which the painting is at the same time subject and object of the thought. In what he calls the 'aesthetic regime of the art' a 'relation without mediation [is created] between the calculus of the work and the pure sensible affect' (Rancière 2009a: 7). Unlike Melville, who does not talk about the historical beginning of painting, for Rancière it is important that art has a beginning, because the intellectual conditions under which what before had counted as painting had to have changed for the same thing to be counted as art now. Before this point, what we today refer to as 'art' strictly speaking did not exist. '"Aesthetics"', says Rancière, 'is not the name of a discipline. It is the name of a specific regime for the identification of art' (Ibid.: 8).

Today, when something artistic proposes to be counted as research, it seems to be the case that a similar process of identification is in place that

may gain historic relevance if it is able to establish its own regime. A 'regime' is not a system within which something can be identified as research following an established external logic; a 'regime' is co-original with something insofar as it establishes that something only as that which it is through that which it is. In other words, the 'regime' is the set, ground or origin that the something provides for it to have a world. Naturally, this is not too far from Heidegger's attempt to relate a work to a world (cf. Heidegger 1978: 169) except that in Rancière's writings 'art' is approached in reference to Michel Foucault in archaeological (cf. Rancière and Hallward 2003: 209) and not ontological terms. This shift is important in the present context, because it signals the fact that 'artistic research' can appear *ex nihilo* without having existed before, whilst once it has appeared it expands its world not only over the future but also over the past.

Furthermore, if artistic activity counts as research, a fissure is indicated within the aesthetic regime of art through a questioning of 'art' as the end of such activity. That is, the future of artistic practice is no longer pre-determined through 'art', but open to the possibility of existing not as art but as research. This implies that aesthetics as the discourse that keeps art in place is not only necessarily and internally contradictory, as Rancière argues, but that it is also fundamentally finished once making art is not the only goal for an artist.

3) Artistic practice as research

In 2007, the Estonian artist Marko Mäetamm visited the Fine Art Research Group at the Royal College of Art in London and contributed a work to the group's exhibition *Productive Matter: Materialising Research*, held at Café Gallery Projects in London. The work he showed was a 15-minute, looped, text-based video that he had shown many times before. Called *No Title*, it tells the fictional story of how he had his family killed. However, on this occasion it was not the work's subject matter that caused dismay. For this particular exhibition, he chose to complement the video with a single A4 sheet of paper, which he hung next to the screen. Here, he described some of the questions that had triggered the work.

The criticism he faced was founded on the perception that the text weakened the artwork by taking away from the illusive space that was created by the narrative on the screen. In response, he agreed with this view, but said that it had been deliberate. The video without text 'worked' in the context of an ordinary exhibition, but for this particular show, announced as a 'research exhibition', he wanted to upset the work's economy. The refusal to integrate video and text into a coherent work would serve to open up a discursive space within which research could take place.

A number of voices in the audience remained unconvinced, and Mäetamm went up to the work and took down the sheet of paper, saying that without the text, the work would be a very different piece. This proved an extraordinary gesture. His removal of the text produced a shock, since without the text something of the work had gone. In creating this shock, Mäetamm made the point that, even if contested, once a work is identified as research, it cannot be returned to art if that return undoes the opening that was provided by the identification of the work as research. Shifting the identification of the work as research back to its identification as art results in a sense, not of artistic achievement, but of intellectual loss. The form that the identification of something as research requires may need to be more appropriate, but the identification of something as art is no answer to the problem of artistic research.

Incidentally, Mäetamm's presentation followed the officially accepted form in which research is to appear. In the UK, for a practice to be seen as research, the Arts and Humanities Research Council (AHRC), for example, 'expect[s] [...] this practice to be accompanied by some form of documentation of the research process, as well as some form of textual analysis or explanation to support its position and as a record of [one's] critical reflection' (AHRC 2011: 59), which is exactly what Mäetamm did.

The AHRC's 'expectation' and regulation has been criticised for the opposition it creates between so-called 'theory' and 'practice', but it should be stressed that in the challenge of practice through writing also lies a chance to question the authority of art. Here, one can not only say that art is not self-sufficient (i.e. autonomous) since it requires writing to count as research, but even question whether or not art is still the primary discourse. Although writing is there only to 'accompany', 'explain' and 'support', it is essential to research, while 'art' is there only to qualify this research as artistic.

Such reasoning appears to support the AHRC, if one assumes that it is clear what 'writing' actually means in this context. If writing only 'accompanies', 'explains' and 'supports', it stands apart from practice and is looked at as 'theory'. If writing were to engage, question or transform art, it would offer a different practice, or perhaps more precisely, a differential practice, in which artistic practice can find itself. Writing would have to matter, which it could only do if it were affected by art. Rather than applying writing to art, writing would have to be developed from a practice and installed in this practice as delay, suspension or critique of an art that increasingly appears as power structure and institution.

4) Artists' artists

Defining artistic research in conflict with art might not be as critical as it appears, since similar moves have been employed during much of the history

of modern art. Such challenges have successively helped to redefine art without fundamentally breaking with its operations. Moreover, a critical questioning of art has become part of any serious artistic endeavour, a fact that has been much debated in relation to the so-called 'neo-avantgarde' (cf. Bürger 1984; Buchloh 2000). To illustrate the importance of distancing procedures, Isabelle Graw includes in her book *High Price* (2009) the example of Gustave Courbet, who painted *The Meeting, or, Bonjour Monsieur Courbet* in 1854. Graw analyses this self-portrait of sorts in relation to the positioning gestures that it entails. Courbet, on the right, meets his patron, Alfred Bruyas, who is accompanied by his servant. Courbet takes up more space in the painting and appears, with his head tilted backwards, to be critically interrogating Bruyas. Bruyas, for his part, seems much more fragile, if not weak, and his greeting gesture looks unenthusiastic, in particular when compared to his servant's, who seems to understand and accept Courbet's dominant position. The representation of Courbet carrying his own tools on his back, showing him as independent, also underlines this, while Bruyas requires somebody else, his servant, to carry his coat.

Courbet, in this painting, puts into relationship two aspects of art. On the one hand, we have a definition of art through its market value for which Bruyas stands, while on the other, we have an independent art that commands respect. According to Graw, the meeting that unfolds on this canvas is a meeting between market and symbolic value, price and pricelessness (Graw 2009: 10). In her analysis, it is not, however, that pricelessness simply 'wins', but rather that the setting up of art as priceless is necessary for the high price demanded by art as exemplified by Courbet, who, was very occupied by the market value of his work. For Graw, such complex interrelation of market and symbolic value forms the basis for a definition of art that can neither be reduced to its market value nor to its symbolic value, despite the various players' different assertions. Rather, only by re-staging the difference between market and symbolic value can the value of art be created.

Art's symbolic value cannot just be assumed, but needs to be grounded. It is difficult to assess what Graw means precisely by 'epistemological gain' (Ibid.) as a basis for art's symbolic value, but it is clear that the gain she sees is first of all in the register of knowledge and not experience. To be sure, she does not use the term 'research' in this context, perhaps to keep her argument more general and focused on the question of art. At the same time, a link between knowledge and value is made on the basis of which I propose to look again at the relationship of art and artistic research. For if artistic research delivers symbolic value to art, claiming an aspiration towards this symbolic value does not make any difference to what we have come to know as art. If artistic research is part of art-making, both in the studio and in the marketplace, it cannot offer a critical distance from

which to question art. Rather, all artistic questions will, as Graw demonstrates, feed into the market, which is the reason why it is so difficult to assess at what point critical practice might turn into critique. On the artistic side, there is the suggestion in Graw's book that the figure of the 'artists' artist' (Ibid.: 81ff.) offers a way out of the problem: the artists' artist is too epistemologically demanding on the market, which fails to capitalize (often during the lifetime of the artist) on the symbolic value that is produced while he or she delivers epistemological gain to his or her peers, who appear to be the only ones able to perceive such value in advance of the market[2]. This is possible, because professional as they are, these peers know what to subtract from the work, i.e. the capitalised symbolic value, before engaging in an assessment of the symbolic remainder. The ability to operate on two symbolic levels and to maintain an inner distance rather than conflating both into a single practice seems to be the particular ability of such artists.

It is clear that we cannot simply claim that 'artists with PhDs', to use James Elkins' term (Elkins 2009), are 'artists' artists', since, although peer-groups may overlap, the status of an 'artists' artist' cannot be awarded by an academy. At the same time, if we think about a (better) future for artistic research, the image of the artists' artist may be useful, since it expresses both a limit and a quality to be sought. We have to imagine such practice at the border of art as just about appearing as art to some while for others it is either invisible or not art. Furthermore, if we do not look from the outset at such practice as art, we might also say that the practice may appear, for instance, as philosophy or as design, depending on which angle one is approaching from, and which destination one is inscribing. Placing research at the border of art means that art may be suspended as the natural site for artistic research. Describing such practice as art *avant la lettre* has the effect of closing the opening up of practice that may have been achieved and demonstrating that the peer who uttered such a description has missed the point. It is better to say that we necessarily cannot (yet) know what it is in the artists' artist's practice that can be credited with epistemological relevance, not even its status as art.

This ambiguity also affects the very notion of the 'artists' artist', which, according to a survey of a handful of artists carried out by *Texte zur Kunst*, reveals a strange set of operations that are employed. Cosima von Bonin speaks

235

2 It goes without saying that the construction of such delay may also be part of a marketing strategy as Ilya Kabakov points out when he reduces the 'epistemological gain' to this arguably cynical question: 'Where can one find absolutely non-commercial art, which could be sold for a lot of money in the future?' (Kabakov 1995: 253) In relation to research, the question is not how expensive such art may become, but rather what it delivers in the meantime.

of the 'consuming' of an artist when their status as 'artists' artist' is proposed; Tobias Rehberger struggles with the fact that such a classification would make the artist 'pitiable'; Lawrence Weiner suggests that 'perhaps artists are all artists' artists'; while Marc Camille Chaimowicz needs to keep his artists' artist a secret, since 'this person ... stand[s] outside of practice and thus wishes to remain anonymous' (Texte zur Kunst 2008: 130ff., trans.).

5) Proto

Leaving my own status aside (which I am, of course, inventing by writing these lines), the description of a practice at the border of art reflects a problem that is part of my artistic research, namely the question of how to show what I make, or rather, into what form I want to make what I make. My recent contribution to *Wissen im Selbstversuch/Knowledge in Self-Experimentation*, an interdisciplinary research project at the Bern University of the Arts (CH), can illustrate this problem. The research utilises a series of EEG measurements that were transformed, using triangulation algorithms developed in previous work, into three-dimensional computer drawings as the blueprint for a set of resin models. Strictly speaking, one could argue that each of these drawings represents my brain activity when exposed to particular stimuli—in this case, an image from the history of art. But there is no real way by which source image and drawing can be compared. Although we can imagine that a drawing represents a particular state of brain activity, this is more wishful thinking than scientific reality, given the artistic, selective process by which the source data was reduced and transformed and the lack of scientific analysis to support any representational claim. That a scientific analysis has not been carried out to date does not mean, however, that research such as mine might not have scientific implications, in particular since it is conceptual in nature. We may thus perhaps speak of a form of proto-science, which I plan to test in future collaborations with scientists.[3]

236

--

3 Such potential to add to science may have been the reason for investments into science/art
 collaborations, such as the Wellcome Trust's *Sciart* programme, which ran from 1996 to 2006.
 Without wanting to judge any contribution to such programmes, it should be pointed out that
 as long as both disciplines remain intact within such constructions, it is highly questionable
 what the 'epistemological gain' can be. Since the artist or scientist is chosen to fulfil the role *as*
 artist or scientist, such interdisciplinary projects may be limited from the outset and discourage
 rather than encourage the shared inhabitation of a border region *before* the respective roles
 have been distributed. All players need to understand that any shortcut that instrumentalises
 artistic research through lazy border definitions on both the side of art and of science will not
 ask epistemologically relevant questions, but will instead repeat and represent what is already
 known. For the Wellcome Trust's report see Glinkowski and Bamford (2009).

Equally, the artistic aspect that is part of both conceptual drawing and material making does not sufficiently determine how such models might be looked at as art. How will they be placed, hung or suspended? On their own or next to each other? How much of the making process will have to be accessible for an audience to understand the work? Unanswered questions like these indicate that the research lacks claim to a final form in art, making it not only proto-science but also proto-art and, again, something to be further developed. Nigel Rolfe once described a practice such as mine as producing results and not conclusions, implying that the drawing of conclusions was one of the skills required for art-making.

At this point, the distinction between art-making and artistic research matters. If an artistic practice is solely oriented towards art-making, anything that is not art will be seen as inadequate. The discipline of art will, as we know from art education, discipline the making process, so that the practitioner is sure to turn out art at the end. The anticipation of a future art-to-come is, paradoxically, a sign for the contemporaneity of a practice: contemporary art has its designation not in the current historical time but in the future, which is, moreover, the vantage point from which art's community as projected totality of art is constructed. For Peter Osborne it has not only a fictional but also a political and economic character (Osborne 2010). While Rancière might agree with Osborne in regard to the contradictory operations in art, their respective treatment of 'community' differs significantly. For Osborne, there is no community of practice outside its fictional projection, while for Rancière community arises when a relationship to knowledge is entered into, where 'ignorance is not a lesser form of knowledge, but the opposite of knowledge; [where] knowledge is not a collection of fragments of knowledge, but a position' (Rancière 2009b: 9). At the same time, along the lines that Osborne describes, art as identified through the aesthetic regime not only emerges from practice but is also a repetition of itself as knowledge and thus an institution. Being part of contemporary art is for the few in the know, while Rancière fails to offer a register for those who do not know, or rather, whose knowledge might undercut precisely the definition of knowledge that he criticises. As such, what the aesthetic regime identifies (art) is precisely the obstacle for an advanced knowledge within the aesthetic through which a community of practice (life) could be found. This in turn would require a notion of practice, to which Rancière refers but does not call 'research' and which he short-changes as long as art as the sole goal for practice in the aesthetic regime remains in place. Although being 'like' (Ibid.: 23) researchers, for Rancière artists are not researchers; that is, they are excluded from the community of practice that forms and develops knowledge.

Tobias Stimmer. Der große Schießstand bei Straßburg. 1576

Paul Cézanne. Nature morte au panier. 1888-90

Artistic research, as I try to illustrate with my models, brings research into practice and suspends not only the potential destination registers of art or science, but also those of architecture or visual thinking, i.e. philosophy, into which the models might equally be developed. Due to our ignorance of potential future formal determinations, the meaning of these models is left unclear, despite their appearance as intelligible. Only because a future form (or future forms) can be imagined, triggered by what is at hand, can a lack of meaning promise knowledge. In other words, I propose to define artistic research as an activity that produces intelligible material whose initial lack of explanation within given contexts (such as 'art', 'science' etc.) is transformed through linkage procedures into identities that count as knowledge. This requires deconstructive operations that open up space for moments of potential knowledge, as well as constructive operations that reconstruct knowledge around what has been made, giving it identity and meaning.

6) Boundary work

Henk Bordorff's notion of 'boundary work'[4] perhaps describes what I have in mind. Boundary work is much less an object than work carried out along the boundaries of disciplines and academia in general, remaining underdetermined by these contexts, or rather, different depending on the context through which the work is approached. Furthermore, Borgdorff links the 'boundary work' to Hans-Jörg Rheinberger's notion of the 'epistemic thing' that is produced through an experimental system. Experimental systems are precisely calibrated apparatuses for the production of knowledge. Crucially, an experimental system 'plays out its own intrinsic capacities' the more the experimenter 'learns to handle his or her experimental system' (Rheinberger 1997: 24) until it is able to surprise the experimenter with characteristics not anticipated by the system's creator (cf. Ibid.: 67). Importantly, for Rheinberger, despite being 'matter of fact' (cf. Shapin 1984: 482ff.; Shapin and Schaffer 1992: 22ff.), an epistemic thing is essentially vague. 'This vagueness is inevitable because, paradoxically, epistemic things embody what one does not yet know' (Rheinberger 1997: 28). Being conceptually underdetermined represents a strength rather than a weakness, because epistemic things create questions and a future of possible knowledge. The practice of experimentation thus also repositions theory: theory is to emerge from experimentation, which it cannot determine. Rheinberger calls the mode by which theory

4 See my interview with Henk Borgdorff in this book, pp. 117-123.

emerges 'thinking' (Ibid.: 31). The experimental space is a space that cannot be reduced to theory.

The moment epistemic things have become conceptually stable they move into the technological fabric of the experimental system—they become technical objects. As this happens, epistemic things do not change materially but functionally, which indicates that within an experimental system functionality is unevenly distributed. If an experimental system becomes too fixed, it stops being 'a machine for the creation of future' (Rheinberger quoting François Jacob in: Ibid.: 28). Applying this understanding to art, I propose that technologies are, in fact, artistic forms that have become identified (and, thus, have a history)[5] and not pieces of engineering that have leaked into art.

Experimental systems have the particular ability to create matters of fact, which we paradoxically believe to have been there all along. What is produced appears as discovery. In other words, it appears as if my knowledge of the world is a reflection of the world as it is and not an elaborate (co)production. This does not mean, however, that all knowledge is made up (and thus culturally determined); it only means that epistemic things lacking identity are strange natural/cultural hybrids, which once they 'decay' into knowledge (i.e. something identifiable) will be associated with either nature or culture. As a consequence, if we attend to the practice of experimentation we lose our bearings, but discover active, non-identified agents that nevertheless have a character (i.e. necessity).

The link between artistic research, proto-science/art/architecture/ philosophy etc., boundary work and epistemic things requires further investigation in order to be consolidated, and thus remains, for the time being, a speculation. If the link is convincing, however, a relationship between practice and knowledge can be established outside human agency, as is often claimed in relation to 'tacit knowledge'. Moreover, to evaluate this knowledge in relationship to practice it is not beneficial to look at it as already identified through a discipline (such as art or science) but rather to suspend such identification for the benefit of future knowledge.

From what I have said so far stems some form of structural similarity between artistic and scientific research—from practice and experiment to stable

241

--

5 Rheinberger's model for the creation of a form follows Georg Kubler's book *The Shape of Time.* (1962) 'Not that Kubler believes that the differences between scientific objects and objects of art can be "reduced", especially not when they take the form of these disciplines' respective products; but he does think them quite comparable with respect to the processual nature of their generation' (Rheinberger 2009: 110).

forms contextualised in art or science respectively. It is research's relation-
ship to stable contexts that seems to enable but also foreclose research—think
about how much research funding is dependant on disciplines and 'research
questions' anchored within them while enabling research. Outside of such
limited expectations, we would have to find a register for knowledge-bearing
creations that we cannot (yet) explain. This highlights a problem I have with
the registers of knowledge within which we have to operate: the definition
of knowledge is so limited and limiting that much research is required to
lose its artistic (i.e. creative) character in servitude to an idea of knowledge
on loan from a history in which what is produced is increasingly detached
from reason. Conversely, it is not sufficient to place artistic research simply
against art, but to use the space of research to challenge the very constitution
of knowledge. If the project of artistic research is ever to be relevant, it will
not only have added to art or 'knowledge and understanding', but will also
have transformed how we know what we know.[6]

7) Knowledge

If artistic research is primarily transforming knowledge and not art, it could
be seen as a form of philosophy, which may confirm a certain philosophical
tendency within art in Modernity. At the same time, however, artistic research
approaches knowledge through artistic practice, a register that is not at all
central to traditional philosophy.

Ever since Plato's treatment of art in his *Republic* (cf. Plato 2003: 608a),
being rejected from the field of knowledge is art's historic reality, which is
echoed in the distinction between 'theory' and 'practice', in which 'truth'
is associated with theory. When the AHRC defines research through the
supplemental relationship between theory and practice, it admits that
practice cannot easily be integrated into the traditional forms of knowledge
development.

If, however, the supplemental relationship within knowledge is admit-
ted and posed as a question of methodology to the artistic researcher, i.e. if
supplementation becomes part of artistic practice, an opening is created for
the possibility of an artistic understanding of knowledge. Although ultimately
'discourse' has to be entered into, making (1) the supplementation of practice

--

6 Karin Knorr Cetina (1999: 1) uses exactly the same formulation when she describes 'epistemic
 cultures'. However, it may be that 'artistic research' is not just another addition to the multiplic-
 ity of existing knowledge cultures; rather, 'artistic research' may require a shift in what is
 considered 'knowledge'.

by theory explicit through deconstructive means and (2) appropriating sup-
plementation in and as practice, pushes forward artistic forms of knowledge.
At the same time, since supplementation is still exercised, the way in which an
artistic research practice supports itself is equally open, allowing for practice-
cum-thinking to penetrate discursive forms in a variety of ways.

As a consequence, in artistic research, as much as in post-deconstructive
philosophy, a way of thinking—that is, a practice—must be attempted that
complements the deconstructive method.[7] In his book *The Honor of Thinking*,
Rodolphe Gasché calls thinking 'the highest form of doing' (Gasché 2007: 9)
that 'derives from conflicting demands of reason'. Crucially, he roots the
practice of such thinking in 'the unconditional and the incalculable, a region
absolutely distinct from a calculating rationality' (Ibid.: 4). The practice of
such thinking emerges from deconstruction, although being practice it
remains what it always has been—a practice of knowledge that produces its
own theoretical limitation—that is, identity.

This not only indicates the limits of science, but also those of philosophy.
Despite recent 'iconic turns' within and outside of philosophy, philosophy is
fundamentally out of its depth when it applies itself to art, and when it does, it
is most of the time complicit with the perpetuation of a discourse about art to
which it delivers ever new terms while never changing the parameters within
which these operate.

Different from any other forms of thinking, artistic research, due to its
relationship to art, is challenged to radically include, that is, think knowledge[8]
through the most nonsensical position brought into existence by art. It is not
research that leads and art that follows, as modernist ideology might have it;
if anything, it is the opposite. The qualifier 'artistic' does not so much stress
a method that makes artistic research different from scientific research, but
a commitment, on loan from art, to build knowledge on what the sciences
and philosophy have intentionally or necessarily excluded and which might
with Friedrich Nietzsche be called 'the end of the longest error' (Nietzsche
1977: 41). After all, it is in the name of art that a radical difference has been

243

7 In Schwab (2008: 217) I discuss a remark by Winfried Menninghaus, who claims that a postmodern
 focus on difference and deconstruction has obscured the equally important question of identity
 that early German Romanticism also addresses.
8 Simon Sheikh proposes a similar distinction between 'truth' and 'knowledge' in order to stipulate
 that '[w]e have to move beyond knowledge production into what we can term *spaces for thinking*'
 (Sheikh 2009). I, on the other hand, propose the transformation of knowledge production into
 a space for thinking.

sketched, which needs to be outside of the register of either knowledge or research. Thus, research that follows art requires art to push the boundaries so that it can transform knowledge in art's wake.

8) Suspense

Artistic research's seeming lack of definition continues to provoke speculation in regard to what it may be. More recently, and perhaps due to the developing international discourse, where national funding regulations matter less than the common ground to be established, the mode in which these speculations are presented has shifted slightly. A previous struggle for validity in the context of the wider landscape of academic research, in particular when compared with a real or imagined 'hard' science, appears to have relaxed, while a pragmatic and proactive reaching-out to other disciplines and to the 'art world' at large seems to have developed. This shift can possibly be illustrated by looking at the name that is given to the enterprise in which we are engaged: notions such as 'practice-based', 'practice-led' or 'studio-based' research are now of less importance, while the term 'artistic research' has gained currency. 'Artistic research' is transdisciplinary and not disciplinary in nature, where 'artistic' refers to a particular way of doing and thinking that is not exclusive to 'the arts' and includes not only other artistic fields such as music or design but any research where artistic considerations matter, even if such research has nothing to do with 'art' whatsoever. Such a move toward transdisciplinarity may indicate that the debate has made a virtue of necessity by claiming that the failure to deliver a definition still amounts to a definition of sorts. It also connects the project of artistic research to that of modernism, which similarly swings around an empty core, while, however, stopping short from sharing its productive assumptions.

Artistic research, just like an epistemic thing, has no identity, and worse, no possible identity, since a lack of identity in knowledge is what it requires if it wishes to express what happens at the heart of practice as it becomes knowledge. Suspense is the sentiment associated with the not-knowing and the quest is to remain in suspense beyond a desired reconciliation, which threatens to undo the exciting opening that is created when both art and knowledge are suspended.

The suspension of art and knowledge cannot be afforded by an identification of artistic research against which such suspension can take place, which would only replace a player and not the conditions of knowledge development; rather, it is not only the not-knowing that matters, but also the complete opening up to life of how not-to-know. As much as we seek to understand better what artistic research might be, it can only be in a register

of knowledge that is proposed by artistic research, through which we might come to know what it may be. The political struggle that we witness as artistic research is embraced by the academy is in relation to the academy's politics of knowledge. If artistic research, as it is invented, will be predetermined by sets of bureaucratic standards, it might come to exist, but it will exist as nothing and be an artistic failure that the academy will cease to support; if, on the other hand, the project that is artistic research is given space to project its own register of knowledge, the academy will be challenged to defend the knowledge that it delivers against the technocracy associated with 'knowledge societies'. Failing to take up this challenge, academies may be tempted to focus on their core business, art, potentially even celebrating its marginal status in the late-romantic tradition, which has rendered art defenceless against its capitalisation.

That artistic research's identity cannot be confirmed does not mean that nothing can be found. What will emerge from the effort invested in artistic research is the notion that from a place between things a type of knowledge may reveal itself in which the between ceases to be secondary and where the failure to constitute a stable identity actually becomes an achievement. How these worlds-in-suspense will become known to a community interested in listening is so radically different from today's positivistic approaches to research that no bridge can currently be built between them.

--

References

AHRC. 2011. 'Research Funding Guide'. Online at: http://www.ahrc.ac.uk/fundingopportunities/ documents/research%20funding%20guide.pdf (consulted 08.08.2011).

Buchloh, Benjamin H. D. 2000. *Neo-Avantgarde and Culture Industry: Essays on European and American Art from 1955 to 1975.* Cambridge, MA and London: MIT Press.

Bürger, Peter. 1984. *Theory of the Avant-Garde* (tr. M. Shaw). Minneapolis and London: University of Minnesota Press.

Elkins, James (ed.). 2009. *Artists with PhDs: On the New Doctoral Degree in Studio Art.* Washington: New Academia Publishing, LLC.

Frayling, Christopher. 1993. *Research in Art and Design.* London: Royal College of Art.

Gasché, Rodolphe. 2007. *The Honor of Thinking.* Stanford: Stanford University Press.

Glinkowski, Paul and Anne Bamford. 2009. 'Insight and Exchange: An evaluation of the Wellcome Trust's Sciart programme'. London: WellcomeTrust. Online at: http://www.wellcome.ac.uk/ sciartevaluation (consulted 08.08.2011).

Graw, Isabelle. 2009. *High Price: Art Between the Market and Celebrity Culture.* Berlin: Sternberg.

— (ed.). 2008. 'Umfrage: Der Zeit ihre Künstler' in *Texte zur Kunst* 71: 130-136.

Heidegger, Martin. 1978. 'The origin of the work of art' in id. *Basic Writings from "Being and Time" (1927) to "The Task of Thinking" (1964).* London: Routledge & Kegan Paul PLC.

Kabakov, Ilya, 1995. *On the "Total" Installation*, Ostfildern: Cantz.

Knorr-Cetina, Karin. 1999. *Epistemic Cultures: How the Sciences Make Knowledge.* Cambridge, MA and London: Harvard University Press.

Kubler, George. 1962. *The Shape of Time: Remarks on the History of Things.* New Haven: Yale University Press.

MacLeod, Katy and Lin Holdridge (eds). 2006. *Thinking Through Art: Reflections on Art as Research.* London and New York: Routledge.

Melville, Stephen. 2001. 'Counting / As / Painting' in *As Painting: Division and Displacement* (Catalogue of the correspondent exhibition. WexnerCenter for the Arts). Columbus: Wexner Center for the Arts, MIT Press: 1-26.

Nietzsche, Friedrich Wilhelm. 1977. *Twilight of the Idols* (tr. R. J. Hollingdale). Harmondsworth, Middlesex: Penguin.

Osborne, John. 2010. 'The Fiction of the Contemporary: Speculative Collectivity and the Global Transnational'. Online at: http://vimeo.com/9087032 (consulted 08.08.2011).

Plato. 2003. *The Republic* (tr. D. Lee). London: Penguin.

Rancière, Jacques. 2009a. *Aesthetics and Its Discontents* (tr. S. Corcoran). Cambridge and Malden, MA: Polity.

—2009b. *The Emancipated Spectator* (tr. G. Elliott). London and New York: Verso.

Rancière, Jacques and Peter Hallward. 2003. 'Politics and Aesthetics: An Interview' in *Angelaki* 8 (2): 191-211.

Rheinberger, Hans-Jörg. 2009. 'Wissenschaftsgeschichte mit George Kubler' in *Texte zur Kunst* 76: 46-51.

246

—1997. *Toward a History of Epistemic Things: Synthesizing Proteins in the Test Tube*. Stanford: Stanford University Press.

Schwab, Michael. 2008. 'First, the Second: Walter Benjamin's Theory of Reflection and the Question of Artistic Research' in *Journal of Visual Art Practice* 7 (3):213-223.

Shapin, Steven. 1984. 'Pump and Circumstance: Robert Boyle's Literary Technology' in *Social Study of Science* 14(4): 481-520.

Shapin, Steven and Simon Schaffer. 1992. *Leviathan and the Air-Pump: Hobbes, Boyle, and the Experimental Life*. Princeton: Princeton University Press.

Sheikh, Simon. 2009. 'Objects of Study or Commodification of Knowledge? Remarks on Artistic Research' in Art & Research: *A Journal of ideas, context and methods* 2 (2). Online at: http://www.artandresearch.org.uk/v2n2/sheikh.html (consulted 08.08.2011).

Weblinks

http://vimeo.com/9087032 (consulted 08.08.2011).

http://www.ahrc.ac.uk/fundingopportunities/documents/research%20funding%20guide.pdf (consulted 08.08.2011).

http://www.artandresearch.org.uk/v2n2/sheikh.html (consulted 08.08.2011).

http://www.wellcome.ac.uk/sciartevaluation (consulted 08.08.2011).

247

PARROT LANGUAGE
AN ORIGINAL IMPROVEMENT
Paul Carter

I am posting a little parrot improvisation on the web.[1] The invitation to contribute
to an 'intellectual birdhouse' made it seem the right thing to do. Bird songs
and calls are an important element in twenty-five years of radiophonic com-
position. A few years ago I wrote a book called *Parrot* (cf. Carter 2006, 2003).
Parrots have a particular poignancy in Australia, where indigenous languages
are under threat. They echo the voices around them, immortalise and transmit
them. They are like radios left on after midnight or tuned in-between stations.
Parrots are like the bad conscience of colonialism, and reserve the shrieks,
cries of a world that is suffering and about to be lost. Anyway, these kinds of
auditory association creep into my treatment of their callings. In these notes
I will summarise the context of the present improvisation, which is inspired
by the eccentric speculations of a self-styled Tasmanian philologist, Hermann
B. Ritz. Ritz was also involved in making the first and last recordings of the
Tasmanian language—a kind of human parrot.[2]

I)
'Contemporary trends,' Russian poet Boris Pasternak wrote in the 1920s,
'assume that art is like a fountain, when really it is like a sponge.' (Pasternak,
1985, 116) More recently this observation has been put into practice. Postmod-
ernist *bricolage* is an example. But perhaps Pasternak had something more
radical in mind. When he explained, 'They have decided that art ought to
gush, but it ought, rather, to suck up and absorb,' he could have had in mind
the new media (Pasternak 1985: 116). Radio, for example, did not simply gush
forth new information. It absorbed, amplified, and mediated the static of the
atmosphere, underwriting electronic speech with a new nonsense language
of noises. The 19th century physicist James Clark Maxwell stressed that new
technologies produced new ways of conceptualising the world. Sound record-
ing, for example, has, as it has progressively enlarged its spongelike capacity
to reproduce the auditory sphere, changed our idea of communication. Media

--

1 From 1 October 2010, to hear the work go to http://www.materialthinking.com.au and follow
 directions (consulted 31.03.2011).
2 Ritz set out his ideas in a number of locally published papers. Those relevant to *Parrot Language*
 are Ritz (1905, 1908, 1909, 1913).

theorists usually focus on the semiotic enclosure of the voice associated with recording and broadcasting, but the advent of these technologies also has drawn attention to the archaeology of sound. As we have learnt to manipulate sound, we have also been drawn to ponder its primary constituents. Although there is still an anthropomorphic tendency to think of the voice as endowed with psychological properties, technological manipulation illustrates the fact that the voice is not an index of subjectivity but a signal like any other.

In my practice, the effect of working in a sound-recording culture has been to push my interests backwards towards the beginnings of communication. The analytical power of *Pro Tools*, say, or even the older *Fairlight*—to spread out sound and allow its division into ever tinier segments—has not led to the discovery of a new grammar, analogous, say, to Roman Jakobson's isolation of 'distinctive features'. Instead, it has forced me to consider the extent to which composition may be a form of auditory world-analysis, that is, an investigation of certain Orphic components of communication. What we identify in the fractured sounds coming back through the loudspeaker is a kind of dream discourse, marked by the extreme promiscuity or suggestiveness of its signals. Stripped of definite signification, these particles of sound make sense only in relation to our listening. They parrot back to us a world of everyday sounds that are generally repressed as extraneous to the business of communication or composition. I have wondered if the experience evoked here is analogous to—perhaps identical with—the possession of absolute pitch. It is as if, in contrast with the ancient ambition to 'tune' the world, the gift of the new sonic sponges with which we compose *detune* the world. A kind of primary auditory scene is approached in which the shallow raft of signification dissolves and we are plunged back into an oceanic noise.

Does this take the poetry out of speech? Perhaps the reverse— 'Intonation: an intention which has become sound,' writes Pasternak's correspondent Marina Tsvetaeva (Ibid.: 91). Disembodied sounds, sounds without sense but enjoying a sonorous logic, are singing. They are the discourse of Orpheus. Poets like Pasternak, Tsvetaeva, and Rilke imagined Orpheus as the All-Poet: the beasts he tamed were all the noises of the jungle that made no sense. He harmonised them, musicalised them, transforming nature into the echo of some divine sonority. Perhaps, but what happens to the noises of the jungle after this? They are demonised, placed on the outside of good communication. Take the parrots for which Australia was once named: what happens to their echoic mimicry when it is transposed to a musical scale? Parrots (it is my impression) do sing, occasionally uttering subdued warbles, little afterthoughts and migrant fragments of a once-wonderful discourse. But, generally, they are more inclined to listen; and such cries, screams, and whistles

they utter—some of which captive birds copy from the radio—resemble sardonic commentaries on the routinised human speech they hear about them. In a way they recall us to the nonsense we talk; and putting its elements into a continuous stream, make a kind of sense of it.

This act of echoic recuperation raises the question of what is being recollected. In a famous Amazonian adventure, Tintin comes across macaws that speak a human dialect that has died out. They speak in the language of the dead. They are avian archaeologists of lost auditory environments. But what do they record? And what function do these fragments of ancient expression play in their own communicational economy? Although these questions apply to parrots, they also apply to human communities who come into contact with disappearing sounds and seek to preserve them and find a use for them in a new cultural context.

Our 'parrots' nowadays are sound recording technologies. These may be more reliable than birds, but they have the disadvantage of their powers of recollection not being matched by any gift for invention: the challenge of interpretation is left entirely up to the sound recordist, the ethnolinguist, the sound artist, or the composer. This enhanced-control technology, which gives us the power of preservation of the strangeness of sound, is an invitation to think ethically about the auditory archaeology we undertake. In relation to the data of the colonial archive, for example, it is important not to perpetuate the often-evident cultural death wish. This consideration is particularly relevant in Australia, a country where disappearing languages and a proliferation of parrots oddly coincide.

II)

To be aware of the nearness of beginnings is a feature of Australian life. Disappearing languages, attenuated sound environments—and their counterpart: the insurge of migrant dialects, the usurpation of architecture's echoic way-finding function by muzak's disorientation—give Australian life a collage quality, a quality of regular breakings-off, hybridisations, and renewals. And this contemporary noise may be an ancient inheritance: from the beginning, the colonisers have been clearing away other sounds. But this tendency has, as I say, always drawn in its wake a counter-curiosity about what is being silenced. In this regard, the self-styled Tasmanian ethnolinguist Hermann B. Ritz is interesting—or at least I have found him so, attempting to apply his system of phonic symbolism to the production of a parrot language. Ritz attempted to apply a gestural theory of meaning to the analysis of Indigenous Tasmanian languages. It is probably no coincidence that his speculative reconstructions coincided with the first wax cylinder recordings of Fanny

Cochrane Smith, an indigenous Tasmanian woman, 1899 and 1901; as, in fact, these were also the last recordings ever attempted of Tasmanian languages. It appears that the chief object of the recordings was to preserve a fragment of a language already assumed to be largely extinct. By recording it, they made its passing easier to justify. At the same time, through the parrot technology of the recording machine, these scientific investigators were confronted with a question: what was meaning of the sounds?

Ritz agreed with the school of thought that 'connect[ed] the original speech sounds with definite psychic states and processes' (Ritz, 1909, 45). With regard to the origins of the Tasmanian languages, he thought a further simplification was possible. 'All things', he theorised, 'were distinguished according to two ideas, namely, rest and motion. The liquid consonants expressed motion, and all the others, rest.' (Ritz, 1909, 54) The form of the languages followed logically: 'By a development of psychic activity, it came to pass that the dental sounds signified rest simply, the labials, rest attained after motion, the gutturals motion after rest, and the liquids, simple motion.' (Ritz, 1909, 54) With the aid of vowels these four classes of consonant could be combined in twelve different ways and as, according to Ritz, the vowels in Tasmanian speech 'are liable to be changed at will' and are therefore 'so unstable as to be of no importance for our demonstration,' (Ritz, 1909, 55) these twelve variations provided a grid into which every conceivable Tasmanian word could be fitted, and its essential significance deduced. The strange thing about this theory was that it could be retrofitted onto an extinct culture. (It could also be applied, of course, to the language of parrots, as it detached speech from any notion of intentionality or intonation.)

Ritz's system of reproduction rendered an original people unnecessary. His psycho-phonic theory was, in a way, applicable to any and all sounds; and his desire to establish a kind of universal phono-semantic 'algorithm' may have been stimulated by the invention of the wax-cylinder recording machine. The possibility of reproducing human sounds in this way allowed them to be played back, played over and over. This encouraged a search for essential meanings, as opposed to a focus on intonation/intention. In the hands of the new philological philosopher, language became a parrot saying back to the scientist something more than mere sound, and something less than sense. In fact, the reduction Ritz proposed implicated all sounds and not only human ones: what, indeed, was to prevent the application of his principles to all vocalic and percussive vibrations? Birds, in particular, were susceptible to this kind of interpretation. And it was this train of thought that led me to think of translating a text into parrot speech and, as an experiment, to 'translate' an early radio script (*Memory as desire*, 1986) back into a set of sounds that preserved the psychic states and

processes it communicated. As Ritz had claimed that these states and processes could be reduced to the contrasting states of 'rest of motion', it also occurred to me that a 'translation' of this kind was also a rewriting of the text as *choreography*, as a score for the physical spacing and timing of human encounter.

III)

According to Ritz,

> Of the consonants, the liquids alone are capable of continuance; they therefore fitly represent motion ... The labial consonants represent a sudden puff, a sending forth of energy, and are therefore very appropriate for expressing action and purpose ... The dental consonants, pronounced by practically shutting the teeth, indicate inclusion and exclusion, and by their sound, a sudden stop or thud ... The guttural consonants may express disgust (as in the sound of retching), or something connected with the dropping of the chin. (Ritz 1909: 53-54)

In addition 'the sounds *r* and *l* ... also denote emphasis, especially the *r*. Of course, a moving thing has more energy than a stationary one' (Ritz 1909: 54). These classes of consonants, combined in different ways, produce a grid of 'essential meanings': Liquid + labial = motion + purpose (l/m + p/b); Liquid + dental = motion + rest (l/m/n/r + t/d); Liquid + guttural - motion + rejection (l/m/n/r + g/k) ... and so on. These principles I originally applied to a section of the script of *Memory as Desire* with the idea of producing a double script, in which the English lines were echoed/translated into Ritz's lexicon of essential states and processes. But the results were disappointing. Either there was a difficulty in saying with any confidence what essential states and processes the lines conveyed, or the minimalist lexicon that Ritz proposed was simply too impoverished to be of much expressive value (at least to our ears). And sometimes, I found, the extraction of an essential meaning created a sequence of phonemes that greatly exceeded the economy of English.

For example, the phrase 'Where are my children?' uttered by one of the characters, which seems to imply an outward spreading of the arms, followed by the words, 'Fill me with your voices, my rooms are empty', with their sense of in-drawing, up-filling and resolution, produced in my parrot language of essential meanings the following:

Voice 3 *(Immediately, and repeated; imitative of mopoke's call; dusky, growing distant): KU-KU, KU-KU.*
Voice 1, 2 *(An eddy of notes, uttered as if from a dream, rising, dying away; variable lengths and pitches can be tried): KU-PA-LU-PA-LU, KU-PA-LU-PA-LU.*

Voice 3: *KU-KU, KU-KU.*
Voice 4 *(Lento, as if 3's phrase has been slowed down and moved to a lower pitch):*
KUR-KUR, KUR-KUR, UR-UR, UR-UR.

The elaborate voice directions in this extract illustrated something else: that, after all, Ritz's language of essential meanings didn't communicate essential meanings. Unless, following Tsvetaeva, one stipulates the intonation, the sounds are meaningless.

The present improvisation emerges from this dissatisfaction. What I am realising is that this first reduction—the attempt at a direct translation of certain sentences into a kind of *Ursprache* of essential states and motions—recapitulates the Structuralist fallacy of imagining that sounds themselves lack symbolic associations. This is ironic, considering that Ritz thought that sounds were essentially symbolic. But Ritz's naivete is to imagine that a direct correlation exists between certain positions—of mouth, tongue, and throat—and the choreography of social interaction. Even if this is true, fundamental sounds only emerge in social and historical contexts, where they acquire their associations echoically or mimetically. That is, from the beginning, what is essential in any sound is not simply its transposition of sound production from the mouth to the marketplace, but the conventional or contextually defined meanings that it holds. For example, it appears that in many if not all Australian Aboriginal languages the names of birds are onomatopoeic. That is, parrots, say, are named after the sounds they make. In this case, it is senseless to translate certain indigenous expressions into a language of essential meanings, as these may already be present in the original language itself.

The same applies to other languages. Ritz's theory tries to replace an onomatopoeic theory of language's origins—but the repressed desire of echoic mimicry returns. There is, as it were, a parrot within the recording machine, an ironic 'other ear' always listening in and recalling us to the origin of language, not in the remote past but in the ever-present interlocutor who defines for us our entry into the jungle of society. These are considerations that I want to explore through 'Parrot Language' and (no doubt) beyond. 'Parrot Language' is itself located within a skein of discourse that goes back-and-forth between memory-as-desire and its sources; and between those exchanges and the continuing echo of those reflections; in these, and in later variations and innovations on their theme.

References

Carter, Paul. 2006. *Parrot*. London: Reaktion Books.

—2003. 'Psittacorum Regio, Papageien des Paradieses in der mythischen Topographie Australiens' in *Lettre International* 61: 75-82.

Pasternak, Boris. 1985. *Letters, summer 1926* (eds Yev. Pasternak, Yel. Pasternak, K.M. Azadovsky, tr. M. Wettlin, W. Arndt). San Diego: Harcourt Brace Jovanovich.

Ritz, Hermann B. 1913. 'Notes on the List of Native Words of the Oyster Bay Tribe'. Presented by J.W. Beattie in *Proceedings of the Royal Historical Society of Tasmania*: 82-94.

—1909. 'The Speech of the Tasmanian Aborigines' in *Proceedings of the Royal Historical Society of Tasmania*: 45-81.

—1908. 'An Introduction to the Study of the Aboriginal Speech of Tasmania' in *Proceedings of the Royal Historical Society of Tasmania*: 73-83.

—1905. 'Evolution of Language' in *Proceedings of the Royal Historical Society of Tasmania*: lix.

Weblinks

http://www.materialthinking.com.au (consulted 31.03.2011).

255

ON THE RESEARCH PARADIGM IN
CONTEMPORARY ART DISCOURSE: A DIALOGUE
Gina Badger & Alise Upitis

The following conversation developed within the framework of *Ground Control: Artistic Practice and Transdisciplinary Research*, a class offered through the MIT Program in Art, Culture and Technology (ACT), during the spring 2010 semester. Seeking to elaborate the particular historical development of art-as-research at MIT, Professor Gediminas Urbonas and teaching assistant Gina Badger invited Alise Upitis to visit the class. Upitis's provocations provided the groundwork for the following written dialogue, initially performed for the final Ground Control event on 5 May 2010, where students publicly presented their research projects.

Gina Badger, ACT alumna, is an artist whose major interests are the time and politics of contemporary ecologies. In her writing and research projects, an overarching concern is the development of alternative infrastructures in the arts. Alise Upitis works as Public Art Curator at the MIT List Visual Arts Center. She previously served as Visiting Scholar at ACT, working as an archivist and researcher in the archive of the Center for Advanced Visual Studies.

Gina Badger: Alise, you mentioned recently that you see an important distinction between what has been termed *artistic research* and *artist's research* When we agreed to pursue this difference, I thought I wanted to avoid simply discussing the merits of one term versus the other. But it occurs to me now that we may have to debate it out after all, at least a little, because it may show that we have different conceptions of the practices that are actually associated with these terms. This may prove a fruitfully circuitous route towards our real goal, which is to clarify the stakes of what could properly be described as a paradigm in contemporary discourse: the labeling of artists' activities as a form of research.

If artistic research and a host of similar terms have indeed become shorthand for artists, curators, critics, and funders alike, we need to ask what they indicate, and what possibilities and repercussions may follow. This is a tall order, and one that certainly requires a more thorough survey than we can undertake here. Nonetheless, I wonder what you and I might be able to see, drawing on our privileged perspectives at MIT, and particularly as affiliates of the ACT programme. With this caveat in mind, can you elaborate on the distinction, as you see it?

Alise Upitis: According to the Anglo-American authority of the Oxford English Dictionary, the primary meanings of *artistic* in use today are: 'of, relating to, befitting, or characteristic of an artist,' 'having personal qualities regarded as typical of an artist,' or 'displaying the characteristics of art.' These meanings—again, as recorded by the OED—first stabilised etymologically in the middle of the 18th century. This is also the period of which Ann Bermingham writes in an article that first made me aware of some of the historically problematic aspects of this term (Bermingham 1993). She elucidates the construction of an 'artistic female' during this era as a woman of bourgeois status whose family engaged paid tutors to instruct her in skills such as painting, drawing, and playing musical instruments. These tutors were enlisted to teach her how to faithfully reproduce the fashionable stylistic conventions of the day; establishing these conventions, however, was the province of male artists. As Bermingham writes:

> The accomplished woman was understood to be "artistic" but not an artist. She was not an artist because she was neither original nor a paid professional. Unlike the artist who was a creator and producer of culture, she was a consumer and reproducer of culture. The word "artistic" inscribes art onto the body and into the personality of the subject who makes art. "Artistic types" are works of art themselves, embodying art without necessarily mastering it. (Bermingham 1993: 7)

These accomplished bourgeois females were at the same time embodying a subjectivity that was itself art-like, through acts of artistic imitation; but also because in 18th-century Britain, visual art itself was tethered to an ideal drawn from figurative mimesis. Meanwhile, male bourgeois of the era were educated to exercise aesthetic judgment—to be connoisseurs. Bermingham considers how the aesthetic training of these men was transposed from the study of art and architecture to the study of women. Women were judged by male connoisseurs using the same criteria as those for judging objects of art, and through this transposition women were transformed from subject to object. So at least two cultural forces were supporting the treatment of artistic females as objects (or more specifically for Bermingham, as commodities on the bourgeois social market): men trained to aestheticise and women trained to act like art.

However, this particular narrative of female objectification lies within a broader historical moment in which the linkage between artist and artwork was one of direct connection between an artist's body and an artist's body of artwork. A facet of this, evidenced in the book by Giorgio Vasari *Lives of the Most Excellent Italian Painters, Sculptors, and Architects, from Cimabue to*

Our Times (1550) and the subsequent prevalence of biographies of artists, was that an artist's moral or ethical actions became conjoined to an artist's work. Given this framework, art was subsequently segregated as autonomous from life's logical or ethical concerns, an autonomy most systematically articulated by Kant in the 18ᵗʰ century. An effect was to conjoin the *role* of an artist with artist as an *identity*: Artist as creator of art is a role or function delineated by the norms of a society's institutions, whereas one's identity can broadly be said to be tied to one's self meaning.

In place of artistic research I believe in advocating for the phrase 'artist's research', because it can raise the question of agency over role or identity. An artist is an agent operating in the world and over time, one who is both constrained and enabled by networks of power. Referring to artist's research attends to the position of artist as agent in the production of her or his work through time. As an artist one must operate relative to societal norms but with the capacity to test, reconfigure, and on occasion overturn them. The unification of artist and art making, evidenced in the meanings of the term 'artistic', is particularly problematic given the current dominance, at least in the US, of one's professional role being united with one's identity. Nonetheless, it is important to note that in the Western context, at least since the Renaissance, art has been persistently limited by the figure of the artist. I believe using the term 'artist's research' acknowledges this history without saying this figure is fixed or immutable. However, imagining a culture in which art could operate in an absolutely free state and develop without passing through the constraining figure of the artist is a romantic indulgence (Foucault 1998).

GB: I had to laugh while reading Bermingham's description of the artistic female, because I couldn't help thinking that the contemporary version of this adjective is, in fact, *artsy*. Like, if your apartment is neo-bohemian chic and in your spare time you like to take pictures of decaying concrete buildings, you might describe yourself as 'artsy'. A descriptor that is both general and trivialising and which, it should go without saying, has always driven me crazy. Besides, it has very little to do with scholarly debates over art-as-research. I agree that as adjectives describing a person, 'artistic' and its contemporary companion, 'artsy', are belittling in a particularly gendered way. In fact, the reason I prefer the term 'artistic research' is that the term applies to the research itself and not the researcher. This is something I will come back to, because it requires more careful attention to the actual practices that I believe constitute artistic research.

The trouble, as I see it, with using the term 'artist's research', is twofold. First of all, I wonder how to include people engaging in artist's research,

259

if they don't identify as artists.[1] This may be a key question: does this type of research need to be done by artists? What happens if non-artists do it? I am curious about how this attempt to de-personalise the term, through a distancing from the psyche and biography of the artist, seems to end up asserting a more specific identification as an artist.

AU: Restricting my answer to the context of MIT, I would say the choice to act as an agent engaged in research is a choice made by each individual while nonetheless inseparable from disciplinary structures and concomitant economic boundaries. One who primarily functions in the role of, say, biologist—but then takes on a project to create a work of art—can perform the research of an artist *in the role of artist*, just as in her biology lab she performs the research required by her professional role as a biologist. This statement does not, however, prescribe the form or content of artistic research. It does not exclude an artist's research drawing from areas of knowledge outside or between traditional disciplinary demarcations; and I would hope that research would include the use of whatever methods and resources of expertise would be most useful in investigating a particular issue and creating a productive outcome—for the production of art, but also hopefully for production in other fields.

260

It is worth noting that thus far the question of the term *research* itself has been left aside. Consider an example from the early 1950s, when the MIT Department of Urban and Regional Planning earnestly sought to form an interdisciplinary site for addressing a host of concerns facing postwar urban areas, what advocates termed a 'centre'. The need to conduct 'basic research' in urban issues or 'problems' was reiterated in numerous documents during the attempt to establish this centre.[2] The ideal, if I may boldly summarise, was that basic research in the natural sciences required programmatic freedom as well as generous funding. This position was articulated by MIT professor and dean-turned-statesman of science Vannevar Bush in his now-canonical 1945 report to President Franklin Roosevelt, *Science: The Endless Frontier* (Bush 1945). In so far as research in the arts resists the instrumentalisation of research towards applied technology, Bush's ideal of researcher autonomy is relevant.

1 In the *Ground Control* class, for instance, we have students who are designers and educators—people who are interested in artistic methods, forms, and formats—but who aren't necessarily artists.
2 See, e.g., MIT Office of the President, Records, 1930-1959 (AC 4), Institute Archives and Special Collections, MIT Libraries, Cambridge, MA. Hereafter IASC; MIT School of Architecture and Planning, Office of the Dean, Records, 1934-1992 (AC400), IASC.

But to bring the topic to a more concrete plane, I would like to revisit a work you and I discussed earlier, by Juan Downey, *A Research on the Art World* (1970), from around the time he served an artist-fellow at the Center for Advanced Visual Studies, or CAVS.[3] This work involved Downey sending questionnaires to 700 artists, collectors, curators, and others—which began: 'I am conducting a research on the Art World covering the social, political, and economic aspects. Please help me by answering the questions below.' Downey then tabulated the answers and made a series of charts together with an installation at Howard Wise Gallery in 1970, called 'Information Center', which incorporated large-format images of the charts and the tabulated responses translated into lights that were illuminated in grid formations.

Gina, I recall that your response was rather strongly against this form of artist's research. Your response seemed very different than your reception of some materials in the CAVS archive I shared earlier during that discussion, which related to projects by CAVS artist-fellows that engaged Cold War technologies, such as Paul Earl's and Otto Piene's work using krypton argon lasers, to create holograms, or projects by Lowry Burgess that sought collaboration with NASA *(see figure 1)*.[4] Could you elaborate on your response at the time, and perhaps further thoughts you have on this work by Downey?

261

GB: This brings me to the second trouble I have with the term 'artists' research': that it seems to reduce a rich conception of process-based art practices and their ways of producing knowledge to a more simple idea of artists using models borrowed from other disciplines in order to do research, as in the Downey example. It's not that I find this work uninteresting or unimportant, but simply that it may seem a little flat in contrast to the great diversity of artistic research methods we've seen develop since the 1970s or so. What we see with Downey, really, is an artist collecting data.

Downey's project, so characteristic of the institutional practice and critique being developed in the art world at the time, does not really challenge the bounds—the discipline—of art in the way that I would like artistic research to do. In order to help me explain this, I'd like to refer to what I consider to be an extremely helpful text, Brian Holmes's *Extradisciplinary Investigations:*

..

3 Documentation relating to this project can be found in the *Juan Downey* folder, 1023/ 5B21a, Archive of the Center for Advanced Visual Studies, MIT Program in Art, Culture and Technology, Cambridge, MA (hereafter ACAVS).

4 See ACAVS folder *Laser Projector res. Project w. digital 84*, 22/ 1A5e; ACAVS folder *NASA: Space*, 787/ 3D17a; ACAVS folder *Lowry Burgess 71-89*, 987/ 5A10e.

Fig. 1) Paul Earls and Otto Piene, laser projects, 1980.
Fig. 2) CAVS, *Centerbeam*, 1977, at *documenta 6*, Kassel, Germany.

Towards a New Critique of Institutions (2006). In it, he periodises institutional critique as having three phases, the current one being characterised by (leftist) political commitments that pull its practitioners both further into the discipline of art—in order to, in part, produce a critique of it—and further out of it, into other domains related to their work. Holmes observes that

> In almost every case it is a political engagement that gives [the artists] the desire
> to pursue their exacting investigations beyond the limits of an artistic or academic
> discipline. But their analytic processes are at the same time expressive, and for them,
> every complex machine is awash in affect and subjectivity. It is when these subjective
> and analytic sides mesh closely together, in the new productive and political contexts
> of communicational labour (and not just in meta-reflections staged uniquely for the
> museum), that one can speak of a "third phase" of institutional critique—or better, of
> a "phase change". (Holmes 2006)

The projects and practices described here by Holmes are not simply institutional critique, but a form of research, one that, as he says, 'cannot be reduced to the "proof" of anything' (Holmes 2006). This is not, then, research on a statistical or scientific model. It does not necessarily follow from a precisely stated hypothesis and proper controls. In fact, I think artistic research is characterised by the flexibility of its methodology, described succinctly in Jill Magid's artist's statement: 'If my subject is made of clay, I will work in clay. If my subject is text, I may write. If my subject is too big, I will grow' (Magid 2008). Magid's approach to artmaking is an excellent example of what I mean by artistic research. The form and process of her work emerge out of an investigation into a particular subject, leading her, for example, to become an embedded artist at the Dutch Secret Service (culminating in the artwork *Authority to Remove*, 2009), or to develop a long, mediated flirtation with Liverpool's Citywatch surveillance apparatus (*Evidence Locker*, 2004). These projects develop qualitative ways of knowing that are at once particular to their own circumstances and relevant to more general political issues, from surveillance and securitisation to gender dynamics and the media's production of femininity.

 Another example could be found in the work of another MIT alumna and ACT resident research affiliate, Jae Rhim Lee. Her ongoing work, *The Infinity Burial Project* (2008-present), involves the development of an urban eco-burial system. Lee's working process is characterised by a rhetoric of design, involving collaborative work with mycologists, research into related social issues such as 'death denial', and documentary film production. The project develops a compelling critique, and its practical applicability remains ambiguous. I would argue that this practice is not only research based—i.e.,

263

it relies on research from other disciplines in order to develop—but that the working process itself becomes a vehicle for the creation of new knowledge—about death, about the ecological relationship between humans and our environment, and so on. But, unlike scientific production of knowledge, it doesn't follow a rigid methodology. The research process itself is different—you might say it's 'artistic'. This goes back to the OED's third definition of the adjective: 'displaying the characteristics of art'.

AU: The Downey work we have been discussing is indeed classifiable as first phase of institutional critique, to use Holmes's periodisation; and it is important to note that you are referencing work from the early 2000s on, while I am referencing work from the 1970s. Downey's work as a mode of research has similarities to the Hans Haacke's *MoMA Poll* from the same year (1970), installed in the 1970 *Information* exhibition at the Museum of Modern Art in New York. Haacke's work asked museum-goers to vote 'yes' or 'no' in response to the question: 'Would the fact that Governor Rockefeller has not denounced President Nixon's Indo-China policy be a reason for you not to vote for him in November?' (At the time, Nelson Rockefeller was running for re-election, and his brother David was chair of the MoMA board). (McShine 1970; Metzler 2006). *MoMA Poll* demonstrates through art how the centralisation of MoMA as an art institution is a cultural symptom of the centralisation of power, via politics and money. Haacke's work is effective because it takes place within the institution of MoMA and requires validation within the institution. I see Downey's work as operating somewhat differently than Haacke's because I see it as an attempt to investigate the process of mediation itself, locating what pre-conditioned the art world in 1970 by exploring its historical context and subtexts. In so doing it uses a critical moment of humor, an 'autocritical humor', to draw upon the words of Gayatri Chakravorty Spivak (Danius, Jonsson and Spivak 1993: 31, 44).

However, Downey's and Haacke's pieces do self-consciously explore ways to do research for art, and this self-reflection becomes content in the artwork in a way that, say, Earl's work with krypton argon lasers does not. Such works have in a sense helped circumscribe research by artists as belonging to a particular method and a specific movement or style, namely: systems-conceptual artwork concerned with the invisible network that constitutes art's ideology and context of values (Kosuth 1999).[5] However,

5 Setting to one side Haacke's position as postwar West German artist and Downey's as Chilean artist.

it is important to acknowledge the self-conscious history of artist's research, and that Haacke's and Downey's conceptual work used a particular method of research—basically, the opinion poll. They challenged the discipline of art at the time, by appropriating and subverting the process of voting in a participatory democracy, media polling practices and, by extension, the popular appropriations of the so-called 'soft' or 'social' sciences, rather than attempting a formal transformation of the so-called 'hard' sciences of physics or the like.

Alternatively, consider the artist-engineer-scientist collaboration *Centerbeam*, first exhibited at *documenta 6* in 1977, which involved around 15 CAVS artists, additional MIT students, and a dozen MIT scientists and engineers (Piene and Goldring 1980). It was a noisy 144-foot-long structure composed of steam, laser, pipes, holograms, video, poetry, a flower-shaped helium-filled inflatable, and more, operating as 'a metaphor for the community of volunteers forming daily symbioses (the relationships of a democratic society)' (Piene according to Alloway 1980: 5) *(see figure 2)*. This work was not well received by the art press at the time—unlike much of *documenta 6* it was neither photography nor video, nor was it easily classified with the more restrained conceptual sculpture contributed by Richard Serra or Haus-Rucker-Co (Cork 1978; Siegel 1977; Shapiro 1977). It was a challenge to the discipline of art, as it produced knowledge that had an uncomfortable voice, one that did not sit easily within the context of art world vogue at the time. At the same time, however, *Centerbeam* was highly uncritical of MIT's military-industrial-academic power structures.

GB: My idea of artistic research is characterised by flexible investigative methodologies, by the production of extra-logical forms of knowledge, and by traces of what Holmes calls 'the old modernist tropism whereby art designates itself first of all, drawing the attention back to its own operations of expression, representation, metaphorisation or deconstruction' (Holmes 2006). It develops a hybrid methodology that cannot be attributed to other disciplines. Saying the research *itself* is artistic insists on the fact that it takes on its own forms and methods, distinct from other types of research. It's the separate but related designation extradisciplinary that infuses artistic research with particular values, making it actively challenging to its own conditions and to those of other disciplines. This distinguishes artistic research from other forms of art practice that do not develop such a confrontational stance.

I'm invested in the 'research' part of the term 'artistic research' because it implies that artistic practice is carried out in time, in relation to history and fields of expertise; and that this process entails the production of knowledge.

3)

266

Fig. 3) Gina Badger and Alise Upitis performing for *Ground Control*, in connection with the MIT Program in Art Culture and Technology class entitled *Ground Control: Artistic Practice and Transdisciplinary Research* (5 May 2010, MIT Wiesner Building). Photograph: Haseeb Ahmed.

It should be noted that the acknowledgement of production is a crucial element of the term 'artistic research', because it designates the particular relationship of art production to capitalist production more generally.

AU: The sense of research I believe we are both trying to articulate produces knowledge through un-codified means, for which there are no handbooks on best practices and for which the form of the work is itself a fundamental question that must be addressed by the researcher. The protocols for the form of a scientific or academic historical paper, for example, are circumscribed; so they do not incur the risk—and here I will say personal risk—that art production demands.

Significantly, Gina, you also mention the research process of art makers as an action different from research in other disciplines, which so in some sense makes it autonomous. My interest in artist's research, I believe similarly, tries to exploit the indeed historically problematic autonomy that has been claimed for art. The autonomy or separation of artists from the class of knowledge producers is longstanding and itself problematic; but there is also a sense in which it provides a circuitous boon. As Spivak has said: 'If we relate to something as knowers, learned people—...the subject of the production of knowledge—it is impossible to have another relationship to learning' (Danius, Jonsson and Spivak 1993: 49). I am not asserting that artists do not produce knowledge; but because artists act outside the traditional or accepted practices of knowledge producers, perhaps most widely associated with scientific researchers, artists are in the rare position of operating outside the borders of codified or standardised modes of learning.

But a more extended discussion of art and knowledge production aside, my interest in using the term 'artist's research' is not to suggest that an artist is an isolated being who imposes her thought directly by giving form to inert matter, or that there is a determinable causal relationship between her intention and the effect of the work on spectators. An artist is a social being, and a work of art is a social object. Institutional, economic, and cultural constraints come into play in the logic of the production of a work, although the artist or the artwork cannot be entirely reduced to or explained by this context.

GB: Alright already, enough of that! Though we each seem to have a special fondness for our own terms, it doesn't seem we've convinced each other either way. Back to debate school then! All joking aside, I think the ruse of disagreement has indeed proven a good occasion to draw out this business of art practice as research. I will offer a couple of speculations in conclusion, which can be thought of as points for further investigation. First, the examples

you've drawn from your archival research, along with my more recent examples, can serve as a particular microcosm of the historical development we're interested in. It would be premature to say that since the early days of framing art practice as a form of research, we can observe a shift in how artists themselves apply this to their practices, but I am tempted to say it anyway. In the early examples we've seen, artists had a tendency to borrow and adapt research methods and knowledge from elsewhere in order to produce their projects. In the more contemporary examples, artists seem to be more self-conscious of the fact that that their knowledge-producing machines operate on terms affected by, but distinct from, those of other disciplines. In a sense, they seem more confident. This opens up the confrontational possibilities of extradisciplinary critique, an expansive critique of institutions that does not limit itself to the bounds of the art world, but takes its political convictions from elsewhere.

Second, we have agreed on some of the stakes of this paradigm, especially where the working process of artists is concerned. We agree—and indeed, this is perhaps the easiest part—that research as part of art production is a process-based affair, with uncertain and sometimes risky experimental methods. We have also discovered that we share some particular values, that we favour extradisciplinary forms of artists' research that can challenge the bounds of art as a discipline. This is interesting to me, because we both have infused the idea of art as research with particular, subversive implications. For us, it is not a neutral term. It seems to merit further investigation as to whether this bias is shared. We might ask: both today and historically, have artists who applied the research label to their work tended to have left-leaning political engagements and/or a desire to upset the *status quo* of the mainstream art market?

Finally, we have agreed that the part of our conversation we've left out for now—relating to questions of knowledge production and capitalist economies—is one that we need to address, and that this can't wait longer than the next conversation![6]

6 The next conversation appeared as Badger and Upitis (2011).

References

Alloway, Lawrence. 1980. 'Introduction' in Piene, Otto and Elizabeth Goldring (eds) *Centerbeam*. Cambridge, MA: Center for Advanced Visual Studies, Massachusetts Institute of Technology; MIT Press: 5-6.

Badger, Gina and Alise Upitis. 2011. 'Perverting the Terms, or, Knowledge Production as Extradisciplinary Critique', in Jess Wheelock (ed) N52: *On Art + Research at MIT*. Cambridge, MA: ACT, MIT: 47-60.

Bermingham, Ann. 1993. 'The Aesthetics of Ignorance: The Accomplished Woman in the Culture of Connoisseurship' in *Oxford Art Journal* 16(2): 3-20.

Bush, Vannevar. 1945. *Science: The Endless Frontier*. Online at: http://www.nsf.gov/about/history/vbush1945.htm (consulted 23.05.2011).

Cork, Richard. 1978. 'What does *Documenta* Document?' in *Studio International* 194(1): 37-47.

Danius, Sara, Stephan Jonsson and Gayatri Chakravorty Spivak. 1993. 'An Interview with Gayatri Chakravorty Spivak' in *Boundary* 20(2): 24-50.

Foucault, Michel. 1998. 'What is an Author?' in id. *Aesthetics, Method, Epistemology*. New York: New Press: 204-222.

Holmes, Brian. 2006. 'Extradisciplinary Investigations: Toward a New Critique of Institutions' in *Transversal. Multilingual Webjournal*. Online at: http://eipcp.net/transversal/0106/holmes/en (consulted 23.05.2011).

Kosuth, Joseph. 1999. '1975' in Alberro, Alexander and Blake Stimson (eds) *Conceptual Art: A Critical Anthology*. Cambridge, MA: MIT Press: 338-339.

Magid, Jill. 2008. *Artist Statements*. Online at: http://jillmagid.net (consulted 23.05.2011).

McShine, Kynaston. 1970. *Information*. New York: Museum of Modern Art.

Metzler, Eve. 2006. 'The Dream of the Information World' in *Oxford Art Journal*, 29(1): 115-135.

Piene, Otto and Elizabeth Goldring (eds). 1980. *Centerbeam*. Cambridge, MA: Center for Advanced Visual Studies, Massachusetts Institute of Technology; MIT Press.

Siegel, Jeanne. 1977. 'Notes on the state of outdoor sculpture at Documenta 6' in *Arts Magazine* 52: 130.

Shapiro, David. 1977. 'View of Kassel (Documenta 6)' in *Artforum* 16: 56-62.

Vasari, Giorgio. 1550 (2005). *Lives of the Most Excellent Italian Painters, Sculptors, and Architects, from Cimabue to Our Times*. New York: Modern Library.

Weblinks

http://eipcp.net/transversal/0106/holmes/en (consulted 23.05.2011).
http://jillmagid.net (consulted 23.05.2011).
http://www.nsf.gov/about/history/vbush1945.htm (consulted 23.05.2011)

PARADOXES EXPERIENCED BY ARTIST-THINKERS
Renée Green

The topic of 'artistic research' is one I've been engaged in thinking about in various ways over the years, although I didn't refer to it by that name. I didn't actually name it. I'd emulated modes of thinking and working that I'd observed in others I'd admired. In recent years the designation 'artistic research' has been becoming more established as a term. As with all terms, it has an etymology that includes a history of relationship between forms of its expression.

One factor in the development of this terminology is the role of higher education. The ways the term is used in different circumstances—in different universities, art schools/academies/institutes, diverse regions, countries—all affect the definition. What continues to interest me is the work of those that I associate with performing what can now be termed 'artistic research', before it was designated as such. How did they do it, and what conditions did they encounter in the moments during which they worked and lived? Those I designate as 'artist-thinkers' each have in com-mon what I describe to be 'modes of curiosity, questioning, and analysis realised through a form of creation'. A distinguishing feature in each of their productions is that even as times continue to change, it can still be compelling to revisit and reconsider what they made and thought. This desire to *re-encounter* is an aspect that distinguishes many works. Gertrude Stein thought about this phenomenon in her particular way. Even when an artist or an idea is no longer fashionable, it can be interesting; fashion doesn't determine whether one wants to return to the work. This is both surprising and mysterious. For many who go by the name of 'artist', this is a wish, even when not acknowledged: for others to want to *return* to their work. At least for different people to return to their works over time. For many, the wish that an aspect of their lives be remembered as significant continues to motivate the actions of the living. Despite the many references to immateriality and the virtual that emerge throughout the ages, complete disappearance does not seem to be a basic human wish.

Even though the direction of the present, pointing to the future, is to increase forms of specialisation via training that becomes more standardised—teaching agreed-upon vocabularies and methods of evaluation, allowing more ease in flowing from one place to another, creating unconfusing terms of exchange—I remain interested in what doesn't fit these patterns. One reason may be that I find it reassuring to know that

through history there have been creator-thinkers who were formed in ways that vary from those encouraged in the present, and that a resonance can exist for what they made and thought that still allows the possibility of imagining differently.

At this point it would be of interest to me to know more about the processes of working and the conditions of support that artist-thinkers have experienced in different circumstances. The designation 'artist-thinkers', as I'm using it, refers to those who are driven by the above-mentioned modes of 'curiosity, sustained questioning, and analysis' to realise their creations—despite, and with an awareness of, the complexity of their life conditions, no matter what the consequences. This is not either an idealistic or romantic view of the artist-thinker. Just an acknowledgement of those who are compelled to create, in ways akin to what I describe, and who've managed to transmute life's complexity into particular and compelling forms and practices under a variety of conditions.

In a conversation regarding the book *A Thousand Plateaus*, Gilles Deleuze suggests the possibility of something that is related to artistic research, yet that may also exceed the term:

> Here once more, it's to do with the way someone's own work can lead to unexpected convergences, and new implications, new directions, in other people's work. And no special status should be assigned to any particular field, whether philosophy, science, art, or literature. (Deleuze 1995: 30)

Although it would interest me greatly to elucidate the preceding comments with examples, case studies of artist-thinkers I'm curious to think with again and again—Muriel Rukeyser and Hollis Frampton, for example—such an endeavour will have to await the right conditions (time and monetary support). What most artist-thinkers face, because they are compelled to follow paths that may not intersect with directions afforded by capitalist-logic, is the effort to create the space within which to work and think, however that may manifest itself. A release from the burden of this challenge is one promise of artistic research within the university: a clear space for concentration and creation. This is a noble fantasy that propels the pursuit of further degrees and more debt. It is an understandable aspiration. A freedom carrot. Sadly, it is a rare circumstance, to which many aspire. What to do? In the following section I provide prods and possible incentives to keep the impetus for such dreams alive, in conjunction with data that reflect the conditions and potential of this particular moment.

The following text is adapted from a presentation given in Brussels at the European Artistic Research Network conference held in June 2010.[1] I offer it here as an example of continuing discussions on artistic research.

Hail the invisible college / 'reason's sense of humor'
The paradoxes of knowledge-pleasure and 'reason's sense of humor' share a sense of adventure to which I'll return. While speaking, slideshows will project images, meant to provide a counterpoint and a refrain that weaves in and out of what I'm saying.[2]

Hail the Invisible College or What Can Matter Now? was my original title. I changed it, to attempt a more upbeat approach; as the times can be depressing enough, and because I continue to be interested in what can be possible, even when it doesn't seem viable by some of the present standards.

To contextualise the tone of what follows, I wrote the preliminary abstract for this presentation while in the heat of the continual transitions and struggles that comprise the academic year, particularly in my roles as a Dean and faculty member, and also as an artist who had just opened *Endless Dreams and Time-Based Streams*, a second large survey exhibition within six months of the first one, *Ongoing Becomings*, which took place on another continent. The abstract reads:

Some reflections on the paradoxes of knowledge-pleasure vs. the spreading business of quantifiable, assessable, profit-generating education in an Anglo-American world. The ramifications and tensions that have increasingly arisen in burgeoning programs of higher education in art and culture. The international diffusion of these models and further questions regarding how to continue.

..

1 Green was a keynote speaker at *The Academy Strikes Back*, the concluding presentation of a
 two-year project aimed at the current academicisation of art education. The project took place
 within the context of the European Artistic Research Network (EARN), and was developed by Jan
 Cools and Henk Slager. The presentation took place at the Sint-Lukas Hogeschool, Brussels,
 4-5 June 2010.
2 For the duration of the talk, images were being projected: *Ongoing Becomings Process 2008-2009*,
 Ongoing Becomings, Musée cantonal des Beaux-Arts, Lausanne 2009, *Endless Dreams and Time-
 Based Streams, Yerba Buena Center for the Arts, San Francisco 2010* and *Spheres of Interest FAM
 Version*, a slide show of the publication aspect of the lecture series. After the slide shows, the
 Spheres of Interest: Experiments in Thinking and Action website was also being projected and
 scrolled through.

273

The focus of my abstract differs somewhat in nuance from the terrain it was suggested that I cover, which begins with the following:

> Subject: "The Graduate Art School in the Bologna era as a sanctuary for critical and experimental practices."

There are a few words in that suggestion that are particularly pertinent to what I will say and these are: *sanctuary, critical, and experimental.* Please keep these in mind. Before making any assertions I'd like first to describe the terrain I will explore. I'll continue to quote more of the description I received, to highlight some common interests and differences. I've italicized what I've interpreted to be keywords or phrases:

> In continental Europe there are currently a lot of concerns about the Bologna agreement which aims at *homogenising* higher ART [*capitalised*] education and *rationalising* it in accord with the Anglo-American model with several, more short degrees with clear and comparable learning outcomes. Probably *the strongest fear*, fed by the *increasing bureaucratisation* and the *result-oriented culture*, [*these would be capital-driven*] around this process is that all *individuality* and possibility for a *longer term, more processual, reflective* and *less outcome-bound model of art education will disappear through this development.*

This seems an accurate assessment.

1. Which conditions have to be fulfilled to let graduate art education [*MA/MFA*] be a possible *sanctuary* for a *critical art practice* within a more *formalistic context of the university system?*
2. *Research in art seems to be a new paradigm [in Europe].* Is it really a new paradigm? Does this also play a role in your institute? What potentialities does it have for an *autonomous and critical artistic practice?*
3. Is there a need for *practice driven theory* in graduate art education?
4. In a *post-Fordist society* the art practice is also subject to *the logic of a neo-liberal market.* Does the *academisation of higher art education* offer an *alternative path for an art practice that is critical and not necessarily product oriented?* Why?/How?

I too am curious about all of the above. I'd like to address some of the points mentioned, focus on some of the keywords italicized, and think about these in relation to conditions and materials I've investigated and encountered. I'd also like to refer to specific histories, which may lead to different questions,

274

and perhaps present other dimensions to how the concerns raised can be pondered. My frame of reference is trans-national, which leads me to attempt to understand specific histories and complex interrelationships historically, in relation to the present.

From what position do I speak? Expert? Artist? Thinker? Media avatar?

From what position do I speak? I do think the question is relevant in this present time of Web 3.0, a time of *produsers* [producer-users], rather than *prosumers* [producer-consumers]. The previous Web 2.0 mode of a decade ago was heralded by the U.S.- produced, internationally distributed media organ *Time* magazine, when in 2007 it announced that, 'The Person of the Year 2007 is YOU!' with capital letters and an exclamation mark (Grinnell 2009: 584). Declaring one's point of view seems to be all that's necessary in the present, especially online; so what distinguishes what one person says from another? Belief systems?

In any case, I speak now having been during the past five years very immersed in what is called the 'San Francisco Bay Area', in California, now ten years after the dot-com bust, yet with plenty of techno fallout and techno lust. This is a particular reference point for this area, as Apple, Google, Oracle, Facebook, and Pixar are all based in this region; and Silicon Valley is nearby. How many people here in the audience have an iPad? [No one raised their hands]. Advertisements for these, supposedly appealing to projected demographics, saturate the billboards seen from streets and highways of this locality. It is still a locality, with physical material conditions, despite a mediatisation that would imply life exists primarily via various sized screens, wherever one is.

The forms of address regarding the questions and concerns I received for this conference signal Enlightenment models of reasoned address that may be akin to parliamentary forms of address, which are at odds with a context of combined aggressive, individualistic or atomistic dispersal and driven connectivity, via advertising and 'life-style' forms—physical, and virtual or online—which I've just described.

These promotional forms surround the place I inhabit and traverse. I believe these forms also occur elsewhere, perhaps to different degrees. I suggest that understanding more about this mixture of forces—Silicon Valley, research and universities, military spending and universities, a global economic crash, many peoples' desires worldwide, capital circulation, and questions of sanctuary for critical artistic practices, for example—be conceived together, as acknowledging these paradoxical intersections is relevant to our discussion.

Fig. 1) Endless Dreams and Time-Based Streams. Animation Activation Space.
 New Humans performance, 2010.
Fig. 2) Endless Dreams and Time-Based Streams. Reading Performance Workshop.
 Rehearsal with Greg Tate, 2010.

We might also think together about these three things: the notion of the expert, the notion of the artist, and the notion of Conceptual art—as I think each relates in some way to what we're discussing, in terms of imagining something called 'artistic research', another designation to be returned to.

What the bologna process is purported to bring, and questions to consider based on other models

'The academy strikes back', like *The Empire Strikes Back*—is a provocative title: what are the stakes and the positionings, who is striking what? Perhaps we could consider the following question as a provocative and possibly enabling refrain or mantra:

> Given our complex situations and conditions *what* is generative for thinking, creation, and action in the present?

If the academy represents institutionalised knowledge and its formations, while artists have historically fought against academisation, what is different in the present scenario that we are attempting to articulate and analyse? What are the roles being enacted, and where is power and knowledge being assigned? What conditions have changed?

The questions posed for this conference are compelling ones that I will address in my circuitous narrative—as I point to some paradoxes, provocations, and further questions that I hope will generate thought and discussion. Am I an expert? What might I be an expert of? What can expertise now signify? What does it allow and entail? How is it determined? How does it matter? How does it matter in relationship to art? To research? To research in relation to art? In what kind of relation?

The question of expertise is a crucial question for the themes of 'striking back', the institutionalisation of knowledge, and how this practice is currently deployed and particularly in relation to what we call art. This will also require some examination and definition, especially as art, despite forms of interdisciplinarity, is peripherally positioned in relation to other disciplinary areas in research universities; in these, science is the guiding form for reason as well as for forms of evaluation regarding what is viable and what should be supported. I'll return to the notions of viability and supportability in relation to art—as we now define it. How it is defined remains a question. Witness debates between faculty regarding viable curricula for an art school of the present, for example. How is expertise granted now, and what and who benefits from this designation? Is it primarily a bourgeois notion, comparable to other 19th-century designations for disciplines, and invented standards

277

meant to shore up professional territories and function as filters; or is it an aspiration for a consensus, to agree upon quality? A post-DIY regression? Can we think more carefully about education and capitalism, and how these have affected each other nationally and transnationally? At present, during the current economic collapse, this is particularly prescient. But some stories and histories may help move along the narrative I'm composing.

Some Formations. Some Contexts.
I've spent seven years in the U.S. since leaving the Academy of Fine Art in Vienna. Reflecting on my encounters related to education during this period may be of interest in the process of imagining future directions. Seeking a territory to enact what may be imagined as a further possibility for 'artistic research' was an objective. As Gilles Deleuze and Félix Guattari remind us in *What Is Philosophy?*:

> We need to see how everyone, at every age, in the smallest things as in the greatest challenges, seeks a territory, tolerates or carries out deterritorializations, and is reterritorialized on almost anything—memory, fetish, or dream.
> (Deleuze and Guattari 1994: 68)

In thinking about these past years, I've noted that I've often been reflecting on the notion of 'formations'. The following titles give an indication to some of what has informed this thinking, and in particular, this presentation: *The Education of Henry Adams. Sentimental Education. Ivy and Industry. Art Subjects. Conceptual Art: Theory, Myth, and Practice. Reading California. Age of Extremes. The New Spirit of Capitalism. Critique of Psychoanalytic Reason.*

Searching for places to perform the work of an artist-thinker continues to be a great challenge. I've now tested this possibility in different locations—from the University of California in Santa Barbara (UCSB), a research university; to a private art institute; as well as various independent-study programs. Part of what has been necessary in this endeavour has involved facing difficult evidence and addressing serious questions regarding how research is defined and perceived in all these different milieus—research university, art academies, art schools/institutes/colleges, and independent studies programs.

An interesting definition of artistic research that can be contemplated and further probed has been developed by Sha Xin Wei, Canada Research Chair, Media Arts and director of Topological Media Lab at Concordia University in Montréal. He describes how art research there differs from other forms of research:

Research in the arts is quite different from research in engineering, which in turn is different from scientific research. It is more akin to the humanities in its attention to the particular rather than the systemic, but it creates knowledge via aesthetic as well as critical inquiry, and engages material and embodied experience as well as concepts.

Like other modes of research, art research generates portable knowledge: it generates insights, how-to's, why's that can be shared by more than one individual; what is learned in the context of one art project can be applied in a different one. Like research in other domains, art research has its own archive, but whereas historians use textual archives, and anthopologists use materials gathered in fieldwork, art research's "body of literature" is the body of prior works and the critical commentaries surrounding them. Like other research, art research is open-ended, we cannot declare in advance what is the 'deliverable': if we already know the answer, then we would not need to do the research.

Art research is not the same as art practice. Why should that be the case? Not every artist shares her working knowledge with her peers, nor need she do so. Art practices range widely, and a large part of their vitality comes from their autonomous ways of making. (Sha 2008)

Various histories

Analysing experiences in education and art in the U.S. through an historical lens, and from a distance as an artist—since *distanciation*, even if temporary, is one of the historically distinguishing possibilities of being an artist and a thinker—as well as creating and writing works and making presentations such as this, has been enabling. Looking at the conditions of artists past and present is a part of this examination of what has been possible and generative. Given that 'artistic research' is little valued in the composition of what has institutional meaning (monetary revenue being of prime concern), and facing lack of support of various kinds, it was necessary to develop an institute within an institute to create sufficient temporary autonomy to experience the desired knowledge-pleasure 'sanctuary', if even for one day a week. This was enacted for five years via *Spheres of Interest: Experiments in Thinking and Action*, a graduate seminar and lecture series that allowed encounters with questions of meaning and engagement, and that functioned as an adaptation of an invisible college.[3]

3 See Green, Renée. 'Spheres of Interest' (Blog). Online at: http://spheresofinterest.blogspot.com (consulted 31.03.2011).

Nomadic and homeless: conceptual art and some consequences
The notion of an invisible college references an essay by Michael Corris, 'An Invisible College in an Anglo-American World' (introduction to Corris 2004), in which he provides an historical analysis of Art & Language, of which he was a part. The notion of 'conceptual art status as an art in exile', and the notion of the early 1970s of conceptual art as a manifestation of 'the artist out of work' or a 'homeless art of the cultural displaced', still resonate.

> Art & Language continues to promote the view of Conceptual art as a practice that emerged unexpectedly out of a desire to resist a notion of professional competence in art. They assert that it had become increasingly apparent to a generation of artists coming of age during the 1960s that "art objects now depended upon a framework of supporting institutions". This led them and others to the conclusion that "what was required was not so much 'works' as work on the circumstances of work". The problem became a search for ways to "go on". (Corris 2004: 2)

Exploring the history of the term 'invisible college' is useful in understanding the duration and permutations of the ideas related to it, and how these resurgences can be understood in relation to the topic of 'artistic research', re-examinations of conceptual art, and recurring notions of the commons:

> The idea of an invisible college became influential in seventeenth century Europe, in particular, in the form of a network of savants or intellectuals exchanging ideas. This is an alternative model to that of the *learned journal*, dominant in the nineteenth century. The invisible college idea is exemplified by the network of astronomers, professors, mathematicians, and natural philosophers in 16th century Europe. Men such as *Johannes Kepler, Georg Joachim Rheticus, John Dee* and *Tycho Brahe* passed information and ideas to each other in an invisible college. One of the most common methods used to communicate was through *marginalia*, annotations written in personal copies of books that were loaned, given, or sold. … The term now refers mainly to the free transfer of thought and technical expertise, usually carried out without the establishment of designated facilities or institutional authority, spread by a loosely connected system of *word-of-mouth* referral or localized bulletin-board system, and supported through barter (i.e. trade of knowledge or services) or apprenticeship. In earlier times the term also included certain *Hegelian* aspects of *secret societies* and *occultism*…
> The invisible college is akin to the old guild system, yet holds no sway in recognized scholastic, technical or political circles. It is merely an attempt to circumvent bureaucratic or monetary obstacles by knowledgeable individuals and civic groups. Said entities generally feel a need to share their methods with fellow journeymen,

so to speak, and to strengthen local techniques through collaboration. Members of an invisible college are often today called *independent scholars*.[4]

In thinking further today about the idea of an 'invisible college', Corris offered the following observation, made in the context of a reflection on the way the knowledge economy embraces communication at a distance; which suggests the requirement by concerned parties for a tactical move in the direction of face-to-face contact:

> The only program that is ethical, in my view, is one that has *nothing to do with the pedagogical model of the academy* ... even "invisible college" presumes too much these days, as we *harvest our atomic friends*. There is good reason to *keep the dream of collectivity alive*.[5]

In all of these ruminations it seems necessary to remember what relates to art, in its fullness and possible profundity, recognizing that its infinite possibility was most likely the initial magnet for engaging at all with an endeavour now being described as 'artistic research'. This includes the history and debates surrounding conceptual art. Such exemplary examples as Art & Language, the Whitney Independent Study Program, Maumaus School of Visual Arts, and various publications and related materials now becoming more available, demonstrate moments of rigorous research related to art, aesthetics, politics, culture, and contact, focused on particular histories and debates pertaining to art in its most complex sense. I've noted that this kind of specificity to an historical reference often falls out of discussions and projects in art schools and art programs when research is promoted without the above-mentioned framework or formation, to the disadvantage of both the endeavours of art and of research. From my perspective as an artist, following the trajectories of Douglas Huebler and Thomas Lawson—both Deans at an art school, Cal Arts—and continuing to make work, making the school part of the 'artistic research' and developing works inspired by these paradoxes and complexities, has been enriching.

 Critical choices are still possible amidst a barrage of options and in spite of Attention Deficit Disorder (ADD), which is something I first encountered

--

4 *'Invisible College'*. Online at: http://en.wikipedia.org/wiki/Invisible_College (consulted 20.06.2010); Corris references the historical 'invisible college' in Corris (1972).

5 Private correspondence with the author, 19 May and 4 July 2010.

at UCSB when students began describing their 'disability' and that they would need special attention devoted to it by me as an instructor. I learned more about these designations and symptoms while working and living in California, a place where new humans have emerged in circumstances about as distant as can be imagined from Kant's intellectual formation and existence, something to consider when thinking about how we consider reason and its applications and how these can now be received.

Ivy and industry shortfall: a conundrum of increased public funding need vs. increased reliance on the private sector

To discuss the present, it is necessary to understand the genealogy that affects the current structures in terms of higher education. One significant difference between Anglo-American models and the European system is that profit has been a major impetus in the organisation of higher education in the U.S. (Newfield 2003).

I'm being somewhat reductive, and sketching this in very broad strokes, but in what I'm outlining are indications of what can be recognised in relation to current conditions that we're discussing. This is not surprising if the larger history of the 'new world' is considered in terms of European mercantile expansion, which in the present we can think about as historically different, yet analogous to globalisation. It is important to recognise this, especially when we discuss what it is possible to realise and what the stakes have been to create situations in which ideas and creation can flourish. Ideas have been possible, but always in a state of embattlement—at someone's cost—and this continues, although the stakes are now even higher. This is part of what is unseen or forgotten, yet becomes apparent when one probes the history of even the most esteemed U.S. thinkers. Partly this can be traced to a tension between an evasion of modern European philosophy (Emerson's Transcendentalism) and projective Manifest Destiny. The struggles to create spaces for knowledge, investigation, and creativity have in the U.S. been primarily linked to industrial and military purposes—and paradoxically also with humanist goals—thus the recurring pragmatic dimension, suggested by the title *The American Evasion of Philosophy: A Genealogy of Pragmatism* by Cornel West.

My perspective is influenced by the times we live in and the evidence that is unavoidable. This is particularly apparent now in the State of California, an imagined paradise for various reasons, among which has been its system of public higher education embodied by the University of California, which has been until now a site for a proliferation of invention, research, and a knowledge-creation base for artists who may be particularly esteemed and

282

emulated for having instigated what can be considered numerous forms of 'artistic research'. These include Allan Kaprow, Eleanor Antin, David Antin, Helen Mayer Harrison and Newton Harrison, Paul McCarthy, John Baldassari, Chip Lord, Babette Mangolte, Steve Fagin, Bruce Yonemoto, Trinh T. Minh-ha and in more recent years Mary Kelly, Barbara Kruger, Teddy Cruz, Yvonne Rainer, Kyong Park, and Trevor Paglen, to name a scant few.

But there is the myth; and there are the conditions. To understand the dynamic of struggle I'm describing, an historical analysis of ways artists have attempted to develop platforms within research universities would be needed; and this is too cumbersome an investigation for this presentation. Instead I've engaged in discussions with artists and colleagues involved in research and in art, who've shared data [*another keyword*] with me, and investigated further towards developing some ideas regarding what seems possible given the circumstances—these being that private funding dominates even the public higher education sector in California, as well as that of private educational institutions. This is in addition to the revenue generated from tuition, which has continually increased while infrastructural needs and academic delivery have declined.

Social geographer Gray Brechin has noted that public education and the concept of the public good have not been advocated since the advent of both the Reagan and Thatcher regimes. Using the University of California (UC) as his example, he notes that in 1967 the public university was free. Now merely tuition is roughly $10,000 per year. The listed UC Berkeley graduate student expenses for California residents per year is $34,286, and $49,526 for non-residents. He describes how the notion that the marketplace should be applied to the public trust increased during Reagan's tenure. He notes that 'if the University of California goes down', this is not simply a U.S. symptom or issue, but rather something of worldwide significance, as it has been a model of what a public research university can effect in the world. The processes of privatisation have been in motion for sometime though, as private individuals and corporations supplanted the public contribution to the university, and in the process have affected the kind of work that gets done. The first big invasion, he observes, was enacted toward UC in the 1990s by Novartis, a chemical agricultural company, and more recently by British Petroleum, with a 500 million dollar 'donation'. He summarises the ensuing processes like this: 'In turn the curriculum becomes radically skewed, because it has its own gravitational field based on the influence of the investors'.

The belief that there is no alternative, he insists, is not true. This was disproven, he claims, by lessons learned—and since forgotten—during the New Deal. As a means to challenge a depressing perception of stuckness,

283

Brechin continues to explore this earlier California history in the *Living New Deal Project*, as a means to utilise other models of what can be possible in the present.[6]

These observations regarding higher education in California and the deficit toward the public are further affirmed by Christopher Newfield in *Avoiding the Coming Higher Ed Wars*. From his perspective, in 2010, he states:

> I am going to focus on what Californians learned in the last year: that higher education leaders are still unable to demonstrate the necessity of rebuilding public funding...
>
> [W]e need to appreciate the structural nature of the funding crisis. California's appalling decline predated the most recent cuts and was produced not by economic downturns but by the American funding model that has reshaped higher education over the past thirty years. The United States relied on low tuition to ensure mass access when it led the world in measures of educational quality and attainment. The American model, however, depends on private funds from students and their families to a greater extent than any other national funding model, and U.S. colleges and universities now charge some of the highest tuitions in the world.
>
> The American funding model has done well at raising tuition and donations and poorly at raising educational attainment. Having the best of both worlds—families willing to pay a premium to send their children to elite colleges and taxpayers willing to provide generous public funding—held the model together. While public funding was high, public universities could function as part of one differentiated but still relatively integrated and generally superior tertiary system. But public funding per student has been flat or falling for nearly thirty years, and this has gradually eroded quality and affordability for the 80 percent of college and university students who attend public institutions. Recent drastic cuts now threaten to make U.S. higher education a tale of two systems: one rich, one poor, much like our mediocre K–12 schools.
>
> The California experience needs to be pondered carefully. It reveals the unvarnished truth that the American funding model isn't a synthesis of opposites but a now unraveling self-contradiction. That is because its success on one side causes its failure on the other: its success with private funding, especially with tuition increases, has helped reduce public funding. (Newfield 2010)

284

6 'Raw Deal for Education' *Against the Grain: A Program about Politics and Culture*. Online at: http://www.againstthegrain.org (consulted 20.06.2010); California's Living New Deal Project. Online at: http://livingnewdeal.berkeley.edu (consulted 20.06.2010).

Conclusion

The importance of creating working bases, nodes, and networks with others; to be able to work, think, and create—beyond corporatised social networks, even when we labour within corporatised universities and art schools—is an inventive necessity, akin to what Isabelle Stengers suggests in her phrase, 'reason's sense of humour', which she describes as an example of 'new ways of working together'. She mentions this in relation to her collaboration with Léon Chertok and the heretical positions they may have both been assigned in their fields; he as a psychoanalyst challenging the basis of the psychoanalytic institution and she as an epistemologist who continues to raise questions and,

> [W]ho doesn't believe that we know—or even that we can know—what reason might be capable of, and who sees in the epistemological discourses on the singularity of modern science a futile effort to found on principle what is clearly a historical fact: namely, that in certain fields and under certain conditions humans have discovered a new and history-producing way of working together. This position opposes her not only to other epistemologists but also to all scientists and critics of science who feel the need of conferring an identity on science. Usually this identity is intended to justify—or condemn—as inevitable categories, and what remains, which is only a subjective appearance. That this split can be *justified* "in the name of science" or "in the name of reason" and not evaluated in its risks and relevance is for her an indication of what remains to be invented: new ways of working together, or what might be called reason's sense of humor. (Chertok and Stengers 1992: xxii)

One such example I recall of a sort of collaborative experiment, that can be understood in relation to artistic research even if it wasn't designated as such, occurred at an arranged meeting between Isabelle Stengers, Friedrich Kittler, Penelope Georgiou, and myself in Vienna during 1993; it was organised by several people who were then evidently interested in exploring what I'd interpret as 'reason's sense of humour': Diedrich Diedrichsen, Stephan Geene, Stella Rollig, Sabeth Buchman, and Jutta Koether. The combination of guest participants was originally meant to include Félix Guattari, who passed away before we could convene.

The meeting was an attempt to create a different form of engagement by means of experimentation—for example, the physical arrangement of creating a non-hierarchical seating, not based on the proscenium, between the guest participants and the audience; or providing immediate reactions to film clips, as well as on-the-spot reactions to questions. This produced improvisational and intuitive modes of engagement, based on diverse forms of knowledge.

Stenger further elaborates on such possibilities, in her description of the Gilles Deleuze and Félix Guattari working combination, which I interpret as an *instanciation of potential*, enacted via 'reason's sense of humour' or the bracing challenge of thinking with another:

> One way or another, when Deleuze did encounter Guattari, the problem did change. The philosopher is no longer thinking by proxy but together with what Americans call an activist, the untiring actor, thinker, cartographer and connecter of collective processes of deterritorialisation, of creations of collective assemblages of enunciation, that are less against capitalism than produced in an affirmative experimental process of escape from both the plane of capital and the plane of subjection. Thinking with Guattari excluded the subjective, depressive complaint—how to be a philosopher in front of solitary heroes, whose ordeal, beyond the limits of sense, may inspire shame to the one who remains on the bank, commenting. Indeed the point was no longer, could no longer be, how to rejoin Artaud, just as Artaud himself, for whom writing was writing "for" the illiterate, "for" the agonizing rat, or the slaughtered calf, did not mean he identified himself with an illiterate, a rat or a calf. The point is becoming and a becoming is always double. (Stengers s.d.)

286 I can recall many different experiments with knowledge and art that can be termed 'artistic research', a necessarily broad designation, despite our specific developing definitions. The slideshows that accompanied this talk presented some examples. Understanding the potential of our various operations, and the continuing efforts needed to create and enact different modes of knowledge despite the obstacles that exist, is crucial—*soul-sustaining* rather than soul-killing.

References

Chertok, Léon and Isabelle Stengers. 1992. *Critique of Psychoanalytic Reason: Hypnosis as a Scientific Problem from Lavoisier to Lacan.* Stanford: Stanford University Press.

Corris, Michael (ed.). 2004. *Conceptual Art: Theory, Myth and Practice.* Cambridge: Cambridge University Press.

Corris, Michael. 1972. 'The Fine Structure of Collaboration' in *Art-Language* 2 (3): 34-37.

Deleuze, Gilles. 1995. *Negotiations.* New York: Columbia University Press.

Deleuze, Gilles and Félix Guattari. 1994. *What Is Philosophy?* New York: Columbia University Press.

Grinnell, Claudia K. 2009. 'From Consumer to Prosumer to Produser: Who Keeps Shifting My Paradigm? (We Do!)' in *Public Culture* 21(3): 577-598.

Newfield, Christopher. 2003. *Ivy and Industry: Business and the Making of the American University, 1880-1980.* Durham: Duke University Press.

—2010. 'Avoiding the Coming Higher Ed Wars' in *Academe* 96(3). Online at: http://www.aaup.org/AAUP/pubsres/academe/2010/MJ/feat/newf.htm (consulted 20.06.2010).

Sha, Xin Wei. 2008. *Art Research?* Unpublished manuscript. Concordia University, Montréal.

Stengers, Isabelle. s.d. *Gilles Deleuze's Last Message.* Online at: http://www.recalcitrance.com/deleuzelast.htm (consulted 20.06.2010).

West, Cornel. 1989. *The American Evasion of Philosophy: A Genealogy of Pragmatism.* Madison: University of Wisconsin Press.

287

Weblinks

http://en.wikipedia.org/wiki/Invisible_College (consulted 20.06.2010).

http://livingnewdeal.berkeley.edu (consulted 20.06.2010).

http://spheresofinterest.blogspot.com (consulted 31.03.2011).

http://www.aaup.org/AAUP/pubsres/academe/2010/MJ/feat/newf.htm (consulted 20.06.2010).

http://www.againstthegrain.org (consulted 20.06.2010).

http://www.recalcitrance.com/deleuzelast.htm (consulted 20.06.2010).

CURRICULUM VITAE

Gina Badger is an artist and writer working in the expanded field of sculpture and installation. Her favoured research methods include listening, walking, eating, and drinking. Gina has presented work at celebrated international venues including The Kitchen (NYC); LACMA (Los Angeles); Issue Project Room (NYC); and the London School of Economics and Political Science, and her writing has appeared in *Scapegoat Journal, Public Journal, and Byproduct: On the Excess of Embedded Art Practices* (YYZ). Currently working between Toronto and Montreal, Badger holds an M.S. in Visual Studies from MIT. A collaborator at heart, Gina is a member of the Montreal-based Artivistic Collective, and is currently the editorial director of *FUSE* Magazine.

Ute Meta Bauer is an associate professor and head of the Program in Art, Culture and Technology at MIT's School of Architecture and Planning. Previously Bauer was professor and head of the Institute of Contemporary Art at the Academy of Fine Arts Vienna. She studied stage design and art at the HfbK Hamburg, and for more than two decades, she has worked as a curator of exhibitions and presentations on contemporary art, film, video, and sound with a focus on transdisciplinary formats. Bauer was a co-curator of *Documenta 11* on the team of Okwui Enwezor, the Artistic Director of the 3^{rd} *Berlin Biennale* and served as the Founding Director of the Office For Contemporary Art Norway (OCA). Her publications include *Education, Information, Entertainment. New Approaches in Higher Artistic Education* (Edition Selene, Vienna, 2001.)

Henk Borgdorff is professor of Research in the Arts at the University of the Arts, The Hague (The Netherlands) and visiting professor of Aesthetics at the Faculty of Fine, Applied and Performing Arts of the University of Gothenburg (Sweden). Editor of the *Journal for Artistic Research* and co-project leader of *The Artistic Research Catalogue*, an international project to develop a digital repository for the exposition of artistic research work. Chair of the working group on validation of SHARE – academic network (Erasmus/ELIA). Chair of the International Quality Board of the Konstnärliga forskarskolan (the national school for artistic research in Sweden). Member of the Strategic Working Group on Research of the HBO-raad (The Netherlands Association of Universities of Applied Sciences). Former secretary of the board of the Dutch Association of Aesthetics. Founding editor of *Dutch Journal of Music Theory*. Honorary member of the Dutch-Flemish Society for Music Theory. His teaching and research concerns the theoretical and political rationale of 'artistic research'.

Paul Carter is a writer, sound artist, and designer based in Melbourne, Australia. New publications include *Ground Truthing: Explorations in a Creative Region* (University of Western Australia Publishing, 2010) and *The Saving Face of Death: anthropology and the scene of knowing*, in *Beyond Text?* edited by Rupert Cox, Andrew Irving, and Christopher Wright, forthcoming Manchester University Press. He is professor of Creative Place Research, Deakin University and the Creative Director of Material Thinking design studio.

Florian Dombois, born in 1966 in Berlin, is an artist who has focused on landforms, labilities, seismic and tectonic activity, scientific and technical fictions, as well as on their various representational and media formats. In order to extend his artistic development, Dombois studied geophysics and philosophy in Berlin, Kiel, and Hawaii. From 2003 to 2011, he was a professor at the Bern University of the Arts and founded the Institute Y. In 2010 he received the German Sound Art Award and Kunsthalle Bern edited a monography *Florian Dombois: What Are the Places of Danger. Works 1999-2009* at argobooks Berlin. He is now a professor at Zurich University of the Arts.

Bracha L. Ettinger is a visual artist working mainly in painting, drawing, photography, notebooks and artist's books, conversation and writing. Exhibitions include shows at Stedelijk Museum, Amsterdam (1996); Kiasma, Helsinki (2006); and Centre G. Pompidou, Paris (*Face a L'Historie*, 1996, *elles@pompidoucentre*, 2010). Solo exhibitions include shows at Musée des Beaux-Arts d'Angers (2011); *Alma Matrix* (dual ex.) at Fundació Antoni Tàpies, Barcelona (2010); Freud Museum, London (2009); the Finnish Academy of Fine Arts, Helsinki (2009); and the Drawing Center, New York (2001). Recent performance/installation and lecturing 'encounter-events' include ICI, Berlin (2010), Poznańskie Towarzystwo Przykaciół Nauk, Poznań (2011), and Ars Nova Museum, Turku (2011). As an artist/psychoanalyst and artist/philosopher, she is the author of numerous articles and a few books on aesthetics and ethics and a chair and professor of Psychoanalysis and Art, Media & Communications EGS. Two books dedicated to her art: *Art as Compassion. Bracha L. Ettinger* (eds. C. de Zegher & G. Pollock) and *Le Cabinet de Bracha* (ed. P. Le Nouene) appeared in 2011.

Sabine Flach is a visiting professor at School of Visual Arts, New York. Studied art history, theory of literature, philosophy and humanities in Marburg, Perugia, Kassel, and Berlin. She has held positions at TU Berlin, HU Berlin, the University of Hamburg, and the University of Kassel. She was a guest professor at Mills College San Francisco in autumn/winter 2003. From

2000 to 2010 she was at the Centre for Literary and Cultural Studies in Berlin, heading the department WissensKünste - Art of Knowledge and Knowledge of Arts. Her research and teaching cover fields ranging from art and art theory to science studies and interdisciplinary issues of modern and contemporary art. Special focuses include knowledge of the arts, epistemology and aesthetics of visual thinking; art theories and art history and their relationships with cognitive, neuro and life sciences; and perceptual psychology. She has (co-) authored numerous books on these topics.

Renée Green is an artist, filmmaker, and writer. *Ongoing Becomings*, a survey exhibition of 20 years of her work, was organized in 2009 by the Musée Cantonal des Beaux-Arts, Lausanne; the book *Endless Dreams and Time-Based Streams*, 2010, was published following her survey exhibition of the same title at the Yerba Buena Center for the Arts, San Francisco. Green is currently an Associate Professor at MIT Program in Art, Culture and Technology, School of Architecture and Planning, and a guest faculty member of the Whitney Independent Study Program in New York and Maumaus – Escola de Artes Visuais, Lisbon.

Penelope Haralambidou is a researcher and lecturer at the Bartlett School of Architecture, UCL, where she coordinates Unit One and the MPhil/PhD Architectural Design. Her work lies between architectural design, art practice, experimental film, and critical theory and has been published and exhibited internationally. She is the author and editor of *The Blossoming of Perspective: A Study* (DomoBaal Editions, 2007), and she has contributed writing on themes such as allegory, figural theory and stereoscopy in architecture to a wide range of publications. She is currently completing a book with the working title *Marcel Duchamp and the Architecture of Desire*, for Ashgate's Design Research in Architecture series. Her research has been funded by the Arts and Humanities Research Council, Architecture Research Fund and Graduate School, UCL, and was shortlisted for the prestigious RIBA President's Awards for Research in 2008.

Florian Hecker, born in 1975 in Augsburg, Germany, deals with specific compositional developments of post-war modernity, electroacoustic music as well as other, non-musical disciplines in his installations, live performances, and publications. He dramatizes space, time, and self-perception in his sonic works by isolating specific auditory events in their singularity, thus stretching the boundaries of their materialization. Their objectual autonomy is exposed while simultaneously evoking sensations, memories, and associations in an immersive intensity. Recent performances include *Push & Pull*, Tate Modern,

London, 2011; *Instal, Tramways*, Glasgow, 2010; *Hebbel am Ufer*, Berlin, 2010. Solo exhibitions include shows at MMK Museum für Moderne Kunst, Frankfurt (2010), Chisenhale Gallery, London (2010), Bawag Contemporary, Vienna (2009) and Sadie Coles HQ London (2008).

Tom Holert, born in 1962, is an art historian, critic, curator, and artist. A former editor of *Texte zur Kunst* and *Spex*, he currently lives in Berlin and teaches at the Academy of Fine Arts Vienna where he holds the chair of Epistemology and Methodology of Art Production. At the Academy he co-coordinates the Centre for Art/Knowledge and the PhD in Practice. Alongside his writings on contemporary and late modernist art and theory, Holert has (co-)authored books on visual culture, politics, war, mobility, glamour, and the governmentality of the present. As an artist Holert recently participated in *Mimétisme* (Extra City, Antwerp, 2007), *Manifesta 7* (Trento 2008), *Fake or Feint* (Berlin 2009), *Modernologies* (MACBA, Barcelona, 2009 and the Museum of Modern Art in Warsaw, 2010), and *8ᵗʰ Gwangju Biennale 2010*.

Sarat Maharaj is currently professor of Visual Arts and Knowledge Systems at the Malmö Art Academy, Lund University. Maharaj was born and raised in South Africa. In 1980 he moved to London and began his doctoral thesis in Art History at Goldsmiths College where he was later appointed Professor of Art History and Art Theory until 2005. Maharaj has published a number of key texts on postcolonial inquiry and notions of cultural difference and translation as well as on art as knowledge production. Sarat Maharaj was the co-curator of the *29ᵗʰ São Paulo Biennial* in 2010 as well as for the *3ʳᵈ Guangzhou Triennale* in 2008 with the theme of *Farewell to Postcolonialism*. In 2002 he co-curated *Documenta XI* in Kassel with Okwui Enwezor. Maharaj is a board member of the European Biennial Manifesta.

Claudia Mareis, born in 1974 in Zermatt, is a designer and cultural scientist specializing in design theory, design history, and design methodology. She holds a research position at eikones, The National Centre of Competence in Research (NCCR) of Iconic Criticism at the University of Basel. Her current research project focuses on the history and practice of creativity and ideation techniques in the short 20ᵗʰ century. Claudia Mareis is a regular lecturer at several art universities in Switzerland and Germany. Since October 2011 she has been a member of the expert panel for art and design research at the Swiss National Science Foundation. Furthermore she is a board member of the German Association for Design Theory and Research, and a member of the Board of International Research in Design at Birkhäuser Publisher.

Sónia Matos, born in 1978 on Azores Islands, is a designer and Context lecturer at Edinburgh College of Art (Design School). Her work intersects ethnography, conceptual tool design, participatory interventions, and writing in ways that attempt to mobilize and reactivate vernacular and culturally situated forms of knowledge in relation to their local ecosystems. For her most recent doctoral project (Centre for Cultural Studies, Goldsmiths College, University of London), Sónia spent four years studying a whistled form of language known as the Silbo Gomero (island of La Gomera, Canarian Archipelago). In close collaboration with the island's community, she developed an ethnographic study of this form of language and designed mediated forms of sensorial exploration that are now used by the local youth in the island's schools.

Jonathan Miles is an artist and a writer who trained at the Slade School of Art (1969-73). He is currently working at the Royal College of Art in the Department of Critical and Historical Studies. His most recent pre-occupation has been work on the interfacing of fiction and painting. He has also published a series of essays on works by artists including Haris Epaminonda, Daniel Gustav Cramer, Mustafa Hulusi, and Ailbhe Ni Bhriain. For him, research highlights both the frustrations of articulating any meaningful relationship between art and theory and the potentiality of opening up new ways of relat- 293 ing object and text to different practices of knowledge.

Raqs Media Collective (Monica Narula, Jeebesh Bagchi, Shuddhabrata Sengupta) have been variously described as artists, curators, editors, and catalysts of cultural processes. Their work, which has been exhibited widely in major international spaces and events, locates them along the intersections of contemporary art, historical inquiry, philosophical speculation, research and theory—often taking the form of installations, online and offline media objects, performances and encounters. They live and work in Delhi, partly based at Sarai, Centre for the Study of Developing Societies, an initiative they co-founded in 2000. They are members of the editorial collective of the Sarai Reader series, and have curated *The Rest of Now* and co-curated *Scenarios* for *Manifesta 7*.

Hans-Jörg Rheinberger is Director of the Max Planck Institute for the History of Science in Berlin and a Scientific Member of the Max Planck Society. He teaches history of science at the Technical University of Berlin. Trained as a philosopher and as a molecular biologist, he has written extensively on the history and epistemology of the life sciences. He also tries to explore relations between the sciences and the arts. Among his books are *Toward a History of Epistemic Things* (1997), *On Historicizing Epistemology* (2010), and *An Epistemology of the Concrete* (2010).

Hannes Rickli studied photography and theory of design and art. He teaches as professor ZFH at the Zurich University of the Arts. Solo and group exhibitions (selected): *Art with Experimental Systems*, Kunstmuseum Thun, 2011; *Videogramme*, Helmhaus Zurich, 2009; *Aggregat Chemnitz*, Galerie Weltecho, Chemnitz, 2008; *Say It Isn't So: Art Trains Its Sights on the Natural Sciences - Naturwissenschaften im Visier der Kunst*, Weserburg, Museum für moderne Kunst, Bremen, 2007. His most recent publication is Hannes Rickli (ed.), *Videograms. The Pictorial Worlds of Biological Experimentation as an Object of Art and Theory*, Zurich 2011.

Michael Schwab is an artist and artistic researcher who investigates post-conceptual uses of technology in a variety of media including photography, drawing, print-making, and installation art. He holds a PhD in photography from the Royal College of Art that focuses on post-conceptual post-photography and artistic research methodology. He is a tutor at the Royal College of Art, London, research associate at the Bern University of the Arts, Switzerland, and research fellow at the Orpheus Institute, Ghent. He has presented his art and research in a number of publications, exhibitions, keynote lectures, conference papers, and seminars. Since 2003 his exhibitions and associated events have increasingly focused on artistic research, and he has been a collaborator and advisor on a number of research projects. He is co-initiator and inaugural Editor-in-Chief of JAR, *Journal for Artistic Research*.

Henk Slager is dean of the Utrecht Graduate School of Visual Art and Design (maHKU), where he is professor of Artistic Research and general editor of *maHKUzine, Journal of Artistic Research*. He is visiting professor in Theory and Artistic Research at the Finnish Academy of Fine Arts. Henk Slager was one of the curators of the *2008 Shanghai Biennale* and, among other curatorial and academic practices, has been a tutor at De Appel's Curatorial Program since 1994.

Marcus Steinweg is a philosopher. He was born in 1971 and lives in Berlin.

Hito Steyerl is a filmmaker and writer, and lives in Berlin. She studied cinematography in Tokyo and Munich, and holds a PhD in philosophy. She is Professor of New Media Art at University of the Arts Berlin. Exhibitions include Documenta 12, as well as biennials in Shanghai, Gwangju, Taipeh, Berlin, and many other places.

Jan Svenungsson, born in 1961 in Lund, Sweden, is a visual artist based in Berlin. He is interested in vertical construction, serial repetition, the creativity of translation, and the intelligence of failure. In 2008 the book *Building Chimneys* was published by Atlantis, Stockholm. Svenungsson was professor of photography at the School of Photography and Film in Gothenburg, Sweden 1996-2000; professor for artistic research at the Academy of Fine Arts in Helsinki, Finland 2007-2009; from 2011 he has been professor for printmaking at the University of Applied Arts, Vienna.

Alise Upitis received her PhD from MIT's department of architecture, where her research considered how norms and the idea of nature were re-conceptualized for design under the impact of early computer-related technologies. She has been a visiting scholar in the archive of the Center for Advanced Visual Studies, investigating how artists' practices have operated as modes of research and knowledge production. She works as public art curator at the MIT List Visual Arts Center. Recent and forthcoming publications are included in the edited volumes *Computational Constructs* (China Architecture & Building Press), *A Second Modernism* (SA + P Press), and *N52: On Art + Research* at MIT (ACT MIT).

Francisco Varela (1946-2001) worked with Humberto Maturana at the University of Chile on *Autopoiesis and Cognition* (1972)—a fresh approach to understanding the biological organism that he developed independently in *Principles of Bioloigical Autonomy* (1979). With the overthrow of the Allende government in 1973 he was forced to flee Chile. During the troubled period that ensued he came into contact with Tibetan Buddhist teachings. It contributed to shaping his intellectual outlook—the ability to cut across the empirical sciences, philosophy, and Buddhist psychology with academic rigour but without academic straightjacketing. Not least, we see this in his contribution to the exhibition *Laboratorium* (1999) curated by Hans Obrist and Barbara Vanderlinden.

COPYRIGHT

Photo Credits
Haseeb Ahmed: p. 266; CAVS/MIT.: p. 262, fig. 2; Free Agent Media: p. 276; Andy Keate: pp. 141, 142, 155; Le Nouveau Musee, Villeurbanne (P. Durand): pp. 198–202, 205–209; Gunter Lepkowski: p. 157; Otto Piene: p. 262, fig. 1; Hannes Rickli: pp. 103, 106; Hannes Rickli/Matthias Rickli: p. 107; Matthias Rickli: pp. 110, 111; Michael Schwab: pp. 238, 239; Henk Slager: pp. 44, 45, 49.

The historical pictures on p. 129 are retrieved from:
Fig. 1: Klotz, Heinrich (ed.) 1991. *Matjuschin und die Leningrader Avantgarde* (Catalogue of the correspondent exhibition. ZKM Karlsruhe). Stuttgart and Munich: Oktogon, 124.
Fig. 2: Barck, Karlheinz. 2002. 'Die Russische Akademie der künstlerischen Wissenschaften als europäischer Inkubationsort' in *Trajekte. Zeitschrift des Zentrums für Literaturforschung* 4: 4.

COLOPHON

Editors: Florian Dombois, Ute Meta Bauer, Claudia Mareis, Michael Schwab
Design: Fabienne Meyer
Cover Image: Florian Dombois, photo on the depicted advertisement by Osborne & Little
Production: DZA Druckerei zu Altenburg GmbH

This publication has been realized with the kind support of Institute Y of Bern University of the Arts, FSP Transdisziplinarität of Zurich University of the Arts, the Royal College of Art London and the MIT Program in Art, Culture and Technology.

First published by Koenig Books, London

Koenig Books Ltd
At the Serpentine Gallery
Kensington Gardens
London W2 3XA
www.koenigbooks.co.uk

Printed in Germany

ISBN 978-3-86335-118-2

Berner Fachhochschule
Bern University of Applied Sciences
Hochschule der Künste Bern
Bern University of the Arts

hdk
Zürcher Hochschule der Künste
Zurich University of the Arts

Royal College of Art
Postgraduate Art and Design

ΠCT
MIT program
in art, culture and
technology
School of Architecture + Planning

DISTRIBUTION

Buchhandlung Walther König, Köln
Ehrenstr. 4, 50672 Köln
Tel. +49 (0) 221 / 20 59 6 53
Fax +49 (0) 221 / 20 59 6 60
verlag@buchhandlung-walther-koenig.de

Switzerland
AVA Verlagsauslieferungen AG
Centralweg 16
CH-8910 Affoltern a.A.
Tel. +41 (44) 762 42 60
Fax +41 (44) 762 42 10
verlagsservice@ava.ch

UK & Eire
Cornerhouse Publications
70 Oxford Street
GB-Manchester M1 5NH
Tel. +44 (0) 161 200 15 03
Fax +44 (0) 161 200 15 04
publications@cornerhouse.org

Outside Europe
D.A.P. / Distributed Art Publishers, Inc.
155 6th Avenue, 2nd Floor
USA-New York, NY 10013
Tel. +1 (0) 212 627 1999
Fax +1 (0) 212 627 9484
eleshowitz@dapinc.com

ISBN 978-3-86335-118-2

9 783863 351182